THE
INTERNATIONAL
DESIGN
YEARBOOK

THE INTERNATIONAL DESIGN YEARBOOK 4

EDITOR ARATA ISOZAKI

GENERAL EDITOR NONIE NIESEWAND

ASSISTANT EDITOR JANET LAW

ABBEVILLE PRESS · PUBLISHERS · NEW YORK

ISBN 0–89659–890–X

This book was designed and produced by **John Calmann and King Ltd,** London

Designer: Mikhail Anikst
Typeset by Suripace Ltd, Milton Keynes
Origination by Colorlito, Milan
Printed and bound in Italy

First edition

The publisher and editors would like to thank the designers and manufacturers who submitted work for inclusion in this book; Peter and Junko Popham for their help in collecting Japanese contributions; and the following photographers and copyright holders for use of their material: Olaf Akhøj (1.105); Gil Alkin (3.54-59); Amedeo (3.23); Kyrre Andersen (2.23-24); Alfredo Anghinelli (1.71); © Aram Designs Ltd (1.17, 1.27, 1.42, 1.46, 1.56, 1.77, 1.85, 1.122, 1.124, 1.131, 1.132, 1.144, 2.15); David Arky (4.45); Allison Atkinson (4.46-47); Attilo del Commune (3.60); Daniel Aubry (1.95); Studio Azzuro (2.21); Aldo Ballo (1.6-7, 1.93, (1.116); Bella & Ruggeri (1.12, 1.62); Bitetto-Chimenti (3.44, 5.70); © Maryse Boxer Designs (3.12); Richard Bryant (1.112-115); Santi Caleca (1.48); Mario Carrieri (3.10, 3.71, 5.64); Graham Challiflour (1.36-37, 2.48); Robin Chapaker (2.25, 5.42); Joseph Cosica (1.10, 1.133, 4.18, 4.22); Kim Crowder (1.107); Richard Davies (1.41, 1.47, 1.51, 1.123); © Donghia Furniture (1.43); Martin Doyle (5.9); Nena Duncan (1.44); Ferran Freixa (1.50); Ilvio Gallo (3.40); John Garbarini (3.61); André Giese (1.138); Arch. G.N. Gigante (2.44); Michael Glover (1.39); Robly A. Glover Jr (2.46); Gröh, Rosenthal-Selb (3.11); Richard Hackett (2.33); Katsuo Hanzawa (1.81); Hiroyuki Hirai (1.88, 1.90); Philippe-Louis Houze (5.53); Impuls (2.40); Gerhard Jaeger (3.67); David Keister, Echo Press (3.45); Simon Kentish (1.40); Howard Kingsnorth (1.3); Jeffrey Krein (4.1, 4.42); Yoshiyuki Kurata (1.1); Jack Lenor Larsen (4.44); John McCarthy (4.27); Chris M. McElhinny (1.74); Ian McKinnell (1.26); Malaret (1.143); Roger Mann (2.36); Shari Mendelson (3.28); MID 1988 (3.42-43); Mineo (1.135); S. Mosna (2.42); Tessa Musgrave (3.62); S. Muto (1.2); Geoffrey Nelson (5.52); Hans Nielsen Industriofotografering (1.57); Northlight Studios (2.43); Kent Nyberg (1.127); Takayuki Ogawa (1.32); © OMK Design Ltd (1.111); Peter Orkin (5.39); Andrew Dean Powell (2.54); Peter Rose (5.21-22); Bent Ryberg, Planet Foto (3.65); Josephine Sacabo (1.31, 2.13); Phil Sayer (3.64); Schnakenburg & Brahl fotografi (1.61, 1.102); Roberto Sellitto (1.92); Yoshio Shiratori (1.78, 1.94, 1.106, 2.37); Diane E. Smith (1.53); Statens Konstmuseer, Stockholm (4.4); Stone & Steccati (1.137); Yoshio Takase (1.96); H. Tamura (4.33-35); © Tempera Fabrics (4.56); Frank Thurston (2.39); Kirti Trivedi (1.80); Jeff Tytel (4.15); Tom Vack (1.139-40); Edina van der Wyck (1.29); Boris Vigne (4.62); Gilles Voisin (3.1, 3.26); Olof Wahlund (3.46-47, 3.50); Tom Wedell (5.35, 5.48); Peter Wood (1.4); Woodworker UK (1.54); Nobuya Yamaguchi (1.136); Melvin Yates (2.35)

CONTENTS

N O N I E N I E S E W A N D

Design, as everyone now knows, is a marketable commodity. Good design sells, so *The International Design Yearbook* is in essence arguably the world's biggest storefront for design. This fourth volume has broken all records for the number of designs submitted. Moreover, this has happened in a year when the money market worldwide was shaken severely, with domino effects on exchange rates throughout Europe, the Americas and Japan. In Australia too, the dollar fell so badly that it became known as the Pacific *peso*. Freight charges made imports anywhere increasingly expensive; from the Cologne furniture fair in January 1987 onwards, no exporter could give a firm cost for a chair, dinner service or length of fabric between the time it was ordered and its arrival on the doorstep. Inevitably, this inhibited bulk buying by the stores———————————

The effect of all this on design was to kick-start a lot of studios into imaginative, limited batch production. These small studios, unlike the mass-production assembly plants, are able to introduce a higher level of craftwork, and some quirky individuality. This revival of hand-work, and an increase in artistry, is reflected in the use of more applied finishes – gilding, hand-carving, acid-etching and sand-blasting, for example. The trend also means greater expense, for one-off pieces for patrons, or small batches of objects, are inevitably more costly to produce than units manufactured for the masses———————————

Even in factories, tooling up is not cheap, so manufacturers have opted for big names to design their new pieces, issuing more artist/architect collections this year than ever before. Objects with designer labels can command high prices, which help profit margins and give the companies a high profile. This year for example, fashion designer Giorgio Armani has introduced his first product – *Notturno,* a telephone with a thin, flashing seam of light like the zipper of a dress; Issey Miyake's *Carry Line* luggage has become a fashionable accessory; Swid Powell have enlisted the talents of an impressive array of internationally known architects for their *Cityline* tableware collection; Sasaki of Japan have signed up Andrée Putman, considered to be the high priestess of style, to design elegant mix-and-match place settings. This international trend makes this year's *Yearbook* more like an exhibition catalogue than a mail-order book———————————

While young designer/craft-workers have been exploring materials they can forge, cast, splinter or sculpt, the big-time manufacturers, in contrast, have been pushing forward technological frontiers in the creation of their most notable new pieces. Gaetano Pesce's *Feltri* chair for Cassina has a felt base stiffened with resin, and a wide-collared, top soft enough to wrap around the sitter. (Pesce has an enviable record in using new technology to revitalize classic items: during the plastics revolution of the 1960s, his polyurethane foam chair was packed flat and marketed in an envelope little larger than a soup packet which, when slit, allowed the foam to swell with air into a supportive form.) Frank Gehry's *Little Beaver* chair for Vitra uses packaging cardboard glued in layers but is capacious and comfortable. Cini Boeri's *Ghost* chair for Fiam is made entirely of glass. It is astonishing to think that forty years ago glass was manufactured only in panes; now it can be contoured into shapes strong enough to support body weight. So striking is Boeri's use of glass that the issue arises: is the piece a chair or a sculpture? The question is posed at a time when more and more artists are using chairs as an expressive medium, and more and more designers are producing chairs that are sculptural rather than comfortable. Although there is nothing to stop us from sitting on a glass chair, or drinking from Bořek Šipek's glass flutes covered in strange spikes, it has been a long time since purpose has been so challenged in domestic design————————

INTRODUCTION

A look at national trends in design reveals some interesting changes. In Japan, textiles contain a wonderful mixture of threads; they are breathtakingly textured, even contoured, but without strong colour or pattern. Small is still beautiful: televisions fit into hip pockets, desk tools are contained in the structure of a pocket-knife, Shinohara's chairs seem to be assembled out of straws. But according to Arata Isozaki, this year's editor and selector of submissions, in Japan at least the slender, clean minimalism of the decade may soon be blown away. Minimalist lines are now so reduced that they seem on the verge of disappearing————

Some of the most notable designs from the United States have traditionally been rooted in the work ethic – whether, at one extreme, in the functional modernity of American office furniture, designed by such well-known names as Charles Eames for Herman Miller, or, at the other end of the spectrum, in the traditional Shaker style (now revived abroad in furniture produced by De Padova in Italy and Grange in France). Now, however, American designers are turning to architecture and the construction industry for inspiration in forms, materials and techniques. Steven Holl's furniture in cast aluminium and steel borrows imagery from the city skyline; Clodagh uses materials from the building site – sand-blasted glass, rusted steel and concrete————

Australian design cannot be characterized simply as vernacular or rustic (though some pieces, such as Diane Smith's music stand, undoubtedly are). While Australian architecture is innovative (witness Glenn Murcutt's Post-Modernist beach-houses in corrugated steel traditionally used on sheep-shearer stations), generally furniture-makers do not show the same inventiveness, either with new forms or with indigenous materials. Designs still tend towards Memphis look-alikes rather than Ayers Rock originals————

In India, national craft traditions are being harnessed to produce some interesting contemporary designs with western applications, but executed in a distinctive Indian idiom. Munshi and Trivedi's bulkhead lights in teak are an example————

Spain currently exhibits an aggressive, competitive design-consciousness, spurred on by its membership of the European Economic Community and preparations for the 1992 Olympic Games in Barcelona. Its furniture is characterized by the fine cabinetry for which Spanish craftsmen are famous, its textiles outstanding for their colourfulness and richness of imagery————

It is tempting to see German design as staid beside all this vigour. After all, Bauhaus is a hard act to follow. But Ingo Maurer's innovative wizardry in lighting design, and Rosenthal's sophisticated, bold tableware, both of which are used in some of the world's most fashionable spaces, highlight a marketable design awareness————

French designers continue to be radical in their design thinking. Radicalism, however, argues Arata Isozaki, is always shortlived. What will happen next in France? Some of the most interesting pieces – Jean Nouvel's storage system and Philippe Starck's chair that seems to sprout wings – look to aerodynamics for their inspiration————

In Britain, Ron Arad actually unpacks aeroplane wings in an investigation of their material, not their form, and stretches the honey-comb wadding on panelled screens. Technical ingenuity is especially evident in Britain, manifested in an almost disturbing tendency to fragment industrial hardware. Fractured glass, tortured steel and bent metal feature in many pieces – a characteristic

7

that Arata Isozaki finds to be an interesting reflection of the frustrations of young designers. Years of poor relationships with manufacturing industry, and experiences of sluggish retailing, have continued to put inventive designers graduating from art colleges on the defensive, and this shows ultimately in the aggressive shapes and materials of their work.————————————

By comparison, many of the pieces produced in Scandinavia may be seen as rather tame, largely associated abroad with a pride in craftsmanship in wood and glass, and with a plain, functional look. But Arata Isozaki believes that Scandinavian industry, with its craft orientation and suitability for small-run production, has a lot to offer, if given imaginative design concepts to work with. The 1950s, he says, may have been the heyday for the Scandinavians – the first piece of western furniture he bought was the Danish *Swan* chair of the 1950s by Arne Jacobsen – but they should exploit their manufacturing strengths again, this time more boldly. Yrjö Kukkapuro from Finland shows how a good design can be revived for the 1990s.————————————

In Italy, the most dynamic manufacturing nation, recent years have seen many designs trivialized by constant repetition on the production lines of large factories. Endless lacquered cabinets, occasional tables and leather sofas represent a dearth of new ideas. Recognizing the problem, Italian designers have begun to explore a variety of new sources for their work: Achille Castiglioni looks to the urban vernacular with his *Basello* table, named after the Milanese dialect word for a stairway; Paolo Pallucco and Mireille Rivier startle with their *Tankette* table, which evokes a war-torn no man's land; Luigi Serafini draws on the current craze for zoomorphic fantasy with his rabbit-eared chair. Morphic shapes inspire many pieces, such as Vico Magistretti's *Spiros* coat rack, which stands like a tree in winter.————————————

In many countries, designers seem to be increasingly interested in reviving the spirit of other ages and cultures. In Britain, Derek Frost houses 1980s videos and hi-fis in pagodas and 1950s-style jukeboxes, and John Outram gives a chest of drawers in the Alma collection a monumental classical façade. Robert Venturi's clock for Alessi reproduces somewhat ironically the typical Swiss watchmaker's clock, complete with resident cuckoo. Jennifer Lee revives centuries-old techniques in her hand-built earthenware pots, which seem as ancient as they are modern. Sue Golden explores tribal influences in her *Shield* chair. And in Japan, Shiro Kuramata pays homage to Hoffmann with a new version of his chair illuminated with lights where the original had upholstery nails.————————————

A new phenomenon appearing in the capitals and large cities of the world is the designer shop, dedicated to the sale of fashionable objects and accessories. Torches, lighters, brushes, scissors (all kinds of items traditionally purchased in hardware stores) are now given the full designer treatment. Precise in function and compact in form, available mostly in shades of black and given the benefit of fantastical window displays, these pieces amount to portable personal statements about their users. Earlier this century Adolf Loos raised a pertinent question about such objects when he addressed the Viennese Secessionists: "To what extent does the design of furniture and objects actually affect lifestyle, or to what extent does a given lifestyle lead to the design of objects necessary for it?" Consider the design of the *Factory* all-in-one collection of desk tools that fits into the mobile worker's pocket, or the lightweight briefcase by Titus Hertzberger, suitable for cyclists, or the new-age speaking book for children by Design Logic: do they promote the lifestyles and trends they claim to reflect?————————————

This year, some products show a combination of stylishness with technological innovation; others represent a preoccupation with either ornamentation or functionality in design. Adolf Loos, again, said that the form of a bicycle reminded him of "the functional spirit of the Athens of Pericles," yet the latest table by Perry King and Santiago Miranda – *La Vuelta,* named after a famous long-distance cycle race – features bicycle handlebar legs designed in quite a different spirit, that of ornamentalism. Ornamentation has existed for as long as the earliest hand-carving, but design purists insist that ornament should express the way in which materials are processed and combined. When this is so, they argue, pieces are capable of being mass produced, and need not be made only in limited batches with hand-work tardily applied to the basic form. However, the fact that there is a demand for, and a trend towards, such hand-work and finishes, as the designs in this volume clearly show, may reflect a growing rejection of the intense sobriety of Modernism. Modernists are beginning to react to this movement; some seem to be closing ranks. Tecta of Germany, who still produce original Bauhaus designs marketed with the Bauhaus label of Oscar Schwemmer, refused to submit entries for this volume, stating that they had no wish to be judged by the Post-Modernists. It is possible that the battle in design will soon mirror in ferocity the battle in architecture⸺

Thus it seems appropriate that this book reflects the vision of an architect. Arata Isozaki describes himself as a Mannerist, explaining that the Mannerist movement manipulates or borrows styles from many periods, repeating, transforming and in some way distorting them. For such architects, the imaginative exploitation of space is important; behind the thin profile of the façade, there must always be a sense of depth, a layering of styles and systems. This effect can be difficult to achieve on the gigantic buildings that Mannerist architects are now being asked to undertake. Arata Isozaki sees a solution in the use of expensive materials on façades, and the revival of age-old, ornamental techniques: stonemasonry, stucco plastering, gilding and pargeting. The Mannerist style book is characterized by grander styles, more complexity of space, more orna-mentation and more complicated depths. From the evidence of this volume of the *Yearbook,* including the manipulated geometry of Arata Isozaki's own watch design for Cleto Munari, the same trends promise to apply to many of the designs of the next few years⸺

THE CURRENT STATE OF DESIGN

ARATA ISOZAKI

The *Yearbook* submissions for 1987/88, both furniture and other domestic design projects, stand in striking contrast to those of the previous few years. For this year has seen major changes in design – not decisively in any one direction, but rather along several, sometimes quite opposed and in any case very distinct, lines. I propose to distinguish and define these developments here, by terming them "Minimalism," "Art," "Modernism," "Simulation" and "Retrospection." This essay is an attempt to trace the individual dynamics of these design concepts while explaining how they overlap and interpenetrate, often sharing characteristics with each other. I hope that this will highlight some of the most important signs of the changes currently taking place in the world of domestic (especially furniture) design – changes which may not be obvious even to those directly involved. The following diagram represents the relationship between the categories of design approach that I have devised———————————————————

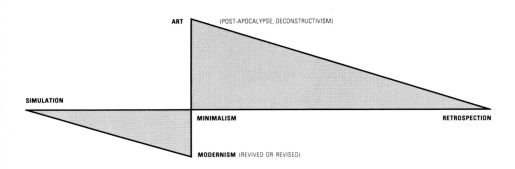

Minimalist design was probably the predominant concept in last year's volume; all discussion orbited round it under the editorship of Philippe Starck. By contrast, two years before, the Retrospective viewpoint could have been placed at the key place in the diagram, for under the editorship of Robert Stern it was apparently regarded as the essential starting-point for a proper understanding of design activity at the time. But this year these aspects of design constitute no more than parts of a more complex pattern. Design has come to be represented by various schools, with its parallelism to the art world a very important consideration in understanding the scene. Of course, again this year a tremendous number of Minimalist pieces have been produced. Indeed, this tendency has now significantly permeated the styling of many products – electronic gadgetry as well as furniture – which are being mass-manufactured under household brand names. The market for such items is now well established. Minimalist design originally grew out of ergonomic, "modern" styling; but ever since it has been growing closer and closer to the abstraction of modern art. At its best, it has achieved a dynamic tension of form which works in design terms; however, Minimalism now often attains a purity and nakedness of appearance which sacrifices comfort and convenience and gives pleasure only to the eye. This is Minimalist design at its most specific. One could say that today it becomes separate and distinct from other design approaches precisely when it loses the concept of utility and purpose all together———————

I have placed Minimalist design at the centre of my diagram. Although I think this positioning would have been equally valid last year, and it certainly holds good this year, this will probably not be the case for very much longer. Even if the external appearances, the expressive qualities of certain newly designed pieces can be described as Minimalist, they now tend to feature techniques and ideas also found in pieces situated at other poles of my diagram – a trend which

strongly suggests that Minimalism as a design concept may be in the process of being dismantled.

Minimalist design has been called the New Modernity, a term which indicates its evolution out of "modern" design. So-called "Modernist" design began by imitating the patterns and forms of the machines of the 1920s, moved on to reflect the streamlined shapes of the machines of the 1950s, and then even further, using the ergonomic styles of the 1970s. The Modernist approach has influenced much design – particularly furniture design – in the twentieth century. It is from within Modernism that other, quite different design tendencies have sprung. The term "Modernism" is therefore another design approach essential to any diagrammatic representation of the current state of design.

In the modern world, "design" is a term used very largely in relation to pieces which are intended to be commercially viable, and which are conceived with mass production and mass sales in mind. Their appearance gives formal expression to the activities of industrial society, reflecting its nature and values. This is the essence of modernity. Modernist styles in design, as opposed to "modern" styles, can now be seen represent only one aspect of the development of twentieth-century culture, albeit a very important one. Looking at design today – in particular, at the submissions to this volume – it is now possible to achieve a clearer perspective on the Modernist approach, and to set it in the wider context of modernity in general.

This being said, there is a clearly discernible reappraisal of Modernism under way – what we could call Revived Modernism. Revived Modernism uses the same modes of thinking and approaches to problems that have always been characteristic of Modernism; it is a smooth continuation of Modernism in the 1980s, using the familiar machine-age imagery. Revised Modernism, by contrast, regards Modernism as of the past; designers of this school attempt to reinterpret it with contemporary overtones. The fascinating thing is that these two attitudes to Modernism can be found operating side by side in design today. It could be argued that, in a sense, Minimalist design is a part of Revised Modernism: it looks again at the modern, techno-logical world and reflects its newest features, such as miniaturization. Having evolved and refined itself out of the earlier streamlined forms of Modernism, it is Minimalism's approximation to modern art that allies it to the abstraction of Revised Modernism in particular.

It was to be expected that design would eventually break almost completely with Modernism. So it is that many entries in this volume of the *Yearbook,* most noticeably perhaps the handmade items, seem something quite new. Many can be seen as works of art; then again they are also close to craft. The majority are not sold through shops but exhibited in galleries and actually marketed as art-works. Such pieces must find a place in my diagram, and they do, under "Art." Pieces of "Art" furniture should be considered less as furniture than as the expressions of the intentions of their creators. More metaphorical than real, such objects also – as if incidentally – acquire the contours of furniture. They are not all spontaneous, handmade works; some are in fact designed for mass production. A significant number are mass-manufactured, because they are simply not commercially viable as one-off items.

There is now enough evidence to suggest that the "Art" approach is one of the most radical – if as yet undeveloped – design concepts of the present. In one form, it could perhaps appropriately be called Deconstructivism, for it takes the elements of Russian Constructivism of the 1920s and

dismantles them, in order to re-combine them in different ways. It works on differences, overlaps, collages – which are also found in the Deconstruction movement of 1970s Post-Structuralism. In its other form, the new radical design receives inspiration from visions of the ruins of the future, the junk of the present and the detritus of the past – even sometimes attempting to evoke the aftermath of nuclear war. The preoccupation with elements of story, even myth, which gives "Art" design a certain concrete quality, is something quite new. This tendency runs parallel to the new expressionist or neo-baroque movement in art. The two movements – both that in art and that in design – have apparently set a limit to abstraction. A world of darkness and enveloping silence in which dead bodies and destroyed things disintegrate and disperse – this is the common image at the basis of this design movement, which is why it can be called Post-apocalyptic.———————

It should by now be clear that in my schematic account of design approaches, Art is linked to Modernism via Minimalism on a non-referential axis. Whereas modern design began by using the machine as its model, becoming ever more refined and abstract, and evolving without reference to history or culture, there is another totally different design approach – Retrospection – which *is* referential, and exists on an axis quite separate from Modernism, connected via Minimalism to an approach which I call Simulation.———————

One of the important characteristics of Post-Modernism is its avowed historicism. In design – perhaps especially in furniture design – many pieces have always been produced which draw on the formal principles of ancient Egypt and the various civilizations that followed. Most of this work could be seen as reflecting the unconscious accumulation of ideas about art, architecture and design as they have evolved throughout history. An awareness of classicism, the Gothic and the vernaculars of different places was present even in Modernist design. But in the last decade or so a distinct design trend has grown which makes a conscious point of exploiting references to one or several past eras. Both the general contours and the finer details of such pieces deliberately evoke the formal principles of the past, relying on remembrance and a sense of déjà-vu, stimulating nostalgic memories. Retrospective design seems to me the best way to describe it.———

We possess an enormous history of design ideas and achievements; no future designs can be undertaken in ignorance of them. However, the essential distinctiveness of new designs depends on how this knowledge is treated or exploited. What I call Retrospective design is characterized by a conscious attempt to adopt the attitudes and approaches of a chosen period or style. Based on nostalgia, it seeks to promote revivals, and in many cases takes the form of pastiche, in which slight refinements often result in parody.———————

At the opposite pole of this referential axis, on the other hand, all nostalgia is rejected. Instead, modern methods and modern attitudes are brought to bear in the assimilation of the ideas of the past and the calm reproduction of their spirit. This year, and precisely this year, this design approach is beginning to develop and manifest its own distinguishing characteristics. I refer to this trend as Simulated design because it embarks on the process of re-creation, drawing on established or imaginary images, with a determination and an earnestness which eliminate all personal or subjective emotions. Today we are swamped by images which reproduce and reflect the conditions surrounding us. We live flooded by the media's overproduction of such images, and it is a flood which never ceases; the mechanisms which facilitate this continuous deluge are virtually emotionless.———————

THE CURRENT STATE OF DESIGN

PHOTOGRAPH BY SHIGEO ANZAI

Arata Isozaki

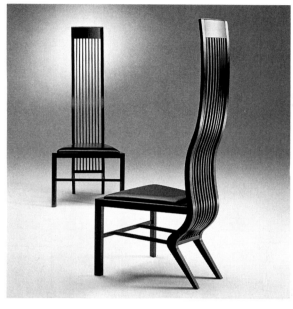

Monroe Chair
Designed by Arata Isozaki

While Simulation uses historical and vernacular ideas – and these are often readily apparent – there is no reliance on nostalgia. Simulated forms are dry, bloodless, highlighting their fundamental difference from the mechanical metaphor employed by Modernism. It is not simply methods of production or methods of promotion and sales which distinguish Simulation, but its dizzy trafficking in images. Thus at a glance Simulated design can look banal. To be Simulated means, I would argue, to contain ideas derived from the popular but driven to their utmost limits, which is why I believe the term is appropriate——————————————

The referential axis on my diagram therefore represents design which expresses itself in images from ancient Egypt onwards. The wealth of images created throughout history is currently being analysed, dismantled and reconstructed in two ways – looking back to the past, nostalgically, but also, in the case of some designers, with a keen eye to the present, unemotionally. The results can be divided accordingly. In complete compatibility with this vision, Minimalism finds its place – located between the two design approaches, at a point which can be identified specifically in time as the design year 1986/87——————————————

My diagram of design concepts is completed by tracing the diagonals connecting Art to Retrospective design, and Modernism to Simulated design quite separately – that is, without the referential and non-referential axes intersecting. The former is more personal, more craft-oriented and subjective, while the latter is more social and gregarious, being more suited to industrial production and more objective. The contrast can be defined as that between refinement and popularization——————————————

This sketch of design today is based on those objects designed or manufactured in 1987/88; doubtless in time these classifications will break down and change dramatically. While I would argue that my diagram should make it possible to predict which way any changes will go, inevitably such a prediction will be only that of its time, the season 1987/88. This time next year the pattern will probably look very different – a destiny surely to be shared by this *Yearbook*——————

Translated by John D. Lamb

Abbreviations
Apart from H (height), L (length),
W (width), D (depth) and Di (diameter),
the following abbreviations are used
in the book:
ABS acrylo-butyl styrene
LCD liquid crystal display
MDF medium-density fibreboard

FURNITURE

1 The twentieth century began with an arts and crafts movement in Britain and America. It seems poised to end with another – not with an earnest revival of handcarving, but with a movement that turns furniture into art. Even factory-assembled pieces are being given hand-worked finishes; the effects of faux concrete, oxidized copper, rusty steel, sand-blasted glass and verdigris iron break up the uniformity of modern industrial materials. ■ The Modernists, however, are still with us. Their designs are functional, devoid of ornamentation. Pieces are often modular, adaptable, adjustable. ■ The Post-Modernists, in furniture as in architecture, employ irony – as much as their ironmongery, upholstery and woodwork will allow – in a self-conscious but original stylization of the past. This mimicry Arata Isozaki calls Simulation. Cerebral, or merely overwrought? It is often difficult to decide. ■ Some designers are more nostalgic in their retrospection. They choose an historic style and re-create its features. And of course manufacturers continue to issue re-editions of the classics. Sometimes they cause controversy; sometimes they show sensitivity to the spirit of the originals. ■ Minimalism is still around, but mutating. "Organic," "zoomorphic" and "anthropomorphic" are popular labels. A four-legged chair by Starck sprouts wings. The legs of Kinsman's table assume a fluid form. Serafini's chair has rabbit ears. Hilton gives a piece the poised legs of an antelope. The tide is turning against the minimalist precision of the last five years. Those mass-produced, linear, matt black, tubular steel designs have become the equivalent in furniture of the little black dress – ubiquitous, but ultimately anonymous. Arata Isozaki is not interested in the fashionable novelty. As the century moves towards its final decade, he predicts an era of neo-baroque. Monumentalism, not minimalism.

1 Aerodynamics often inform the designs of Philippe Starck. Streamlined, bullet-nosed, winged and often flapped, the taut shapes of his furniture suggest the tension of a projectile. Earlier, Starck transformed the club chair, setting it on three legs: now he turns to the four-legged dining chair to create a high-flying concept with a difference. From the front *Miss Milch* is straight-forward, but the sides are "uplifted" by mercurial wings, exhibiting a sense of humour characteristic of many of Starck's pieces. Idée describe it as a "sym-pathetic and humorous piece in steel on the edge of unknown worlds." Appropriately, Starck claims that he "lives in planes and drinks only champagne."

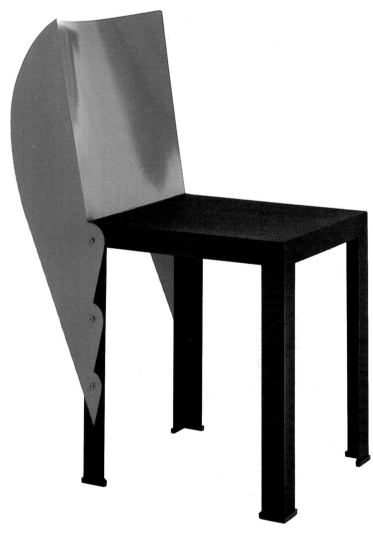

Philippe Starck
Chair, Miss Milch
Steel
H80 cm (31½ in). W33 cm (13 in).
D52 cm (20½ in)
Manufacturer: Idée, Japan

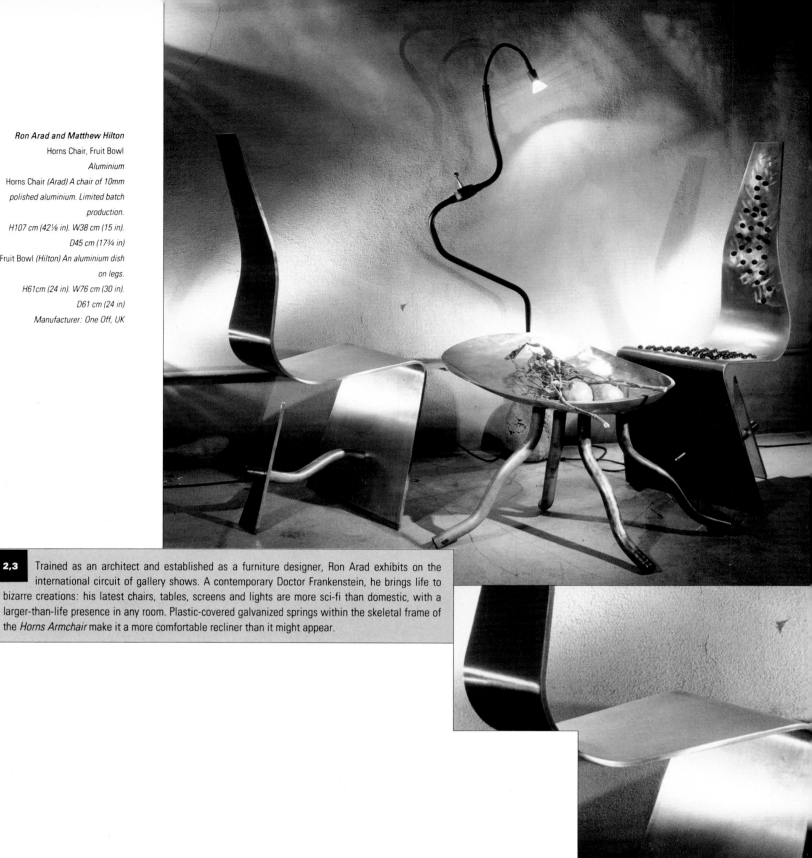

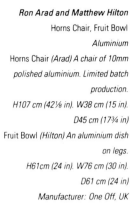

Ron Arad and Matthew Hilton
Horns Chair, Fruit Bowl
Aluminium
Horns Chair (Arad) A chair of 10mm
polished aluminium. Limited batch
production.
H107 cm (42⅛ in). W38 cm (15 in).
D45 cm (17¾ in)
Fruit Bowl (Hilton) An aluminium dish
on legs.
H61cm (24 in). W76 cm (30 in).
D61 cm (24 in)
Manufacturer: One Off, UK

2,3 Trained as an architect and established as a furniture designer, Ron Arad exhibits on the international circuit of gallery shows. A contemporary Doctor Frankenstein, he brings life to bizarre creations: his latest chairs, tables, screens and lights are more sci-fi than domestic, with a larger-than-life presence in any room. Plastic-covered galvanized springs within the skeletal frame of the *Horns Armchair* make it a more comfortable recliner than it might appear.

Ron Arad
Horns Armchair
Aluminium, steel, PVC
A decorated aluminium chair with wide
armrests and plastic-covered galvanized
springs. Limited batch production.
H120 cm (47¼ in). W120 cm (47¼ in).
D120 cm (47¼ in)
Manufacturer: One Off, UK

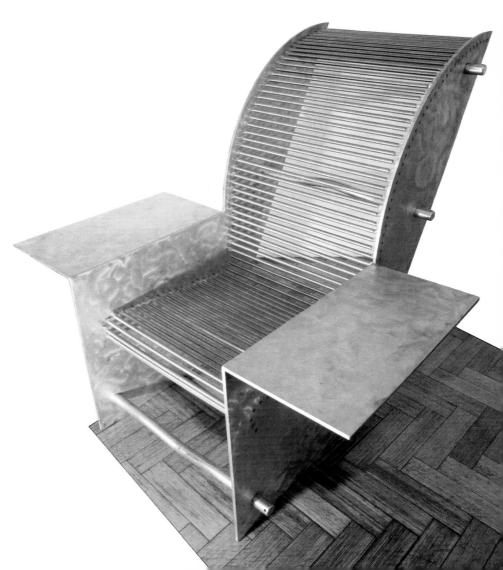

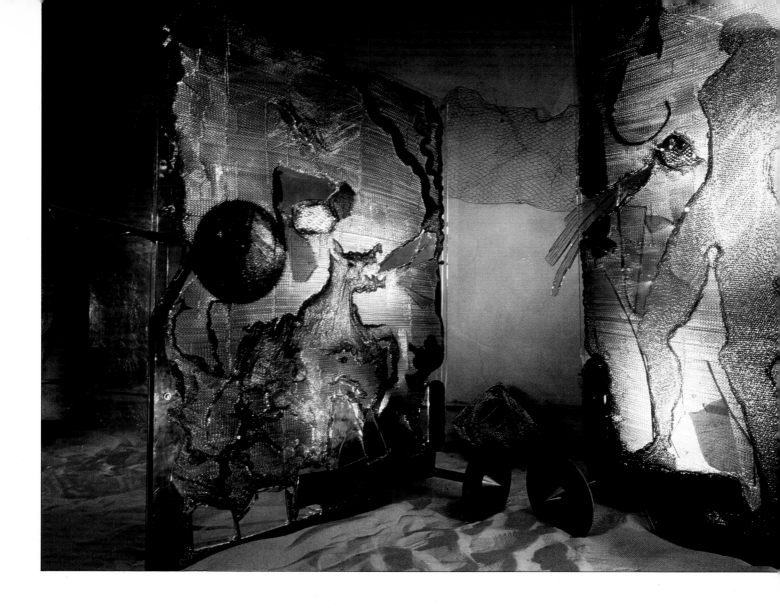

Giant pterodactyl-like wings splay from a central tubular pipe in Ron Arad's *Curtain Call*, an indoor screen that seems at once futuristic and primeval. In the case of *Deep Screen*, industrial aluminium honey-comb, a component of aeroplane wings, is stretched between steel frames to create a double-sided divider, opaque when viewed from one side but revealing silhouettes when viewed from the other. His designs involve meticulous hand-work, and go into limited batch production.

4

Ron Arad
Deep Screen
Glass, aluminium, steel, rubber, silicone
Screen in two sizes, made of toughened
glass sandwiched with infill; handle and
wheels of steel. Limited batch
production.
H210 cm and 170 cm (82⅝ in and 67 in).
W90 cm and 120 cm
(35½ in and 47¼ in). D4 cm (1½ in)
Manufacturer: One Off, UK

5

Ron Arad
Screen, Curtain Call
Aluminium, steel
A textured screen of honeycombed
aluminium with a triangular steel base.
One-off.
H200 cm (78¾ in). W200 cm (78¾ in).
D50 cm (19⅝ in)
Manufacturer: One Off, UK

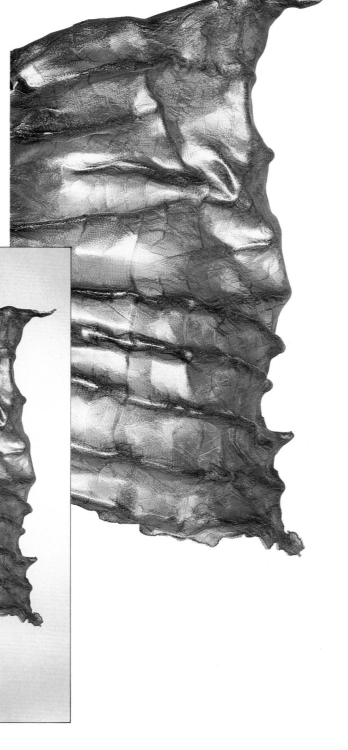

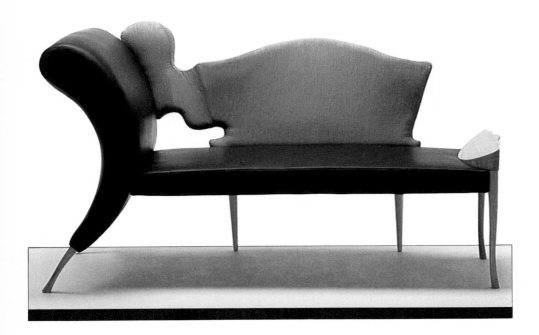

Bořek Šipek
Chaise longue, Sni
Steel, polyurethane foam, wood
A chaise longue in the Prosim range of
living-room furniture with a steel frame
padded with cold-worked polyurethane
foam. The visible frame is of polished
matt cherry-wood and the seat and arm
covers are of black leather.
H100 cm (39½ in). W166 cm (65⅜ in).
D84 cm (33 in)
Manufacturer: Driade, Italy

6 Functionalism must inform a design at the beginning, while materials should ornament and adorn it, according to Bořek Šipek: he dislikes symbolism. Turning from his early ideological stance, he apparently now welcomes the opportunity to be introduced through his Driade furniture into living-rooms around the world, cheerfully describing his attitude as "opportunistic in the sense of a fellow Czech, the Good Soldier Švejk." His *Prosim Sni* chaise longue, with its boot-shaped backrest, has the slightly comical outlines of a two-dimensional cut-out.

7 Bořek Šipek likes to combine precious materials with humble ones, working in metal, wood, marble, glass, iron, ceramics, brass and silk. He can forge metal, blow and etch glass, cast in bronze, upholster and do woodwork, setting up within each piece "a dialogue between geometric and organic form." He describes his early one-off pieces as his manifesto – unduplicated statements about himself, as a drawing might be for an artist. Then the Driade factory in Italy put a few of his designs into production; in contradiction to his previous concerns, they are factory-assembled and even comfortable.

Bořek Šipek
Chair, Sedni
Steel, polyurethane foam, wood
A chair in the Prosim range of living-
room furniture with a steel frame padded
with cold-worked polyurethane foam.
The visible frame is of polished matt
cherry-wood and the seat and arm
covers are of black leather.
H94 cm (37 in). W96 cm (37¾ in).
D74 cm (29 in)
Manufacturer: Driade, Italy

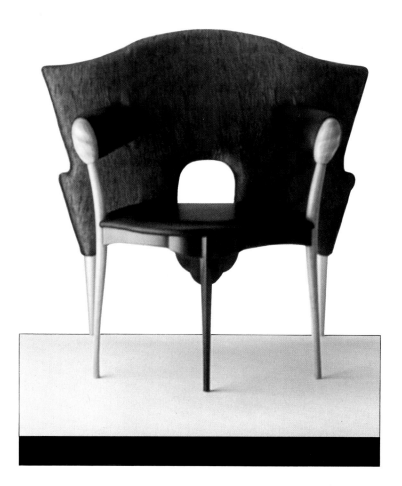

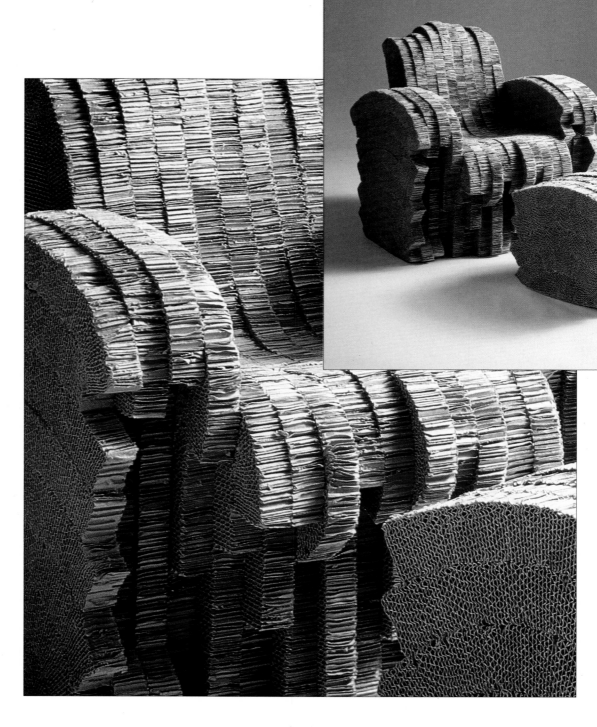

8 The *Little Beaver* chair and stool, constructed in packaging cardboard, illustrate Frank Gehry's belief that everyday materials that are usually discarded can be recycled into serviceable objects. His work, in buildings and furniture, challenges established norms by reinterpreting – even celebrating – the potential of the unexpected media he uses. The capacious lines of this unorthodox club chair, despite the gnawed edges, support the sitter in comfort.

Frank O. Gehry
Chair and stool, Little Beaver
Cardboard
A chair and stool that use a "poor"
material to create a rich object. Limited
batch production.
Chair H87 cm (34¼ in). W81 cm
(31¾ in). D86 cm (33⅞ in)
Stool H41 cm (16⅛ in). W44.5 cm
(17½ in). D56 cm (22 in)
Manufacturer: Vitra International,
Switzerland

9

Perry King and Santiago Miranda /
King-Miranda Associati
Tables, La Vuelta
Steel, chrome metal
A range of tables and desks for domestic
and public use. The model shown is
Timoner, an oval table in four sizes with
painted and chrome metal legs and a
medium-density steel top with different
finishes.
H75cm (29½ in). W125 cm (49¼ in).
L320 cm (126 in)
Manufacturer: Akaba, Spain

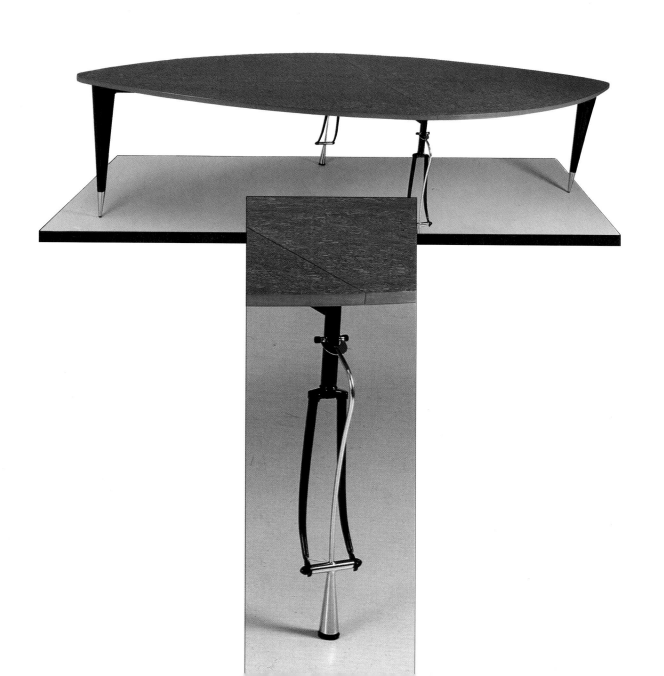

10

James Evanson
Masque Chair
Colorcore, wood
*A chair made of colorcore, birch plywood
and Honduras mahogany. Limited batch
production.*
*H79 cm (31 in). W68.5 cm (27 in).
D56 cm (22 in)
Manufacturer: Art et Industrie, USA*

Luigi Serafini
Armchair, Fusion
*Metal, polyurethane foam, aluminium
A zoomorphic armchair with large ears,
Fusion has a metal structure covered
with expanded polyurethane foam. The
backrest is in silk, the seat and armrests
in leather and the feet are of cast
aluminium. Limited batch production.
H120 cm (47¼ in). W85 cm (33½ in).
D90 cm (35½ in)
Manufacturer: Sawaya & Moroni, Italy*

11 Luigi Serafini's furniture for Sawaya & Moroni continues to have a zoomorphic character. Last year his entry in the *Yearbook* was a chair with a delicate wrought-iron back spiralled like a snail's shell. This year, the proportions and mass have changed dramatically: his chair, rabbit-eared in blue silk, has a firmly corseted form set on remarkably small feet. Sawaya & Moroni, the Milanese company who produce many iconic and surrealist pieces, claim for this one a "poetic innocence."

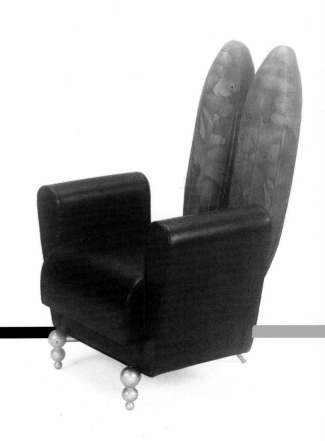

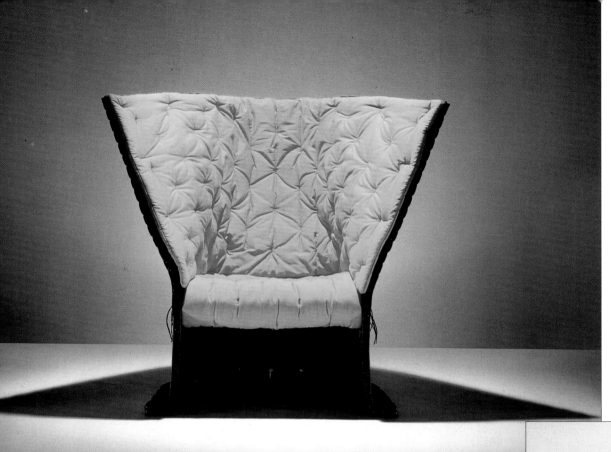

Gaetano Pesce

Chair, Feltri

Felt

*Prototype of a chair made from thick
wool felt. The lower part is impregnated
with polyester resin to provide support
and resistance. The seat is fixed to the
supporting frame by hemp strings that
also trim the soft edges of the chair, and
the whole is completed by a mattress of
quilted fabric and down padding.
H140 cm (55⅛ in). W74 cm (29 in).
D64 cm (25⅛ in)
Manufacturer: Cassina, Italy*

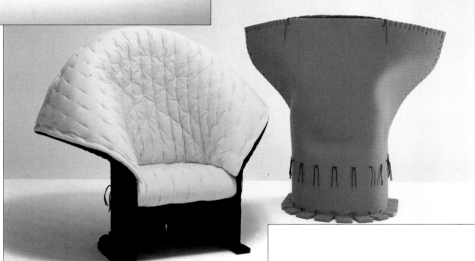

12 Despite its innocuous appearance, reminiscent of a protective hood, the quilted *Feltri* by Gaetano Pesce caused fierce controversy when it was unveiled in the Cassina showrooms in Milan during the 1987 furniture fair. Cassina have explored new technological processes using polyester resin to stiffen wool felt for the base, leaving the rest flexible and soft enough to wrap around the sitter. Pesce, who divides his time between studios in Paris and New York, wrote in the publicity material accompanying the launch that his pieces do not claim to anticipate future trends. Why? "It seems to me frankly impossible in our atomic age. They are autonomous objects, fragments that have been placed so as to indicate or demarcate a shape which in any case is not yet clear."

13 The Italian word *"bolide"* can be used of any object which travels at high speed, whether a Ferrari or a bullet. The Bolidists, a group of ten young Italian architects, have certainly fired off a salvo of challenging designs alongside their manifesto for the next decade. One of their number, Massimo Iosa-Ghini, is also a cartoonist and set designer for TV. He has given his sideboard the aggressive thrust of a missile, and set it on a "launch pad" of tripod frame legs. A corrugated back panel is like a vibraphone, which electronically beats out the rhythms of hip-hop and rap music.

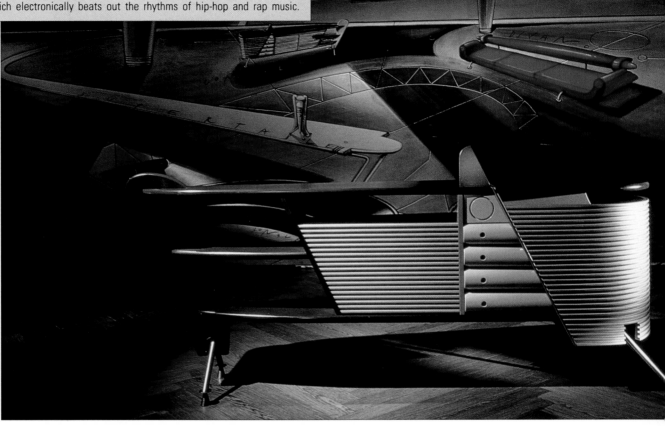

Massimo Iosa-Ghini
Sideboard, Bertrand
Wood, metal
H90 cm (35½ in). W221 cm (87 in).
D53 cm (20⅞ in)
Manufacturer: Memphis, Italy

Paolo Deganello
Documenta Chair
Steel, wicker, leather, plastic
Prototype
H97 cm (38¼ in). W63 cm (24⅞ in).
D53 cm (20⅞ in)
Manufacturer: Vitra International,
Switzerland

14

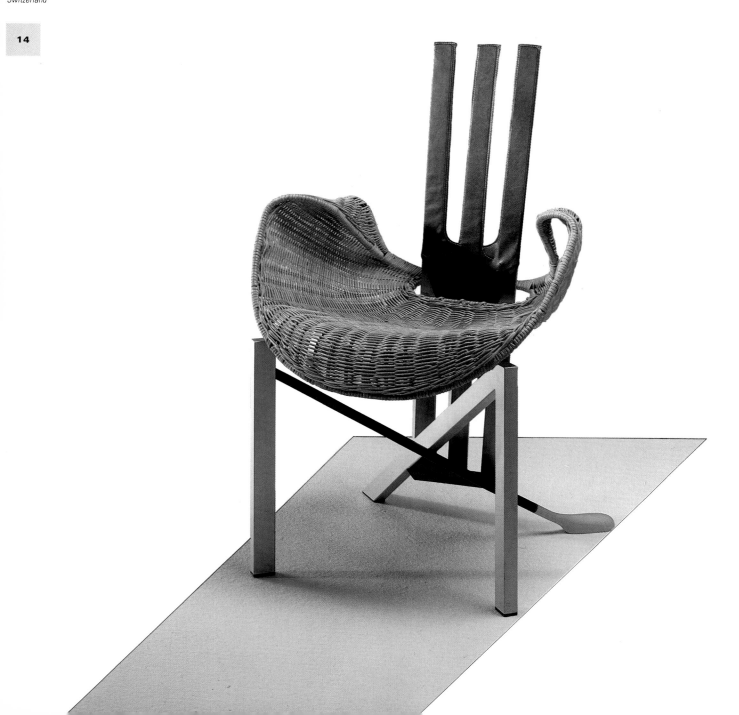

Matthew Hilton
Antelope Table
MDF, aluminium, wood, stainless steel
A small, three-legged table with two
legs of aluminium and one of oak. The
top is of MDF and stainless-steel inlay.
Limited batch production.
H70 cm (27½ in). Di 85 cm (33½ in)
Manufacturer: Matthew Hilton, UK

15 "Anthropomorphic" is the label that Matthew Hilton attaches to his work. The *Antelope Table*, with its two antelope legs as though poised to spring, takes its inspiration from the bush animals of Africa where he grew up. There is less handcraft in his pieces than their quirky individuality suggests: he is seriously concerned with the technicalities of production in reasonable numbers, and with methods of tooling up factories for batch runs.

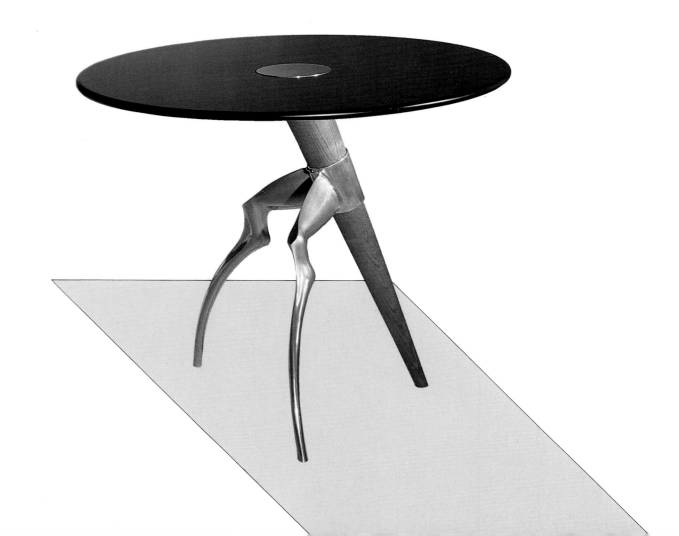

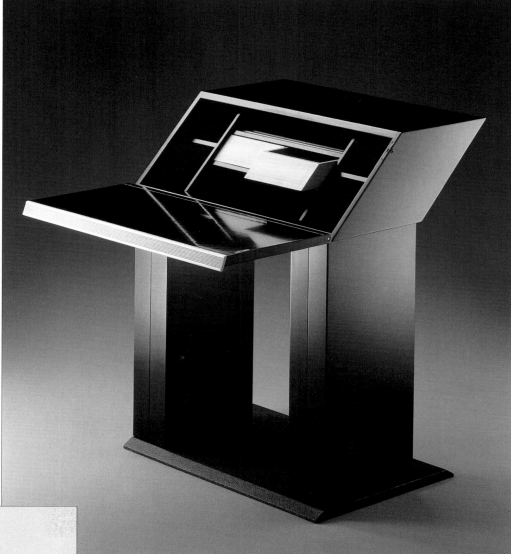

Jürgen Lange
Writing desk, Privé
Lacquer finish
A writing desk/bureau that can be
used either seated or standing. The sides
are fitted with acrylic containers for
storage. Available in a white, grey or
black lacquered finish with differently
coloured handles and drawers.
H99 cm (39 in). W77 cm (30¼ in).
D53 cm (20⅞ in)
Manufacturer: Rosenthal, West
Germany

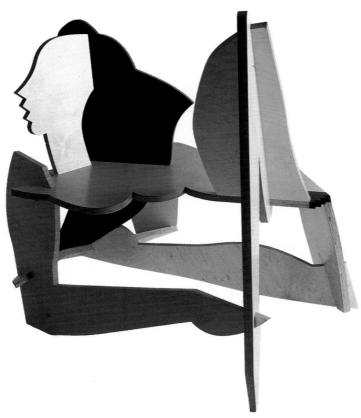

Ricardo Blanco
Chair, Dario
Wood, leather
Limited batch production
H95 cm (37½ in). W45 cm (17¾ in).
D45 cm (17¾ in)
Manufacturer: Diseño + Diseño,
Argentina

17

Allen Jones
Love Seat
Wood
Constructed of 25 mm Finnish birch
plywood, natural and dark stained, and
finished in clear polyurethane lacquer.
H111 cm (43¾ in). W120 cm (47¼ in).
D100.5 (39½ in)
Manufacturer: Aram Designs, UK

18

Sue Golden
Shield Chair
Aluminium, wood
A sculptural chair inspired by African
artefacts. One-off.
H180 cm (70⅝ in). W90 cm and 100 cm
(35½ in and 39½ in)
Manufacturer: Sue Golden, UK

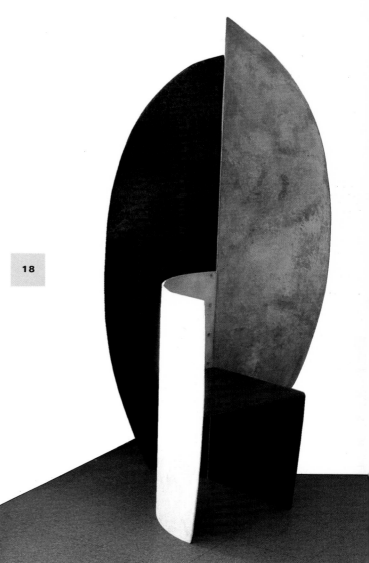

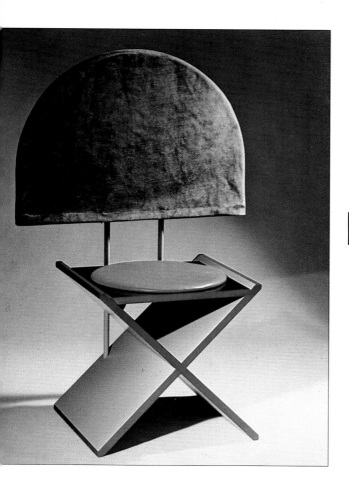

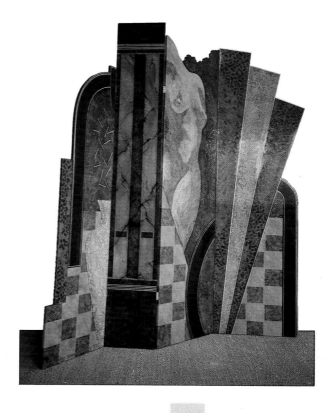

20

Bev Houlding
Screen, Pullman
MDF
A hand-painted screen with textured
surfaces incorporating marbling,
tortoiseshelling and lacquering. One-off.
H172.5 cm (68 in). W183 cm (72 in).
D1.27cm (1/2 in)
Manufacturer: Screens Gallery
Workshop, UK

Peter Shire
Sofa, Big Sur
Wood, wool
A sofa of lacquered wood upholstered in
100 per cent pure wool.
H96 cm (37¾ in). W210 cm (82⅝ in).
D72 cm (28½ in)
Manufacturer: Memphis, Italy

21

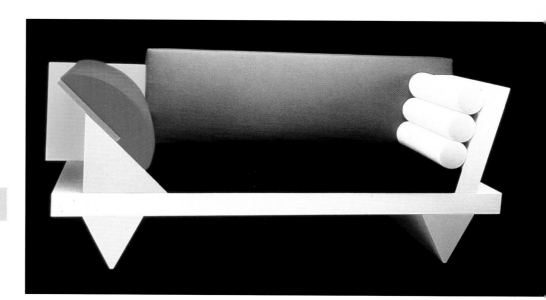

F
U
R
N
I
T
U
R
E

Furniture as art

Andrea Branzi aims at a "marriage between poetic theory, design and artisan-craftsman production." The severity of the line of *Andrea* is exaggerated by its length but softened in one corner by a padded seat, its shape reminiscent in miniature of a grand piano isolated in the concert hall. Arata Isozaki, in his foreword to Branzi's book *The Hot House,* has called the approach of the Alchimia group (to which Branzi belongs) "constraint-free rationalism" – the reduction of technology, surfaces, colours and materials to the level of components, and their synthesis into art.

22

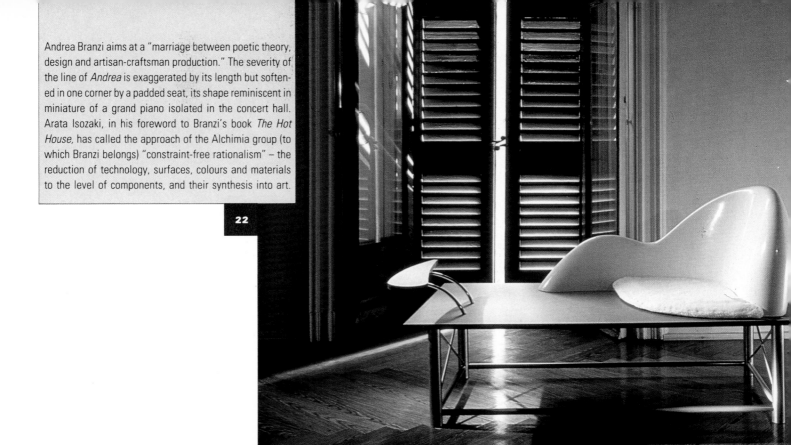

Andrea Branzi
Chaise longue, Andrea
Wood, steel tube, fibreglass, sheepskin
A chaise longue with a moulded
fibreglass backrest and a small swivel
table. Limited batch production.
H95 cm (37½ in). W80 cm (31½ in).
L150 cm (59 in)
Manufacturer: Memphis, Italy

23

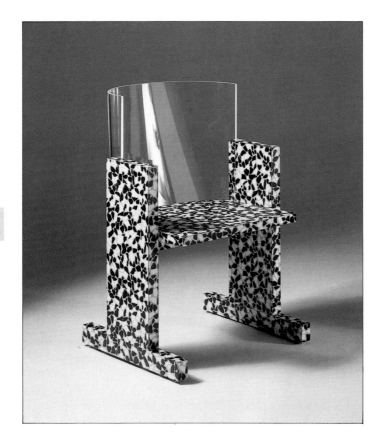

Ettore Sottsass
Chair, Teodora
Wood, laminate, plexiglass
A throne-like chair with a base covered
by stone-patterned laminate and a back
of transparent plexiglass.
H88.5 cm (34⅞ in). W58.5 cm (23 in).
D54.5 cm (21⅜ in)
Manufacturer: Vitra International,
Switzerland

Marco Zanuso Jr
Table, Cleopatra
Wood, steel, aluminium
Limited batch production
H72 cm (28½ in). Di35 cm (13¾ in)
Manufacturer: Memphis, Italy

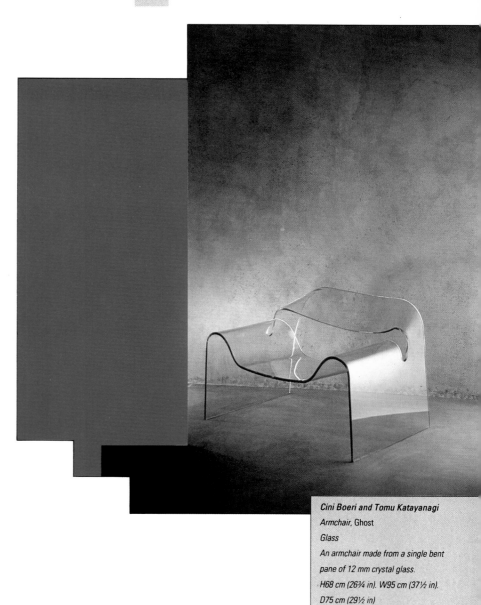

25

24

Cini Boeri and Tomu Katayanagi
Armchair, Ghost
Glass
An armchair made from a single bent
pane of 12 mm crystal glass.
H68 cm (26¾ in). W95 cm (37½ in).
D75 cm (29½ in)
Manufacturer: Fiam, Italy

Piers Gough

Chaise Langue

Steel, upholstery

A bench seat of folded and welded sheet steel with a perforated steel sheet platform and finished in cellulose paint. The removable seat mattress is upholstered in leather or fabric. Limited batch production.

H72 cm (28½ in). W62.5 cm (24½ in). L206 cm (81⅛ in)

Manufacturer: Aram Designs, UK

26

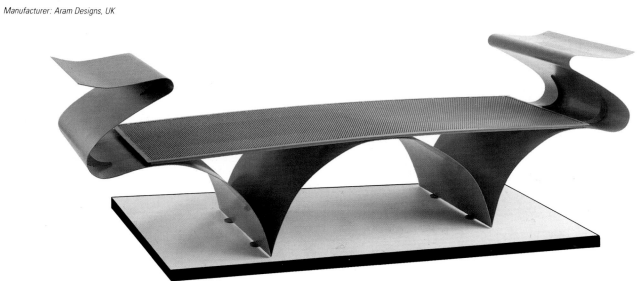

27

28

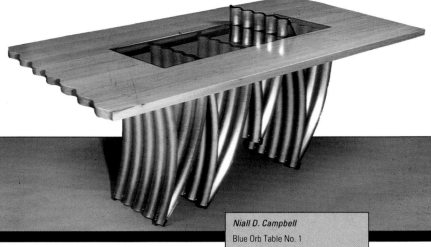

Niall D. Campbell
Blue Orb Table No. 1
Steel, wood, glass, rubber
A dining table in Blue Orb corrugated
steel that sandwiches rubber tubing to
give a soft edge. One-off.
H73 cm (28¾ in). W110 cm (43 in).
L180 cm (70⅝ in)
Manufacturer: Niall D. Campbell,
Australia

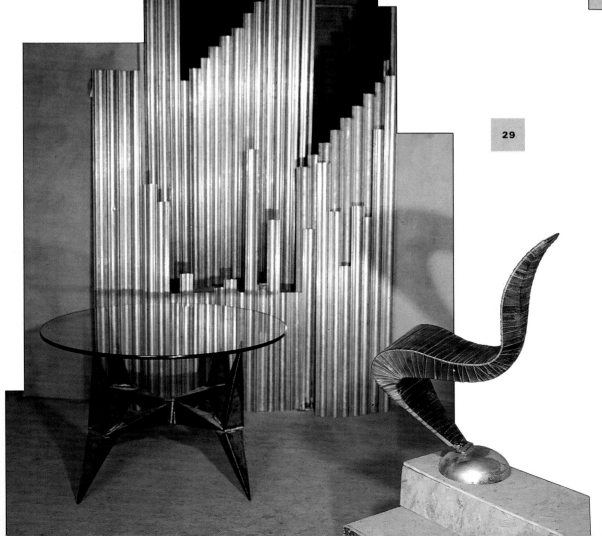

29

Thomas Dixon
Screen, chair, table
Screen *An organ-pipe screen of*
galvanized steel.
H (max) 200 cm (78¾ in). Di 8cm (3⅛ in)
Folding table *A table with a base of*
welded sheet steel and a glass top.
The base can be folded for storage.
Limited batch production.
H70 cm (27½ in). Di122 (48 in)
Chair *An S-shaped chair of rubber on a*
steel frame and sitting on a cast
aluminium base. Limited batch
production.
H95 cm (37½ in). W40 cm (15¾ in).
D50 cm (19⅝ in)
Manufacturer: Thomas Dixon, UK

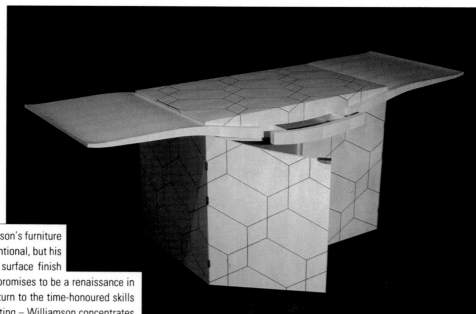

Rupert Williamson

Sideboard

Wood

*A sideboard in holly and walnut-wood.
The inlaid, interlocking hexagons cut
through a "wave" to form the top.
One-off.
H71 cm (28 in). L183 cm (72 in).
D61 cm (24 in)
Manufacturer: Rupert Williamson
Furniture, UK*

30 The forms of Rupert Williamson's furniture may seem somewhat conventional, but his preoccupation with materials and surface finish certainly is not. In tune with what promises to be a renaissance in ornamentation – an imaginative return to the time-honoured skills of carving, joinery, gilding and painting – Williamson concentrates on achieving geometric accuracy in a pattern like the shell of a tortoise, with finely grooved hexagons in holly and walnut-wood. Williamson's traditional training as a cabinetmaker has not resulted in the conservatism so often associated with British craftsmen.

Mario Villa

Villa Chair

Steel, brass

*A chair made of welded steel with a
brass back, available in verdigris, red or
natural (with rust-inhibiting finish).
Limited batch production.
H89.5 cm (35¼ in). W40.6 cm (16 in).
D47 cm (18½ in)
Manufacturer: Mario Villa Designs, USA*

31 The Gallic heritage of New Orleans, home of the Nicaraguan designer Mario Villa, provides the inspiration for his furniture and lights. Rejecting the stylistic options of "Louis-the-something" or rustic Provençal, he calls upon the flamboyance of French Empire style. Simply welded steel frames with a verdigris finish to simulate the patina of age are combined in his chairs with French Empire motifs of swags and drapes to achieve a skeletal minimalism which is none the less rich in imagery.

Shiro Kuramata
Chair, Homage to Josef Hoffmann Vol. 2
Cloth, metal pipe
A chair with blinking lamps operated and
adjusted by remote control. One-off.
H92cm (36 in). W90 cm (35½ in).
D76 cm (30 in)
Manufacturer: Kuramata Design Office,
Japan

32 Shiro Kuramata exemplifies the "retrospective" design approach with this nostalgic piece. Josef Hoffmann's *Haus Koller* armchair, designed in 1911, is immediately identifiable to designers and design students. In his *Homage to Josef Hoffmann Vol. 2,* Kuramata retraces the chair's solid, classic form, using tiny flashing lights, adjustable by remote control, in place of upholstery nails; in a visual pun they literally lighten the weightiness of the original concept. The result, as with all his pieces, has an elusive, haunting quality which is powerful.

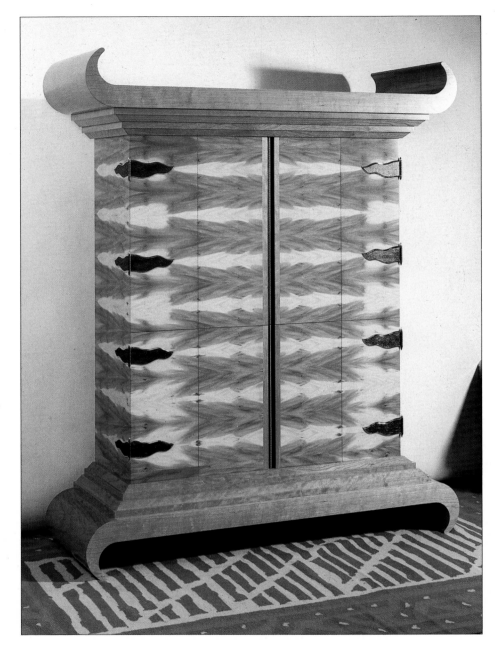

Derek Frost
Horn Chest
Wood, glass, granite, brass
A two-tiered cupboard concealing a
mirrored, marble bar with glass shelves.
The top and base are in cherry hardwood
and the frame is clad in yew veneer
showing contrasting heart-wood and
sap-wood in striped patterns. The spear
hinges are of gold- and bronze-plated
brass. One-off.
H197.5 cm (77¾ in). W158.75 cm
(62½ in). D56.25 cm (22¼ in)
Manufacturer: Derek Frost
Associates, UK

33 Beneath the pagoda roof of the overscaled *Horn Chest,* tiger-striped with yew veneers, are tiers of cupboards and a mirrored cocktail bar with glass shelves. Once again the craft traditions of marquetry, lacquering, gilding and painting have found imaginative new uses – here, with some irony, to conceal the showy paraphernalia of late twentieth-century consumerism.

Derek Frost
Stereo cabinet
A stereo cabinet with three lift-up lids
containing a counter, two turntables and
mixing controls. Three sliding doors
conceal a television on a swing arm,
amplifiers, and storage for CDs and
cassettes. The lower level has three
storage drawers. Finished in blue matt
cellulose with white-gold oil gilding. The
silver doors are by Yumi Katayama.
One-off.
H98 cm (38½ in). W127 cm (50 in).
D55 cm (21½ in)
Manufacturer: Derek Frost
Associates, UK

Decorators who move into furniture design invariably bring with them a sumptuousness of finish and an extravagant use of colour and surface pattern. Derek Frost is no exception. His furniture collection is boldly derivative in its exaggeration of familiar forms from the past. A 1950s jukebox is the inspiration for a stereo cabinet with sliding doors that holds the latest in electronic sound systems, as well as a TV that pivots out on a swing arm.

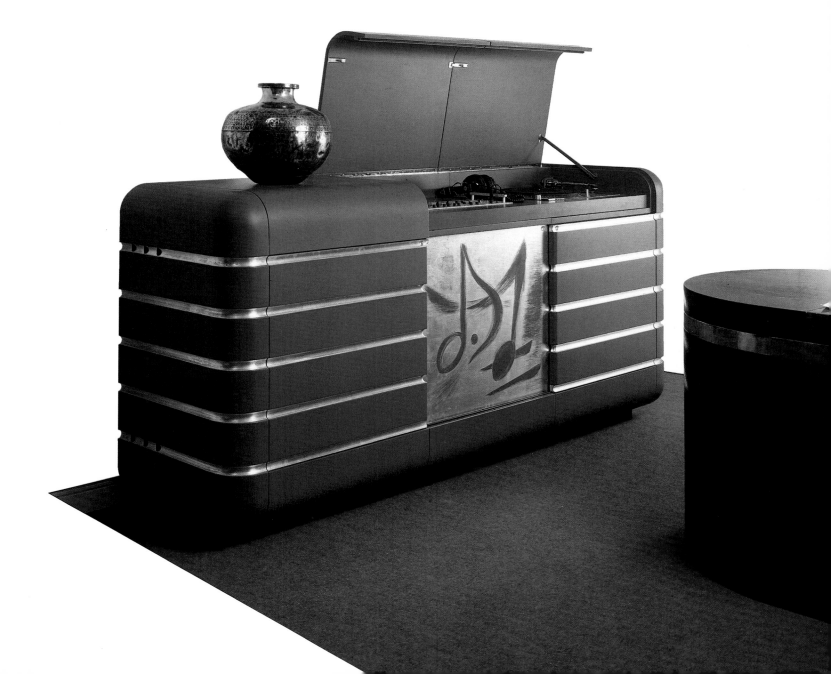

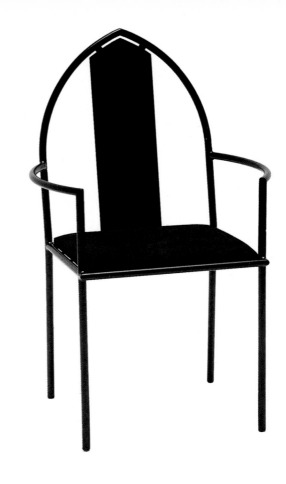

Mondo Studio
Sofa
Wicker
*Part of the Déjàvu Collection. Available
in natural, antique, white or coffee.*
*H103 cm (40½ in). W155 cm (61 in).
D95 cm (37½ in)*
Manufacturer: Mondo, Italy

35

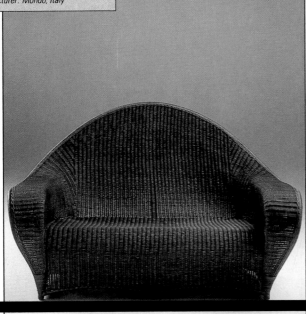

36 *Peter Leonard / Soho*
Gothic Carver Chair
Steel, upholstery
*A carver chair with arched back and arms
made of tubular and sheet steel with an
upholstered seat.*
*H101 cm (39¾ in). W59 cm (23¼ in).
D50 cm (19⅝ in)*
Manufacturer: Soho Design, UK

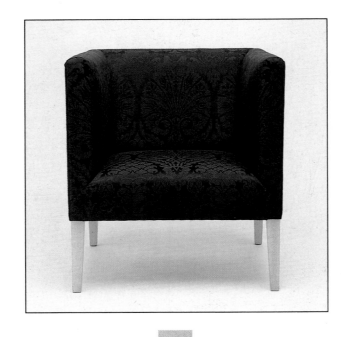

Peter Leonard / Soho
Romilly Chair
Wood, upholstery
*A chair with a solid beech frame and
tapered legs in natural or black-stained
beech. The sprung seat is traditionally
upholstered.*
*H84 cm (33 in). W75 cm (29½ in).
D75 cm (29½ in)*
Manufacturer: Soho Design, UK

37

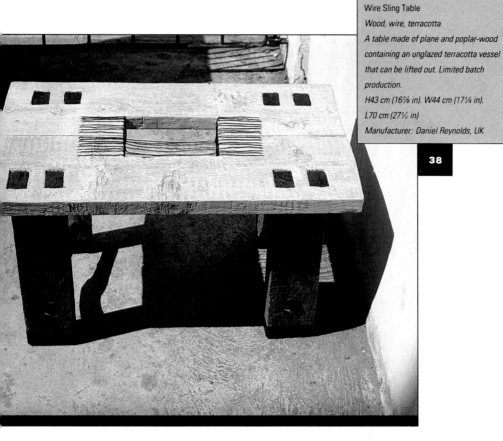

Daniel Reynolds
Wire Sling Table
Wood, wire, terracotta
A table made of plane and poplar-wood
containing an unglazed terracotta vessel
that can be lifted out. Limited batch
production.
H43 cm (16⅞ in). W44 cm (17¼ in).
L70 cm (27½ in)
Manufacturer: Daniel Reynolds, UK

38

Paul Ludick
Claw Paw Side Chair
Wrought iron, wood, leather
A prototype chair with a wrought-iron
frame and wooden back. The leather
cushion stuffed with polyurethane resin
can be removed.
H70 cm (27½ in). W46 cm (18 in).
D68 cm (27 in)
Manufacturer: Furniture of the
Twentieth Century, USA

39

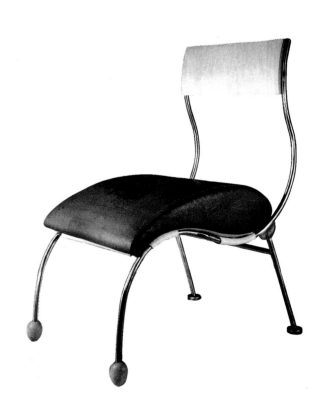

F
U
R
N
I
T
U
R
E

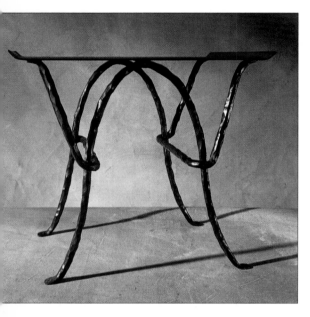

Mattia Bonetti and Elisabeth Garouste
Stool, Tabourêt Râ
Iron
A stool made of beaten iron. Limited batch production.
H40 cm (15¾ in). W46 cm (18 in).
D35 cm (13¾ in)
Manufacturer: En Attendant les Barbares, France

Scott Crolla
The Cathedral Chair
Upholstery, hide
A variation on the wing chair, available in left- or right-handed versions and in a selection of fabrics. The feet are of hide. Limited batch production.
H140 cm (55⅛ in). W110 cm (43¼ in).
D76 cm (30 in)
Manufacturer: Alma, UK

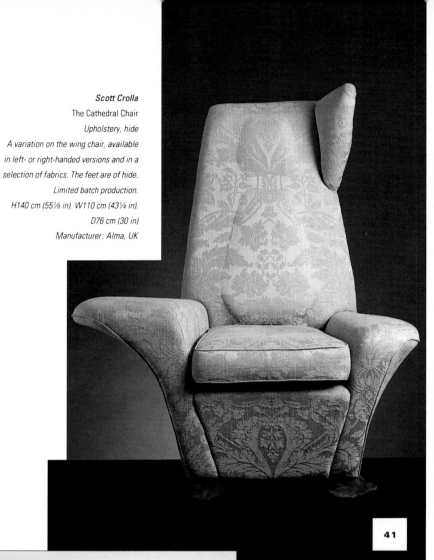

41

Eva Jiricna
Ze Trolley
Steel, aluminium
A multi-purpose flexible trolley with a central steel post and spacers on three legs with lockable wheels. The supporting brackets, which can be moved, are of aluminium, and the shelves are of clear or black glass or of perforated or rigidized steel. The trolley is fitted with a low-voltage spot lamp for indirect lighting.
H243 cm (95½ in). Di92.5 cm (36⅜ in)
Manufacturer: Aram Designs, UK

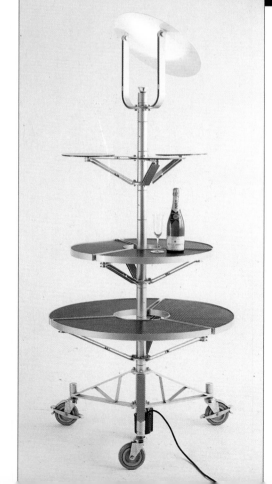

42

In the United States Angelo Donghia and John Saladino are well-known mainstream names in interior decoration. As with many decorators who move into furniture design, the lines of their pieces show the ornamental tendencies of a bygone classical age rather than minimalist trends. Donghia's *Paris Hall* chairs were designed – like haute couture fashion – to be seen from the back, with their inlaid checked veneers in walnut and birch. Saladino's *Tulip Chair* has a streamlined simplicity that is modern, but is clothed in tailored upholstery that promotes it to the status of a timeless classic.

John Saladino
Tulip Chair
Wood, upholstery
An armchair with a maple frame and
separate back cushion. Limited batch
production.
H74 cm (29 in). W70 cm (27½ in).
D66 cm (26 in)
Manufacturer: Saladino Furniture, USA

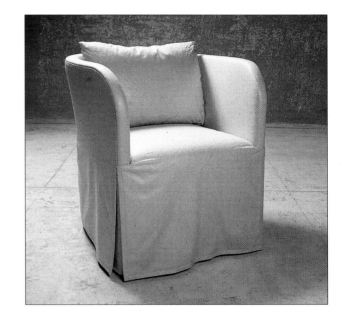

44

Donghia Design Studio
Paris Hall Chair No. 7911
Wood, upholstery
A chair with a maple-wood frame and
tapering legs. The flat back is inlaid with
walnut and birch veneer.
H87.5 cm (34½ in). W47 cm (18½ in).
D53.5 cm (21 in)
Manufacturer: Donghia Furniture, USA

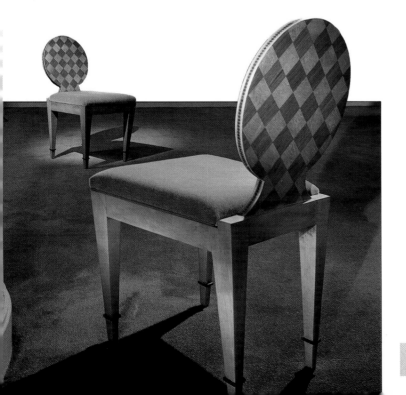

43

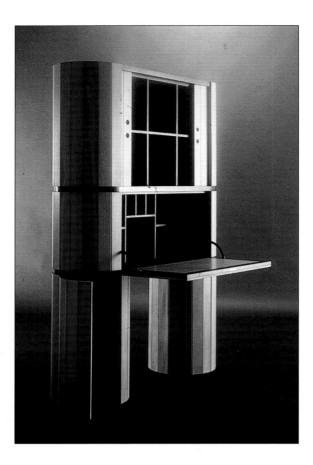

45

Norman Foster
Bed, Zabed
Wood
Prototype of a large square bed in solid
beech and plywood with eight storage
units which can also be used as
platforms. The mattresses are
handmade futons.
H42 cm (16½ in). W200 cm (78¾ in).
L200 cm (78¾ in)
Manufacturer: Aram Designs, UK

Adolfo Natalini and Guglielmo Renzi
Cabinet, Volumina
Wood
A study cabinet designed for reading,
writing, collecting and storing. Two tall
columns of cypress or walnut or cherry-
wood contain and support a lift-top desk.
The interiors are in wengee or Japanese
maple. All the wood has been seasoned
for up to forty years. Limited batch
production.
H179 cm (70½ in). W123 cm (48½ in).
D (open) 79 cm (31 in); (closed) 40 cm
(15¾ in)
Manufacturer: Sawaya & Moroni, Italy

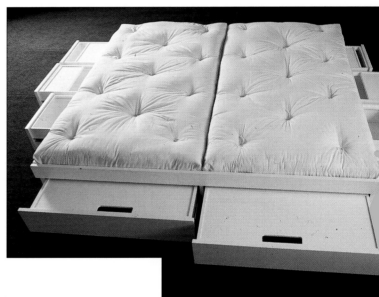

46

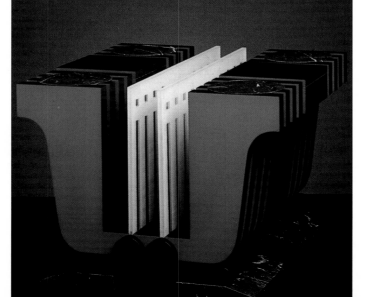

47

Terry Farrell and Doug Streeter
Canterbury
Marble, glass, wood
An extruded lyre-shaped object with
etched glass divisions. Marble discs are
sunk into the top around sycamore-lined
compartments. Limited batch
production.
H40.6 cm (16 in). W56 cm (22 in).
D61 cm (24 in)
Manufacturer: Alma, UK

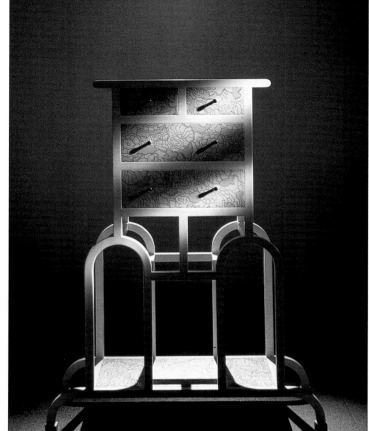

George J. Sowden
Chest, George
Wood, laminate
A chest of lacquered wood and plastic
laminate. Limited batch production.
H130 cm (51⅛ in). W100 cm (39½ in).
D38 cm (15 in)
Manufacturer: Memphis, Italy

49

Franz R.R. Romero
Chair, DS-57
Metal, wood, leather
An armchair with a wood and metal
frame covered with leather.
H 67 cm to 92 cm (26⅜ in to 36 in).
W90 cm (35½ in). D100 cm (39½ in)
Manufacturer: DeSede, Switzerland

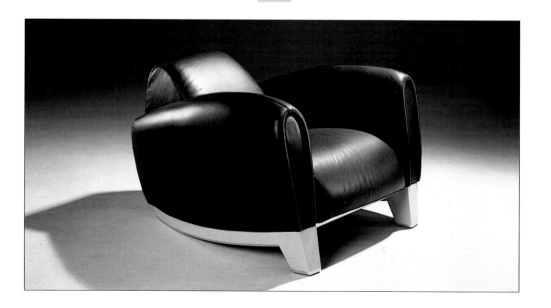

Retrospection

F U R N I T U R E

45

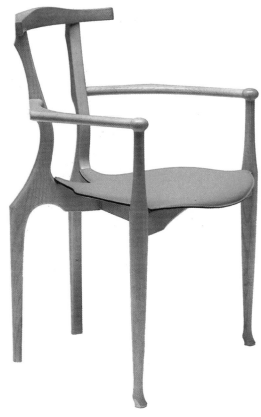

Oscar Tusquets Blanca

Chair, Gaulino

Wood, leather

A stackable armchair in oak with natural, black or mahogany finish and a leather seat in beige, black, dark grey or red.

H86 cm (33⅞ in). W48 cm (18⅞ in).

D46 cm (18 in)

Manufacturer: Carlos Jané, Spain

Robert Adam

Pembroke Table

Wood, bronze

A table with a top of myrtle burr with ebonized inlay, edged in satinwood. The frame is of maple-wood and the decorative heads are of cast bronze. Limited batch production.

H71 cm (28 in). W79 cm (31 in).

L79 cm (31 in)

Manufacturer: Alma, UK

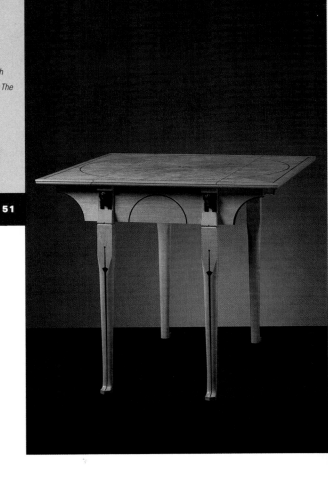

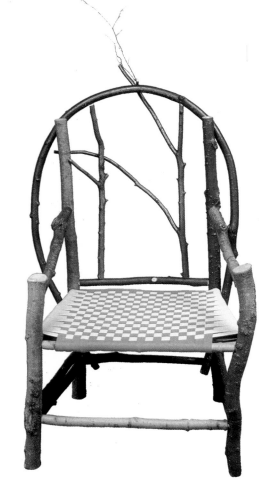

Daniel Mack

Bentwood Armchair

Wood

A chair made of sugar maple and hickory with a tape seat.

H114 cm (45 in). W61 cm (24 in).

D51 cm (20 in)

Manufacturer: Daniel Mack Rustic Furniture, USA

54

Diane E. Smith
Music stand
Wood, aluminium
A music stand made of casuarina wood
and aluminium rods covered with blue
lacquer. It has an independent
adjustable support for sheet music
that is attached to the upright with
leather-covered aluminium hooks.
One-off.
H150 cm (59 in)
Manufacturer: Diane E. Smith, Australia

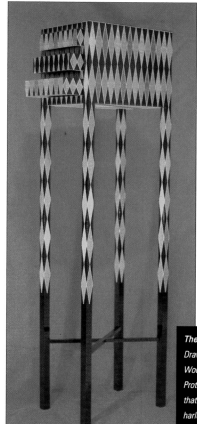

The Imperial Woodworks
Drawer stand
Wood
Prototype of a drawer stand in mahogany
that has been oil-painted with
harlequin diamonds.
H116.8 cm (46 in). W20.3 cm (8 in).
D20.3 cm (8 in)
Manufacturer: The Imperial
Woodworks, UK

53

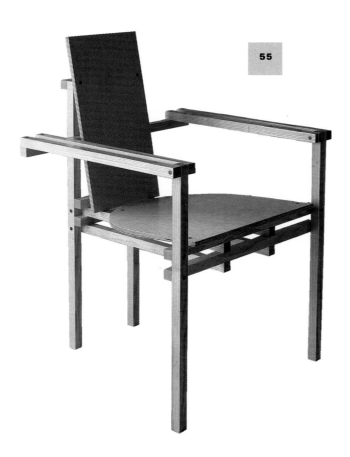

55

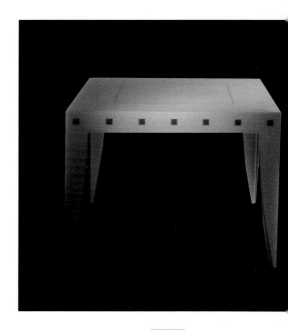

56

Willie Landels

Chair, One x One

Wood

A chair made with 1-in by 1-in solid ash glued, screwed and pelleted. The seat and backrest are of Finnish birch plywood. Finished in clear polyurethane lacquer or cellulose paint. Also available without arms. Limited batch production. H88 cm (34⅝ in). W61 cm (24 in). D56 cm (22 in)

Manufacturer: Aram Designs, UK

57

Lars Mathiesen

Chair, Expresso

Steel, metal sheet, upholstery

A stackable chair with polyester-coated tubular steel frame and a seat of metal sheet coated with lacquer. Available with or without upholstered seat and back.

H70 cm (27½ in). W49 cm (19¼ in). D49 cm (19¼ in)

Manufacturer: Brent Kroghs, Denmark

Charles Jencks
Spring Table
Wood
A table of solid wood structure finished
with rare veneers of lemon-wood, bird's
eye maple and Mexican yucca. The
inlays are of ebonized wood. Available in
rectangular or square versions. Limited
batch production.
H75 cm (29½ in). W97 cm (38¼ in).
L97 cm, 141 cm or 183 cm (38¼ in,
55½ in or 72 in)
Manufacturer: Sawaya & Moroni, Italy

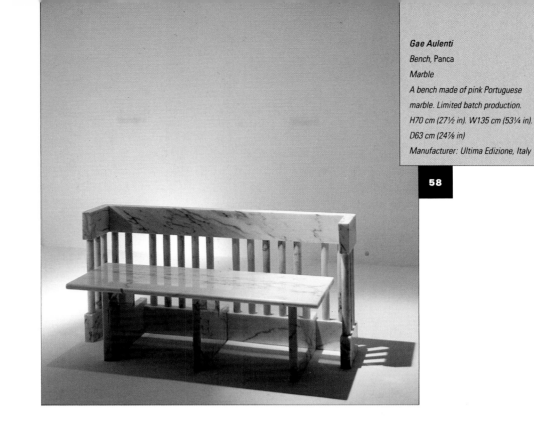

Gae Aulenti
Bench, Panca
Marble
A bench made of pink Portuguese
marble. Limited batch production.
H70 cm (27½ in). W135 cm (53¼ in).
D63 cm (24⅞ in)
Manufacturer: Ultima Edizione, Italy

58

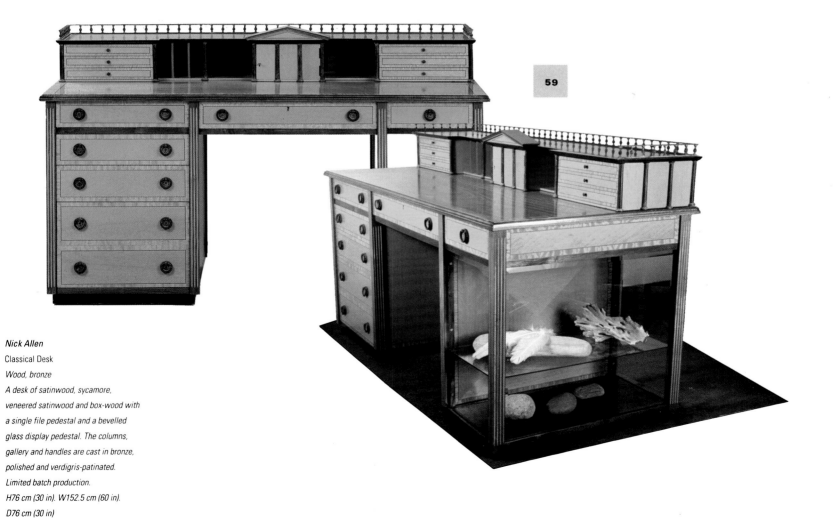

59

Nick Allen
Classical Desk
Wood, bronze
A desk of satinwood, sycamore,
veneered satinwood and box-wood with
a single file pedestal and a bevelled
glass display pedestal. The columns,
gallery and handles are cast in bronze,
polished and verdigris-patinated.
Limited batch production.
H76 cm (30 in). W152.5 cm (60 in).
D76 cm (30 in)
Manufacturer: Suffolk Furniture, UK

49

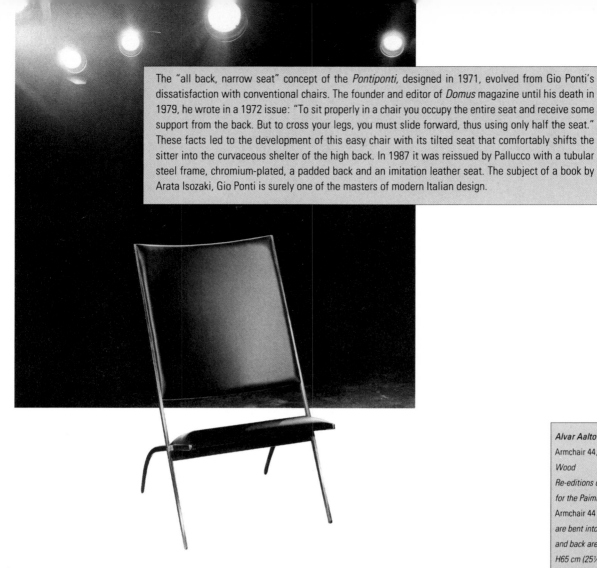

The "all back, narrow seat" concept of the *Pontiponti*, designed in 1971, evolved from Gio Ponti's dissatisfaction with conventional chairs. The founder and editor of *Domus* magazine until his death in 1979, he wrote in a 1972 issue: "To sit properly in a chair you occupy the entire seat and receive some support from the back. But to cross your legs, you must slide forward, thus using only half the seat." These facts led to the development of this easy chair with its tilted seat that comfortably shifts the sitter into the curvaceous shelter of the high back. In 1987 it was reissued by Pallucco with a tubular steel frame, chromium-plated, a padded back and an imitation leather seat. The subject of a book by Arata Isozaki, Gio Ponti is surely one of the masters of modern Italian design.

Gio Ponti

Armchair, Pontiponti

Steel

An armchair with a frame of satined, chrome-plated tubular steel, upholstered in imitation leather.
H100.65 cm (39⅝ in). W59 cm (23¼ in).
D61 cm (24 in)
Manufacturer: Pallucco, Italy

60

Alvar Aalto

Armchair 44, Table 915

Wood

Re-editions of items originally designed for the Paimio Sanatorium 1931-2.
Armchair 44 *The laminated birch sides are bent into a closed curve. The seat and back are sprung and upholstered.*
H65 cm (25½ in). W60 cm (23½ in).
D85 cm (33½ in)
Table 915 *Again, the laminated birch sides are bent into a closed curve. The top and shelf are of moulded plywood.*
H60 cm (23½ in). W51 cm (20 in).
L60 cm (23½ in)
Manufacturer: Artek, Finland

61

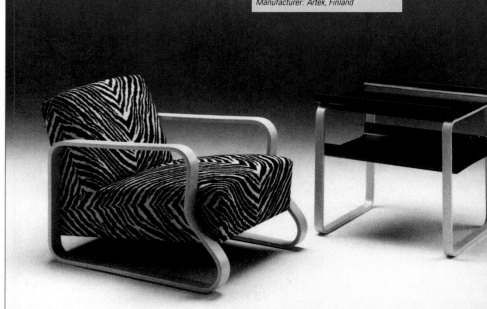

Mario Bellini

Chair and sofa, 415 Cab

Steel, leather, polyurethane foam

A new version of Bellini's Cab range. The armchair and two-seater sofa have enamelled steel frames covered with polyurethane foam and polyester padding, upholstered in leather zipped on to the frame.

H81 cm (31¾ in). W93 cm and 162 cm (36½ in and 63¾ in). D81 cm (31¾ in)

Manufacturer: Cassina, Italy

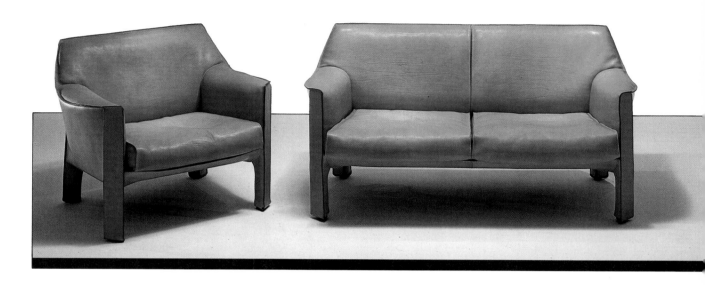

62 The current editor of *Domus*, Mario Bellini, is arguably Italy's most articulate trend-spotter and debunker, as well as being a highly disciplined designer and architect. Many of his designs can be said to have become classics in his own lifetime. The fact that there are no fewer than six terms in Italian to describe a seat – *"poltrona," "sedia," "sedia con braccioli," "poltrocina," "divanetto"* and *"divano"* – illustrates its evolutionary possibilities, and these he has exploited to the full. The *Cab* series for Cassina developed from Bellini's 1976 design for a dining chair, its seat, back and four legs covered in hide, stitched to ensure a perfect fit and zipped on to a lightweight steel body. The series grew to encompass an armchair (1979) and a small sofa (1982). The new *divano* that now completes the group has therefore accumulated the stature of a re-edition. Bellini once wrote that a chair was perhaps the most difficult and fascinating object to design, being "virtually unaltered, apart from diversification in style, since ancient Egyptian times."

63

Eileen Gray

Sofa, Montecarlo

Steel, wood, latex, Dacron

A re-edition of sofa originally designed in 1929. It has a chromium-plated tubular steel construction and a supported wooden framework.

H60 cm (23½ in). W280 cm (110¼ in). D92 cm (36 in)

Manufacturer: Vereinigte Werkstätten, West Germany

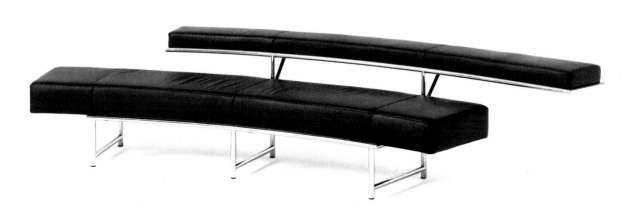

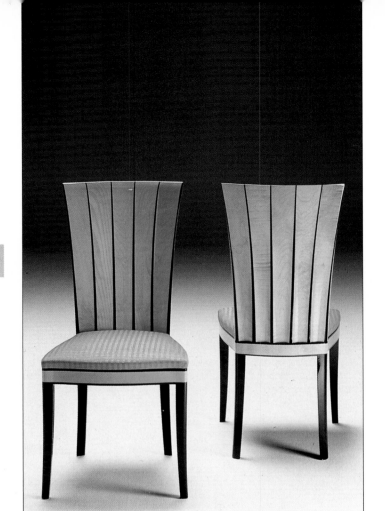

64

Eliel Saarinen

Saarinen House Side Chairs

Wood

Re-editions of the Saarinen House
Dining Room *furniture designed in 1929-
30 by Saarinen for his Cranbrook home.
The originals are in the Cranbrook
Museum, USA. Made of solid hardwood
and maple.*
*H95 cm (37½ in). W43 cm (16⅞ in).
D48 cm (18⅞ in)*
Manufacturer: Adelta, Finland

Eliel Saarinen

Saarinen House Living Room

Wood

*Re-editions of an armchair and sofa from
the* Saarinen House Living Room
*designed by Saarinen in 1929-30 for his
house in Cranbrook. Made from solid
hardwood with walnut, maple and
mahogany veneers.*
*Sofa H79 cm (31 in). W132 cm (52 in).
D55 cm (21½ in)*
*Armchair H79 cm (31 in). W63 cm
(24⅞ in). D55 cm (21½ in)*
Manufacturer: Adelta, Finland

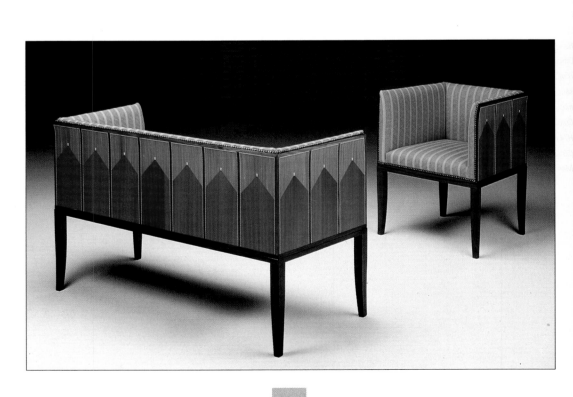

65

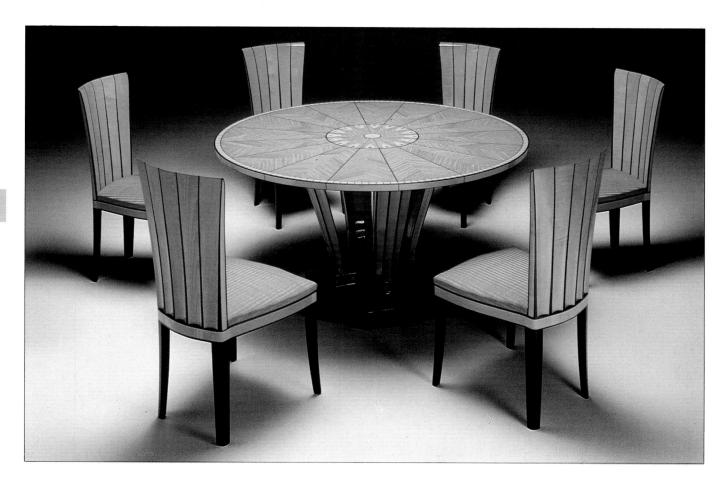

Eliel Saarinen
Saarinen House Dining Table and Side
Chairs
Wood
Re-editions of the Saarinen House
Dining Room *furniture. The circular table*
is of solid hardwood and maple with
satinwood, American and European
maple veneers. The original is in the
Cranbrook Museum, USA.
H74 cm (29 in). Di 135 cm or 161 cm
(53¼ in or 63⅜ in)
Manufacturer: Adelta, Finland

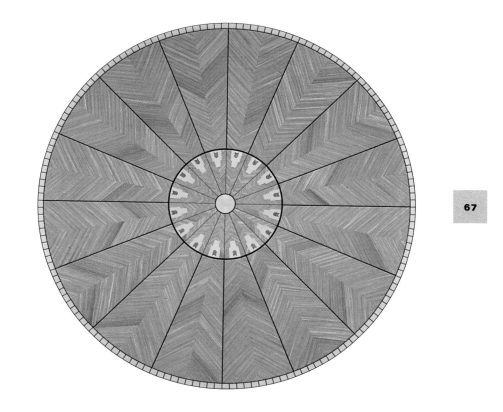

67

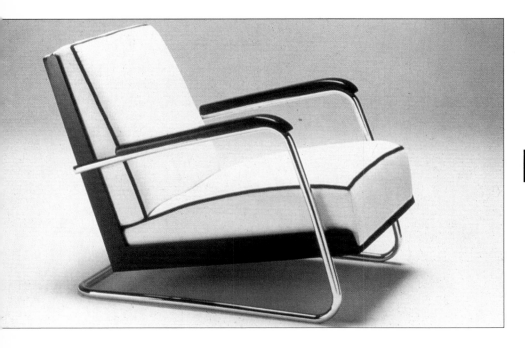

68

Pauli Ernesti Blomstedt

Armchair, Post Deco 8160

Steel, wool, upholstery

Re-edition of an armchair from the early
1930s, made of tubular chromed steel,
birch with black or white lacquer finish
or birch veneer. It is upholstered in fabric
or leather.

H78 cm (30¾ in). W62 cm (24⅜ in).
D83 cm (32½ in)
Manufacturer: Adelta, Finland

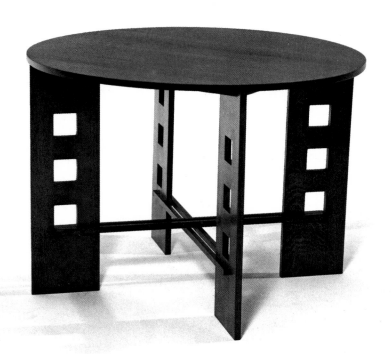

69

Charles Rennie Mackintosh
Round Table
Wood
A re-edition in stained (rather than
ebonized) solid oak of a Mackintosh
design of 1903. Special finishes are
available. Limited batch production.
H73 cm (28¾ in). Di98.6 cm (38⅞ in)
Manufacturer: Freud, UK

Charles Rennie Mackintosh

Chairs

Re-editions of Mackintosh chairs. Limited batch productions. From left to right:

Medium-backed Tea Room Chair *Originally designed in 1900 for Miss Cranston's Ingram Street Tea Rooms in Glasgow. Made of solid oak or solid maple with an upholstered seat.* H106 cm (41¾ in). W47 cm (18½ in). D43.2 cm (17 in)

High-backed Tea Room Chair *Also designed in 1900 for Miss Cranston's Tea Rooms and made of solid oak or solid maple with an upholstered seat.* H149.5 cm (58⅞ in). W47 cm (18½ in). D43.2 cm (17 in)

Hill House Writing Desk Chair *Originally designed in 1903-4 and made in ebonized wood. Now available in solid maple finished in black or natural lacquer with an upholstered seat.* H111.7 cm (44 in). W41 cm (16⅛ in). D42.6 (16¾ in)

Ladder-backed Chair *Originally designed in 1903. Made of solid beech with a curved back, elliptical legs and an upholstered seat.* H140 cm (55⅛ in). W40 cm (15¾ in). D39.5 cm (15½ in)

Blue Bedroom Chair *Originally designed in 1904. Made of solid American oak with an upholstered seat. Finished in natural waxed oak or ebonized oak.* H77.5 cm (30½ in). W42 cm (16½ in). D42.2 cm (16⅝ in)

Manufacturer: Freud, UK

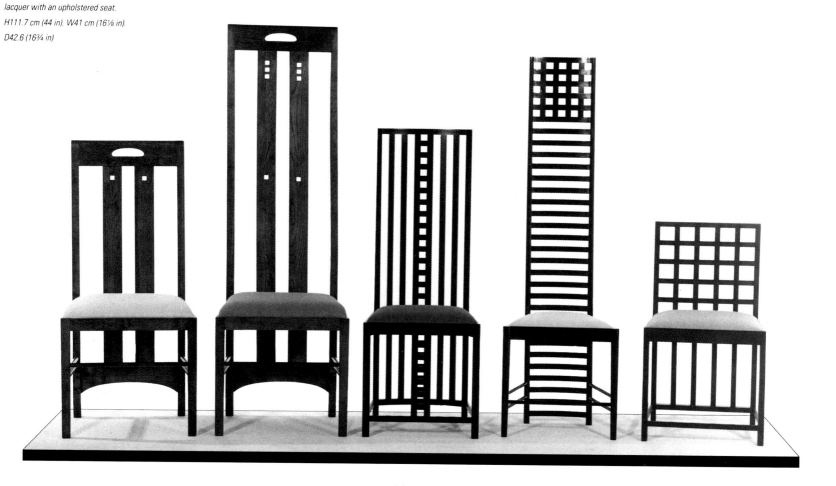

70 Re-editions of classic furniture designs were the subject of court actions throughout 1987. Arguments over royalties and licences continue in the district courts of Italy, the country of origin of so many re-editions. According to British law, copyright on works of art expires fifty years after their creator's death – hence the appearance of a rash of new, cheap copies of great pieces of this century, not all of them faithful to their originals, which precipitated the current legal wrangle. Some collections are unchallenged, such as the Freud collection of Charles Rennie Mackintosh's furniture designs, dating from between 1900 and 1918. As Mackintosh was a designer and not a furniture maker, it has been Freud's policy to follow the drawings where possible rather than to risk compounding the mistakes of an earlier producer. The Freud collection, which is made in Britain, consists of eight pieces, all in wood. Of those shown here, the manufacturers claim that the *Hill House Writing Desk Chair* and the *Blue Bedroom Chair* have never been reproduced before.

71 Porsche is a designer name now associated with such diverse items as sunglasses and luggage, as well as the famous cars. It is also the name behind the well-known ergonomic *Antropovarius* chair produced by Poltrona Frau and based on the original car seat designs. In the new *Antropovarius Office* series, the chairs retain a feature of that earlier piece: its steel vertebrae, which are covered in PVC and linked by a sheet of carbon fibre within the comfortably padded exterior. As a driver can adjust his seat, so levers allow movement of the chair's backrest; the chair can be lengthened in front and adjusted in height.

Ferdinand A. Porsche
Chair, Antropovarius Office
Steel, leather, polyurethane
A series of chairs for domestic and office
use – the model shown is the President
armchair. The structure is built of steel
vertebrae covered by PVC and joined by a
strip of carbon fibre; armrests are of
steel covered with leather; and the base
is of steel covered with semi-rigid
polyurethane and integral leather.
H130 cm (51⅛ in). W72 cm (28½ in).
D70 cm (27½ in)
Manufacturer: Poltrona Frau, Italy

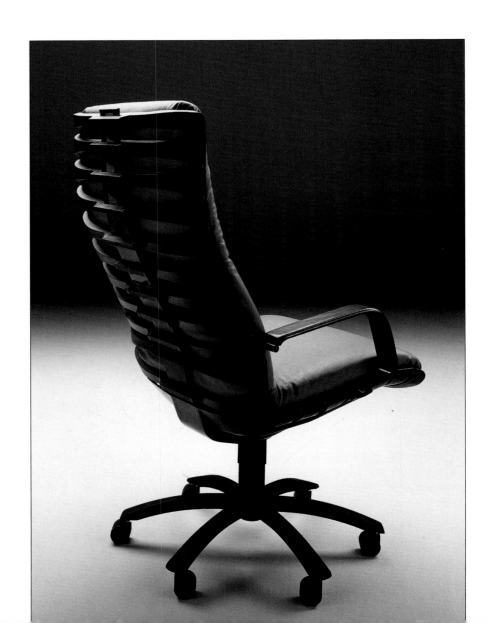

Lola Castello Colomer

Chair, Nit

Wood

A chair with a solid ash-wood frame and moulded plywood seat and back. Available in several colours and with an upholstered seat.

H80 cm (31½ in). W42 cm (116½ in). D44 cm (17¼ in)

Manufacturer: Punt Mobles, Spain

72 This chair from the Valencian-born designer Lola Castello Colomer reads as well from the back as from the front. The curved black backrest, like a capacious cloak, is geometrically balanced by the line of the splayed legs. The cut-out space is reminiscent of the shape of cathedral windows or Moorish arches, yet at the same time is as graphic as a pencil point – an ancient/modern form.

73

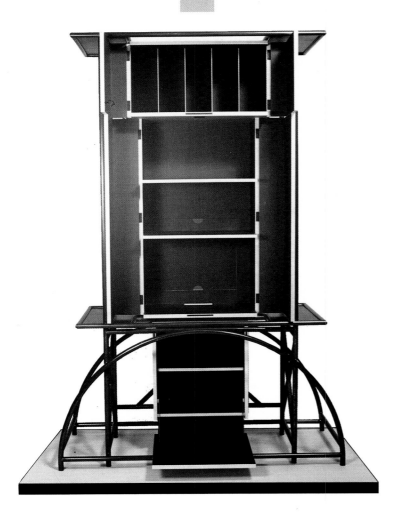

Keith L. Gibbons
Cabinet
Steel, wood
A cabinet designed to house stereo
equipment. The frame is of patinated
tubular steel and supports cupboard
units veneered in sycamore on the
outside and black-stained bolivar on the
inside. One-off.
H210 cm (82⅜ in). W150 cm (59 in).
D53 cm (20⅞ in)
Manufacturer: Keith Gibbons Design
and Production / Rupert Williamson
Furniture, UK

Chris M. McElhinny
Chair
A dining chair in jarrah-wood and suede
leather. One-off.
H80 cm (31½ in). W50 cm (19⅝ in).
D43 cm (16⅞ in)
Manufacturer: Chris M. McElhinny,
Australia

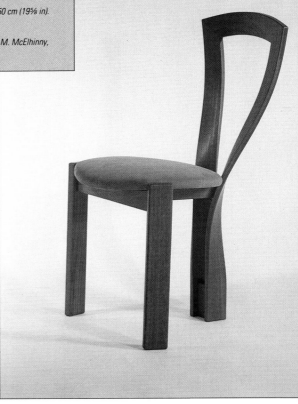

74

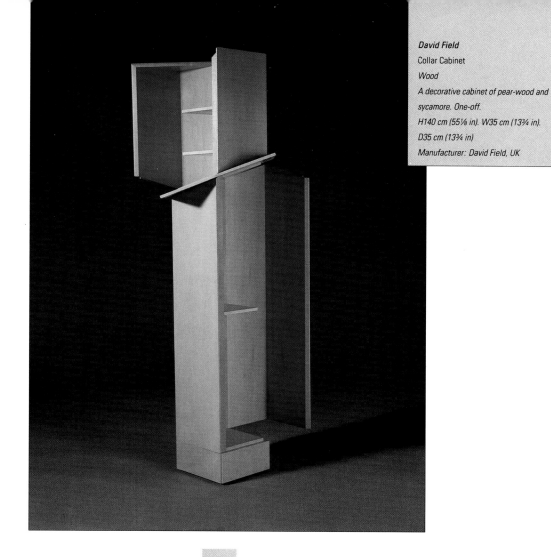

David Field
Collar Cabinet
Wood
A decorative cabinet of pear-wood and
sycamore. One-off.
H140 cm (55⅛ in). W35 cm (13¾ in).
D35 cm (13¾ in)
Manufacturer: David Field, UK

Verner Panton
Sofa, Pantheon
Wood, upholstery
An upholstered sofa with an
asymmetrical back and armrests of
different heights.
H87 cm (34¼ in). W205 cm (80¾ in).
D78 cm (30¾ in)
Manufacturer: Erik Jørgensen,
Denmark

75

76

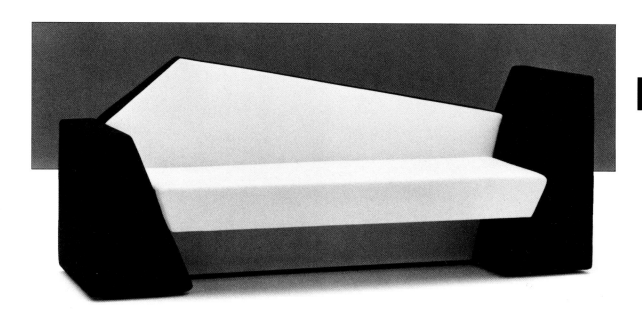

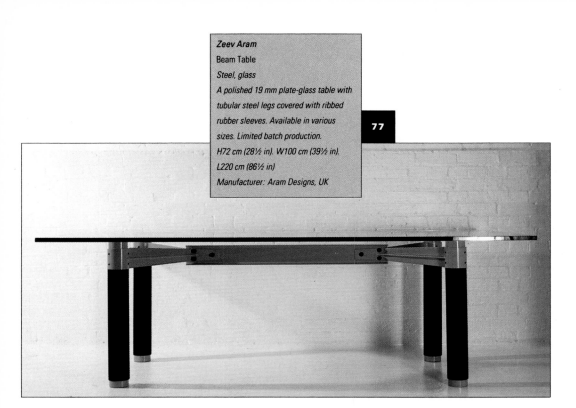

Zeev Aram
Beam Table
Steel, glass
A polished 19 mm plate-glass table with
tubular steel legs covered with ribbed
rubber sleeves. Available in various
sizes. Limited batch production.
H72 cm (28½ in). W100 cm (39½ in).
L220 cm (86½ in)
Manufacturer: Aram Designs, UK

77

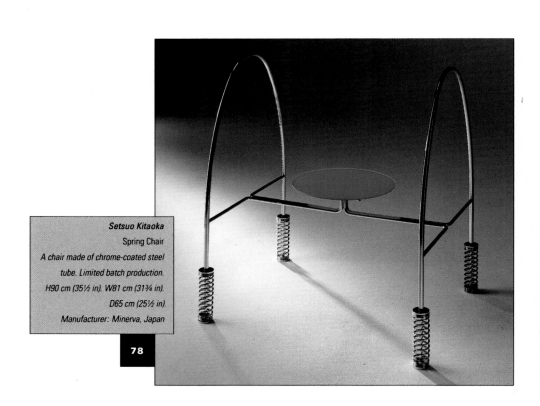

Setsuo Kitaoka
Spring Chair
A chair made of chrome-coated steel
tube. Limited batch production.
H90 cm (35½ in). W81 cm (31¾ in).
D65 cm (25½ in).
Manufacturer: Minerva, Japan

78

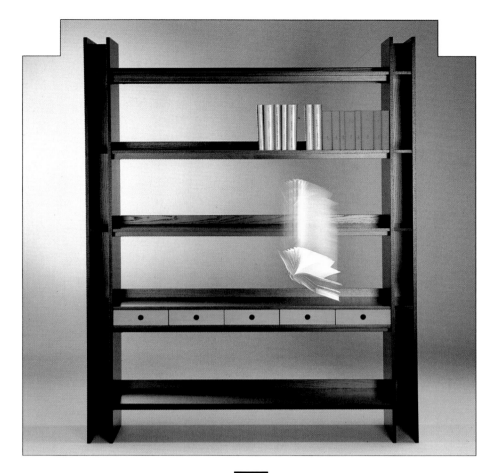

79

Gianfranco Frattini
Shelving, Libreria Proust
Wood
A shelving unit for the home or office. The two uprights have display spaces for small items and support four shelves and a horizontal drawer unit with five small pear-wood drawers. Finished in ebonized black ash.
H194 cm (76⅜ in). W152 cm (59¾ in). D38 cm (15 in)
Manufacturer: Morphos/Acerbis International, Italy

80

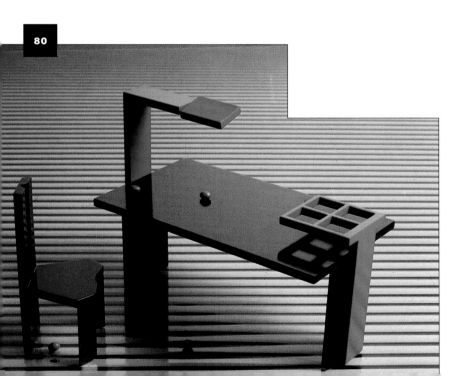

Kirti Trivedi
Tables
Wood
A range of office tables with matching chairs in lacquered wood. Different models have built-in features such as shelves, lamps and drawers. Limited batch production.
H68.5 cm (27 in). W68.5 cm (27 in). L122 cm (48 in)
Manufacturer: The Design Cell, India

Jochen Hoffmann
Chair, Luna
Wood, upholstery
A high-backed chair upholstered in
leather or a choice of fabrics.
H105 cm (41⅜ in). W73 cm (28¾ in).
D84 cm (33 in)
Manufacturer: Franz Wittmann, Austria

82

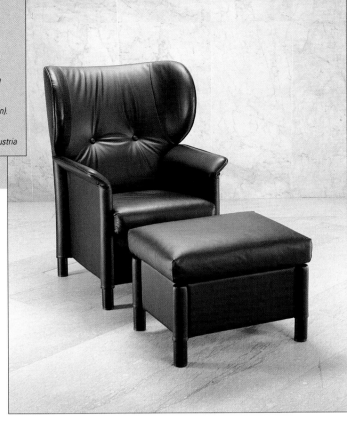

Marc Newson
Charlotte Chair
Steel, leather
A chair with a steel pipe frame
upholstered in leather.
H74 cm (29 in). W63 cm (24⅞ in).
D87 cm (34¼ in)
Manufacturer: Idée, Japan

83

81

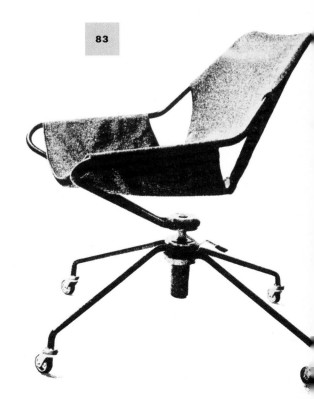

Paulo Mendes da Rocha
Chair, The Paulistano (executive version)
Steel, canvas
A reclining, swivel armchair with a
tarnished epoxy-coated tubular spring
steel frame and a sling seat of canvas.
The height can be adjusted.
H97 cm (38¼ in). W70 cm (27½ in).
D90 cm (35½ in)
Manufacturer: Nucleon Oito, Brazil

Corrado Dell'Orso
Chair, Milos
Steel, leather
A reclining chair with an adjustable
support for the head. The steel structure
is epoxy-coated or chrome-plated.
H70 cm (27½ in). W63 cm (24⅞ in).
D195 cm (76¾ in)
Manufacturer: Strässle Söhne,
Switzerland

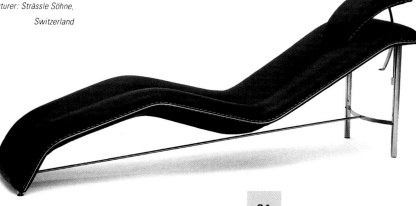

84

Anthony Hunt
Table and chair, Alco
Alucobond sheet
Furniture made of folded silver-anodized
aluminium composite sheet with joints
of stainless-steel blocks and
countersunk bolts. Limited batch
production.
Dining table H72 cm (28½ in). W69 cm
(27⅛ in). L149 cm (58⅝ in)
Armchair H81 cm (31¾ in). W68 cm
(26¾ in). D58 cm (22⅞ in)
Manufacturer: Aram Designs, UK

85

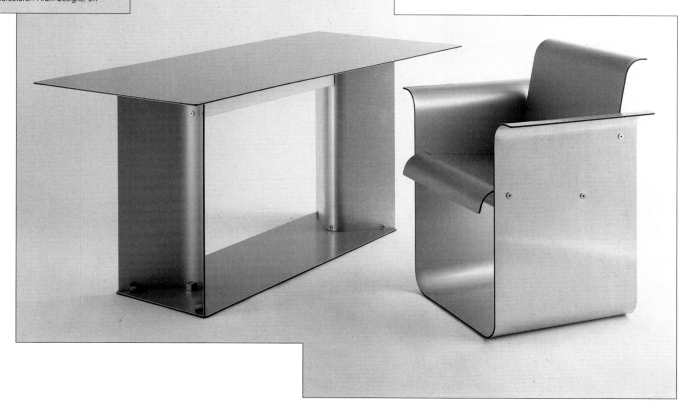

Corporate Industrial Design (CID)
PEOS – Philips Electronic Office System
*A modular furniture system designed for
a fully automated office. The basic
elements are horizontal, bridge-like
cable beams and worktops. Various
elements are attached to the cable
beams by means of wing-nut
connections. The worktops can be
adjusted in height and angle.*
Lower beam *H50 cm (20 in)*
Worktop *H66 cm to 78 cm (26 in to
30¾ in)*
*Manufacturer: Philips NV,
The Netherlands*

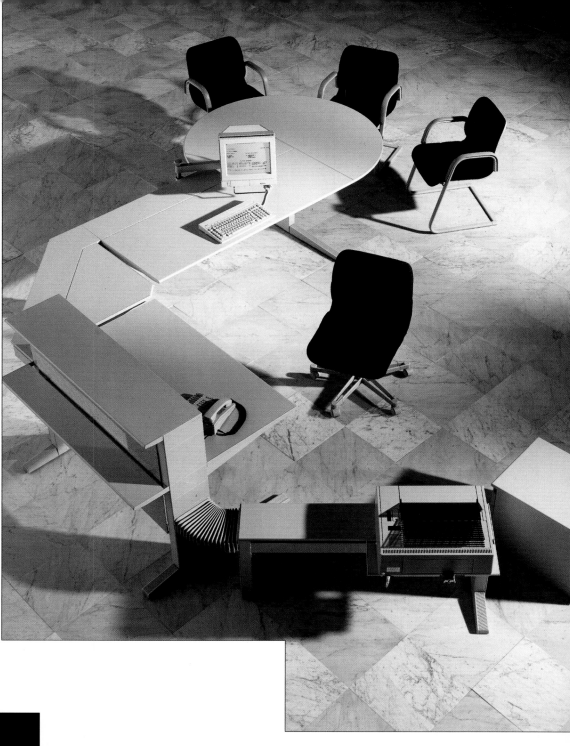

Pietro Arosio
Chair, Monopoli
Steel
*A stacking armchair with a tubular steel
structure finished in chrome or black,
with seat and back of perforated steel
sheet finished in matt black. The seat is
also available in a leather finish.*
*H78 cm (30¾ in). W50 cm (19⅝ in).
D60 cm (23½ in)*
Manufacturer: Airon, Italy

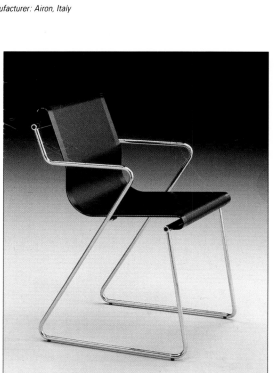

86

The Philips Electronic Office System helps to marshal the bulky masses of wires required to run the electronic equipment that is so much a part of modern working life. It recognizes the need for wires and cables to be accessible for maintenance without having to lift floor tiles or carpets; it also recognizes that people are at their most productive when their surroundings are both efficiently ordered and comfortable. The basic elements of the system are two horizontal cable beams in various lengths. The low one carries power ducts from the floor or wall as well as cables from

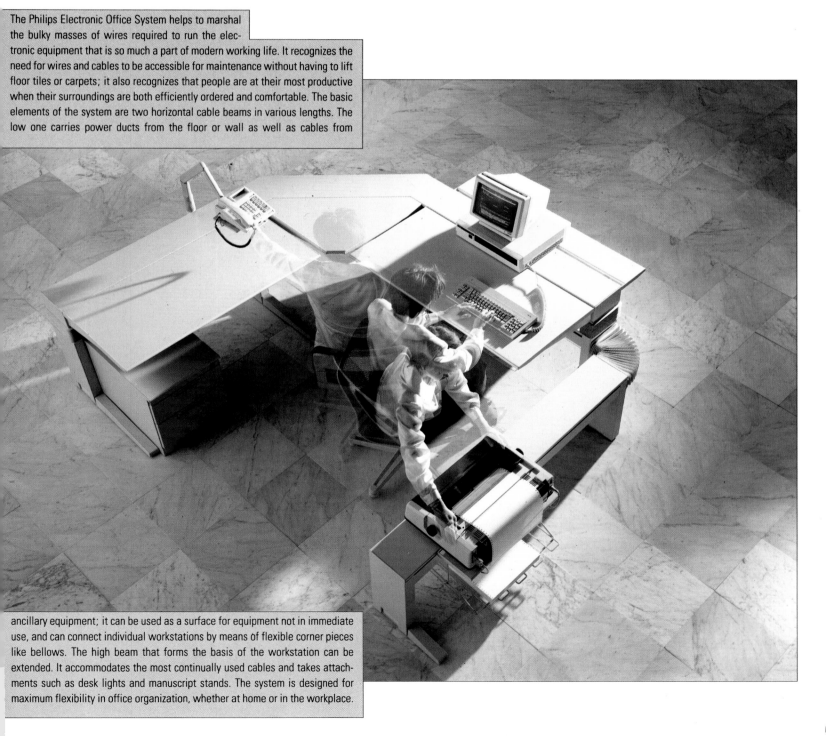

ancillary equipment; it can be used as a surface for equipment not in immediate use, and can connect individual workstations by means of flexible corner pieces like bellows. The high beam that forms the basis of the workstation can be extended. It accommodates the most continually used cables and takes attachments such as desk lights and manuscript stands. The system is designed for maximum flexibility in office organization, whether at home or in the workplace.

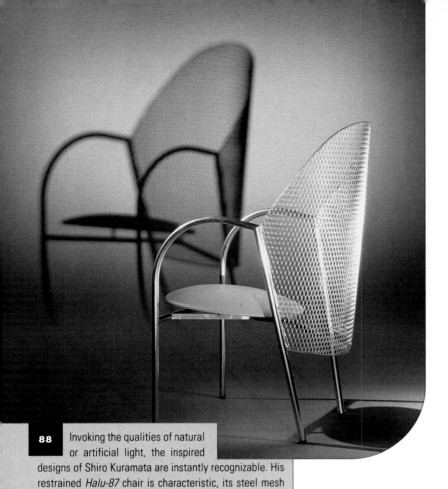

Shiro Kuramata
Chair, Halu-87
Steel pipe, steel
A chair with a frame of steel pipe with
galvanizing, chromic acid treatment
finish, seat of vinyl or leather and back of
steel.
H101.5 cm (40 in). W52 cm (20½ in).
D65 cm (25½ in)
Manufacturer: Vitra International,
Switzerland

88 Invoking the qualities of natural or artificial light, the inspired designs of Shiro Kuramata are instantly recognizable. His restrained *Halu-87* chair is characteristic, its steel mesh backrest, supported in a simple tubular steel frame, filtering light in a delicate interplay of pattern.

89 Steven Holl's work captures in form the fascination of the American city skyline; a skyline that he himself is currently altering with commissions for buildings and storefronts. Using metal, steel, chrome and glass for these, he employs steely supporting struts and verticals in his furniture too, echoing in small scale, with great delicacy, the lines of the skyscraper.

Steven Holl
I Table
Steel, wood
A table with a steel base and sculpted
ash top divided by the legs and seams.
H74cm (29 in). W180 cm (70⅝ in).
D128 cm (50⅛ in)
Manufacturer: Pace, USA

Minimalism

F U R N I T U R E

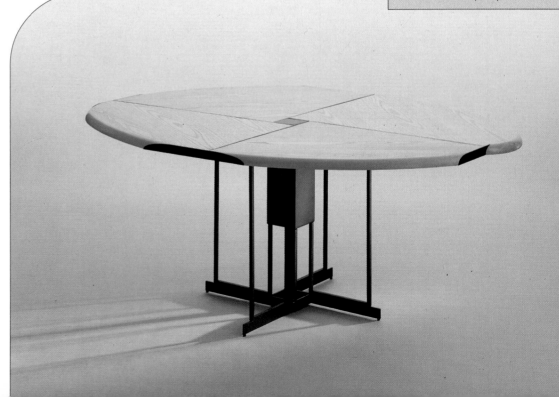

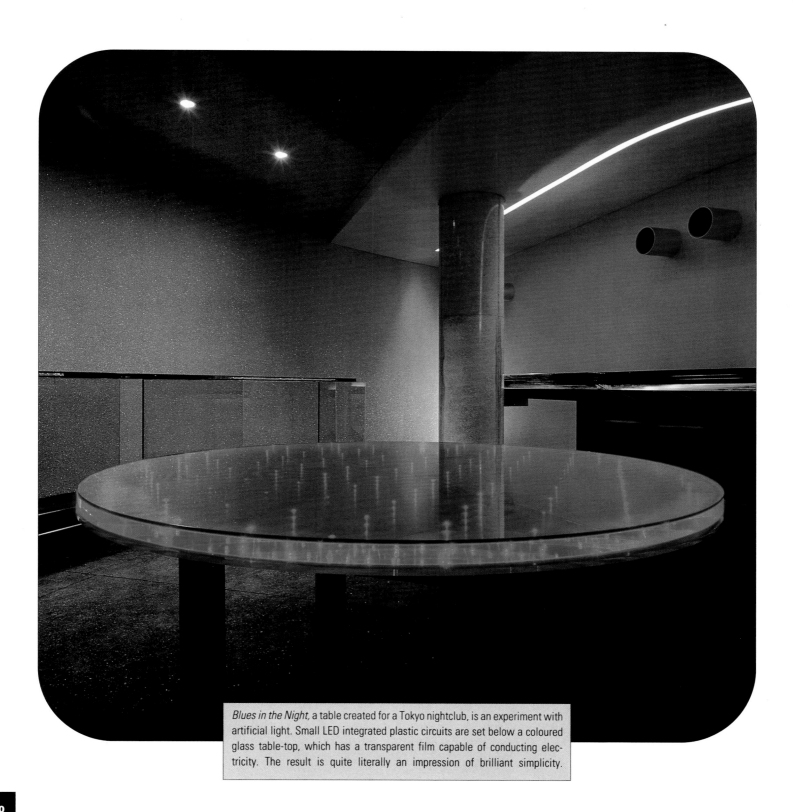

Blues in the Night, a table created for a Tokyo nightclub, is an experiment with artificial light. Small LED integrated plastic circuits are set below a coloured glass table-top, which has a transparent film capable of conducting electricity. The result is quite literally an impression of brilliant simplicity.

Shiro Kuramata
Table, Blues in the Night
Glass, steel pipe
A table designed for the interior of a
Tokyo restaurant/bar, with steel pipe
legs, a transparent glass top and an LED
integrated plastic circuit. One-off.
H73 cm (28¾ in). Di120 cm (47¼ in)
Manufacturer: Kuramata Design Office,
Japan

Mario Botta

Chair, Latonda

Steel

A small armchair with a black steel
frame and perforated steel seat painted
black or copper-green.
H77 cm (30¼ in). W60 cm (23½ in).
D63 cm (24⅞ in)
Manufacturer: Alias, Italy

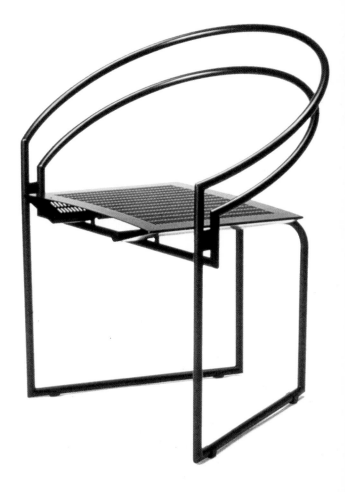

Achille Castiglioni

Table, Basello

Lacquer, steel

A double-height table with a black
lacquered, medium-density frame and a
black enamelled steel joint.
H45 cm (17¾ in). W30 cm (11⅞ in).
L65 cm (25½ in)
Manufacturer: Zanotta, Italy

91 The work of Achille Castiglioni, the grand master of Italian design, spans many products and companies. At the 1987 furniture fair in Milan he confessed that, alongside a lamp switch that is still sold worldwide after thirty years, *Basello* is a favourite creation. The table is in two parts, which can be set at different heights and angled in various directions like a turning staircase: *"basello"* means "stairway" in Milanese street dialect.

92 Mario Botta's first furniture collection was manufactured in 1984 by Alias. This youthful Italian company, in just eight years of production, has gained a reputation for hand-picking the classics of the future: those Botta pieces are now on permanent exhibit at the Museum of Modern Art, New York. The *Latonda* chair demonstrates once again his skill with mass and volume, which he handles with the restraint that characterizes his designs as "minimalist." *Latonda* appears sparse in its linear grace, the backrest gracefully curved in slender tubular steel, the parallel bars appearing as a visual underlining of its low-key elegance.

93 Cartoon drawings of thunderbolts are usually shaped something like Philippe Starck's *Ed Archer* chair, which seems to ground itself on a single shaft-like leg at the back. The front legs are clad in leather, which is thonged like a quiver; the seat and back are tautly bowed.

Philippe Starck
Chair, Ed Archer
Aluminium, steel, leather
A dining chair with a frame of aluminium
casting and leather-covered body of
tubular steel with flexible components.
H98 cm (38½ in). W47 cm (18½ in).
D55 cm (21½ in)
Manufacturer: Driade, Italy

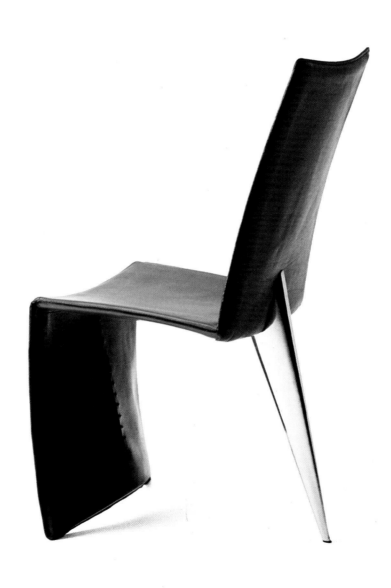

FURNITURE

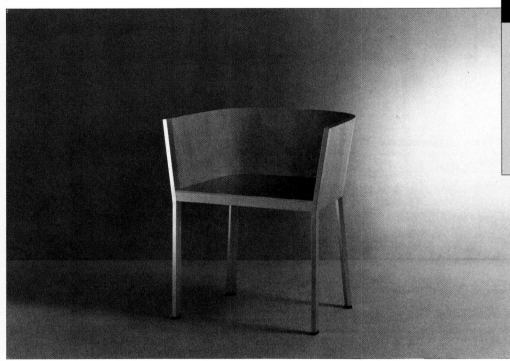

94 The woman behind Japan's successful Comme des Garçons fashion empire, Rei Kawakubo, began her product design studio two years ago. Now her furniture collection numbers twenty designs. This chair shows all the refinements of her minimalist approach, using the set-square and the protractor to achieve its form. The piece is somehow contradictory: curiously, the solidity of the angular legs harmonizes with the overall impression of delicacy. In another version of this chair, the back fully encloses the semi-circular seat just two-thirds of the way round, leaving one side completely bare.

Rei Kawakubo
Chair, Comme des Garçons No. 16
Wood, aluminium
A half-oval chair in Japanese linden and
aluminium. Limited batch production.
H65 cm (25½ in). W56.5 cm (22¼ in).
D44.2 (17⅜ in)
Manufacturer: Comme des Garçons,
Japan

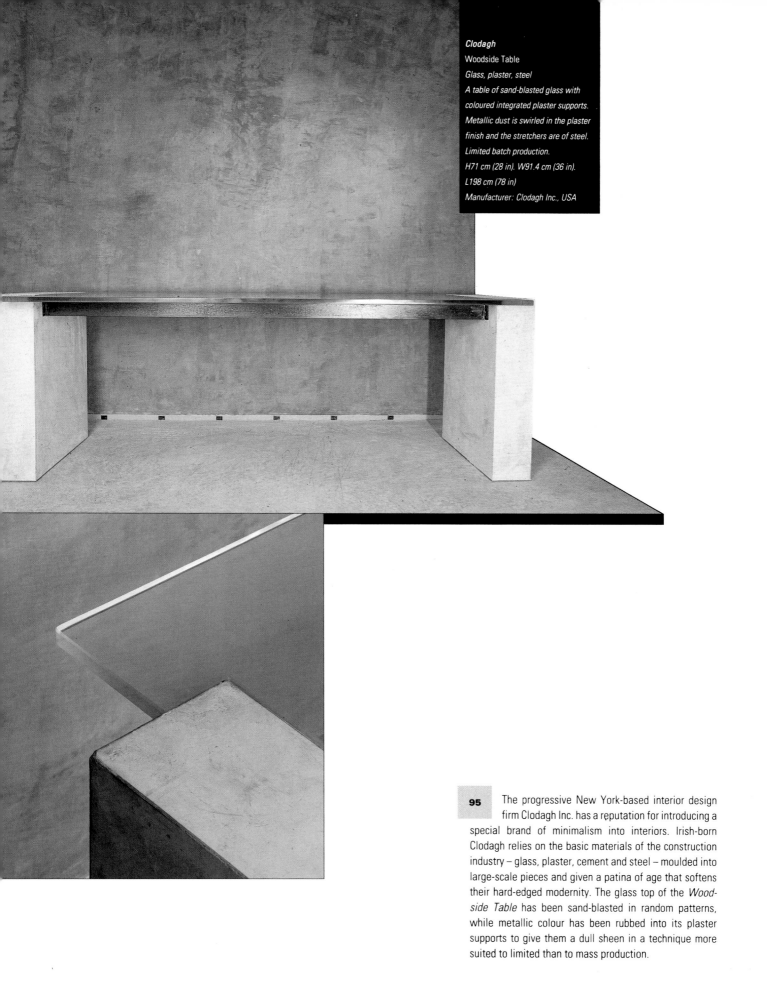

Clodagh
Woodside Table
Glass, plaster, steel
A table of sand-blasted glass with
coloured integrated plaster supports.
Metallic dust is swirled in the plaster
finish and the stretchers are of steel.
Limited batch production.
H71 cm (28 in). W91.4 cm (36 in).
L198 cm (78 in)
Manufacturer: Clodagh Inc., USA

95 The progressive New York-based interior design firm Clodagh Inc. has a reputation for introducing a special brand of minimalism into interiors. Irish-born Clodagh relies on the basic materials of the construction industry – glass, plaster, cement and steel – moulded into large-scale pieces and given a patina of age that softens their hard-edged modernity. The glass top of the *Woodside Table* has been sand-blasted in random patterns, while metallic colour has been rubbed into its plaster supports to give them a dull sheen in a technique more suited to limited than to mass production.

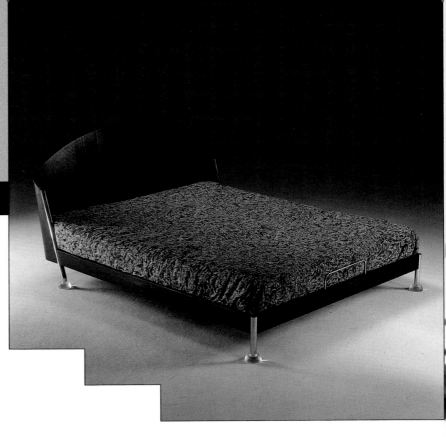

Vicent Martinez
Bed, La Vela
Wood
A bed with a headboard of curved ash board and feet of metal chrome-plated, resting on glass supports.
H100 cm (39½ in). W163 cm (64⅛ in). L210 cm (82⅝ in)
Manufacturer: Punt Mobles, Spain

97

Guen Bertheau-Suzuki
Chair, Côte d'Azur
Steel
Prototype of an armchair made of chromed steel pipe and fabric.
H92 cm (36 in). W68 cm (26¾ in). D70 cm (27½ in)
Manufacturer: Ishimaru, Japan

96

Bridgestone Design Co.
Bed
Steel, wood
A low-standing (28.5 cm / 11¼ in) bed of steel and wood with a polyurethane mattress.
H72 cm (28½ in). W112.5 cm (44¼ in). L225 cm (88½ in)
Manufacturer: Bridgestone Corporation, Japan

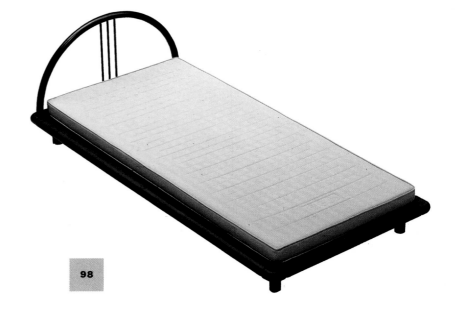

98

99 Jean-Michel Wilmotte calls himself an interior architect rather than an interior designer. Since the early designs that precipitated him into the public eye – his work for President Mitterrand's private apartment in the Elysée Palace – he has continued to aim for classical forms interpreted in modern materials. After a period utilizing the "proportion, equilibrium and nobility" of French classical style, Wilmotte, who has studios in Tokyo and Paris, has turned to Japanese minimalism for inspiration: sparse, rugged forms in wood, glass, stone and leather often support steel shapes finished experimentally in chrome and epoxy. His *Palais Royal Chair* was designed for the gardens in Paris.

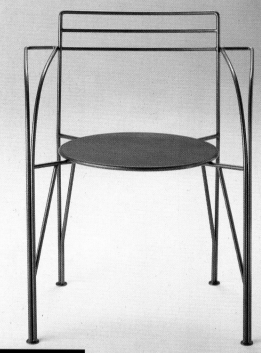

Pascal Mourgue
Chair, Lune d'Argent
Steel
A stackable steel armchair finished with two coats of lacquer in grey or black, or chromium-plated.
H75 cm (29½ in). W61 cm (24 in). D50 cm (19⅝ in)
Manufacturer: Fermob, France

100

Jean-Michel Wilmotte
Palais Royal Chair
Iron wire
A garden chair. Limited batch production.
H77 cm (30¼ in). Di43.5 cm (17 in)
Manufacturer: Academy, France

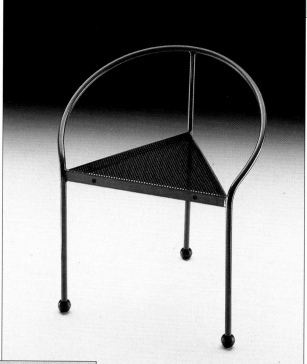

Carlos Miret
Chair, Bermudas
Iron, rubber
A chair of iron tube with punched iron plate seat. The legs terminate in black rubber balls. Also available in red, black or grey.
H72 cm (28½ in). W58 cm (22⅞ in). D41 cm (16⅛ in)
Manufacturer: Amat, Spain

101

Niels J. Haugesen
Haugesen Table
Wood, steel
A worktable with flaps that can be secured in two positions – as an extension of the table-top or folded underneath it. The top and flaps are covered with maple veneer and edged with maple. The base is matt steel. H71 cm (28 in). W 86 cm to 97 cm (33⅞ in to 38¼ in). L182 cm to 293 cm (71½ in to 115⅜ in).
Manufacturer: Fritz Hansen, Denmark

102

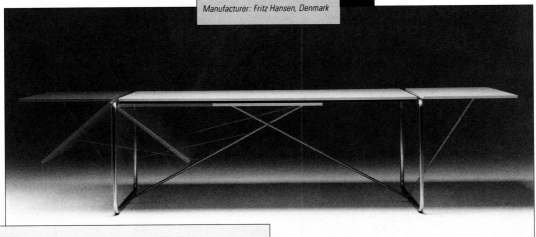

103 Kazuo Shinohara, a contemporary of Arata Isozaki, has exercised great influence in turning the tide away from the "megastructural" viewpoint of the 1960s generation of Japanese architects. Sawaya & Moroni have now launched the Shinohara steel collection, which includes the *Straw Chair*. Struts of steel as slender as straws are assembled to combine a slim, three-barred back with a wider base. Its deceptively simple geometry is contradicted by the light that is filtered on a horizontal plane throughout its form.

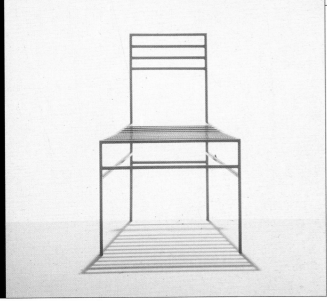

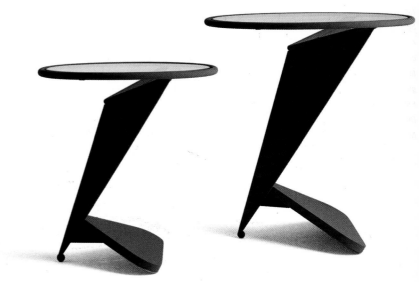

Kazuo Shinohara
Straw Chair
Metal
A metal chair with two finishes: epoxy-coated in various colours or black nickel-plated chrome. Limited batch production. H80 cm (31½ in). W52 cm (20½ in). D47 cm (18½ in)
Manufacturer: Sawaya & Moroni, Italy

104

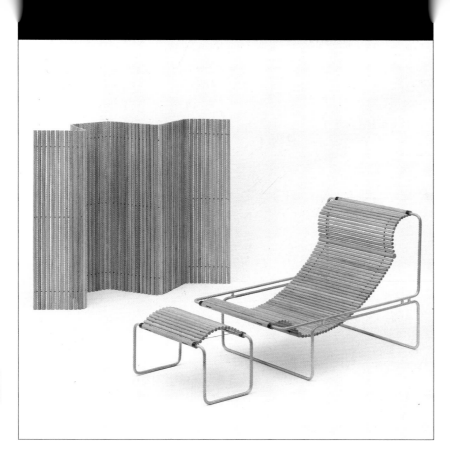

Hans Amos Christensen
Outdoor furniture
Steel, wood
Prototypes of outdoor furniture in 14 mm
galvanized steel bar and 16 mm teak-
wood sticks supported by steel wire.
After exposure out of doors the materials
will have a silver-grey patina.
Chair H75 cm (29½ in). W70 cm
(27½ in). D100 cm (39½ in)
Stool H34 cm (13⅜ in). W30 cm
(11⅞ in). L55 cm (21½ in)
Screen H110 cm (43¼ in).
L188 cm (74 in)
Manufacturer: Søren Horns, Denmark

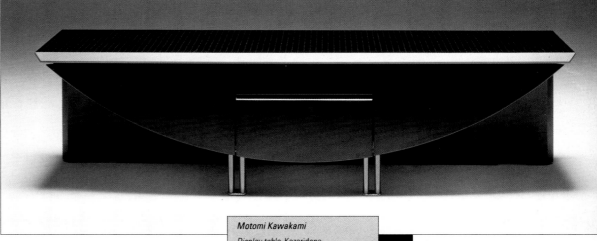

Bruni Brunati and Carlo Zerbaro
Tables, Viki
Steel, wood, glass
A series of tables with a steel frame
chromium-plated or painted black. The
foot is of varnished wood and the top of
glass.
H55 cm or 45 cm (21½ in or 17¾ in).
Di50 cm or 40 cm (19⅝ in or 15¾ in)
Manufacturer: Casprini, Italy

Motomi Kawakami
Display table, Kazaridana
Wood
A cabinet/table in dark grey wood. The
top is silk-screen printed in silver with a
dot pattern. The edges and underside are
in lacquer with silver metallic finish.
Limited batch production.
H50 cm (19⅝ in). W180 cm (70⅝ in).
D45 cm (17¾ in)
Manufacturer: Yamaha, Japan

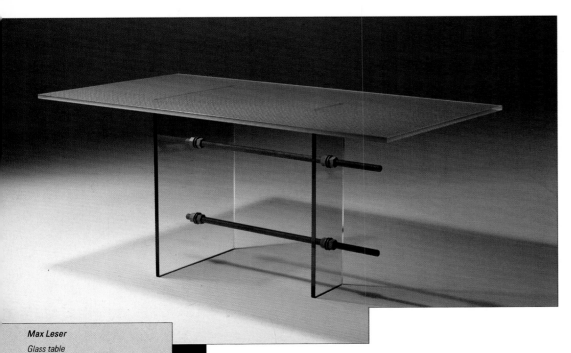

Stephen Povey
McStack Table
Steel
A table with a stacking trestle-base system in tubular steel with self-levelling screws, finished in black polyester powder coating or chrome. The top shown is of glass.
Base H69.5 cm or 30 cm (27⅜ in or 11⅞ in). W30 cm (11⅞ in). L50 cm (19⅝ in).
Top W60 cm (23½ in). L140 cm (55⅛ in)
Manufacturer: Diametric Modern Furniture, UK

Max Leser
Glass table
Glass, stainless steel
A table/desk constructed with ¾-in structural glass. The top has an etched linear pattern on the underside and the asymmetrical legs are supported by 1-in diameter stainless-steel rods. Available in a variety of sizes.
H76 cm (30 in). W86.5 cm (34 in). L162.5 cm (64 in)
Manufacturer: Leser Design, Canada

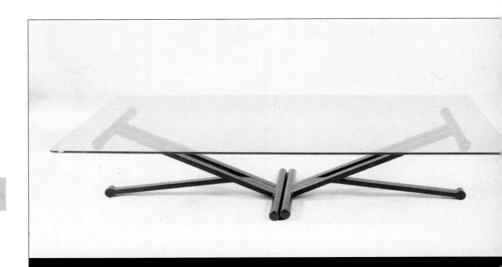

108

Vittorio Livi
Cabinet, Ellisse
Glass, wood
An ellipse-shaped show cabinet in 6 mm curved crystal glass with the top and base in black lacquered wood and lit by spotlights.
H160 cm (63 in). W140 cm (55⅛ in). D50 cm (19⅝ in)
Manufacturer: Fiam, Italy

110

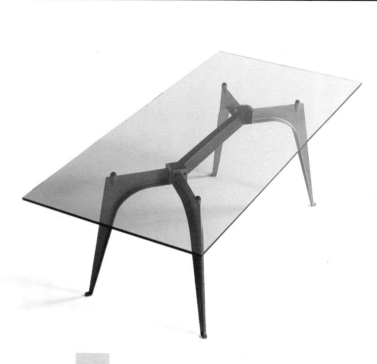

James Rosen
Piombo Cabinet
Wood, lead
A four-legged cabinet/tower in black ash with lead feet. Two or more cabinets can be connected by shelves to form a wall unit. Limited batch production.
H183 cm (72 in). W53.5 cm (21 in). D53.5 cm (21 in)
Manufacturer: Pace, USA

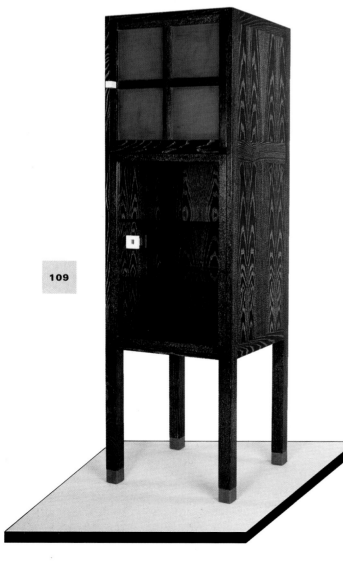

109

111

Rodney Kinsman
Detroit Table
Aluminium, glass
A table with cast aluminium legs with a sand-blasted or polished glass top.
H72 cm (28½ in). W80cm (31½ in). L180 cm (70⅝ in)
Manufacturer: OMK Design, UK

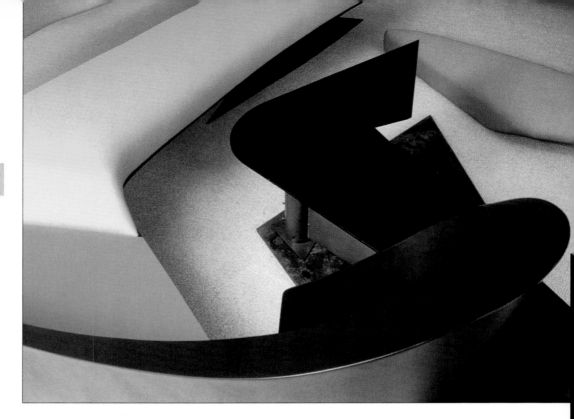

Zaha Hadid
Metal Carpet Table *and* Wavy Back Sofa
Prototypes. The Metal Carpet Table *has*
a bronze base and a wooden top.
H50 cm (19⅝ in). W140 cm (55⅛ in).
L300 cm (118 in)
Manufacturer: Zaha Hadid with Michael
Wolfson, UK

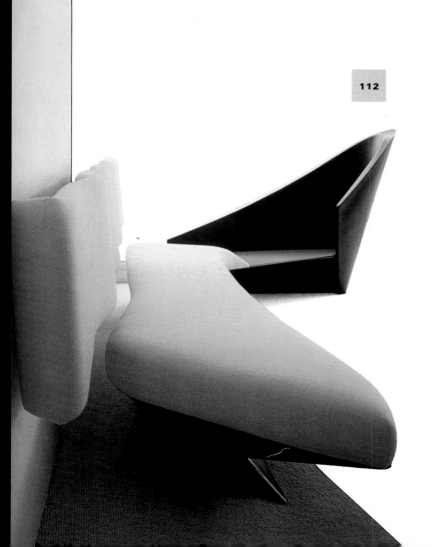

Zaha Hadid
Wavy Back Sofa
Lacquered wood, felt, wool
Prototype of a sofa in lacquered wood,
upholstered in wool.
H120 cm (47¼ in). W70 cm and (max)
200 cm (27½ in and 78⅜ in).
L380 cm (149½ in)
Manufacturer: Zaha Hadid with Michael
Wolfson, UK

Although these pieces were purpose-built for their space, Zaha Hadid considers them to be prototypes for production. Different elements are combined in an ambitious free-standing sculpture that occupies the whole room (the client's brief was that the interior should not be adapted). Their extraordinary volume and amoebic shape make them appear to float in the space. Each piece has more movement than its continuous, organic forms convey: chairs swing, tables pivot. The powerful sculptural qualities of this Iraqi-born architect's work illustrate the capacity for "simulation" of the truly inspired designer – the ability to combine mimicry with irony and none the less create something new. By some quirk of fate she seems to have encountered the streamlined style, primary colours and sense of space associated with De Stijl and the Constructivists, but to have absorbed them, interpreted them afresh and made them totally her own.

Zaha Hadid
Whoosh Sofa
Scuba, lacquered wood, wool
Prototype of a sofa upholstered in wool.
H93 cm (36½ in). W85 cm (33½ in).
L425 cm (167⅜ in)
Manufacturer: Zaha Hadid with Michael
Wolfson, UK

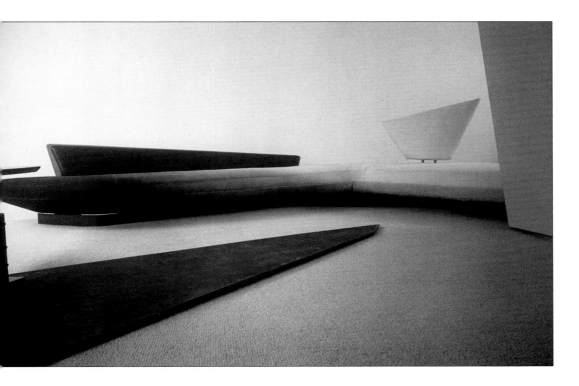

114

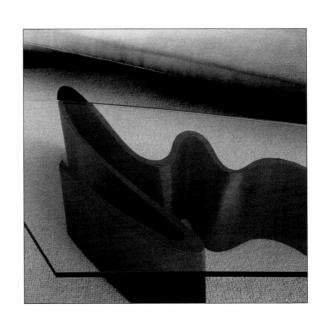

115

Zaha Hadid
Sperm Table
Bronze, glass
A prototype coffee-table with a
removable glass top.
H35 cm (13¾ in). W84 cm (33 in).
L206 cm (81⅛ in)
Manufacturer: Zaha Hadid with Michael
Wolfson, UK

116 The steel frame, copper seat and brass back of *Anebo Tak* appear metamorphosed into an organic shape. The prototype for this chair was first forged in an Amsterdam studio by the young Czechoslovakian architect and designer Bořek Šipek, who likes to work the metals himself. The vigour of hand-crafting informs all his pieces. The phrase *"Anebo Tak,"* in translation from the Czech, means literally "can be like this."

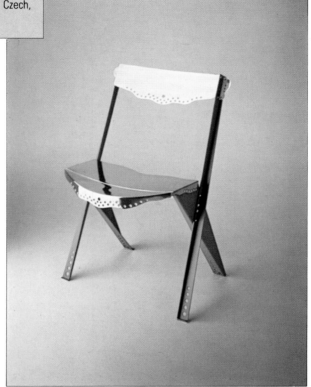

Bořek Šipek
Chair, Anebo Tak
Steel, copper, brass
A chair with a frame made of sheet steel painted blue. The seat is of formed and drawn sheet copper and the back of formed and drawn sheet brass. The metal is polished with antioxidant.
H82 cm (32¼ in). W54 cm (21¼ in). D39 cm (13⅜ in)
Manufacturer: Driade, Italy

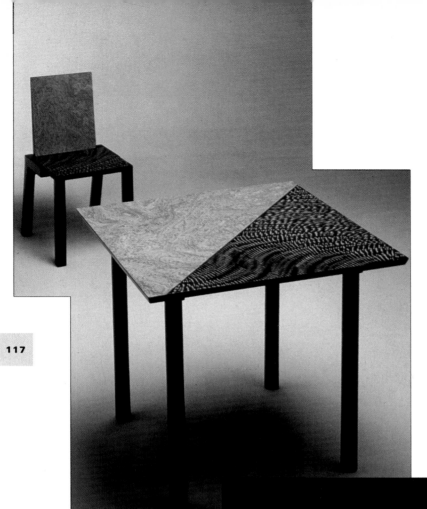

Constantin Boym and Lev Zeitlin /
Red Square
Nota Bene Table
Wood
A folding table available in different
combinations of decorative re-composed
wood veneers. It serves both as a dining
table and, folded, as a console. Limited
batch production.
H71 cm (28 in). W92 cm (36 in).
L92 cm (36 in)
Manufacturer: Nota Bene, USA

117

Red Square is a multidisciplinary design studio in New York run by two young Russians who are beginning to enjoy some success: they were invited to exhibit with the company Furniture of the Twentieth Century at the city's 1987 "Designer Saturday." Their *Nota Bene Armchair* is seemingly unselfconscious in its Constructivist simplicity; Boym and Zeitlin describe it as a "simple architectonic chair with a variety of decorative veneers." The table can be used for games when fully extended, and as a console table when folded.

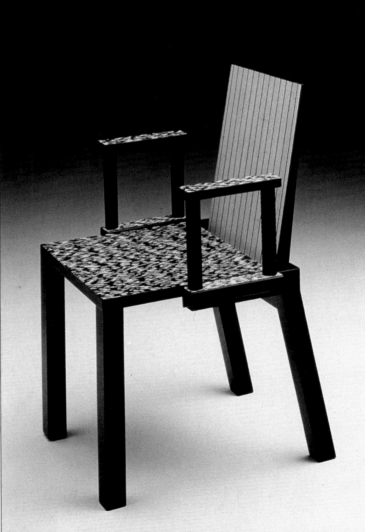

118

Constantin Boym and Lev Zeitlin /
Red Square
Nota Bene Armchair
Wood
An armchair available in a variety of
decorative re-composed wood veneers.
Limited batch production.
H81 cm (32 in). W51 cm (20 in).
D53 cm (20⅞ in)
Manufacturer: Nota Bene, USA

119 The *Tankette* is uncompromisingly aggressive, as well as being a startling new concept. The originality of this movable table was suitably highlighted by its surroundings at the Milan furniture fair in 1987: a stand suggestive of a barren no-man's-land, its sanded floors inset with glaring TV screens and fenced by hostile rolls of barbed wire. Articulated elements connected to an inner frame, reminiscent of the structure of a military tank, enable the table to be trundled around at a push, always presenting a level surface.

Paolo Pallucco and Mireille Rivier
Table, Tankette
Steel, spring, aluminium smelting
A movable table with a frame of steel channel section and springs. The peripheral wheels are in aluminium smelting. Epoxy powder finish.
H34.8 cm (13¾ in). W77.5 cm (30½ in). L125.5 cm (49½ in)
Manufacturer: Pallucco, Italy

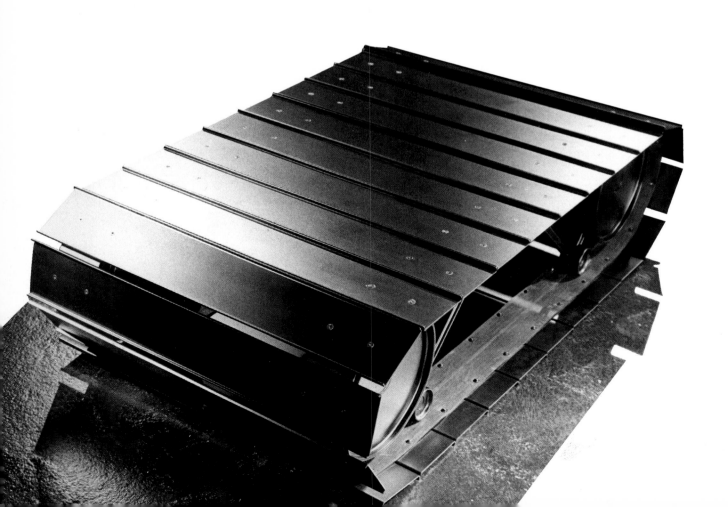

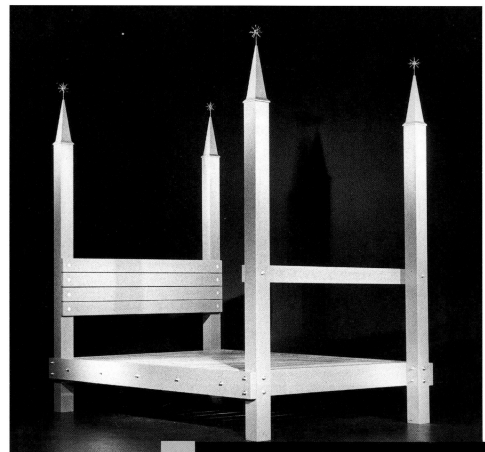

120 John Hejduk's drawings of city skylines show the same love of fantastical minarets, domes, spires and finials as his furniture, including this attenuated wood and steel four-poster bed. He achieves a poetic quality in his use of geometry: "I seek time/less/ness in objects of use, and I go after the mystery of logic."

John Hejduk
Bed, Cilia
Wood
A bed available in various sizes, with perimetric frame and square section jambs in solid beech with a natural or grey finish; metal parts are matt chrome-plated.
H225cm or 239 cm (88½ in or 94 in).
W151 cm or 171 cm (59½ in or 67½ in).
L224 cm or 231 cm (88¼ in or 91 in)
Manufacturer: Pallucco, Italy

Scott Burton
Soft Geometric Chair
Foam, fabric
A chair made of foam upholstery covered
with fabric, creating a strict geometric
form from soft materials. Prototype.
H94.5 cm (37¼ in). W86.5 cm (34 in).
D83 cm (32½ in)
Manufacturer: Vitra International,
Switzerland

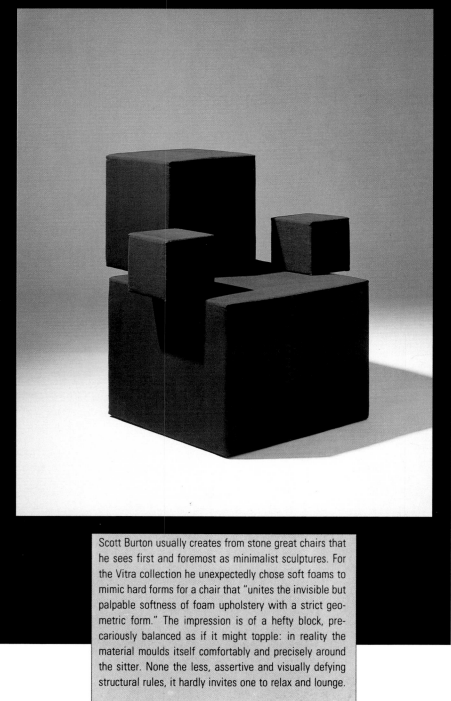

Scott Burton usually creates from stone great chairs that he sees first and foremost as minimalist sculptures. For the Vitra collection he unexpectedly chose soft foams to mimic hard forms for a chair that "unites the invisible but palpable softness of foam upholstery with a strict geometric form." The impression is of a hefty block, precariously balanced as if it might topple: in reality the material moulds itself comfortably and precisely around the sitter. None the less, assertive and visually defying structural rules, it hardly invites one to relax and lounge.

FURNITURE

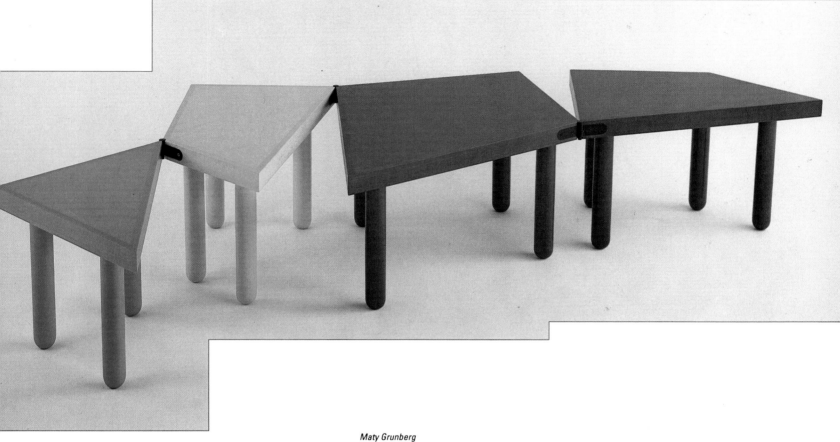

Maty Grunberg
D-Tables
Wood
Low and high tables in solid beech and plywood. They are produced in four hinged sections that can be formed into a square or a triangle. Available in various colours. Limited batch production.
H72 cm or 40 cm (28½ in or 15¾ in).
Square W and D138.5 cm or 92.5 cm (54½ in or 36½ in)
Triangular, each side 210 cm or 140 cm (82⅝ in or 55⅛ in)
Manufacturer: Aram Designs, UK

John Outram

Chest, Confucius

Wood

A four-drawer chest with ebonized
corners, vertical "sand" pipes and
spinach design encasing a red lacquer
flake motif. Limited batch production.
H91.4 cm (36 in). W86.3 cm (34 in).
D56 cm (22 in)
Manufacturer: Alma, UK

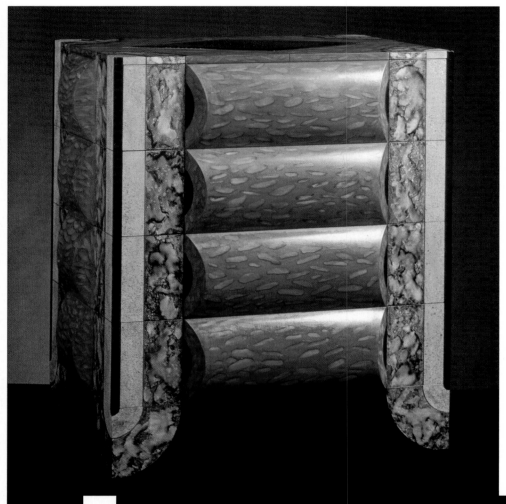

123 An unashamedly cerebral piece, British architect John Outram's *Confucius* is full of ironic references to the classical orders, and uses the decorative finishes of the eighteenth-century cabinetmaker. The red brick columns sometimes featured in his façades for buildings are here incorporated horizontally as drawer fronts and given the ruddy finish of red lacquer with a flake motif. Its architectural qualities and elaborate surface treatments give *Confucius* a studied monumentality.

124 When the British artist Peter Blake was asked by the furniture importer and designer Zeev Aram to design a piece, his first thought was of a simple table. "I chose to have it made from thick plywood, to make the legs from ply and to turn the 'constructed' surface to the front of the table to show how it was made. The construction of the corners is always the same, so a table can be made to order by simply giving the size of the table top and the height." The result is a little like a kitchen table, as guileless as a child's drawing.

125

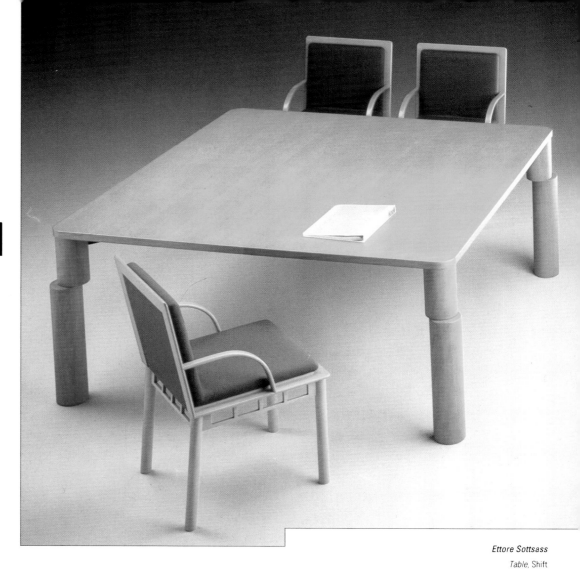

Peter Blake

Simple Tables

Wood

A range of high and low tables made of birch-faced plywood, either natural or stained. Limited batch production. Dining table H71.5 cm (28⅛ in). W90 cm (35½ in). L90 cm (35½ in) Console table H73 cm (28¾ in). W42.5 cm (16¾ in). L185 (72⅞ in) Low table H38 cm (15 in). W62.5 cm (24⅝ in). L62.5 cm (24⅝ in) Manufacturer: Aram Designs, UK

Ettore Sottsass

Table, Shift

Wood or marble

A table with top and legs in natural or dark stained beech-wood or marble. The legs consist of columns of solid wood or marble connected with steel pins. H72 cm (28½ in). W150 cm (59 in). L150 cm (59 in) Manufacturer: Knoll International, West Germany

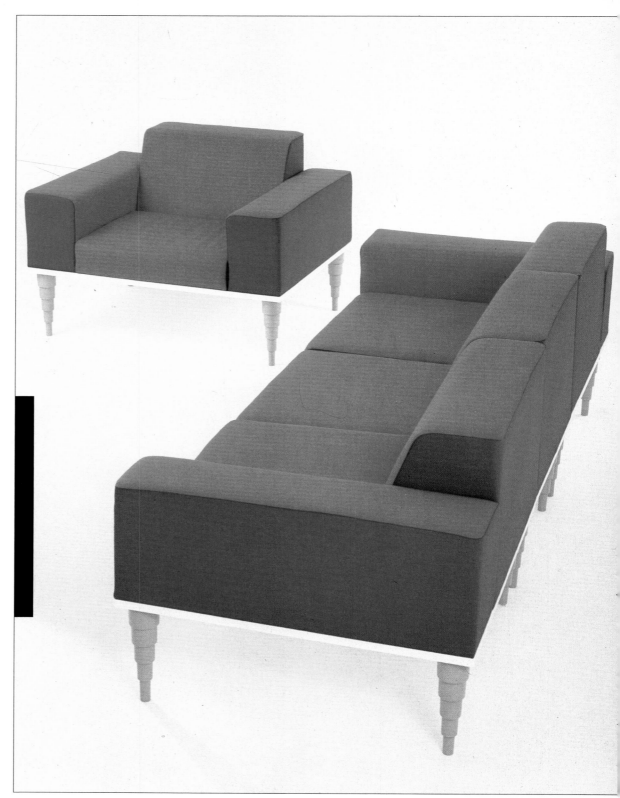

Yrjö Kukkapuro
Sofa and chair, Variaatio
Steel, plastic foam
Originally designed in the 1960s,
Variaatio has been remodelled for the
1980s. The subframe is of steel tube
painted black and the telescope legs are
also black. Padded with plastic foam
with Dacron wadding and upholstered in
leather and/or fabric.
Chair H72 cm (28½ in). W100 cm
(39½ in). D80 cm (31½ in)
Three-seat sofa H72 cm (28½ in).
W220 cm (86½ in). D80 cm (31½ in)
Manufacturer: Avarte, Finland

In Finland, where designers are national heroes on a par with football stars, Yrjö Kukkapuro keeps a low profile. But his name is increasingly mentioned by young Finnish designers today, who are tending to turn away from traditional designs using wood and towards more adventurous combinations of wood and tubular steel. Moving on from his timeless pieces of the 1960s he is now producing the same designs in a more decorative manner. His *Variaatio* is so named because it is modular, and can be adapted to a variety of seating layouts. Its steel frame can be painted black, and the upholstery executed in leather or fabric. Generously scaled and brightly coloured, *Variaatio* looks impressive in any room.

Jonas Bohlin
Seating, Nonting
Steel, covered in fabric or leather
H45 cm (17¾ in). W45 cm or 70 cm
(17¾ in or 27½ in). L200 cm (78¾ in)
Manufacturer: Collection Källemo,
Sweden

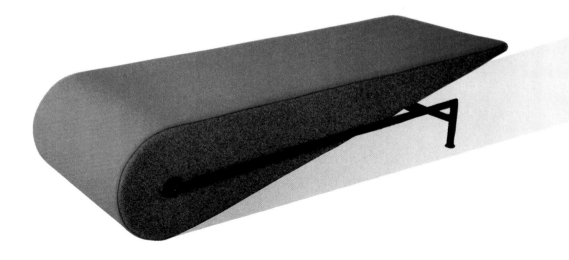

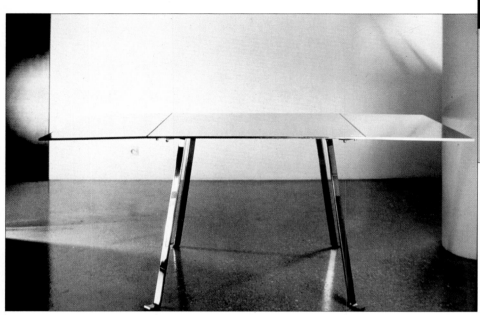

128

Jean Nouvel
Table, IAL
Aluminium
Prototype of a folding table in sheet
aluminium with stainless-steel feet.
W (open) 180 cm (70⅝ in). W (closed)
90 cm (35½ in). D90 cm (35½ in)
Manufacturer: Jean Nouvel, France

129

Jean Nouvel
Shelving, AAV
Aluminium
Telescopic shelving made of aluminium,
each part of which fits inside the other.
Placed back to back it resembles the
wing of an aeroplane.
W35 cm x 2 (13¾ in x 2). L300 cm to
500 cm (118 in to 196¾ in)
Manufacturer: Ecart International,
France

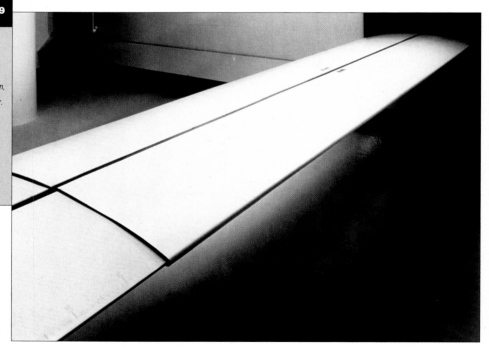

Architect Jean Nouvel may be a newcomer to the world of product design but his first furniture collection won him the coveted International Designer of the Year award for 1988 at the Paris furniture show. The judges focused on the furniture of young architects, underlining the enthusiasm shown by many architects today for the challenge of designing products. Nouvel's use of cast aluminium sheets to create his aerodynamic shapes owes more than a little to the aircraft industry. The telescopic shelving system, *AVV*, when banked back to back, resembles an aircraft wing and seems to offer space for cargo. The chest of drawers, *BAO*, like a giant toolbox cast in lightweight aluminium plates, would not look out of place in an aircraft hangar; at the same time, in more domestic spaces it has a graceful weightlessness, promoting an illusion that it is floating above its surroundings. The aluminium-topped table *IAL* has folding legs of stainless steel, which make it more workmanlike than its slender form suggests. Cunning devices that swivel, open out, hinge up or telescope down give extra dimensions to Nouvel's designs, that are light, flexible and mobile. His other interest – the theatre – is perhaps revealed in the ambiguous character of every piece.

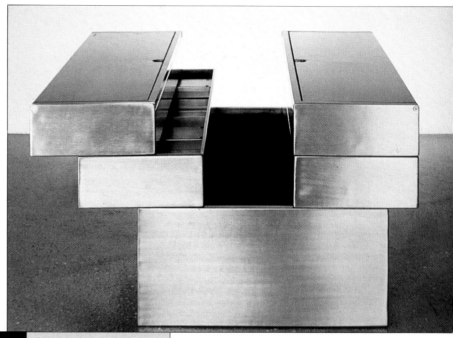

130 *Jean Nouvel*
Chest, BAO
Aluminium
Prototype of an aluminium chest of drawers that looks like a giant toolbox.
H60 cm (23½ in). W120 cm (47¼ in).
D65 cm (25½ in)
Manufacturer: Jean Nouvel, France

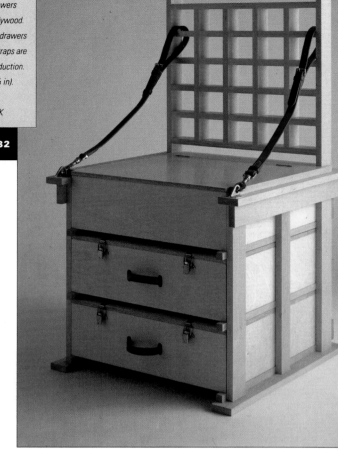

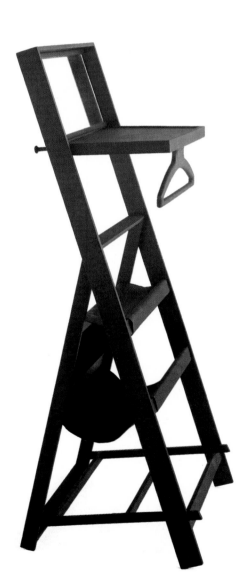

Eduardo Paolozzi

Sculptor's Chair

Wood

A storage cabinet/chair with drawers
made of solid beech and birch plywood.
It has a removable back and two drawers
with lids. The handles and arm straps are
in coach hide. Limited batch production.
H109 cm (43 in). W61.5 cm (24¼ in).
D57 cm (22⅜ in)
Manufacturer: Aram Designs, UK

132

131

Snowdon

Weekend Wardrobe

Wood

A portable and stowable wardrobe made
of solid beech and plywood with a
natural or cellulose paint finish. Limited
batch production.
H131 cm (51½ in). W53.5 cm (21 in).
D46 cm (18 in)
Folded H135 cm (53¼ in).
D5.5 cm (2¼ in)
Manufacturer: Aram Designs, UK

Simulation

F U R N I T U R E

133

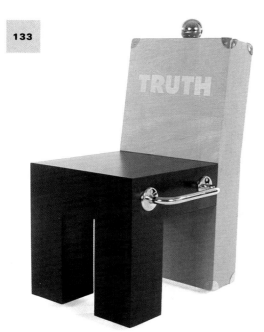

Dan Friedman
Truth Chair
*A chair in plastic lamolient, fibreboard
and chromed steel. Prototype.
H87 cm (34¼ in). W52 cm (20½ in).
D61 cm (24 in)
Manufacturer: Art et Industrie, USA*

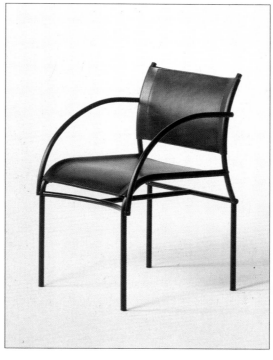

Michele De Lucchi
Chair, Terrace
*An armchair with a painted tubular steel
frame. The seat and backrest consist of a
single piece of self-supporting hide or
interwoven leather.
H80 cm (31½ in). W53 cm (20⅞ in).
D60 cm (23½ in)
Manufacturer: Bieffeplast, Italy*

134

135

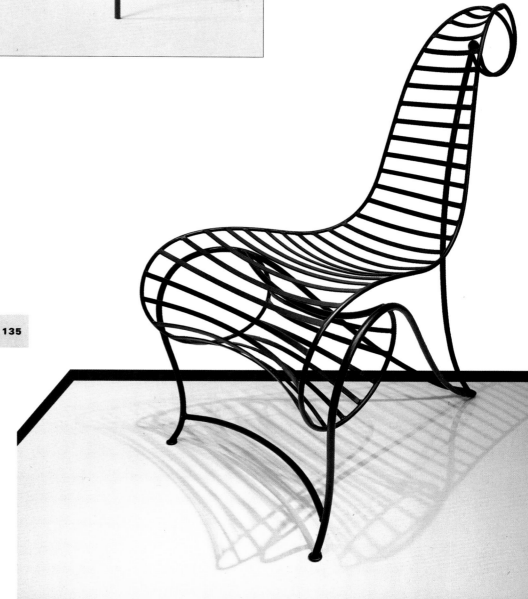

*André Dubreuil
Chair
Iron
Limited batch production
H90 cm (35½ in). W53 cm (20⅞ in).
D67 cm (26⅜ in)
Manufacturer: Personalities, Japan*

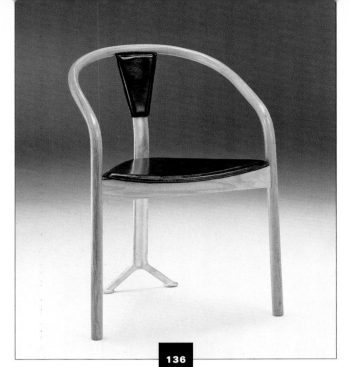

136

Toshiyuki Kita
Chair, Tacchi
Wood, aluminium, leather
An armchair with a cast aluminium
frame, bentwood legs, and seat and back
in leather.
H75 cm (29½ in). W54.2 cm (21⅜ in).
D51 cm (20 in)
Manufacturer: Aidec, Japan

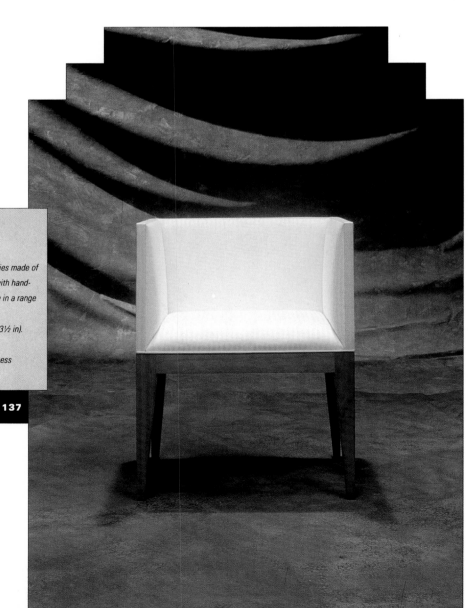

137

Michael Vanderbyl
Chair, Cambridge
Wood, upholstery
A chair in the Cambridge *series made of*
solid cherry-wood finished with hand-
rubbed lacquer and available in a range
of upholstery.
H80 cm (30½ in). W60 cm (23½ in).
D53.5 cm (21 in)
Manufacturer: Hickory Business
Furniture, USA

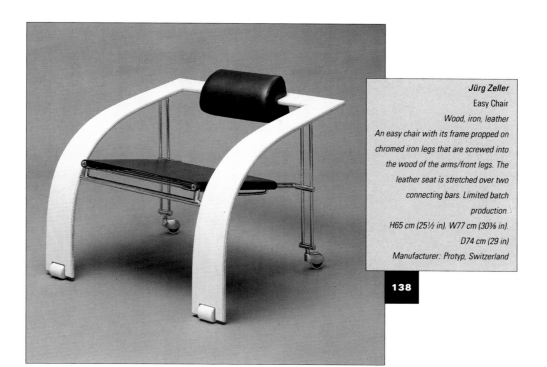

Jürg Zeller
Easy Chair
Wood, iron, leather
An easy chair with its frame propped on chromed iron legs that are screwed into the wood of the arms/front legs. The leather seat is stretched over two connecting bars. Limited batch production
H65 cm (25½ in). W77 cm (30⅜ in). D74 cm (29 in)
Manufacturer: Protyp, Switzerland

138

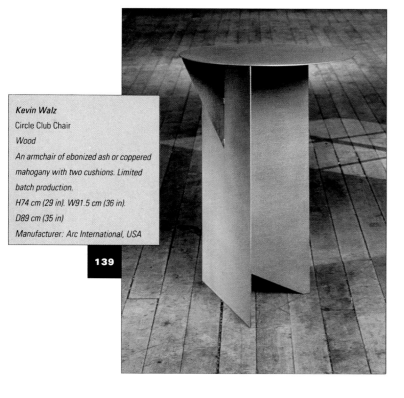

Kevin Walz
Circle Club Chair
Wood
An armchair of ebonized ash or coppered mahogany with two cushions. Limited batch production.
H74 cm (29 in). W91.5 cm (36 in). D89 cm (35 in)
Manufacturer: Arc International, USA

139

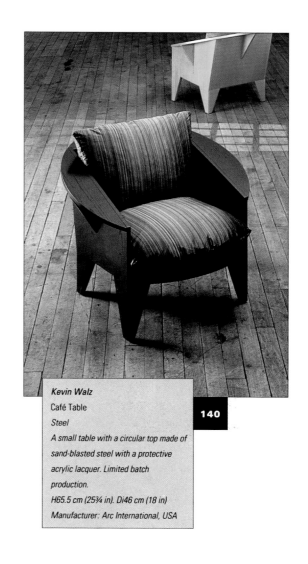

Kevin Walz
Café Table
Steel
A small table with a circular top made of sand-blasted steel with a protective acrylic lacquer. Limited batch production.
H65.5 cm (25¾ in). Di46 cm (18 in)
Manufacturer: Arc International, USA

140

Attilio Urbani
Chair, Polflex 713
Leather, steel tube, metal
A leather chair with a high back and
circular arms, inspired by a painting by
Vittore Carpaccio. The structure is made
of a single piece of steel tube and the
base is of lacquered metal. A gas-action
lift, operated by a single lever, adjusts
the position and height of the chair.
H125 to 135 cm (49¼ in to 53¼ in).
W70 cm (27½ in). D76 cm (30 in)
Manufacturer: Polflex Salotti, Italy

142

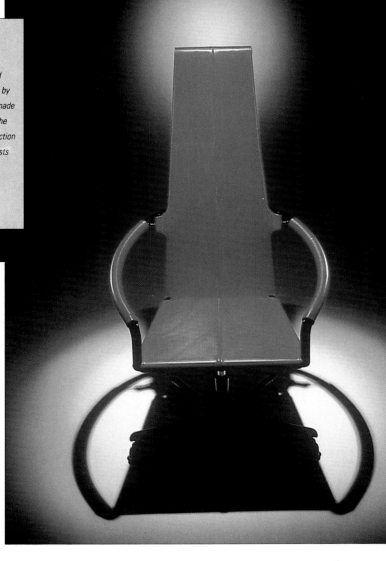

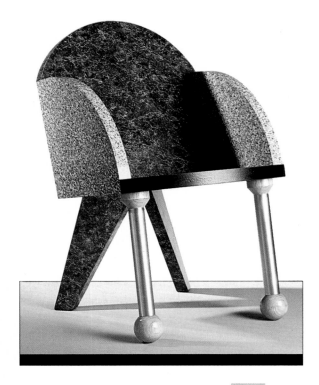

James Kutasi
Stone Chair
Marble, granite and slate laminate,
wood, aluminium
A chair individually carved and scuplted.
One-off.
H90 cm (35½ in). W50 cm (19⅝ in).
D50 cm (19⅝ in)
Manufacturer: James Kutasi, Australia

141

Jasper Morrison
Thinkingman's Chair
Steel
An armchair with a tubular steel frame
and steel strip seat and backrest;
armrests with circular steel discs.
Limited batch production.
H65.7 cm (25⅞ in). W63 cm (24⅞ in).
D93 cm (36½ in)
Manufacturer: Aram Designs, UK

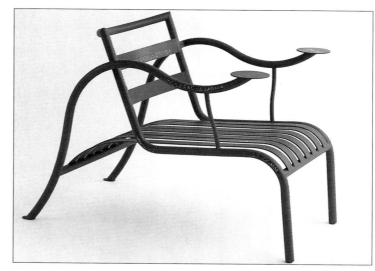

143

144

François Bauchet
Desk, à PF
Wood
A writing desk in lacquered wood,
described by the manufacturer as "a
portrait of the young French painter
Philippe Favier." Limited batch
production.
H80 cm (31½ in). W70 cm (27½ in).
D70 cm (27½ in)
Manufacturer: Neotu, France

William M. Sawaya
Chair, Diva
Wood
A chair with a frame of solid wood,
lacquered or polished. Available in
various woods – e.g. mahogany, linden –
and with an upholstered leather seat.
Limited batch production.
H88 cm (34⅝ in). W44 cm (17¼ in).
D46 cm (18 in)
Manufacturer: Sawaya & Moroni, Italy

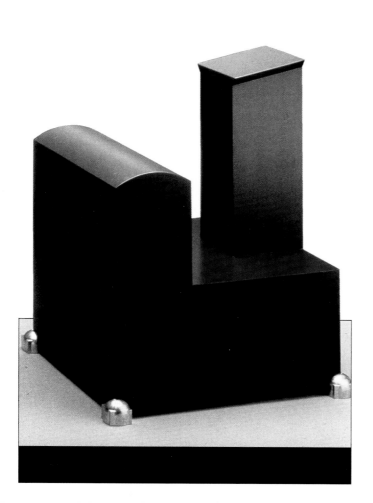

145

LIGHTING

2 In 1987 lights went even more over the top, not metaphorically but literally. Two of the biggest assemblies of different overhead lights ever marshalled on single tracking systems were launched, by Bellini and by Gecchelin, for domestic or contract use. Inspired by theatrical lighting, they have a similar variety of effects. Each designer has harnessed banks of spotlights – from compact fluorescents to metal halides, from incandescent to low-voltage halogen, phosphor and high-pressure discharge lamps – and strung them alongside each other with baffles, shields, reflectors and coloured glass discs to change angle, and to widen or colour the beams. They have also taken Fresnel lenses, named after the French physicist Augustin Fresnel, and until now used solely in the theatre, to soften the edges of shafts of light. ■ More conventional light fittings, too, now assume several characters. Castiglioni's wall light has a twist-over shield; Ordeig's floor lamp can wear a choice of shades, tempering the white fluorescent source commonly associated with supermarkets; the round bulkhead lights by Munshi and Trivedi are available with different decorative details and in various sizes; and Kurokawa's orbs of glass come in versions emitting more or less light. ■ Task lights, either desk or standard, are now benefiting from an element of craftsmanship that the lighting industry usually avoids. Bayley works with industrial studding corroded in chemicals to re-interpret rococo style; Leonard invokes a Gothic candlelight; Eisl uses corrugated sheet iron as the conductor for a low-voltage lighting which illuminates its frosty finish; and Villa harks back to French Empire with desk lamps in welded metal. ■ Light switches might become obsolete following such innovations as Maurer's electronic transformer on his renowned trapeze lights. They can be turned on and off at the tap of a wire which, carrying only twelve volts, is as safe as a child's train-set. The era of light at our fingertips, of many qualities and moods, is at hand.

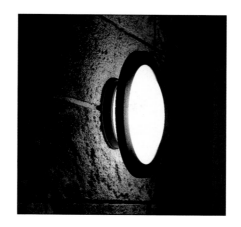

Masayuki Kurokawa
Wall lamp, Virgo
A wall lamp for outdoor use in
translucent acrylic with epoxy
finish. Available in different versions,
with an obscuring disc in the centre or
with a black rim only.
H13 cm (5⅛ in). Di35 cm (13¾ in)
Manufacturer: Yamagiwa Corporation,
Japan

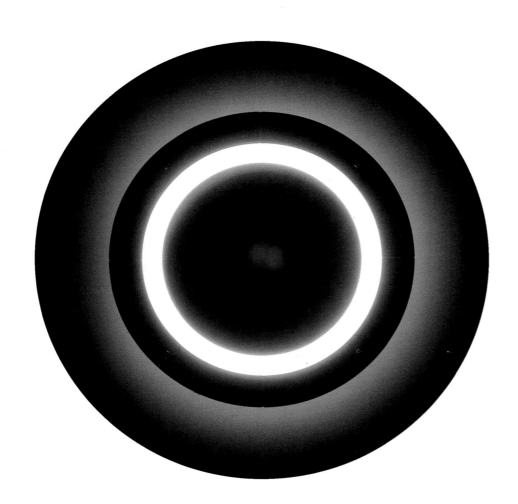

1

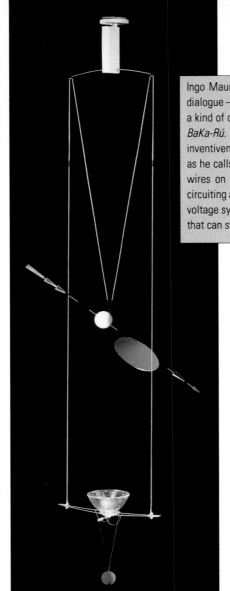

Ingo Maurer's tiny low-voltage lights strung up on trapeze-like wires appear to be taking part in a dialogue – not just in the way they relate to each other, but through the names he gives them. Named in a kind of designers' Esperanto, his earlier *YaYaHo* and *Cheerioh!* have now been joined by *Iló-Ilú* and *BaKa-Rú*. They are playful and provocative, and pull in the crowds at every exhibition. But Maurer's inventiveness is not confined to devising new items for the same system. His "light at your fingertips," as he calls it, fitted to *Iló-Ilú* lights, enables the light source to be tapped on and off at a touch of the wires on which they are suspended. The electronic transformer and sensor protect against short-circuiting and sound interference. *BaKa-Rú*, as safe as a child's toy train-set, is based on the same low-voltage system as the original *YaYaHo*, but is now refined further to include smaller lighting elements that can swivel in any direction.

2

Ingo Maurer and Team
Ceiling lamps, Iló-Ilú
Glass, metal, plastic
An adjustable lighting system incorporating a transformer and sensor/ dimmer. The lamp lights up when touched and the automatic dimmer operates if touch is maintained. Takes 12V 50W halogen lamps.
H (max) 140 cm (55⅛ in).
W20 cm (7⅞ in)
Manufacturer: Design M Ingo Maurer, West Germany

Ingo Maurer and Team
Ceiling lamps, BaKa-Rú
Glass, metal, porcelain, plastic
A system of low-voltage lights which can be swivelled in any direction. They are attached to three cables with sprin[g] clips. Takes lighting elements of 20W [or] 50W; maximum capacity per transformer – 200W.
W 40 cm (15¾ in). L (max) 10 m (32¾ feet)
Manufacturer: Design M Ingo Maurer, West Germany

3

Mario Bellini

Spotlight, Eclipse 2

Aluminium

The Eclipse 2 *spotlight uses metal*
halide and high-pressure discharge
lamps to project circles and to
illuminate objects and surfaces
sharply at an angle ranging from 8
to 72 degrees.
W27.8 cm (10⅞ in). L body 29.5 cm
(11⅝ in). L (max) 41.5 cm (16⅜ in).
D to top track arm 20.8 cm (8⅛ in)
Manufacturer: Erco, West Germany

4

Eclipse illustrates the current design preoccupation with
using an integrated system to theatrical effect. Rather
than designing individual light fittings, Mario Bellini de-
vised *Eclipse* as a complete system for exhibitions. Low-
voltage halogen lamps are housed in fittings that hold a
choice of special light heads and accessories, which
include a honeycomb anti-dazzle screen, infra-red reflec-
tors, and ultra-violet and coloured filters. The filters can
warm up or cool down the quality of the light from white
to golden, transforming the mood of a space from the
effect of a warm midsummer haze to silver moonlight.
Metal halides, the newest generation of light sources, are
housed in bigger fittings, to which three discs with three
differently sized apertures can be added to control the
intensity and focus of the projected beam. Patterned or
inscribed glass plates can be ordered, to create special
effects; for example, they can be used to transform a
room into a leafy glade, dappled with shadows, or a
company logo can be projected in light.

7

Piero Castiglioni

Ceiling lamp, Emulo

Pyrex glass, brass

A ceiling lamp which is also suitable
for inclined surfaces. The ceiling
attachment and the connecting tube
are in brass and the diffuser is in
frosted Pyrex glass with a
transparent circular band in the
centre. Takes a 150W 220V E14
halogen lamp.

H110 cm, 140 cm or 170 cm (43¼ in,
55⅛ in or 67 in). Di 20 cm (7⅞ in)

Manufacturer: Fontana Arte, Italy

5 Like its namesake in space, the *Shuttle Spot* sheds
sections and casings as required. Different shields
and reflectors fit on to a cylinder that houses over twenty-
two varieties of lamp to allow immense variety in the
quality of light. A choice of filters for these lamps includes
coloured lenses; Fresnel theatrical lenses, which are step-
ped to give a greater diameter of light with a soft-edged
beam; louvres to shield the glare of some lamps; filters
for any infra-red rays emitted by metal halide lamps; flaps
to limit the light emission; and wall-washer reflectors.
With different accessories, the beam can become a
thread, a blade or a sea of light. An important technical
innovation is the use of electronic transformers for the
spots as well as the electrified tracks that support these
spots. The tracks can run across ceilings, or be clamped on
to pipes and shelves. Considering its complexity, the
system is relatively economical; and it is easy to mount,
designed for universal application rather than for more
specialist uses at the top end of the market.

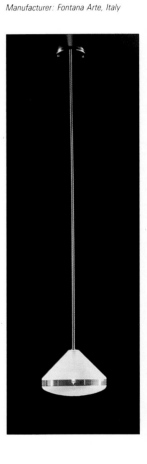

Bruno Gecchelin

Shuttle Spotlight

The Shuttle *range of spotlights*
consists of a basic oval-shaped
element in two sizes on which
cylindrical casings are fitted
according to the type of lamp used.
Twenty-two different lamps are
available.

Manufacturer: Guzzini, Italy

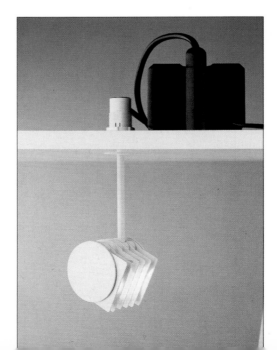

6

Lumiance Design Team /
Chris Hiemstra

Ceiling lamp, Primostar Louvre Cool 50

Aluminium

A low-voltage spotlight with a slim
mounting rod that can be plugged
directly into "Primo Power" or "Primo
Point." The spot can be rotated 360
degrees. Takes 50W 12V halogen lamps.
H19 cm (7½ in). W6.5 cm (2½ in).
L6.5 cm (2½ in)

Manufacturer: Lumiance, The
Netherlands

9

Corporate Industrial Design / CID
Philips White Son Spotlight
Polycarbonate
A spotlight that has no infra-red or
ultra-violet. The electronic circuitry
is integrated in the housing.
Available in 50W, rail and wall
versions in black and white.
H25 cm (9⅞ in). Di15.5 cm (6⅛ in)
Manufacturer: Philips NV, The
Netherlands

Gregory Tew
Grifo
Anodized aluminium, resin
A wall, floor or table light in anodized
aluminium and black or red. Takes a
100W E27 lamp.
H38.5 cm (15¼ in). Di diffuser 10 cm
(4 in). Di overall 68 cm (26¾ in)
Manufacturer: Artemide, Italy

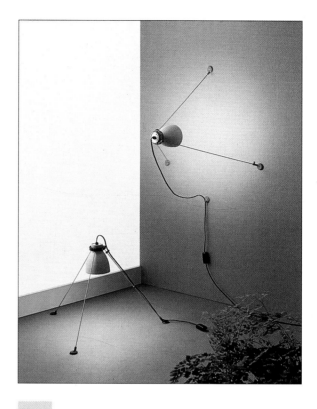

10

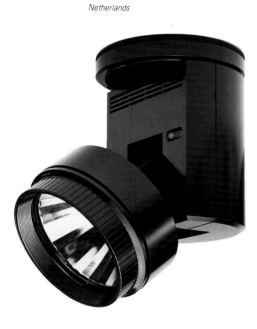

8

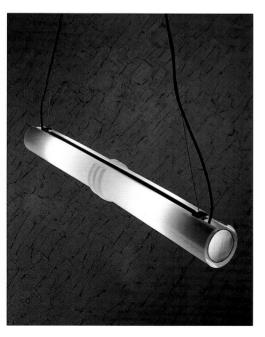

Roberto Pamio
Ceiling lamp, Sol
Glass
A lamp for ceiling or wall in double-
glazed blown glass with inserted
threads of the same colour. In white or
light blue with crystal and opaline glass
threads.
L38 cm or 70 cm (15 in or 27½ in).
Di8 cm (3⅛ in)
Manufacturer: Leucos, Italy

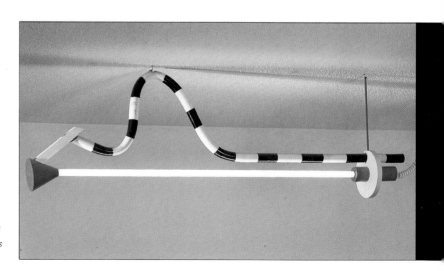

11

Johannes P. Klien
Ceiling lamp, Serpentina
Acrylic, steel
A hanging lamp in red and yellow
acrylic and black and white painted
steel making a new use of the
fluorescent tube. Limited batch
production.
H50 cm (19⅝ in). W18.5 cm (7¼ in).
L150 cm (59 in)
Manufacturer: Design Form
Technik, Liechtenstein

K. Munshi and Kirti Trivedi
Teak-wood Lamps

K. Munshi and Kirti Trivedi
Teak-wood Lamps
A range of table lamps with turned
teak-wood bases and glass diffusers.
The finish is natural wood with painted
bands. Limited batch production.
H25.5 cm to 30.5 cm (10 in to 12 in).
Di23 cm to 28 cm (9 in to 11 in)
Manufacturer: The Design Cell, India

India has a tradition of translating designs that originate in the West into a vernacular style. Patterns from style-books acquire an originality, with traditional craftsmanship and exotic local materials, that owes little to the industrial age. This modern ship's bulkhead light design is re-worked in the Indian craft tradition. Teak is commonly available in India, and Munshi and Trivedi used solid blocks, golden and beautifully grained, to explore the formal possibilities of turned wood. Made in a workshop by hand, the lights have small coloured bands painted on the bases to accentuate the texture of the material.

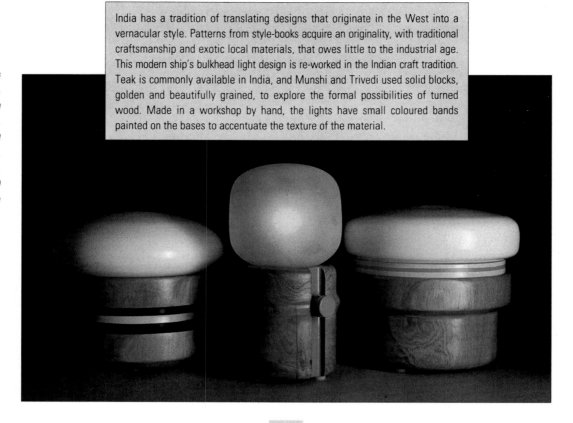

12

Mario Villa
Table lamp, Circle Cross Lamp
Welded copper, brass, steel
A lamp with a line cord switch and a
choice of shades. Takes a 60W lamp.
Limited batch production.
H63.5 cm (25 in). W base 15 cm (6 in).
D base 15 cm (6 in)
Manufacturer: Mario Villa, USA

13

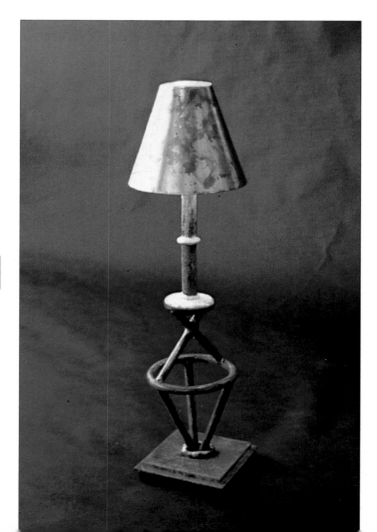

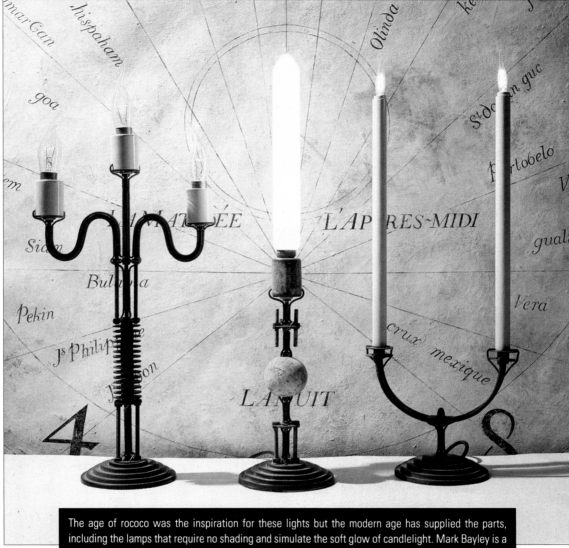

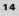
The age of rococo was the inspiration for these lights but the modern age has supplied the parts, including the lamps that require no shading and simulate the soft glow of candlelight. Mark Bayley is a young English photographer who had the idea for this collection while devising a rococo background in his studio. At the first stage of assembly the industrial materials are "still silvery and grey, very high tech," so he distresses the surface finish: the metre-lengths of thread and bolt studding from the building trade that are used for the fittings are corroded with chemicals. The wires leading into each lamp are hidden by coloured embroidery silks wound around the grooves in the studding. Lamp bases are cast in fibreglass mixed with iron filings, borrowing a method that sculptors employ in order to add weight and to achieve a corroded finish.

Mark Bayley

Candelabra, single candlestick, fork candlestick
Fibreglass resin, steel studding
Limited batch production
Candelabra *Takes three 15W lamps.*
H100 cm (39½ in). W25 cm (9⅞ in).
Di base 14 cm (5½ in)
Single candlestick *Takes one*
60W lamp.
H75 cm (29½ in). Di base
14 cm (5½ in)
Fork candlestick *Takes two 15W*
chandelier lamps.
H50 cm (19⅝ in). Di base 14 cm
(5½ in). Di arch 18 cm (7 in)
Manufacturer: Mark Bayley, UK

Peter Blake
Step Lamps
Wood
A range of table and floor lamps in
natural or stained Finnish birch
plywood and fitted with square, off-
white, handmade lampshades.
Limited batch production.
H79 cm, 112 cm and 145 cm (31 in,
44 in and 57 in). W33 cm (13 in).
D33 cm (13 in)
Manufacturer: Aram Designs, UK

15

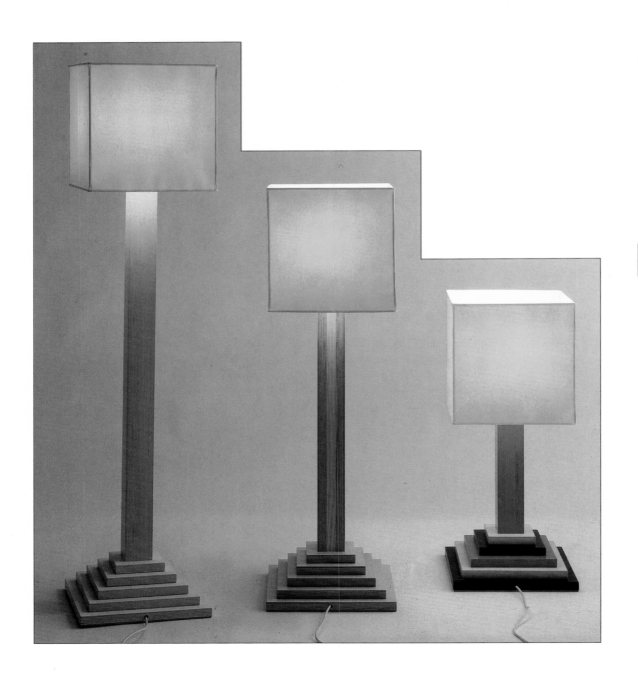

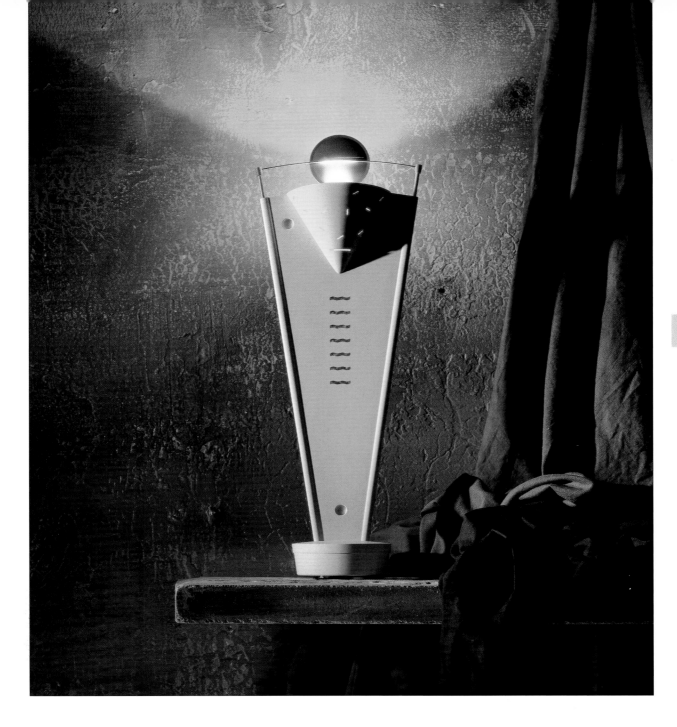

Moggridge Associates /
Philip Davies
Table lamp, Nile
Metal
Prototype of a low-voltage decorative
mini-uplighter with a flexible reflector
which can be manipulated to create a
variety of effects. The dichroic light
source is diffused through the
decorative perforations.
H40 cm (15¾ in). W16 cm (6¼ in).
D12 cm (4¾ in)
Manufacturer: IDM Modelmakers, UK

Otto Krüger
Table lamp, Tragara
Brass
A table lamp with swivelling arms based on Krüger's 1908 design. In brass, high-polish nickel-plated, and opal glass. Takes a 60W incandescent lamp.
H57 cm (22⅜ in). W82 cm (32¼ in). Di base 28 cm (11 in)
Manufacturer: Vereinigte Werkstätten, West Germany

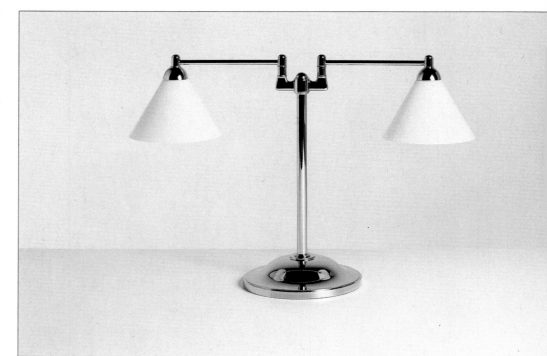

17

18

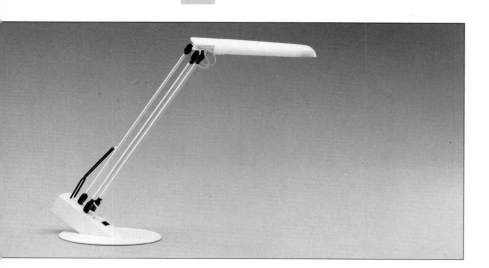

19

Yamagiwa Design Team
Table lamp, D-3
Aluminium, aluminium paint, plastic
A table lamp which can be moved from side to side as well as up and down. Takes a U-shaped fluorescent tube.
H57 cm (22⅜ in). W24 cm (9⅜ in). D86 cm (33⅞ in)
Manufacturer: Yamagiwa, Japan

Nikodemus Einspieler
Table lamp, Andronia
A table lamp in white stone, stainless steel, glass and brass.
H55 cm (21½ in). W37 cm (14½ in). D23 cm (9 in)
Manufacturer: Woka Lamps Vienna, Austria

A conventional table lamp is often still the most effective form of task light. In the case of the *Tragara,* the light can be controlled not only in angle and range by the shades, but in position by the swivelling arms. Originally designed in 1908 by Otto Krüger, the piece has now been reissued in the *die Klassiker* collection of Vereinigte Werkstätten, who specialize in reproducing the designs from earlier decades. They say that these re-editions are based on the original drawings that are held in their enormous archives.

21

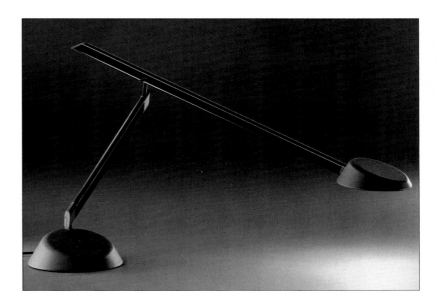

20

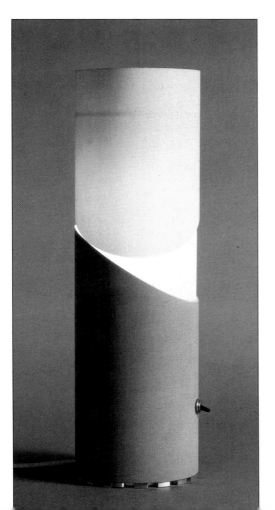

Vico Magistretti
Table lamp, Lester
Aluminium
An adjustable table lamp with a
balanced arm in lacquered aluminium
that rotates 360 degrees at the base
and at the pivot support. The reflector
remains horizontal. The base and
reflector are lacquered in black Nextel.
Available in black, grey and green.
H (max) 80 cm (31½ in). L (max)
100 cm (39½ in)
Manufacturer: O-Luce, Italy

Laslo Čonek
Table lamp
PVC, aluminium
Prototype
H38 cm (15 in). Di12.5 cm (5 in)
Manufacturer: Laslo Čonek,
Yugoslavia

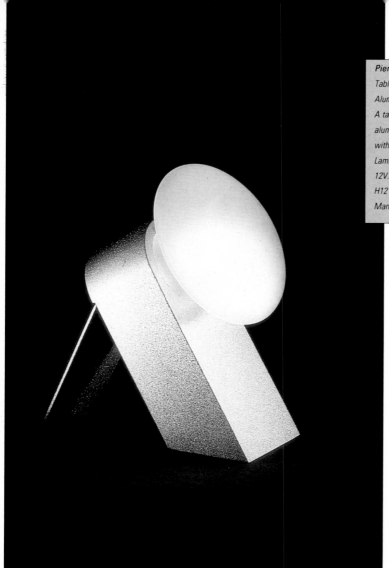

Piero Castiglioni
Table lamp, Sillaba
Aluminium
A table lamp in painted die-cast
aluminium in black or metallic grey
with a heat-resistant glass shade.
Laminated transformer 25W 220/
12V. Takes a 20W 12V halogen lamp.
H12 cm (4¾ in). W12 cm (4¾ in)
Manufacturer: Fontana Arte, Italy

Kyrre Andersen
Table lamp
Steel, acrylic, wood
A table lamp that takes twenty-
five 5V microbulbs. Limited batch
production.
H38 cm (15 in). W9 cm (3½ in).
D12 cm (4¾ in)
Manufacturer: K. Andersen / Trikk,
Norway

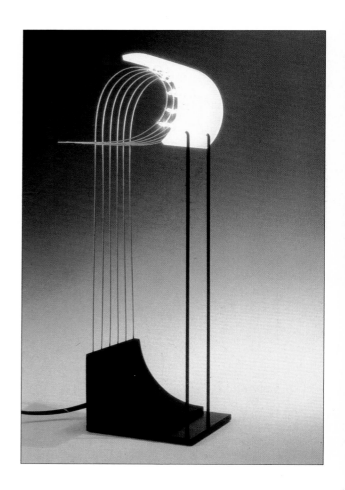

25

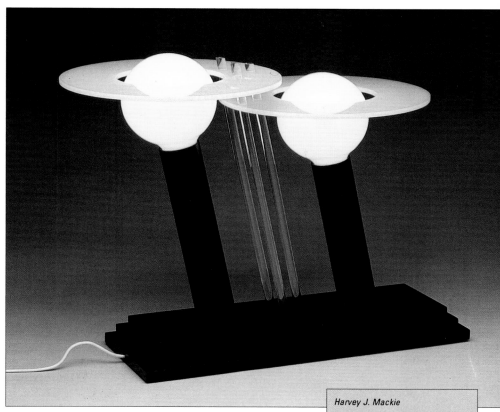

Harvey J. Mackie
Table lamp, Lucy and Tania
MDF, perspex, lacquer
A table lamp with opal perspex "halos"
supported by three perspex rods on an
MDF cellulose lacquered base. Comes
with a free-standing matching in-line
dimmer switch. Takes two 60W ES
globe lamps. Limited batch production.
H33 cm (13 in). W top 23 cm (9 in).
W base 14 cm (5½ in). L44 cm (17¼ in)
Manufacturer: Colorado, UK

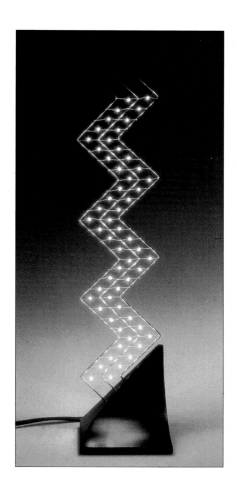

24

Kyrre Andersen
Table lamp
Stainless steel, wood
A table lamp that takes fifty-eight
5V microbulbs. Limited batch
production.
H40 cm (15¾ in). W9 cm (3½ in).
D9 cm (3½ in)
Manufacturer: K. Andersen / Trikk,
Norway

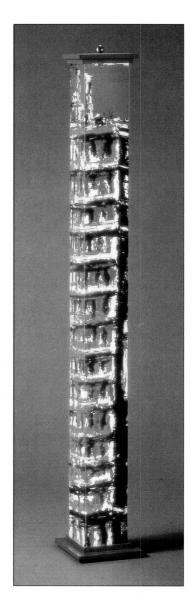

26

Gabriel Ordeig
Floor lamp, La Bella Durmiente
A fluorescent floor lamp with a central
tube and silk-screen print shade. This
version has a shade in homage to Piet
Mondrian.
H172 cm (67¾ in). W15 cm (6 in).
D15 cm (6 in)
Manufacturer: Santa & Cole, Spain

Gabriel Ordeig and Vicenç Viaplana
Floor lamp, La Bella Durmiente
A fluorescent floor lamp by Gabriel
Ordeig with a central tube and silk-
screen print shade. This version has a
shade by Vicenç Viaplana.
H172 cm (67¾ in). W15 cm (6 in).
D15 cm (6 in)
Manufacturer: Santa & Cole, Spain

27

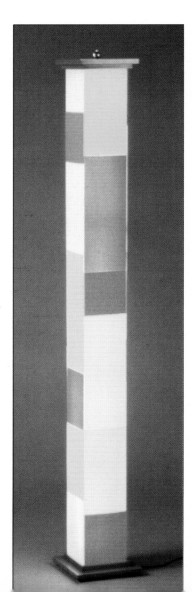

112

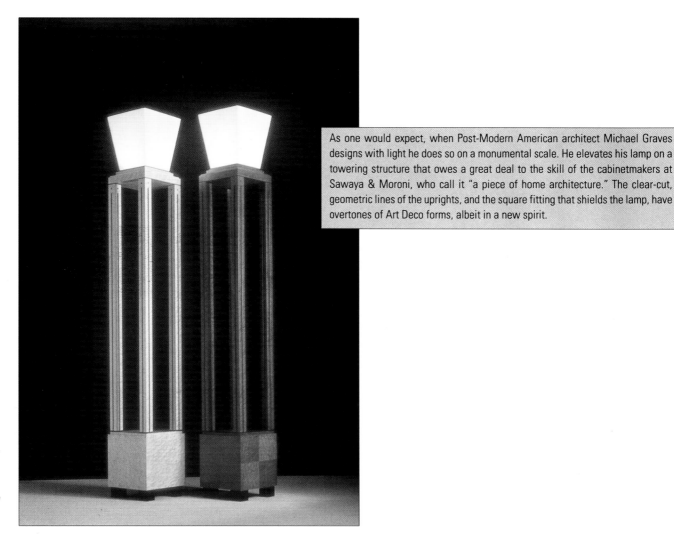

As one would expect, when Post-Modern American architect Michael Graves designs with light he does so on a monumental scale. He elevates his lamp on a towering structure that owes a great deal to the skill of the cabinetmakers at Sawaya & Moroni, who call it "a piece of home architecture." The clear-cut, geometric lines of the uprights, and the square fitting that shields the lamp, have overtones of Art Deco forms, albeit in a new spirit.

Michael Graves
Floor lamp, Ingrid
Wood, onyx
A floor lamp with a wooden structure of bird's eye maple veneer (natural or tinted mahogany) with a green Pakistan onyx shade and a foot-operated dimmer. Limited batch production.
H191 cm (75 in). W26.5 cm (10⅜ in). D26.5 cm (10⅜ in)
Manufacturer: Sawaya & Moroni, Italy

28

The name of this light, *The Sleeping Beauty*, reflects the dramatic reawakening that is taking place currently in Spanish design. The past fifty years have cast Spain mainly as the producer of solid cabinetry and wrought-iron garden furniture, and little more. But Spain's recent membership of the EEC, coupled with the approach of the Olympic Games in Barcelona in 1992, has encouraged its marketing strategy to become much more aggressive. There is a new richness in design output. Challenging shapes, vigorous patterns and bold colours are executed with a confidence founded in the vernacular craft tradition. Gabriel Ordeig's simple fluorescent tube, usually associated with the white light of supermarkets, can be clothed in interchangeable shades, silk-screened in colours that filter the light source. Ordeig's own shade uses bold, rhythmic primary colours; Vicenç Viaplana depicts on his an urban landscape against the fiery glow of a red sky – "the vertical city."

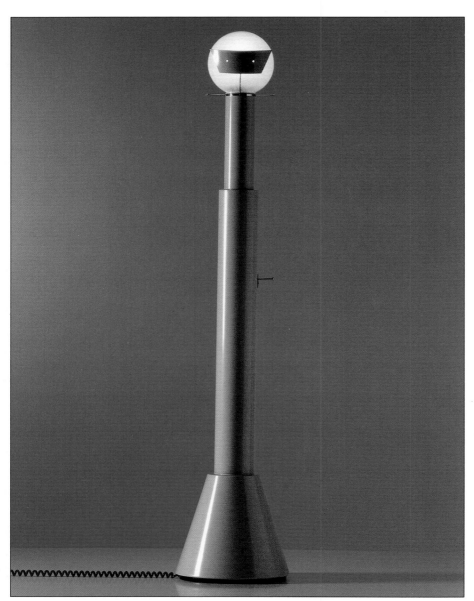

29

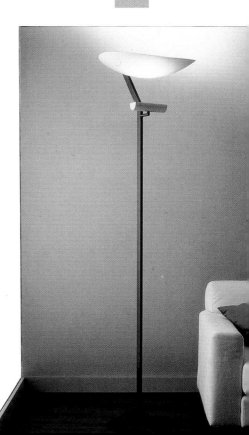

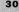 **30**

Alessandro Mendini
Floor lamp, Lampada di Milo
Lacquered metal
A floor lamp with dimmer switch and
diffuser in polished lacquered metal.
The head can be swivelled through 360
degrees. Takes a 220V/250W E27 lamp.
H170 cm (67 in). Di base 34 cm
(13⅜ in). Di head 20 cm (7⅞ in)
Manufacturer: Segno, Italy

Ernesto Gismondi
Floor lamp, Zen
Metal, anodized aluminium
A floor lamp in painted metal and
anodized aluminium with two
diffusers. The upper diffuser is for
general lighting and the lower
diffuser provides indirect, gentler
lighting. Takes one each of 300W
and 200W halogen lamps.
H200 cm (78¾ in). W51 cm (20 in).
Di base 36 cm (14⅛ in)
Manufacturer: Artemide, Italy

Lights, like books, can furnish a room. The low-voltage lamps on Thomas Eisl's corner unit light up when a switch is touched because they are in contact with its corrugated steel shelves: the structure itself acts as the conductor. It also functions as a storage unit. Eisl intends the lights, as well as the piece, to have a dual character: "At times my lights should be contemplated as works of art, at others, simply used for the function for which they are designed." Corrugated steel appeals to him for its combination of strength with thinness, and especially for its galvanized finish, which he likens – poetically – to a chemical frost.

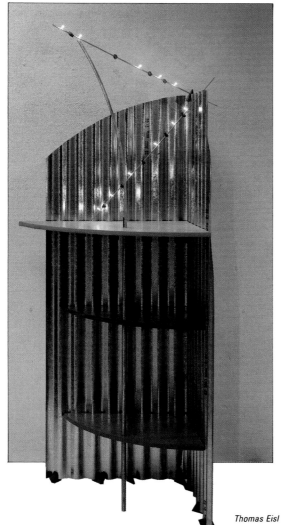

31

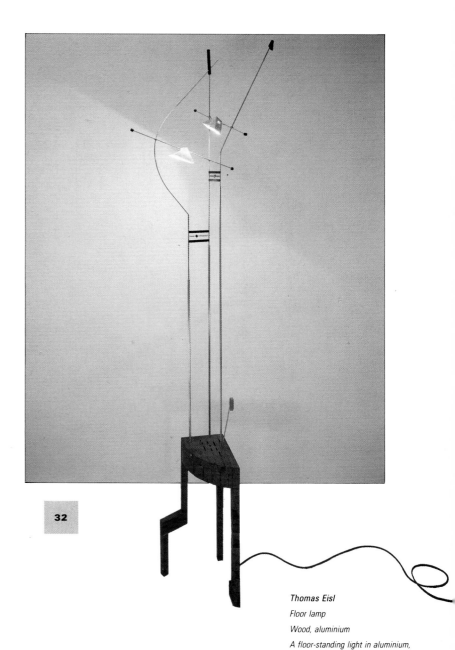

32

Thomas Eisl
Shelf unit with light
Galvanized steel, sterling board,
aluminium
A one-off shelf unit suitable for a
corner or free-standing, with two
light bars and corrugated sheets as
conductors. Takes eleven 5W 12V
lamps.
H210 cm (82⅝ in). W83 cm (32½ in).
D60 cm (23½ in)
Manufacturer: Thomas Eisl, UK

Thomas Eisl
Floor lamp
Wood, aluminium
A floor-standing light in aluminium,
yew and ebony with two adjustable
reflectors. Takes two 50W 12V
halogen lamps. One-off.
H215 cm (84½ in)
Manufacturer: Thomas Eisl, UK

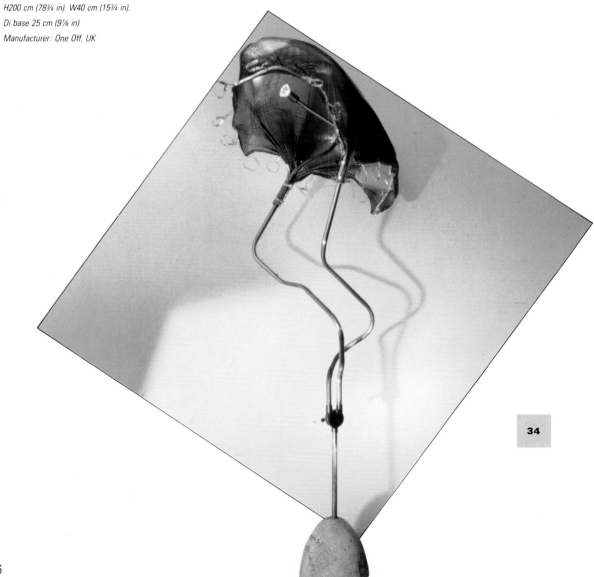

33

Ron Arad
Floor lamp, Armadillo
Concrete, steel, aluminium
A concrete-based steel double
halogen 12V light with an aluminium,
armadillo-shaped shade and a
dimmer switch. Limited batch
production.
H200 cm (78¾ in). W40 cm (15¾ in).
Di base 25 cm (9⅞ in)
Manufacturer: One Off, UK

Leo Blackman and Lance Chantry
Floor lamp, Quahog
Aluminium, folded rice paper
Prototype of a standing light fixture.
The switch controls the
simultaneous unfolding of the shade
and the brightening of the halogen
lamp.
H183 cm (72 in). W 19 cm (7½ in).
D20.5 cm (8 in)
Manufacturer: Leo Blackman and
Lance Chantry, USA

34

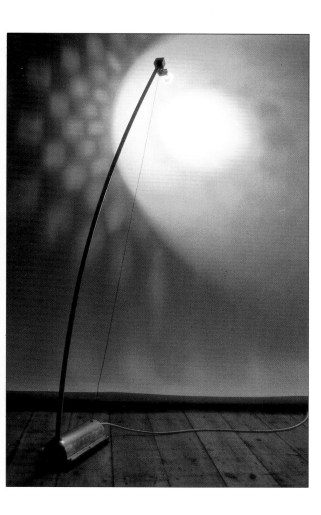

Shiu Kay Kan
Floor lamp, Stickleback
Aluminium
A low-voltage light using an
electronic transformer. Also
available in wall and table lamp
versions.
H170 cm (67 in). W15 cm (6 in).
D10 cm (4 in)
Manufacturer: SKK Lighting, UK

Dinah Casson and Roger Mann
Uplighter
Aluminium, copper, leather
An uplighter with a dish of spun
aluminium and an adjustable,
vertically curved copper stem
striped with verdigris treatment. The
base is a leather bag filled with
sand that wedges into the
floor/skirting junction. Two arms
hook the back to the wall. Takes a
300W halogen lamp. Limited batch
production. (Finish to the dish
applied by Julian Gibb.)
H280 cm (110¼ in). Di dish
80 cm (31½ in)
Manufacturer: Traffic
Technology, UK

35

36

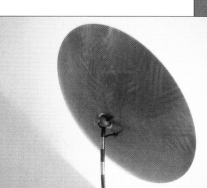

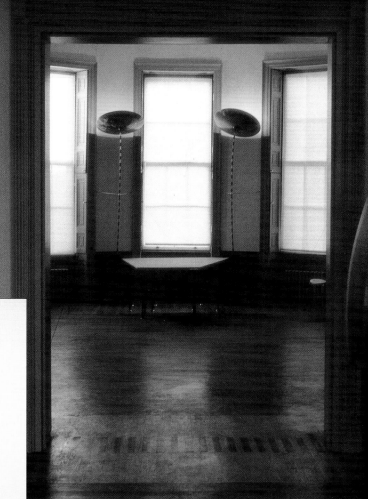

L I G H T I N G

Setsuo Kitaoka
Floor lamp
Aluminium
Prototype.
H164 cm (64½ in). Di tube 7.6 cm
(3 in). Di base 30 cm (11⅞ in)
Manufacturer: Sparks, Japan

39

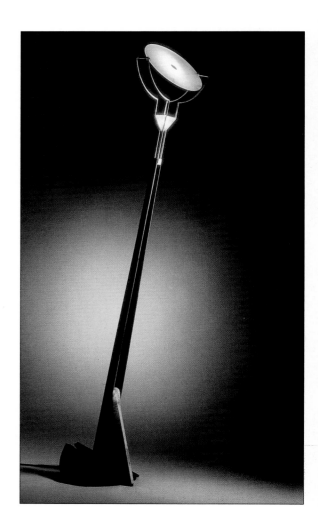

37

38

L. Suzanne Powadiuk
Floor lamp, The Arc Light
Stainless steel, brass
A light consisting of stainless-steel fins
that are held in tension at the top by a
pair of steel springs and at the base by
a structural tree of brass pins. A brass
arc containing the tungsten halogen
lamp pierces the fins. One-off.
H182 cm (71⅝ in). W43 cm (16⅞ in).
D43 cm (16⅞ in)
Manufacturer: L. Suzanne Powadiuk,
Canada

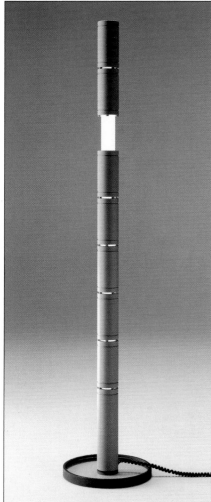

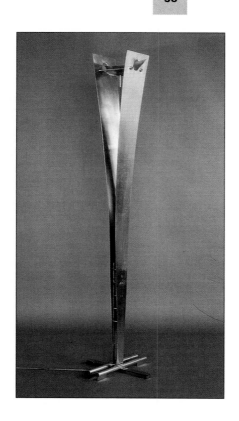

Thomas Muller
Floor lamp
Aluminium, concrete, steel, glass
A floor-standing lamp with a cast
concrete pendulum at the base that
holds the column at an angle. The
direction of the light is controlled by
swivelling the glass disc. Limited batch
production.
H185 cm (72⅞ in). W35 cm (13¾ in).
D18 cm (7 in)
Manufacturer: Thomas Muller,
West Germany

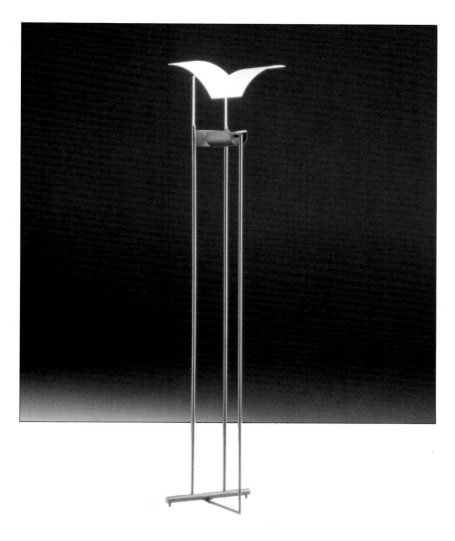

Ullrich Höreth
Floor lamp, Laser
A floor lamp in glass and stainless
steel tube, with an iron base.
H205 cm (80¾ in). L47 cm (18½ in).
Di base 35 cm (13¾ in)
Manufacturer: Woka Lamps Vienna,
Austria

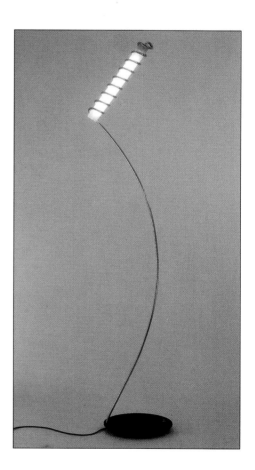

Jorge A. Garcia Garay
Floor lamp, Fenix
Metal
A floor lamp in black metal or
chromium in two pieces, one of
which is L-shaped and contains the
halogen lamp. The white wings
reflect the light.
H195 cm (76⅞ in). W40 cm (15¾ in).
D40 cm (15¾ in)
Manufacturer: Garcia Garay
Design, Spain

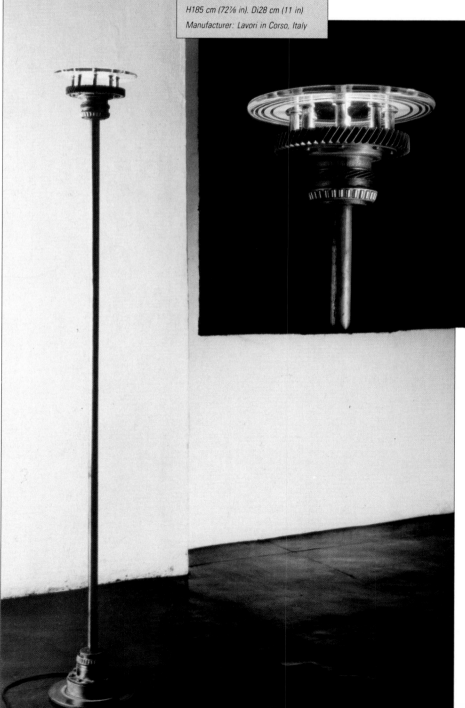

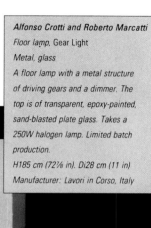

Alfonso Crotti and Roberto Marcatti
Floor lamp, Gear Light
Metal, glass
A floor lamp with a metal structure
of driving gears and a dimmer. The
top is of transparent, epoxy-painted,
sand-blasted plate glass. Takes a
250W halogen lamp. Limited batch
production.
H185 cm (72⅞ in). Di28 cm (11 in)
Manufacturer: Lavori in Corso, Italy

42

43

Andrzej Duljas
Floor lamp, Andréa F-5180
Polished brass, chrome
Floor lamp with a full-range sliding
floor dimmer. Takes a 500W halogen
lamp.
H188 cm (74 in). W25.4 cm (10 in).
D25.4 cm (10 in). Di shade
18 cm (7 in)
Manufacturer: Koch + Lowy, USA

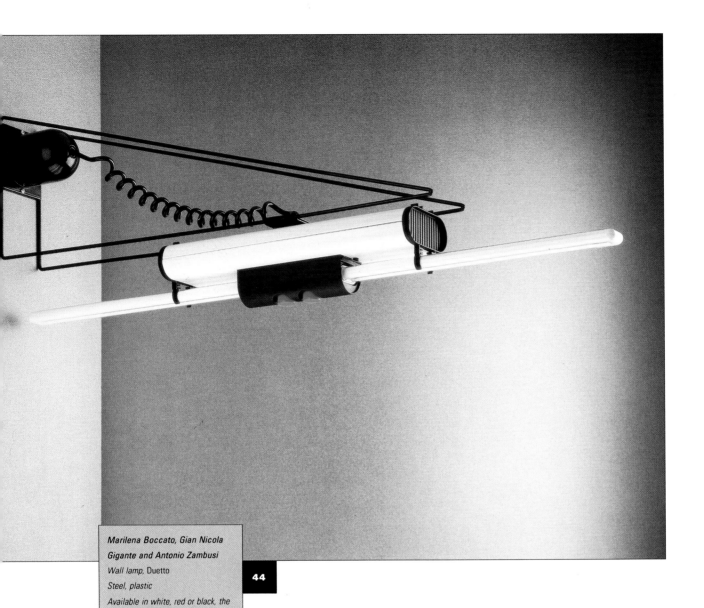

Marilena Boccato, Gian Nicola Gigante and Antonio Zambusi
Wall lamp, Duetto
Steel, plastic
Available in white, red or black, the Duetto can be used as a wall, ceiling or suspension lamp. Takes two fluorescent Dulux PL 18-24-26W lamps.
H9.5 cm (3¾ in). W10cm (4 in). L64cm, 73 cm or 92 cm (25⅛ in, 28¾ in or 36 in)
Manufacturer: Zerbetto, Italy

44

Achille Castiglioni
Wall lamp, Bisbi
Aluminium, ceramic
A wall lamp with a ceramic socket
and a die-cast aluminium rotating
reflector. Takes a 150W E14 halogen
lamp.
W20 cm (7⅞ in). D16 cm (6¼ in)
Manufacturer: Flos, Italy

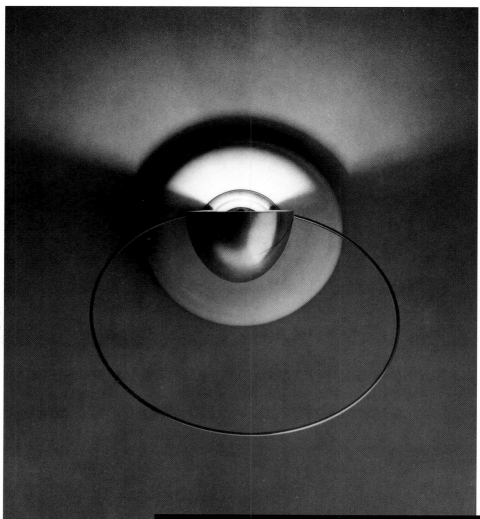

A twist of the ring changes this light from an uplighter to a wall-washer; the ring is angled so as not to create a shadow. The *Bisbi,* which has a relatively high output for a small lamp, evolved as a companion to the *Bibip,* a floor-standing lamp with a ceramic base and head designed by Achille Castiglioni in 1976. More commonly found in desk lamps, ceramics are employed here too. As usual with Castiglioni, this new piece seems effortlessly to achieve a look of refreshing simplicity.

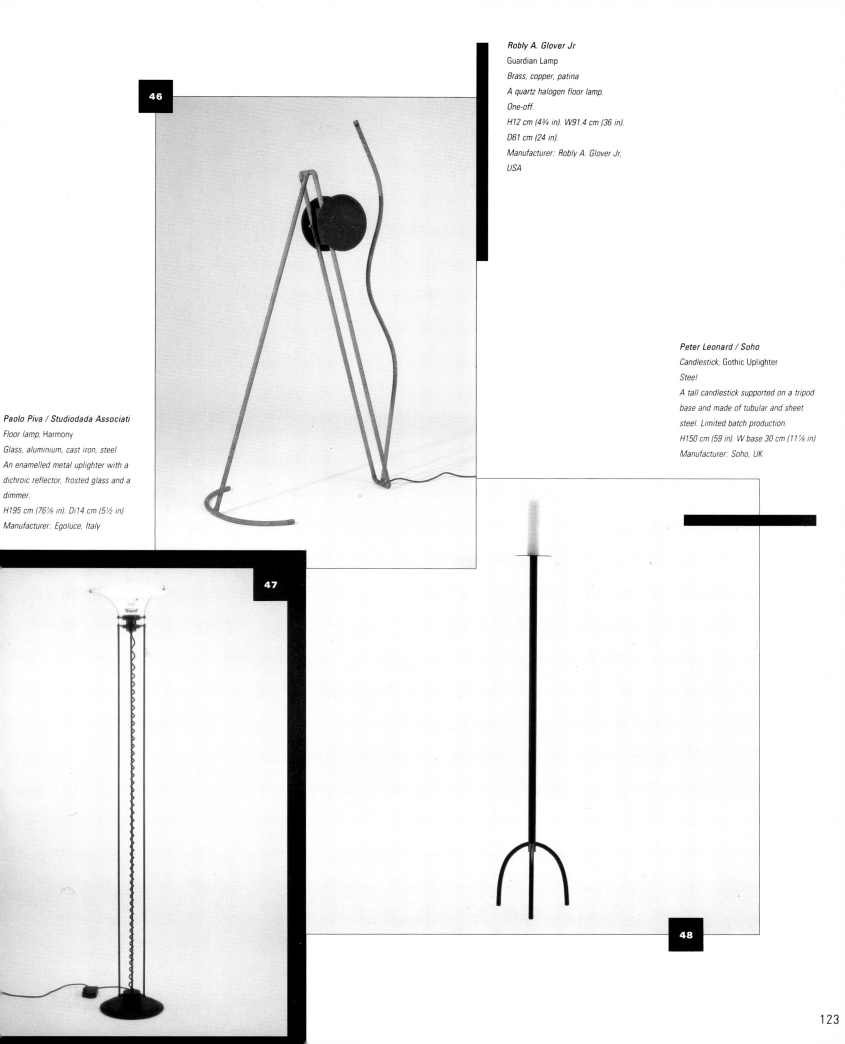

46

Robly A. Glover Jr
Guardian Lamp
Brass, copper, patina
A quartz halogen floor lamp.
One-off.
H12 cm (4¾ in). W91.4 cm (36 in).
D61 cm (24 in).
Manufacturer: Robly A. Glover Jr,
USA

Peter Leonard / Soho
Candlestick, Gothic Uplighter
Steel
A tall candlestick supported on a tripod
base and made of tubular and sheet
steel. Limited batch production.
H150 cm (59 in). W base 30 cm (11⅞ in)
Manufacturer: Soho, UK

Paolo Piva / Studiodada Associati
Floor lamp, Harmony
Glass, aluminium, cast iron, steel
An enamelled metal uplighter with a
dichroic reflector, frosted glass and a
dimmer.
H195 cm (76⅞ in). Di14 cm (5½ in)
Manufacturer: Egoluce, Italy

47

48

Steven Lombardi
Wall lamp, Filicudara
Anodized aluminium, polyester
A wall lamp in black or white anodized
aluminium and resin with a diffuser in
impregnated polyester. Takes a 100W
E27 incandescent lamp or a candle.
H43.5 cm (17 in). W30.5 cm (12 in).
D from wall 23.8 cm (9¼ in)
Manufacturer: Artemide, Italy

Antonio Citterio
Wall lamp, Enea
Anodized aluminium, resin
A wall lamp with an adjustable
diffuser which controls the direction
of the light. Takes a 100W opaline
E27 lamp.
H28.5 cm (11⅜ in). W18 cm (7 in).
D from wall 22.5 cm to 36 cm
(8⅞ in to 14⅛ in)
Manufacturer: Artemide, Italy

Gianfranco Frattini
Wall lamp, Tiara
Glass
A wall lamp in white moulded and
glazed glass. Takes a 300W halogen
lamp.
H11 cm (4⅜ in). W25 cm (9⅞ in).
D from wall 22.5 cm (8⅞ in)
Manufacturer: Artemide, Italy

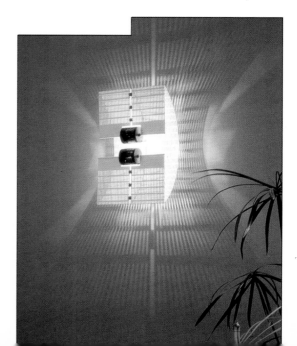

Mario Botta
Wall lamp, Fidia
Perforated plate
A wall lamp with an adjustable head
in white-painted perforated plate.
Takes two 50W 12V halogen lamps.
H46 cm (18 in). W27 cm (10½ in).
D from wall 24.8 cm (9¾ in)
Manufacturer: Artemide, Italy

Tom Ahlström and Hans Ehrich /
A & E Design
Table lamp, Orbit
Lacquered metal
An adjustable light with decorative
details in black polycarbonate and a
two-step switch for normal and half
power. Takes a 12V tungsten
halogen lamp.
H9 cm to 13 cm (3½ in to 5⅛ in).
On stand H75.5 cm (29¾ in).
L60 cm (23½ in)
Manufacturer: Ateljé Lyktan,
Sweden

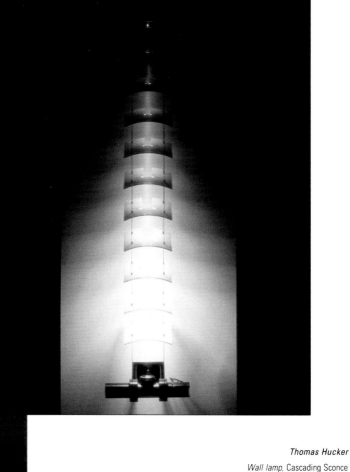

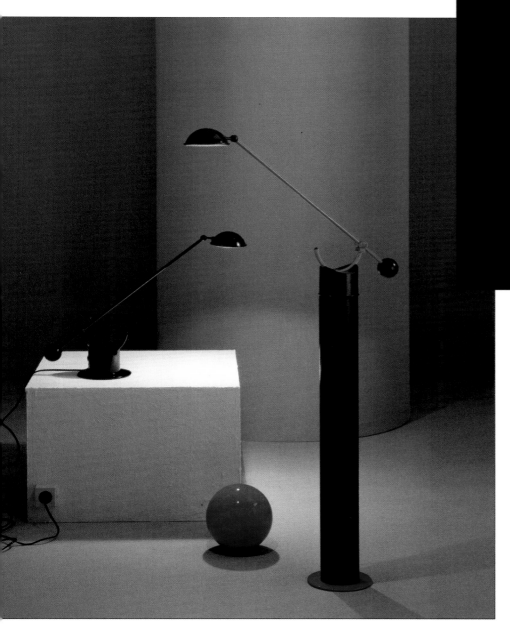

Thomas Hucker
Wall lamp, Cascading Sconce
Anodized aluminium
Prototype of a collapsible wall-
suspended unit in which the light is
focused through plates. Each plate
acts as an aperture reflecting part of
the light back into the environment.
H183 cm (72 in). W51 cm (20 in).
D25.4 cm (10 in)
Manufacturer: Thomas Hucker
Design, USA

LIGHTING

TABLEWARE

3 A fur cup, saucer and spoon by Méret Oppenheim, on permanent exhibit at the Museum of Modern Art, New York, still shock. Only a decade ago, the British Design Council refused an award to a teapot with stockinged feet (though it became an international success). One could be considered sculpture, the other a working object; both say something about prevailing attitudes to tableware. In tableware design, form follows function more readily than in other design areas less concerned with such basic needs as hunger and thirst. ■ Dinner services still conform to the conventions of regular shapes, matching designs and accepted sizes. But some designers are questioning the rules. Boxer uses lotus shapes, circles and rectangles in stacking three-course place settings; Putman provides individual pieces marketed singly rather than as a service so that colours and patterns can be mixed and matched in distinctive combinations; and Marchesi, himself a chef, varies the inner circumference of plates, not their overall size. Responding to the recent preoccupation with presentation, designers are now framing food. ■ Here, as in other areas of design, there is a rediscovery of materials. Sabattini explores the inherent malleability of silverware, working it into sinuous curves. Other metals are pitted, corroded and sand-blasted to give the patina of age, or to highlight the signs of craft-work. Lee revives ancient techniques to hand-build clay for her pots in metallic colours. Šipek's fluid lines in glass bristle with spikes which, he says, are entirely functional. ■ Mies van der Rohe, the Bauhaus designer and architect, said that "Less is more." Post-Modernist American architect Robert Venturi rejoined with "Less is a bore." He has now designed some elaborately patterned tableware for the Swid Powell collection which is not on show but on sale at the Museum of Modern Art – a pertinent reminder that design in tableware, however ornamental, must always remember its function.

Olivier Gagnère
Teapot
Glass, steel, wood
A teapot in frosted glass, hammered
golden steel and wood. Limited
batch production.
H24 cm (9⅜ in). Di10 cm (4 in)
Manufacturer: Galerie Adrien
Maeght, France

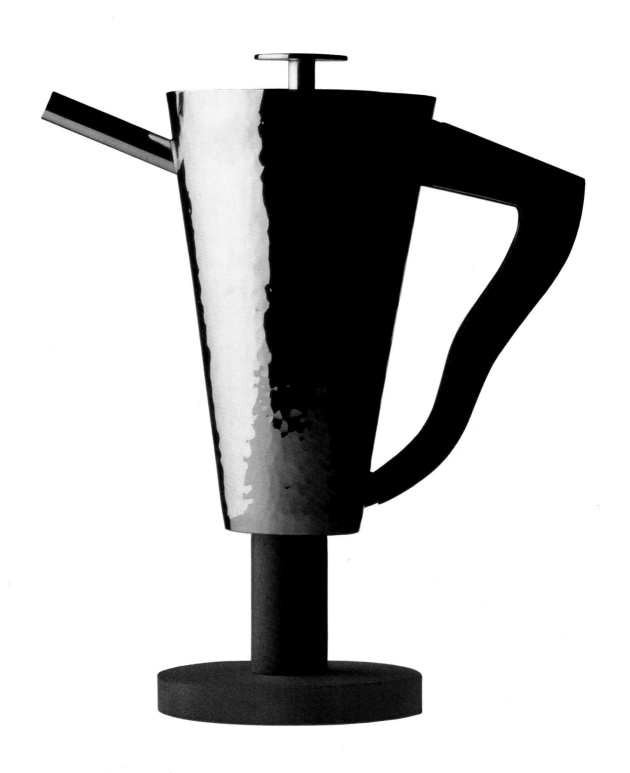

Masahiro Mori
Soy pots
Porcelain
H7 cm (2¾ in). Di7.3 cm (2⅝ in)
Manufacturer: Hakusan Porcelain,
Japan

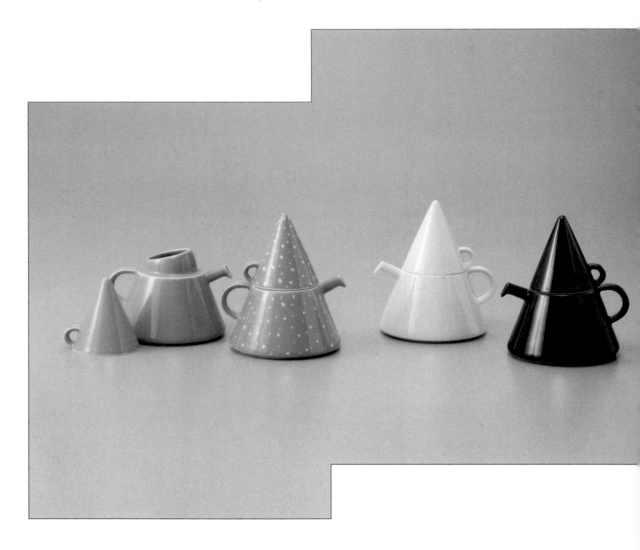

The hierarchical distinction between fine art and craft does not exist in Japan as it does in the West; there is often little difference between an everyday, utilitarian item and a piece of sculpture. In the Japanese household, the soy pot is essential. Masahiro Mori first devised his award-winning classic design in 1958 to harmonize with Japanese dishes and utensils. Now he has refined it, scaling it down with a lid reminiscent of a tea-cosy cover, its downward-pointing spout capable of measuring out minute quantities without drips; any trickles occur only in the beautiful ceramic glazes, which are hand-painted in delicate, natural-seeming colours.

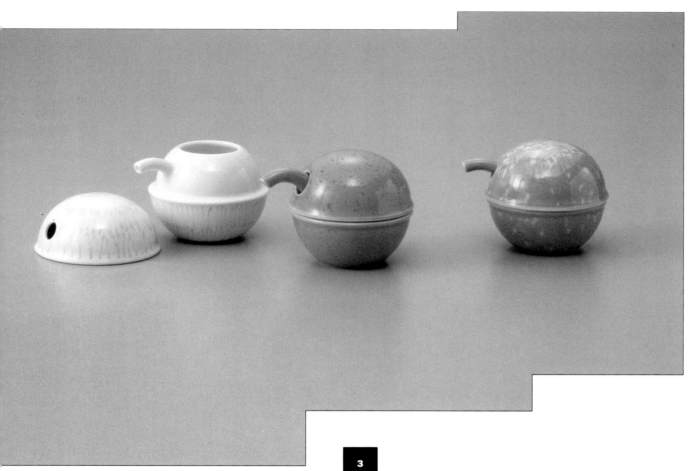

3

Masahiro Mori
Soy pots
Porcelain
H13 cm (5⅛ in). Di9.5 cm (3¾ in)
Manufacturer: Hakusan Porcelain,
Japan

Like the famous Alessi kettles, the new Swid Powell *Cityline* collection, also designed by architects, has already acquired fashionable "designer" status. At international product and furniture fairs, stylists use the plates as props; interior shots in magazines often feature items in the range; and twenty per cent of the collection is on exhibit at the Metropolitan Museum of Art, New York.

The kaleidoscope-like colours and patterns of Andrée Putman's plates allow for many individual settings. Sold separately, they can be mixed and matched according to taste. The intention is that, like good dinner guests, they should each have charm and a distinctive character. Putman's description of her collection makes it clear what she admires: "The patterns of these plates are not the same, but they are friends. They are all very chic and *soignée*."

4

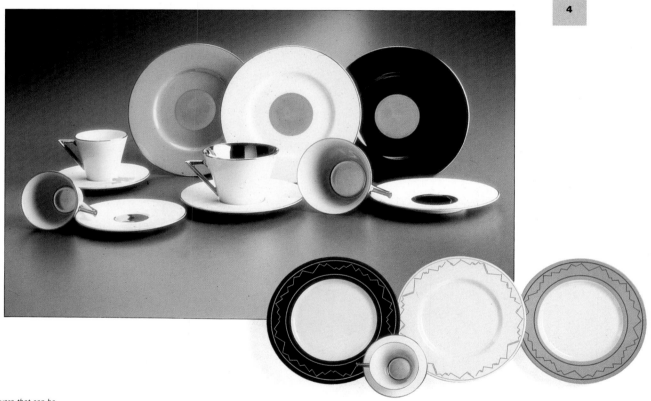

Andrée Putman

Tableware

Porcelain

A collection of tableware that can be mixed and matched according to the occasion. The colours are verdigris, cobalt blue, grey, black and white, and platinum is used both in solid circles and as a trim.

Service plate *Di30.5 cm (12 in)*

Dinner plate *Di27.3 cm (10¾ in)*

Salad plate *Di19.7 cm (7¾ in)*

Saucer *Di16 cm (6¼ in)*

Cup *H6.5 cm (2½ in)*

Manufacturer: Sasaki, Japan

Coming from the man who coloured the Olivetti typewriter red and put Mickey Mouse feet on a typist's chair, Ettore Sottsass' new tableware for *Cityline* may seem a little tame. The south Indian city of Madras is known for its flower market as much as for its plaid cottons; inspired by the place, Sottsass has coloured simple floral outlines in Jaipur pink, sky blue and sunny yellow – a similar colour scheme to that of his *Memories of India* earthenware, which was launched in Milan in 1987.

Stanley Tigerman cheerfully confessed to the nickname "Teapot" – on account of his shape – long before he was asked to design a teapot for Alessi, as he did a few years ago. Known for his highly individual buildings with bizarre names, he has designed these plates, with partner Margaret McCurry, using the theme of an aerial view of an ancient walled city.

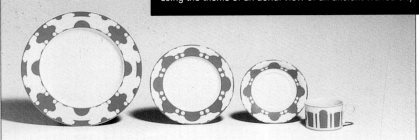

Tigerman McCurry
Tableware, Verona
Ceramic
Dinner plate, dessert plate, cup and saucer from the Verona *collection in the* Cityline *series.*
Dinner plate Di27.3 cm (10¾ in)
Dessert plate Di18 cm (7 in)
Saucer Di15 cm (6 in)
Cup H9cm (3½ in)
Manufacturer: Swid Powell, USA

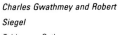

Charles Gwathmey and Robert Siegel
Tableware, Gotham
Ceramic
Dinner plate, dessert plate, cup and saucer from the Gotham *collection in the* Cityline *series.*
Dinner plate Di27.3 cm (10¾ in)
Dessert plate Di18 cm (7 in)
Saucer Di15 cm (6 in)
Cup Di9 cm (3½ in)
Manufacturer: Swid Powell, USA

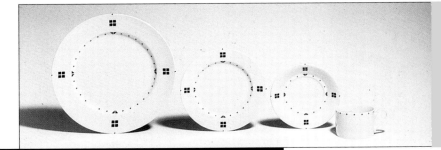

Gwathmey Siegel are known in architecture for a different kind of design from this; it is surprising that their series for *Cityline* seems to show some indebtedness to the Viennese Secessionists and/or to American pop culture. They have apparently named their pieces after Batman's birthplace, Gotham.

Ettore Sottsass
Tableware, Madras
Ceramic
Dinner plate, dessert plate, cup and saucer from the Madras *collection in the* Cityline *series.*
Dinner plate Di27.3 cm (10¾ in)
Dessert plate Di18 cm (7 in)
Saucer Di15 cm (6 in)
Cup H9 cm (3½ in)
Manufacturer: Swid Powell, USA

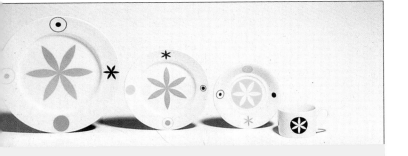

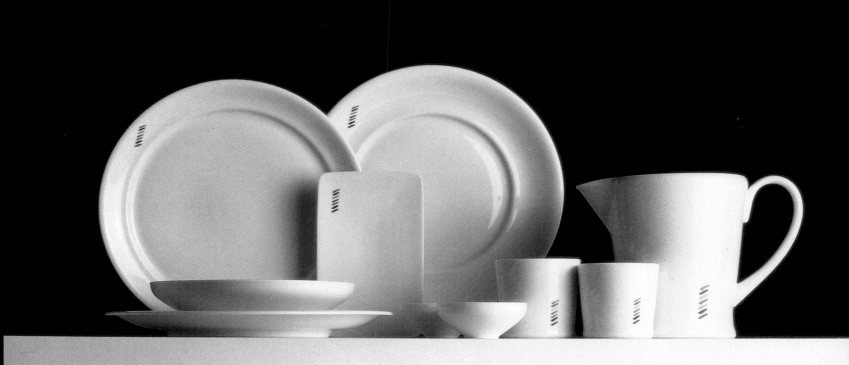

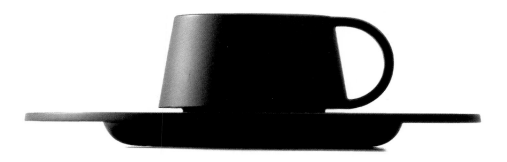

9

Marcello Morandini
Cup and saucer, Tazzina da Thè
Ceramic
A teacup and saucer that fit together so
snugly that they look like a single piece.
H6 cm (2⅜ in). Di20 cm (7⅞ in)
Manufacturer: Unac Tokyo, Japan

Gualtiero Marchesi, one of the great Italian cooks of the decade, has created this table service with the porcelain manufacturer Richard Ginori. The producers argue forcibly that to vary the sizes of plates for different courses serves no functional purpose. Instead, they have demarcated three differently sized inner circles on identically sized, plain white plates, thus making one suitable for hors d'oeuvres, one for main courses and one for fish and desserts. The idea is striking in its simplicity; even the daubs of colour which are the only decorative detail seem like the colour-testing runs undertaken on china glazes in the first stages of putting new tableware ranges into production.

Gualtiero Marchesi

Tableware, Gualtiero Marchesi Idea

Porcelain

An eight-piece table setting comprising three plates, one soup bowl, two tumblers (water and wine), one small bowl, one rectangular tray and a carafe. The plates have the same external diameter but central rings of different sizes to allow flexibility in the presentation of food.

Manufacturer: Richard Ginori, Italy

Ambrogio Pozzi

Cup and saucer

Porcelain

A cup in the Collector's Cups series. Limited batch production.

Cup H8 cm (3⅛ in).

Saucer Di15 cm (6 in)

Manufacturer: Rosenthal, West Germany

11

10

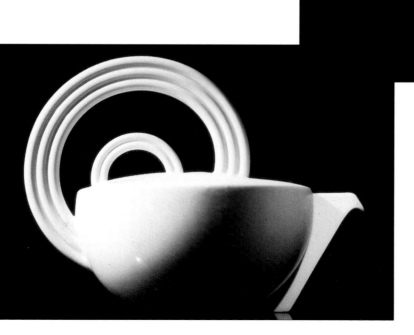

Mario Bellini

Teapot, Cupola

Porcelain

Teapot from the Cupola teaset.

H19.7 cm (7¾ in). Di including spout and handle 25.6 cm (10 in)

Manufacturer: Rosenthal, West Germany

12 The lotus-shaped bowl or plate, the square or rectangular tray and the round plate in Maryse Boxer's collection build up neatly into individual place settings. The earthenware stacks attractively, is entirely functional and looks decorative. Tunisian-born Boxer was a stylist and colourist for textile and cosmetic companies before she was persuaded by fashion retailer Joseph Ettedgui in London to try her hand at tableware. Now her work is exhibited at the Centre Georges Pompidou, Paris and in the Victoria and Albert Museum, London.

Maryse Boxer
Tableware, Lotus
Earthenware
Tableware in various shapes and glazes
that can be used in different
combinations to create individual
settings for any occasion.
Di10 cm to 35.5 cm (4 in to 14 in)
Manufacturer: Honiton Pottery, UK

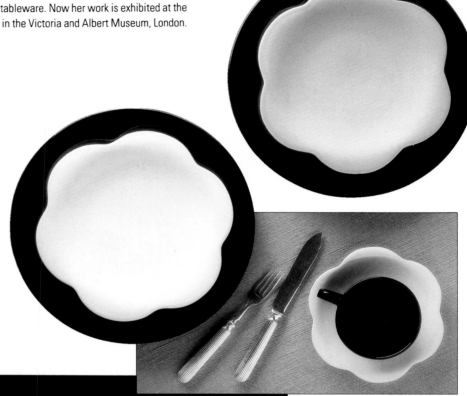

13

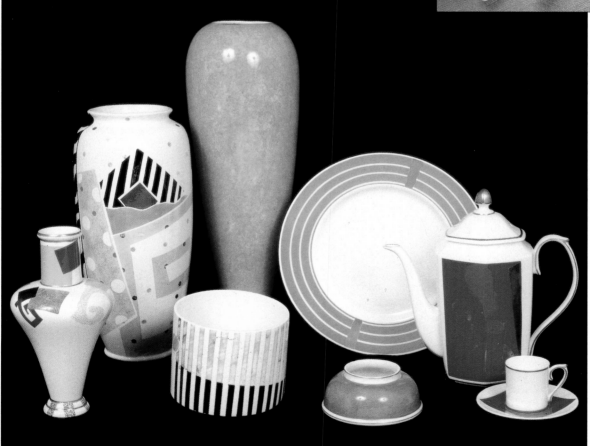

Peter Ting
Limited batch productions. Left to right:
Egyptian vase *Slip-cast in white*
earthenware with hand-applied on-
glaze decoration. Gilding in 22 carat
burnishing gold.
H20 cm (7⅞ in)
Vase *Slip-cast in white earthenware*
with hand-applied under-glaze.
H34 cm (13⅜ in)
Yellow vase *Slip-cast in white*
earthenware with hand-applied on-
glaze decoration.
H43 cm (16⅞ in)
Vessel *Slip-cast in white earthenware*
with hand-applied under-glaze.
H14 cm (5½ in)
Purple brush pot *Slip-cast in white*
earthenware with hand-applied on-
glaze decoration.
H6 cm (2⅜ in)
Dinner plate *Bone china.*
Di27 cm (10½ in)
Coffee pot *Bone china with 22 carat*
burnishing gold.
H23 cm (9 in)
Coffee cup and saucer *Bone china with*
22 carat burnishing gold.
Cup H5 cm (2 in). Di4.5 cm (1¾ in).
Saucer Di11 cm (4⅜ in)
Manufacturer: Tingware, UK

134

Dorothy Hafner
Teaset, Flash
Ceramic
A fifteen-piece teaset.
Manufacturer: Rosenthal,
West Germany

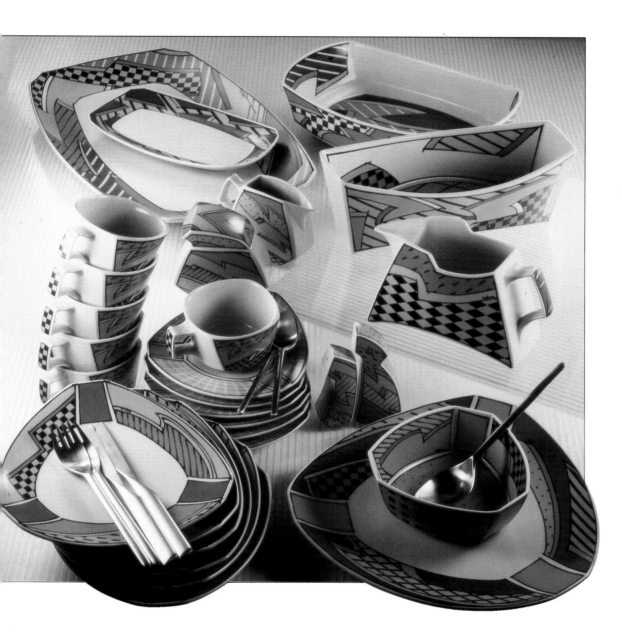

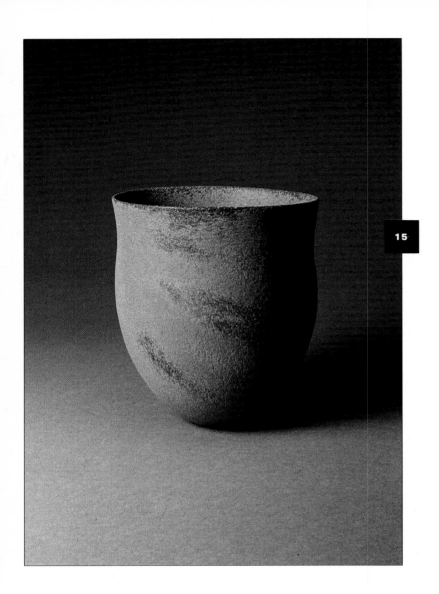

Jennifer Lee
Vase
Stoneware
A vase of hand-built, coloured
stoneware. One-off.
H17.5 cm (6⅞ in). Di15 cm (6 in)
Manufacturer: Jennifer Lee, UK

Jennifer Lee expresses great sympathy with the archai
simplicity of the pots of Minoan, Mycenaean and Pre-Co
ombian civilizations. Her own stoneware pots, made b
the ancient methods of hand-pinching and clay-rolling s
nearly rendered obsolete by the potter's wheel, have a
timeless beauty. She adds colour – cobalt, copper and iro
oxides, manganese, vanadium, rutile and ilmenite, groun
with water and sieved – to the wet clay, making it inherer
to the form. As the hand-built coils overlap and ar
smoothed inside and out, the colour bands are diffusec

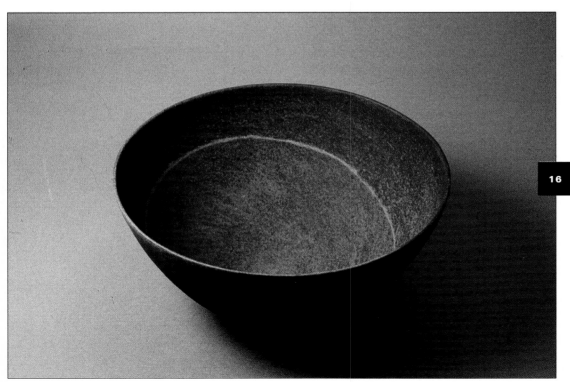

Jennifer Lee
Bowl
Stoneware
A bowl of hand-built, coloured
stoneware. One-off.
H20 cm (7⅞ in). Di36 cm (14⅛ in)
Manufacturer: Jennifer Lee, UK

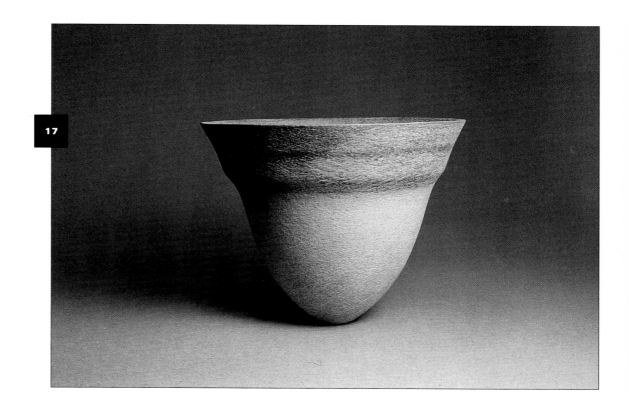

Jennifer Lee
Vase
Stoneware
A vase of hand-built, coloured
stoneware. One-off.
H20 cm (7⅞ in). Di24 cm (9⅜ in)
Manufacturer: Jennifer Lee, UK

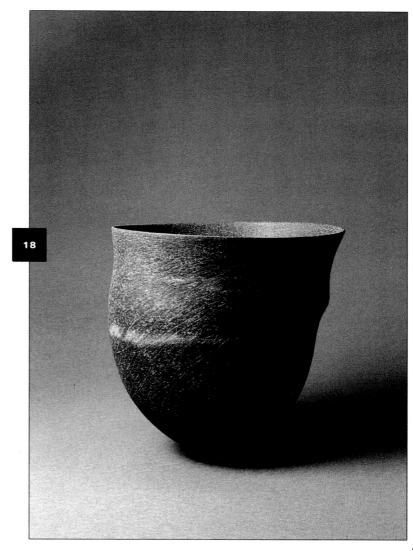

Jennifer Lee
Vase
Stoneware
A vase of hand-built, coloured
stoneware. One-off.
H21.5 cm (8½ in). Di20 cm (7⅞ in)
Manufacturer: Jennifer Lee, UK

David Hertz
Inverted Cone Vases
Pre-cast concrete
Vases consisting of a hollow, pre-cast
lightweight concrete cone inserted into
a concrete cube. Limited batch
production.
H35.5 cm, 51cm or 76 cm (14 in, 20 in or
30 in)
Manufacturer: Syndesis Studio /
David Hertz, USA

19

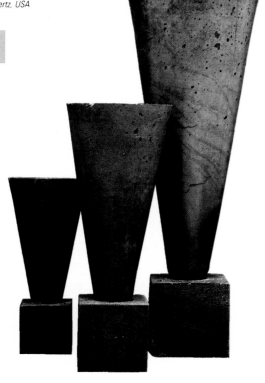

20

Suku Park
Lighting Object
Porcelain
A vessel without glaze, shaped like a
flat shell. It is intended to be
illuminated by sunlight or by a light bulb
placed inside it. Reduction fired at 1280
degrees centigrade. One-off.
H28 cm (11 in). W32 cm (12½ in).
D12 cm (4¾ in)
Manufacturer: Pentik Novus,
Finland

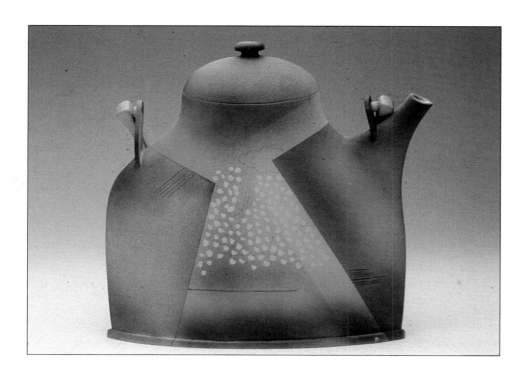

Suku Park
Teapot, Winter Night
Stoneware, wood
A teapot in stoneware and birch-wood,
decorated with an air-spray gun and
glaze-binder. Oxidated at 1280 degrees
centigrade. One-off.
H35 cm (13¾ in). W29 cm (11⅜ in).
D14 cm (5½ in)
Manufacturer: Suku Park Studio,
Finland

21

TABLEWARE

Sigi Mayer and Wolfgang Schatzl
Jewel box, The Sphere Project
Wood
A jewel box in two sizes, made of black-
varnished maple-wood and pear-wood.
The upper part can be removed. Limited
batch production.
H18 cm (7 in). Di12.5 cm (5 in)
Manufacturer: Franz Schatzl, Design
Werkstätte, Austria

22

23

24

Sigi Mayer and Wolfgang Schatzl
Jewel box, The Cone Project
Wood
A jewel box in two sizes, made of black-
varnished maple-wood and pear-wood.
The upper part can be removed. Limited
batch production.
H18 cm (7 in). Di14.5 cm (5¾ in)
Manufacturer: Franz Schatzl, Design
Werkstätte, Austria

Sigi Mayer and Wolfgang Schatzl
Jewel box, The Prism Project
Wood
A jewel box in various sizes, with a
hidden drawer, made of black-varnished
maple-wood and pear-wood. Limited
batch production.
H12 cm (4¾ in). W 7 cm (2¾ in)
L25 cm (9⅞ in)
Manufacturer: Franz Schatzl, Design
Werkstätte, Austria

25

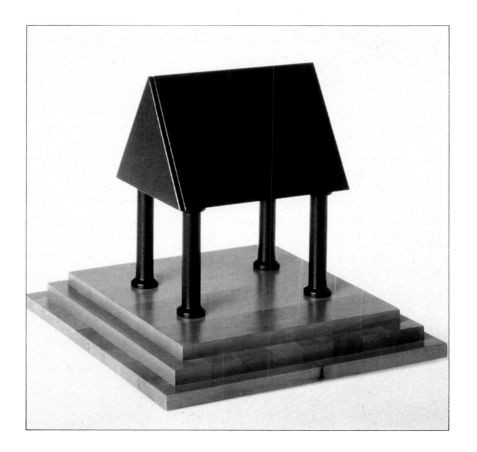

Sigi Mayer and Wolfgang Schatzl
Jewel box, The Temple Project
Wood
A jewel box in two sizes, with a
compartment in the roof, made of black-
varnished maple-wood and pear-wood.
Limited batch production.
H25 cm (9⅞ in). W28 cm (11 in).
L28 cm (11 in)
Manufacturer: Franz Schatzl, Design
Werkstätte, Austria

Using frosted glass as a base to support bronze columns and a shallow steel fruit bowl is a shock tactic equivalent to setting a Brunel bridge atop Joseph Paxton's Crystal Palace. The reversal of structural norms is typical of the work of Olivier Gagnère, a young French designer whose Memphis collection was launched in Milan in 1987. His objects have a monumental quality, by virtue not only of their mass and volume but also of their materials, which are carefully distressed to give them the patina of age.

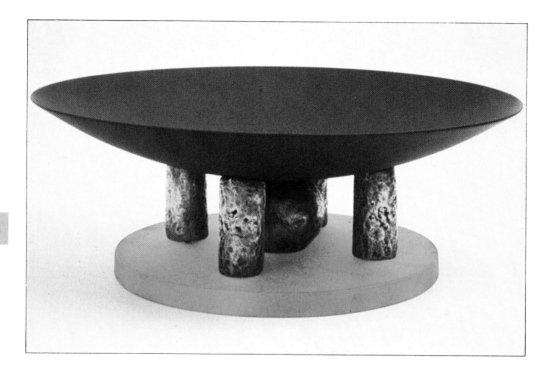

26

Olivier Gagnère
Bowl
Steel, bronze, glass
A fruit bowl in black steel, golden
bronze and frosted glass. Limited batch
production.
H15 cm (6 in). Di30 cm (11⅞ in)
Manufacturer: Galerie Adrien Maeght,
France

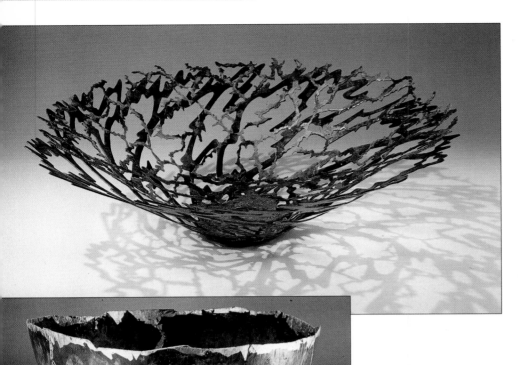

Helen Shirk
Bowl, Bare Tracery
Copper, brass
A double bowl. The outer bowl is
copper, spray-etched and patinated. The
inner bowl is brass, etched, copper-
plated, patinated and heat coloured.
One-off.
H12.5 cm (5 in). Di43.5 cm (17 in)
Manufacturer: Helen Shirk, USA

27

29

28

Shari M. Mendelson
Bowl No. 1
Copper, patina, gold foil
One-off
H46 cm (18 in). Di46 cm (18 in)
Manufacturer: Shari M. Mendelson,
USA

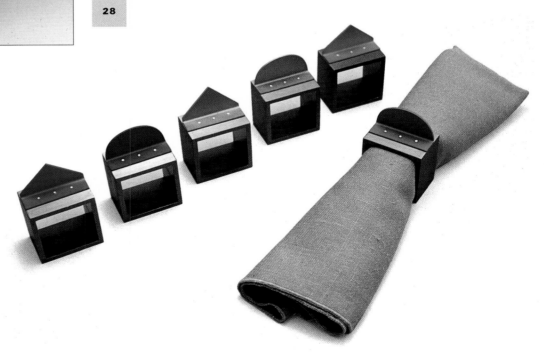

David Tisdale
Napkin rings
Anodized aluminium
H6.5 cm (2½ in). W3.8 cm (1½ in).
D2.5 cm (1 in)
Manufacturer: David Tisdale Design,
USA

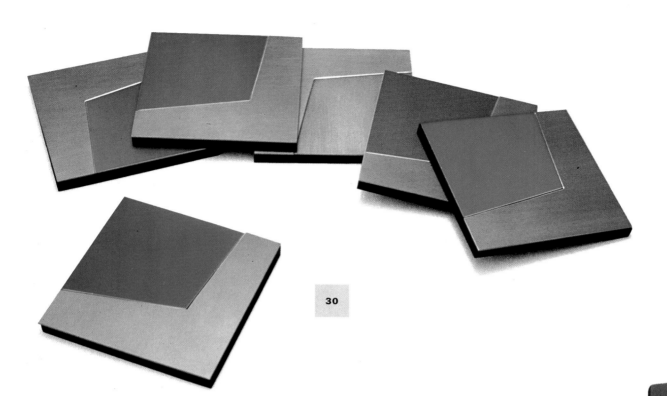

David Tisdale
Coasters
Anodized aluminium, acrylic
W7.5 cm (3 in). L7.5 cm (3 in).
Manufacturer: David Tisdale Design,
USA

30

31

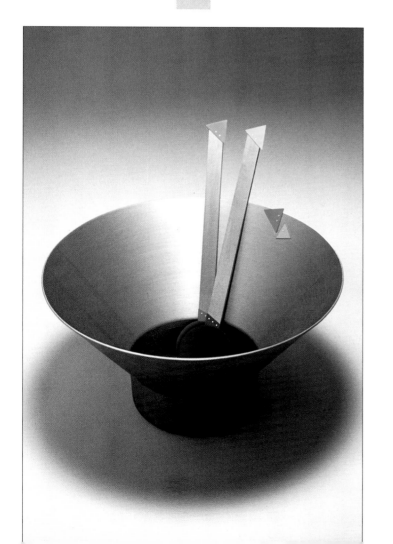

David Tisdale
Picnic flatware
Anodized aluminium
Fork W2.5 cm (1 in). L18 cm (7 in)
Knife W2.5 cm (1 in). L20.5 cm (8 in)
Spoon W3.8 cm (1½ in).
L16.5 cm (6½ in)
Manufacturer: David Tisdale Design,
USA

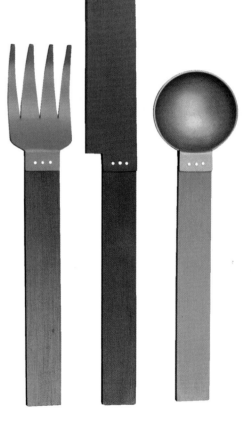

32

David Tisdale
Salad bowl with spoons
Anodized aluminium
Bowl H25.5 cm (10 in). Di33 cm (13 in)
Spoons W7 cm (2¾ in). L33 cm (13 in)
Manufacturer: David Tisdale Design,
USA

Matthew Hilton
Bowl
Cast aluminium or bronze
Limited batch production
H11.5 cm (4½ in). W20.5 cm (8 in).
L51 cm (20 in)
Manufacturer: Matthew Hilton, UK

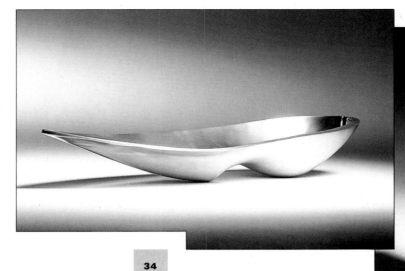

34

33

Bruce Metcalf
Salt and pepper holders
Pewter, acrylic plastic
Salt and pepper shakers "in the shape
of angst-ridden young punks."
H10 cm (4 in). W5 cm (2 in). D5 cm (2 in)
Manufacturer: Bruce Metcalf, USA

36

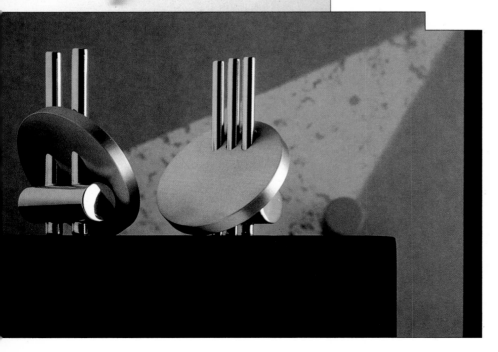

Geert Koster / Solid
Salt and pepper holders
Chromed steel, aluminium
Limited batch production
H12 cm (4¾ in). W6.5 cm (2½ in).
D5.5 cm (2⅛ in)
Manufacturer: Ronchetti F. lli, Italy

Matthew Hilton
Crane Candlesticks
Cast aluminium or bronze
Limited batch production
H42 cm (16½ in). W base 6 cm
(2⅜ in)
Manufacturer: Matthew Hilton, UK

37

Matthew Hilton
Candlestick
Cast aluminium or bronze
Limited batch production
H35.5 cm (14 in). W base 16.5 cm
(6½ in)
Manufacturer: Matthew Hilton, UK

Michael Rowe
Cylindrical container
Brass
A cylindrical form in brass with a tinned
finish. One-off.
H20 cm (7⅞ in). Di34 cm (13⅜ in)
Manufacturer: Michael Rowe, UK

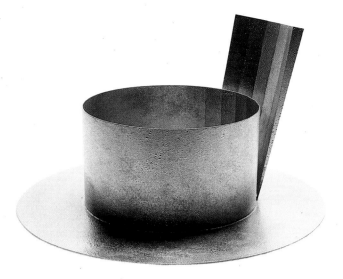

39

George J. Sowden
Fruit bowl
Stainless steel
H15.7 cm (6⅛ in). Di33.8 cm (13¼ in)
Manufacturer: Bodum, Switzerland

38

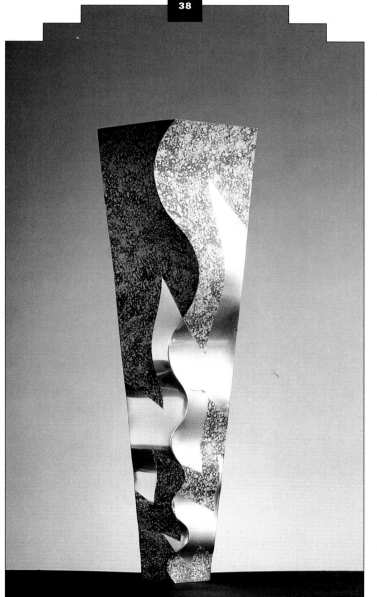

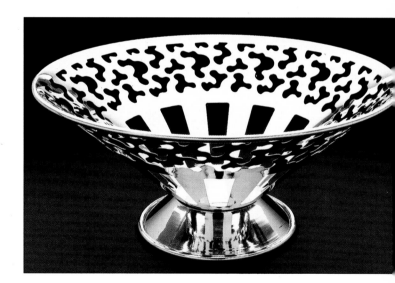

40

Toby Russell
Vase
Pewter
A pewter vase in square section with
acid-etched finish, highly polished.
Limited batch production.
H48 cm (18⅞ in). W14 cm (5½ in)
Manufacturer: Toby Russell, UK

Internationally, silversmiths seem to have abandoned elaborate hand-work in favour of modern industrial methods. Partly through the influence of stainless steel, there has been a return to a more rigid line. Lino Sabattini is one of the few designers who demonstrates an intrinsic understanding of the malleability of silver and gives his silverware a marvellously fluid form. The knife and fork handles on his brass alloy flatware, which is heavily silver-plated, are twisted in opposite directions so that both are symmetrical when held. His sinuous vases borrow the flowing organic line of age-old clay vessels; ornamentation is added with column-like studs around the bases.

Lino Sabattini
Cutlery, P-1
Prototypes of cutlery for Rosenthal in
brass alloy, heavily silver-plated.
L22 cm (8⅜ in)
Manufacturer: Argenteria Sabattini,
Italy

41 The work of the great architect Frank Lloyd Wright was never repetitive, routine or derivative. His impatience with the way clients cluttered up his restrained interiors led him to design not only furniture but also tableware. This collection, reintroduced by Tiffany in celebration of their 150 years of trading, shows his characteristically sharp and angled forms. The tureen is strikingly reminiscent of Wright's central building at the Imperial Hotel in Tokyo, destroyed in the 1960s, with its oriental, roof-like lid set low on a polygonal form.

Frank Lloyd Wright
Tableware
Silver, crystal
A re-edition by Tiffany of Frank Lloyd
Wright designs in sterling silver
and crystal.
Jug H10 cm (4 in). W10 cm (4 in)
Pitcher H25.5 cm (10 in)
Sugar bowl H7.5 cm (3 in).
W10 cm (4 in)
Candle holder H9 cm (3½ in). W (base)
10 cm (4 in). D10 cm (4 in)
Tureen H12.5 cm (5 in). W40 cm
(15¾ in). D28 cm (11 in)
Salt and pepper H7.5 cm (3 in)
Manufacturer: Tiffany, USA

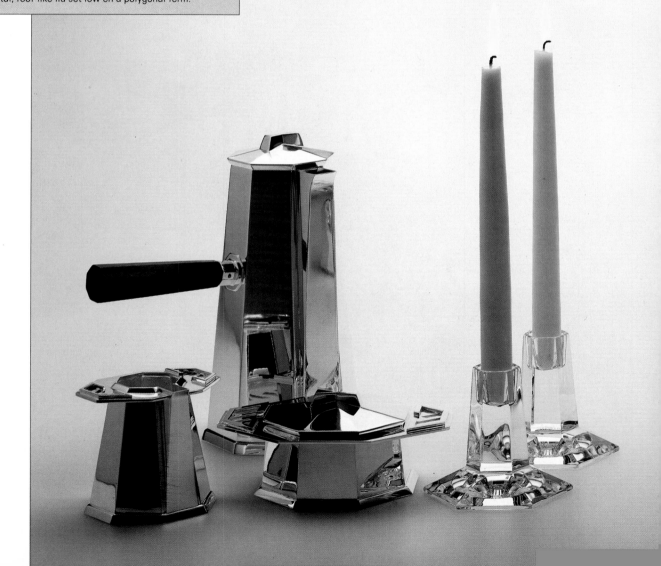

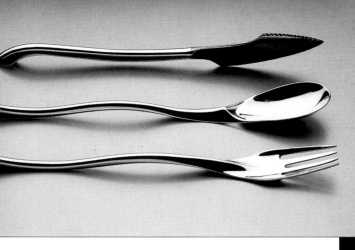

42

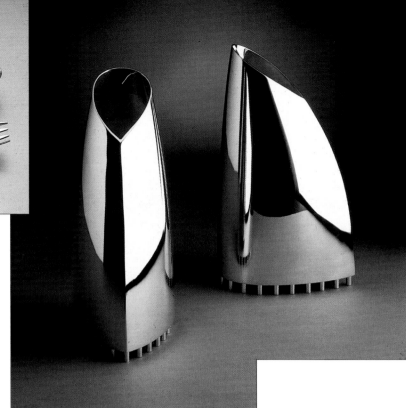

Lino Sabattini
Vase, Colonnato
A vase in brass alloy, heavily
silver-plated.
H27cm (10½ in)
Manufacturer: Argenteria Sabattini,
Italy

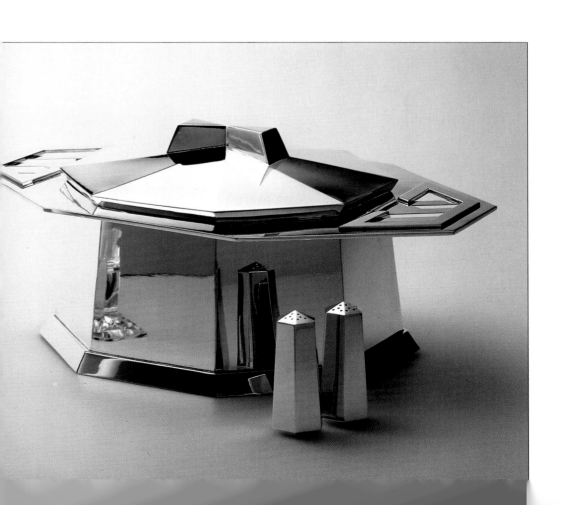

Titi Cusatelli and Roberto Marcatti
Cutlery, Eatalien
Silver
Prototypes of a new kind of cutlery to
be worn on the fingers.
Fork H2.5 cm (1 in). L8.5 cm
(3⅜ in). D8.5 cm (3⅜ in)
Knife H4.5 cm (1¾ in). L4.5 cm
(1¾ in). D6 cm (2⅜ in)
Spoon H3 cm (1⅛ in). L9.5 cm
(3¾ in). D6.5 cm (2½ in)
Manufacturer: Noto, Italy

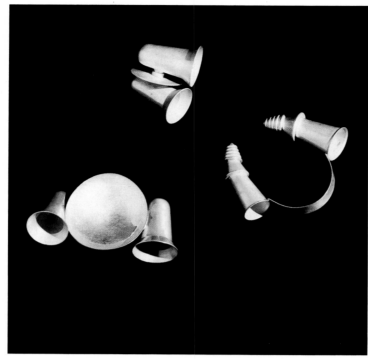

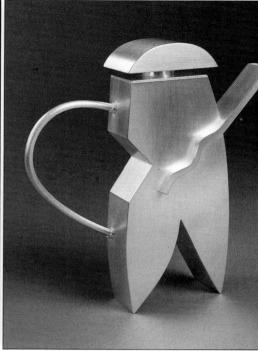

Nancy Slagle
Teapot, Loret for Tea
Silver
A sterling silver teapot. One-off.
H19 cm (7½ in). W16.5 cm (6½ in).
D5.7 cm (2¼ in)
Manufacturer: Nancy Slagle, USA

Richard Meier
Tray, peppermill, candlestick
Silver plate
Tray Di38 cm (15 in)
Peppermill H17.1 cm (6¾ in). Di4.5 cm
(1¾ in)
Candlestick H28 cm (11 in). W12.5 cm
(5 in). D12.5 cm (5 in)
Manufacturer: Swid Powell, USA

Richard Meier
Boxes
Silver plate
Small H7 cm (2¾ in). W10 cm (4 in).
D8 cm (3⅛ in)
Large H8.2 cm (3¼ in). W12.5 cm (5 in).
D9.8 cm (3⅞ in)
Manufacturer: Swid Powell, USA

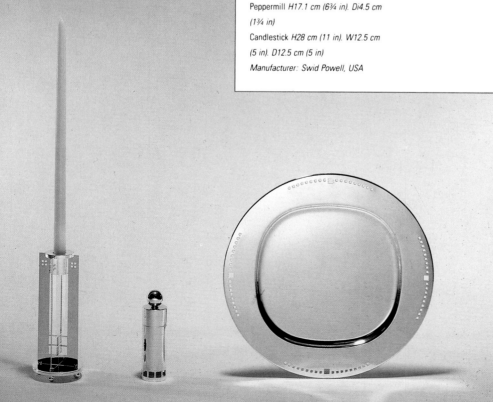

Angelo Micheli / Solid
Oil and vinegar holders
Silver
Limited batch production
H17.6 cm (7 in). W8 cm (3⅛ in).
D6 cm (2⅜ in)
Manufacturer: Ronchetti F. lli, Italy

Robert Haussmann and
Trix Haussmann
Mickey Peppermill
Silver
H14.5 cm (5¾ in). Di4.5 cm (1¾ in)
Manufacturer: Swid Powell, USA

Richard Meier
Ana Frames
Silver Plate
Photographic frames in three sizes.
Small H15 cm (6 in). W14.5 cm (5¾ in)
Medium H18.4 cm (7¼ in).
W17.1 cm (6¾ in)
Large H23 cm (9 in). W16.5 cm (6½ in)
Manufacturer: Swid Powell, USA

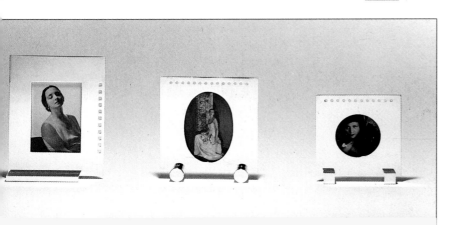

T A B L E W A R E

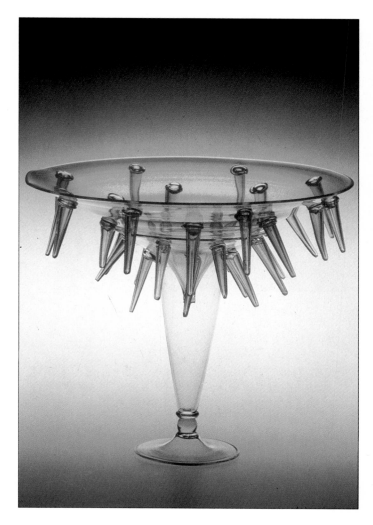

Bořek Šipek
Neboj Champagne Glass
Glass
A champagne glass, hand-blown by the
traditional Murano glass manufacturing
method. The points are designed to
keep the hand away from the glass and
to minimize spillage when it is set
down. Limited batch production.
H29.5 cm (11⅝ in). Di base
7 cm (2¾ in). Di top 7.5 cm (3 in)
Manufacturer: Sawaya & Moroni, Italy

Bořek Šipek
Glass
A vessel that can be used as a
centrepiece for the table or as a fruit
holder. In two parts that can be used
independently as a vase and a large
plate. Hand-blown by the traditional
Murano glass manufacturing method.
Limited batch production.
H28 cm (11 in). Di base 10.5 cm (4⅛ in).
Di top 33.5 cm (13⅛ in)
Manufacturer: Sawaya & Moroni, Italy

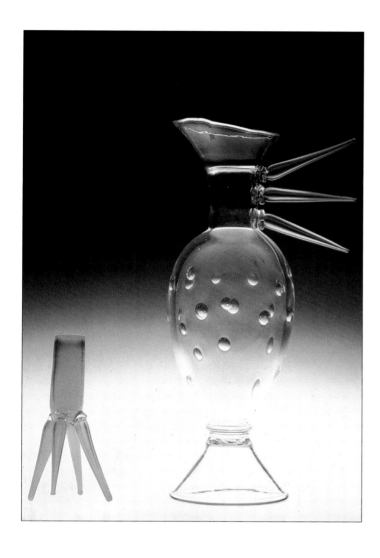

Dispensing with geometric rigour, Bořek Šipek produces glass cones, cups, bottles and bowls which have fundamentally fluid lines, well suited to their liquid contents. Many of the glasses roll over, but, propped on their surprising charioteer's spikes, do not spill. Spikes on the champagne glasses provide supports for the hand, thus ensuring that the contents remain chilled. The two parts of the fruit holder can be used individually as a large plate and vase; the glass stopper to the decanter doubles up as a drinking vessel. Their casual, quirky artistry is thus deceptive: these are useful as well as original objects.

Bořek Šipek
Glass
A carafe with a cap that can also be used as a drinking glass. Hand-blown by the traditional Murano glass manufacturing method. Limited batch production.
H37 cm (14½ in). Di base 10.5 cm (4⅛ in). Di top 9.5 cm (3¾ in)
Manufacturer: Sawaya & Moroni, Italy

Max Leser
Scent bottle, Fan
Glass
A fan-shaped scent bottle made from
25 mm structural glass with an aqua
tint and with sand-blasted lines on the
surface.
H11.5 cm (4½ in). W13 cm (5⅛ in)
Manufacturer: Leser Design, Canada

Max Leser
Scent bottle, Circle
Glass
A circular scent bottle available in two
sizes and made from 25 mm structural
glass with an aqua tint.
Di7 cm or 10.5 cm (2¾ in or 4⅛ in)
Manufacturer: Leser Design, Canada

Max Leser
Scent bottle, Semi Circle
Glass
A scent bottle made from 25 mm
structural glass with an aqua tint and
with sand-blasted lines on the surface.
H13 cm (5⅛ in). W10 cm (4 in)
Manufacturer: Leser Design, Canada

Max Leser
Scent bottle, Triangle No. 2
Glass
A triangular scent bottle made from
25 mm structural glass with an aqua
tint.
H11.5 cm (4½ in). W15 cm (6 in)
Manufacturer: Leser Design, Canada

58

57

Max Leser
Scent bottle, Square
Glass
A square scent bottle made from 25 mm
structural glass with an aqua tint and
with sand-blasted lines on the surface.
H13 cm (5⅛ in). W14.5 cm (5¾ in)
Manufacturer: Leser Design, Canada

Max Leser
Vase, Triangle
Glass
Triangular vase made from 25 mm
structural glass with an aqua tint and
with sand-blasted lines on the surface.
H10.5 cm (4⅛ in). W23 cm (9 in)
Manufacturer: Leser Design, Canada

59

Beauty does not always combine with utility when precision engineering is employed in the manufacturing process. Max Leser's scent bottles are cut from sheets of glass about half an inch thick, of the kind used on façades. The glass has a green tint, edge-on, without any lead crystal. In his Canadian studio, British-born Leser receives from an American manufacturer the cut forms of the bottles, then sand-blasts them to achieve patterns of vertical, horizontal and diagonal lines. He hollows out a core to hold the scent. Glass stoppers are precision-shaped to the same diameter so that each bottle is tightly sealed. In ground rather than polished glass, these stoppers can be used to dab on perfume more efficiently than can a smooth glass surface. Their production involves a mixture of hand-work and mass manufacture. Leser makes about thirty each month.

60

Judy Smilow

Plates, Dots and Dashes

Glass

A three-piece set designed to be used in a variety of ways both for eating and serving. The designs are frosted on to clear glass.
Di18 cm, 23 cm and 30.5 cm (7 in, 9 in and 12 in)
Manufacturer: Judy Smilow Design, USA

61

Sergio Asti

Lingam, Bidogale

Glass objects, part of a collection designed 1964-6 and first produced in 1987.
Lingam *Made of "zanfirico," filigree and black and white marble-like glass.*
H33.5 cm (13⅛ in). Di base 18 cm (7 in)

Bidogale *Has a central part of milk-scab glass, filigree and "zanfirico;" base and upper part of watermelon-red glass with black edging and black "ears."*
H48.5 cm (19 in). Di 22 cm (8⅝ in)
Manufacturer: Vistosi, Italy

62

Peter Layton
Coral
24 per cent lead crystal
A free-blown form inspired by a visit to the Great Barrier Reef. Black on white, acid etched. Part of the Kimono series.
One-off.
H25 cm (9⅞ in). W39 cm (15⅜ in)
Manufacturer: London Glassblowing Workshop / Peter Layton, UK

Diana Hobson
Triangular Form No. 1
*Lead glass, stones, ceramic enamel,
brick, sand, shingle, metal mesh
A thin-walled vessel made of found
natural materials fused in a kiln with
lead glass, resulting in a fragile
granular surface which is translucent
(pâte de verre). One-off.
H16 cm (6¼ in). Di13 cm (5⅛ in)
Manufacturer: Diana Hobson, UK*

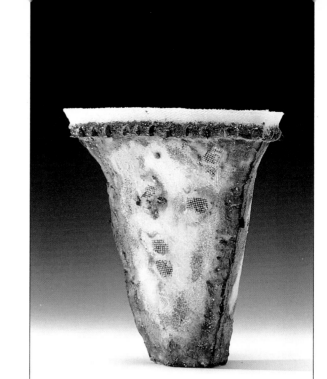

64

Laura Griziotti
Liqueur bottle, Deco
Crystal
The tall liqueur bottle from the Deco
series.
*H33 cm (13 in). W9.5 cm (3¾ in).
D7 cm (2¾ in)
Manufacturer: Arnolfo di Cambio, Italy*

63

65

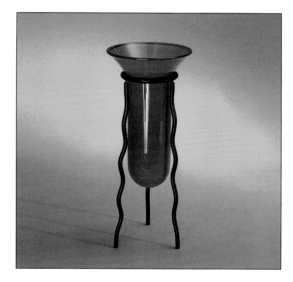

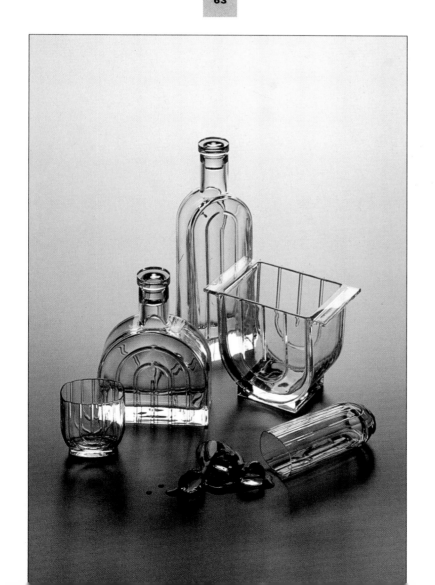

Nathaniel Smith
Vase
Glass, steel
*A hand-blown glass with a rounded
base, held upright in a black steel
frame. Limited batch production.
H35 cm (13¾ in). Di17 cm (6⅝ in)
Manufacturer: Ark Design Studio,
Denmark*

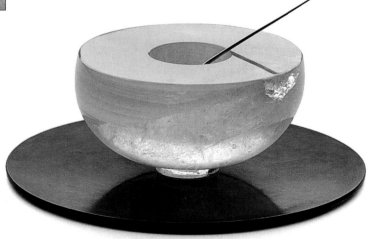

Martinus A.A. Van Schijndel
Glasses, Touch and Go
Glass
*Prototype of a drinking-set in which all
the glasses are of the same height and
in which the base and cup are
interchangeable. Made from a single
sheet of glass heated to softening point
and transformed into two cones with an
overlapping seam.
H13 cm (5⅛ in)
Manufacturer: Martech,
The Netherlands*

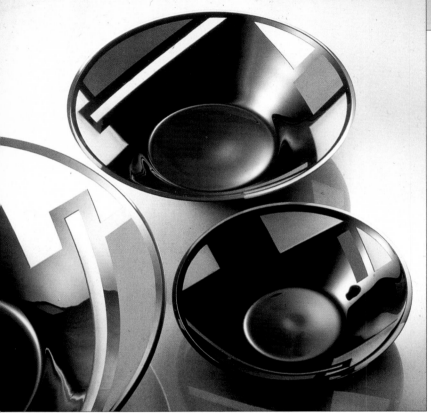

**Philip Baldwin and Monica
Guggisberg**
Bowls, Aztec
Glass
*A series of bowls in three sizes, mould-
blown, cracked off and polished, using
black glass with clear glass over.
Pattern is sand-blasted to differing
surface depths on the bowls when cold.
H (max) 9 cm (3½ in). Di (max)
40 cm (15¾ in)
Manufacturer: Rosenthal, West
Germany*

Christoph Jünger
Bowl
Crystal, silver, copper
*A small bowl in rock crystal, silver and
copper which can be used for salt or
pepper. Limited batch production.
H6 cm (2¾ in). Di12 cm (4¾ in)
Manufacturer: Christoph Jünger,
West Germany*

68

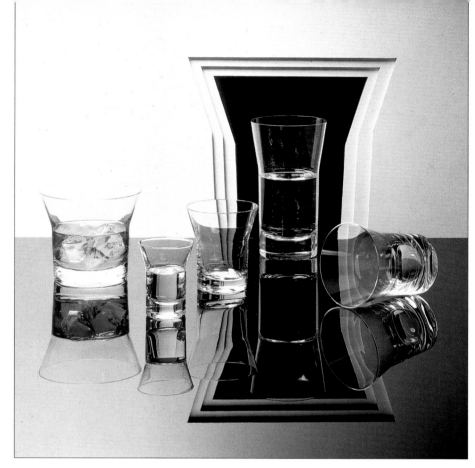

69

71

Matteo Thun

Glass, Via col vento

Crystal

A hand-blown long drinking glass
designed for Campari. Limited batch
production.

H20.5 cm (8 in). W9 cm (3½ in).

D6 cm (2⅜ in)

Manufacturer: J. & L. Lobmeyr, Austria

Alvar Aalto

Glass

Aalto Tumblers

First production of blown-glass tumblers
in five different sizes designed in 1933.
They range from 5 cl (2 oz) to
36 cl (13 oz).

Manufacturer: Iittala Glassworks,
Finland

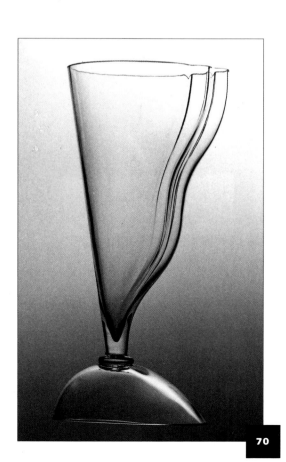

70

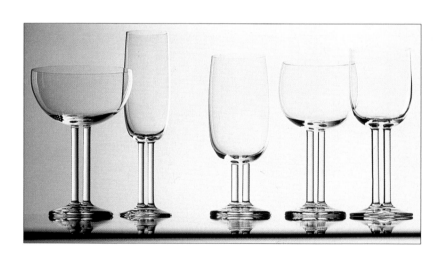

Mario Bellini

Glassware, Cupola

Crystal

Items from the Cupola *glassware series.*

Champagne *H16.5 cm (6⅜ in).*

Di10.7 cm (4¼ in)

Champagne flute *H21.5 cm (8½ in).*

Di4.6 cm (1⅞ in)

Sherry *H18 cm (7 in). Di4.3 cm (1⅝ in)*

Red wine *H18 cm (7 in). Di7.7 cm (3 in)*

White wine *H19 cm (7½ in).*

Di6.7 cm (2⅝ in)

Manufacturer: Rosenthal,

West Germany

157

TEXTILES

4

A tendency to break up smooth surfaces and regular lines is evident in all areas of design: in furniture, concrete is rough-cast, aluminium tortured, glass splintered; in tableware, metals are sand-blasted and pitted. There is a similar preoccupation in textiles. Fractured lines, shadowy printings and scumbled backgrounds all suggest the quality of hand-work, though few are screen-printed and most are in mass production. ■ Texture is especially important on plain fabrics, which are being transformed by new technology. In Japan, Arai's computerized looms combine different threads, which are heat-treated to achieve "landscaped" patterns, ridged and troughed on open weaves. Miyamoto's tangled and bobbled threads in stripes, fringes and bands look more like hand- than machine-weaving. Even plain vinyl wallpaper acquires a new dignity once Simon pleats it finely, giving it an extra dimension. ■ The patterns on prints are changing, too. Monochrome geometric designs become more colourful, softened by background effects, broken lines and diagonal weaves. The prints of Javier Mariscal look hand-painted, and have a vigour that outclasses the traditional stylized birds and flowers on the chintzes so favoured by interior decorators. ■ Should rugs be considered as individual works of art and hung on the wall, or put into production and trampled underfoot? The debate continues. But the two extremes are represented here by Bartolini in Italy and Morrison in the UK. Whatever their view and style, designers are using colour and motifs with an exhilarating freedom. Tusquets Blanca brings a breathtaking originality to the circular rug; Mariscal employs freehand artwork to adapt the conventional emblems of a Turkish carpet. Some of the top designers have turned to textiles for the first time in 1987, and the results are invigorating.

Scot Simon
Wallpleats
Vinyl
Wall-covering made of pleated vinyl and
backed with fabric. Available in various
matt and pearlized colours.
W76 cm (30 in)
Manufacturer: Innovations, USA

1 Vinyl wall-coverings are generally used on kitchen or nursery walls, their textures considered practical because they wipe down, rather than attractive. But Scot Simon has transformed their finish by introducing fine pleats like those of Roman blinds; the material remains flexible enough to be sold by the roll, and is fabric-backed ready to paste on the wall. Available with a matt or pearly surface, it is as practical as ever but is also now good-looking enough to move into the drawing-room.

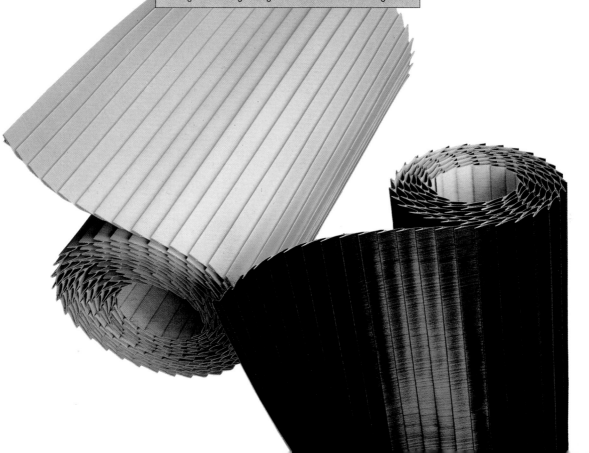

2

Oscar Tusquets Blanca
Rug, Luna
Wool
Circular carpet, handmade in Turkish
knots, representing the moon. Limited
batch production.
Di120 cm (47¼ in)
Manufacturer: B.d. Ediciones de diseño,
Spain

"Tierra" (earth) is often the first word a Spanish child utters, followed by *"sombra"* (shadow), *"fuente"* (fountain) and *"muro"* (wall), according to the designer Santiago Miranda, writing on his homeland in an issue of *Abitare.* Oscar Tusquets Blanca's *Tierra* thus has a special cultural significance; in addition it seems to symbolize Spanish designers' new mood of curiosity, and their urge for discovery of a wider world. The three-dimensional quality of this handmade piece is quite extraordinary; the knotting technique re-creates the mystery and grandeur of a satellite image. *Luna* is no less impressive. For once a rug, normally trampled underfoot, achieves an extra-terrestrial quality that is far from down-to-earth.

3

Oscar Tusquets Blanca

Rug, Tierra

Wool

Circular carpet, handmade in Turkish

knots, representing the earth. Limited

batch production.

Di250 cm (98½ in)

Manufacturer: B.d. Ediciones de diseño,

Spain

4 This rug by Astrid Sampe has an almost Constructivist style, based on geometry and dynamic principles. *Titanic* is full of opposing forces – shapes like ships' funnels, bows and hulls afloat in a frame of jagged waves and spray, unified only by a small black bar in the centre.

Astrid Sampe, Hon RDI
Rug, Titanic
Wool
Exhibited at the Statens Konstmuseer,
Stockholm, with furniture by Mies van
der Rohe. Limited batch production.
W300 cm (118 in). L500 cm (197 in)
Manufacturer: Hitex, Sweden

5

Peret
Rug, Soviets
Wool
A rug made using the Axminster gripper
weaving system.
W200 cm (78¾ in). L300 cm (118 in)
Manufacturer: Nani Marquina, Spain

6 There is a growing craft movement in Italy known as the "*tapis artistes.*" Responding to this trend, Paolo Moroni of Sawaya & Moroni has commissioned a piece from a prominent artist, Luciano Bartolini, and issued a limited edition of his design. As it takes four students in technical colleges several months to hand-knot the specially dyed yarn in the classic Ghiordes knots, the double knots used for oriental carpets, there are only twelve editions, sold at a high price. Although the company have been approached by manufacturers keen to put the rug into production, they feel that such commercialism would undermine their intentions, changing the project from art into industry. Typical of Bartolini's work are references to Indian and Greek mythology – here the black symbol like crossed blades which is the sign of the dance steps of Shiva, the Hindu god of dance. The jagged splinters of colour in *Junglepiece* are reminiscent of his paintings, which are usually on a giant scale, executed on paper that is then stretched tautly over canvas.

Luciano Bartolini
Rug, Junglepiece
Wool
Handmade carpet using Ghiordes knots.
Limited batch production.
W200 cm (78¾ in). L300 cm (118 in)
Manufacturer: Sawaya & Moroni, Italy

Jasper Morrison

A Rug of Many Bosoms

Wool

Limited batch production

W152 cm (60 in). L213 cm (84 in)

Manufacturer: Jasper Morrison, UK

7 British designer Jasper Morrison says that the idea for *Rug of Many Bosoms* developed from his admiration of the subject-matter. Its light-hearted but confident dot and squiggle pattern in black and white achieves a freshness that is usually difficult to obtain without colour. "It's ornamental without being ornamental. And in no way is it whimsical," he says. "I thought it was a pretty pattern." Made of pure wool, the rug is intended for mass production; he thinks that limited editions are pretentious, regarding himself as a machine-age designer, not a craftsman.

8

Christian Duc

Rug, Temps d'Arret Hiver

Wool

Limited batch production

W200 cm (78¾ in). L200 cm (78¾ in)

Manufacturer: Toulemonde Bochart,

France

Elegant, unobtrusive and individual, these rugs typify the special style of Andrée Putman. In *Constance* a central "pool" is bordered by a mass of dots that give the illusion of a poolside splashed with sparkling drops of water. Despite flat contrasts of black and white, the carpet appears magically to float.

Andrée Putman
Rug, Côme
Wool
Limited batch production
W180 cm (70⅝ in). L270 cm (106¼ in)
Manufacturer: Toulemonde Bochart,
France

10

Andrée Putman
Rug, Constance
Wool
Limited batch production
W180 cm (70⅝ in). L270 cm (106¼ in)
Manufacturer: Toulemonde Bochart,
France

9

Javier Mariscal
Rug, Estambul
Wool
A rug made using the Axminster gripper
weaving system.
W200 cm (78¾ in). L300 cm (118 in)
Manufacturer: Nani Marquina, Spain

Ugo Nespolo
Rug, Trecentonovantuno
Wool, cotton, hemp
Hand-knotted carpet made with 40,000
Ghiordes knots per square metre. Cotton
weft and hemp warp. Limited batch
production.
W150 cm, 200 cm, 250 cm or 300 cm
(59 in, 78¾ in, 98 in or 118 in). L300 cm,
400 cm, 500 cm or 600 cm (118 in,
157½ in, 197 in or 236 in).
Manufacturer: Palmisano Edizioni
Tessili, Italy

Lucy Clegg
Rug, Abstract 1
Rug tufted in 80/20 carpet wool backed
with latex and hessian. Limited batch
production.
W165 cm (65 in). L287 cm (113 in)
Manufacturer: Lucy Clegg, UK

John N. French
Rug, Tryptich No. 3
Wool
A handmade wool pile wall-hanging.
One-off.
W100 cm (39½ in). L300 cm (118 in)
Manufacturer: John French Atelier, UK

Leah Nelson
Rug, Conception
Inlaid carpet, paint, nylon, polyester
An area rug or wall-hanging inspired by
Zuni Indian symbols. Limited batch
production.
W109 cm (43 in). L223 cm (93 in)
Manufacturer: Leah Nelson, USA

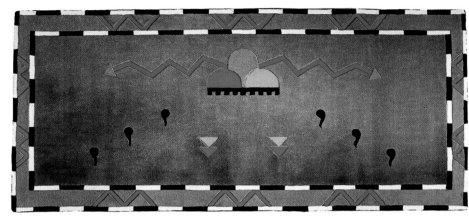

Ugo Nespolo
Rug, Ottocentoquaranta
Wool, cotton, hemp
Hand-knotted carpet made with 40,000
Ghiordes knots per square metre. Cotton
weft and hemp warp. Limited batch
production.
W135 cm, 175 cm, 200 cm or 250 cm
(53¼ in, 69⅞ in, 78¾ in or 98 in).
L200 cm, 250 cm, 300 cm or 375 cm
(78¾ in, 98 in, 118 in or 147½ in)
Manufacturer: Palmisano Edizioni
Tessili, Italy

16

Nani Marquina
Rug, Ibiza
Wool
A rug made using the Wilton-type
weaving system.
W170 cm (67 in). L240 cm (94½ in)
Manufacturer: Nani Marquina, Spain

17

Elizabeth Browning Jackson
Keystone Rug
*Rug made from a combination of yarns
mixed with hand-work. The* Keystone
Bench *is of stainless steel. Limited batch
production.*
Rug *W122 cm (48 in). L259 cm (102 in)*
Bench *H40.6 cm (16 in). W122 cm (48 in).
D259 cm (102 in)*
Manufacturer: *Art et Industrie, USA*

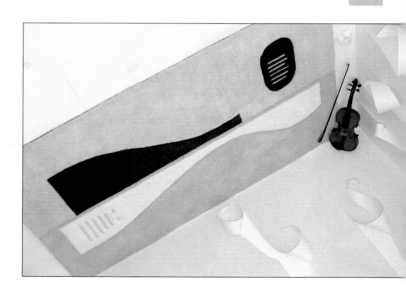

Celia Harrington
Rug, Zig-Zag
Wool
A hand-tufted wool pile rug. One-off.
W152 cm (60 in). L213 cm (84 in)
Manufacturer: Celia Harrington, UK

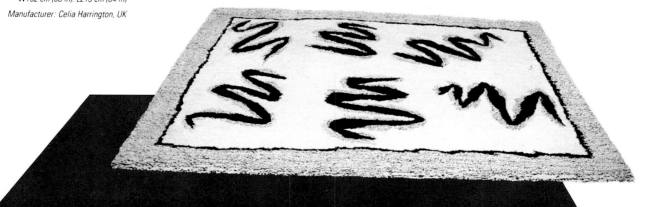

Liz Kitching
Rug, Portico No. 1
Wool
Hand-tufted wool rug. One-off.
W147 cm (58 in). L213 cm (84 in)
Manufacturer: Liz Kitching, UK

22

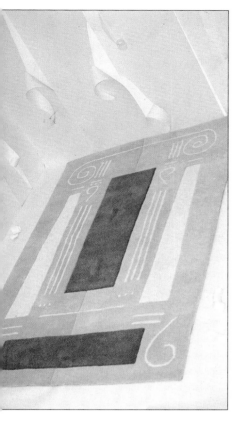

21

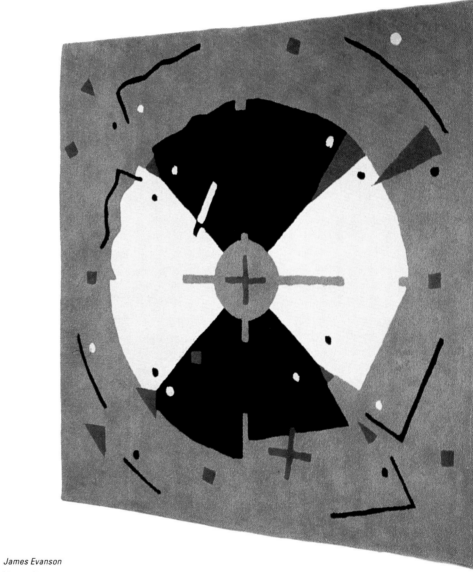

Liz Kitching
Rug, Still Life No. 2
Wool
Hand-tufted wool rug. One-off.
W147 cm (58 in). L213 cm (84 in)
Manufacturer: Liz Kitching, UK

James Evanson
Masque Rug
Wool
Limited batch production
W198 cm (78 in). L198 cm (78 in)
Manufacturer: Art et Industrie, USA

23

24

Eliel Saarinen and Loja Saarinen
Rug, Cranbrook Rug II
Wool
A hand-tufted rug designed by Eliel Saarinen and his wife Loja in 1928-9 for their house in Cranbrook, USA. The original is in the Cranbrook Museum.
W100cm or 160 cm (39½ in or 63 in).
L280 cm or 450 cm (110¼ in or 177⅛ in)
Manufacturer: Adelta, Finland

25

Eliel Saarinen worked as an architect from 1897 to 1923 in Helsinki and from 1923 to 1950 at Cranbrook in Michigan. This two-part career is reflected in his work: in Finland, his designs leant towards the flowing, sinuous lines of Art Nouveau, or what the Finns term the National Romantic Style; in America, he favoured the stylish geometry of Art Deco. The *Cranbrook Rug II,* which Saarinen designed with his wife Loja for their house in Cranbrook in 1928-9, highlights that dichotomy. The "totem pole" pattern looks back nostalgically to the columns of Helsinki Station, designed by Saarinen in 1904. One has only to compare this piece with Eileen Gray's contemporaneous abstract rug designs in black and white to be aware of the extent of Saarinen's nostalgic viewpoint.

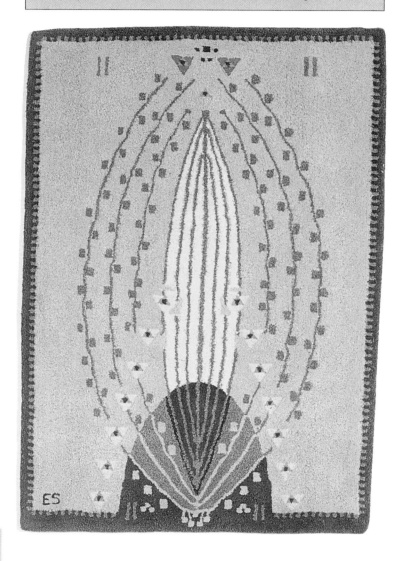

26

Helen Yardley
Rug, No. 69
Wool
Hand-tufted wool rug. One-off.
W250 cm (98½ in). L375 cm (147½ in)
Manufacturer: A-Z Studios, UK

27

Eliel Saarinen
Rug, Rose
Wool
Re-edition of a hand-tufted rug designed by Saarinen in 1904 for a competition organized by "Friends of Finnish Handicraft."
W120cm or 188 cm (47¼ in or 74 in).
L180 cm or 284 cm (70⅝ in or 111⅞ in)
Manufacturer: Adelta, Finland

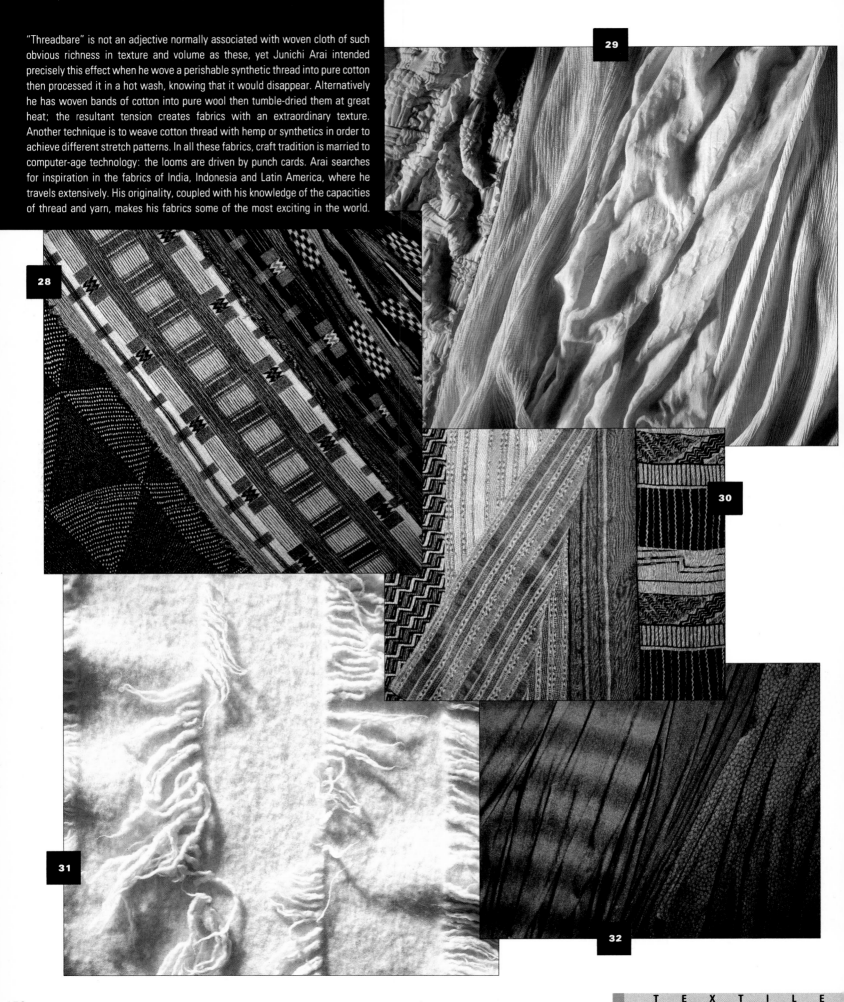

"Threadbare" is not an adjective normally associated with woven cloth of such obvious richness in texture and volume as these, yet Junichi Arai intended precisely this effect when he wove a perishable synthetic thread into pure cotton then processed it in a hot wash, knowing that it would disappear. Alternatively he has woven bands of cotton into pure wool then tumble-dried them at great heat; the resultant tension creates fabrics with an extraordinary texture. Another technique is to weave cotton thread with hemp or synthetics in order to achieve different stretch patterns. In all these fabrics, craft tradition is married to computer-age technology: the looms are driven by punch cards. Arai searches for inspiration in the fabrics of India, Indonesia and Latin America, where he travels extensively. His originality, coupled with his knowledge of the capacities of thread and yarn, makes his fabrics some of the most exciting in the world.

28

Junichi Arai

Fabrics

100 per cent cotton

Top and middle: patterns inspired by African designs. Bottom: pattern inspired by Micronesian designs. In strong cotton woven to give different stretch patterns. Limited batch production.

Manufacturer: Arai Creations System, Japan

29

Junichi Arai

Fabrics

Top: cotton, polyurethane, polyester, nylon, rayon. Bottom: 100 per cent cotton. Limited batch production.

Manufacturer: Arai Creations System, Japan

30

Junichi Arai

Fabric

Cotton, hemp

A pattern inspired by Micronesian designs, in cotton thread coated with hemp fibres. Limited batch production.

Manufacturer: Arai Creations System, Japan

31

Junichi Arai

Fabric

Wool

Limited batch production

Manufacturer: Arai Creations System, Japan

32

Junichi Arai

Fabric

Cotton, polyester

Limited batch production

Manufacturer: Arai Creations System, Japan

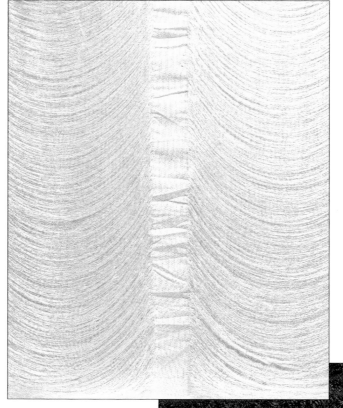

33

Eiji Miyamoto

Fabric

Cotton, rayon

One-off

Manufacturer: Miyashin, Japan

34

Eiji Miyamoto

Fabric

100 per cent cotton

One-off

Manufacturer: Miyashin, Japan

Using cotton and man-made rayon, Eiji Miyamoto works on the warp and weft of threads to stunning effect. Giant seersuckers bobbled in bands of cream and white, silky threads used to fringe plain fabrics with a stripe, bobbles tangled into a striped grey weave – these fabrics retain the quality of hand-weaving in a machine age, employing a lovely but subdued palette of creams, greys and blues.

35

Eiji Miyamoto

Fabric

100 per cent cotton

One-off

Manufacturer: Miyashin, Japan

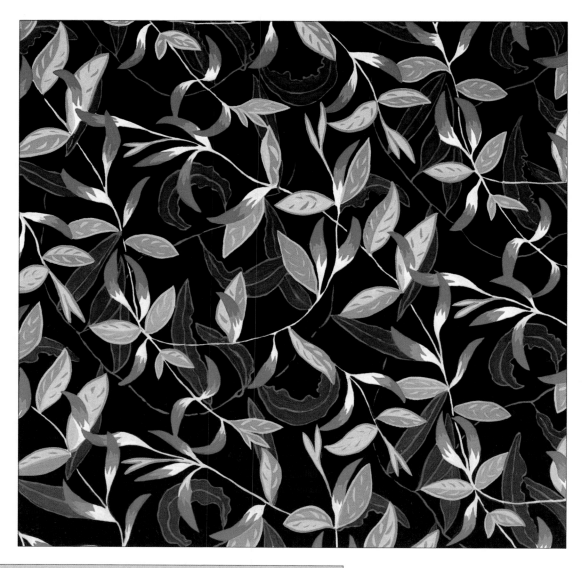

36 The Swan River that winds through Western Australia, its banks fringed with flowering trees, inspired *Swan River Pea,* a design by a young Australian, Sally Armfield. The features of the grey-leafed tree are given a scroll-like formality, in an ornamental style akin to that of William Morris. There is a promising growth of indigenous talent in Australia today; commercially viable designs are beginning to compete with imported furnishings and furniture. This is especially true of fabric designs. Jane de Teliga, a lecturer in fashion and textile design at the Sydney College of Art who recently organized a show on Australian fashion fabrics in Britain, says of Australian textiles now: "The strength of colour comes through in all the work. It's exuberant. There is a movement away from the more overt Australian imagery. Fabric design has become more sophisticated."

The Swiss textile house Baumann Fabrics recently commissioned twelve artists from different countries each to design a flag; the results went into an exhibition in the Musée d'Art et d'histoire, Geneva, in 1987. Luciano Fabro's idea is executed in the colours of the Italian flag and mimics the boot shape of the country, highlighting the nationalistic sentiments inevitably linked to the flag format. For Jörg Baumann, the exercise was an opportunity to explore how fabrics look floating in the breeze, not simply hanging: "The way these artists approached this loaded piece of fabric and inspired it with a new life was, to me, the greatest experience." While draughts can give most materials a sinister quality, flags display their true beauty only in the breeze.

Luciano Fabro
Flag
100 per cent cotton
A flag commissioned by Baumann for the
exhibition "Artists' Flags." One-off.
W190 cm (74⅞ in). L400 cm (157½ in)
Manufacturer: Création Baumann,
Switzerland

38

Kiyoshi Yamamoto
Fabric, Dio
100 per cent cotton
Silk-screen printed fabric.
W150 cm (59 in)
Manufacturer: Fujii Living, Japan

T E X T I L E S

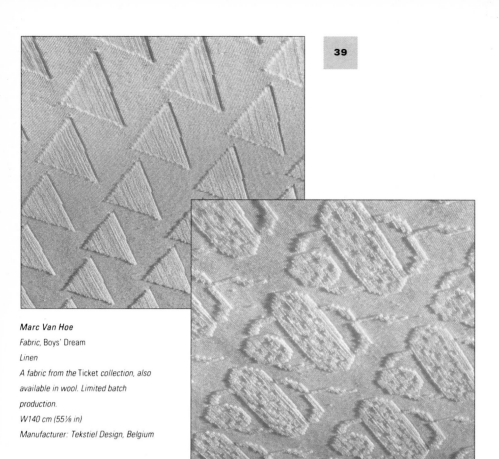

39

Marc Van Hoe
Fabric, Boys' Dream
Linen
A fabric from the Ticket *collection, also*
available in wool. Limited batch
production.
W140 cm (55⅛ in)
Manufacturer: Tekstiel Design, Belgium

40

Marc Van Hoe
Fabric, Tickets for Secret Park
Linen
A fabric from the Ticket *collection, also*
available in wool. Limited batch
production.
W140 cm (55⅛ in)
Manufacturer: Tekstiel Design, Belgium

41

Roberto Barazzuo
Fabric
100 per cent cotton
Manufacturer: Esprit, USA

Scot Simon
Mirage
Vinyl
Deeply embossed vinyl floor-covering.
W183 cm (72 in)
Manufacturer: Lonseal, USA

42

Fujiwo Ishimoto
Fabric, Uoma
100 per cent cotton
Tablecloth, part of the Sydantalvi
collection.
W140 cm (55⅛ in)
Manufacturer: Marimekko, Finland

43

Jack Lenor Larsen
Fabric, Bar None
60 per cent worsted wool, 40 per cent
cotton
Fabric woven in Scotland. Available in
sand, chestnut and jungle. Project
director: Mark C. Pollack.
W127 cm (50 in)
Manufacturer: Jack Lenor Larsen, USA

Jack Lenor Larsen
Fabric, Monograph
94 per cent cotton, 6 per cent rayon
A group of fabrics woven in Italy.
Available in ink black, graphite and
sepia. Project director: Lisa Scull.
W140 cm (55 in)
Manufacturer: Jack Lenor Larsen, USA

45

44

Ruth Skrastins
Fabric, Australian Native
Screen-printed fabric.
Manufacturer: Ruth Skrastins. Australia

46

48

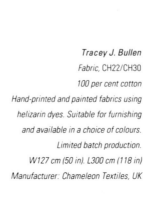

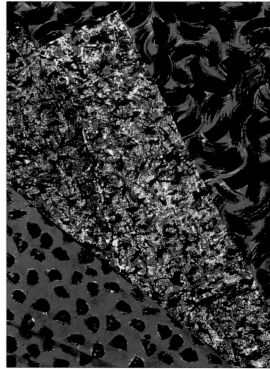

Ruth Skrastins
Fabric, Grieg
Screen-printed fabric.
Manufacturer: Ruth Skrastins, Australia

47

Tracey J. Bullen
Fabric, CH22/CH30
100 per cent cotton
Hand-printed and painted fabrics using
helizarin dyes. Suitable for furnishing
and available in a choice of colours.
Limited batch production.
W127 cm (50 in). L300 cm (118 in)
Manufacturer: Chameleon Textiles, UK

50

Kiyoshi Yamamoto
Fabric, Sou
100 per cent cotton
Silk-screen printed fabric.
W150 cm (59 in)
Manufacturer: Fujii Living, Japan

49

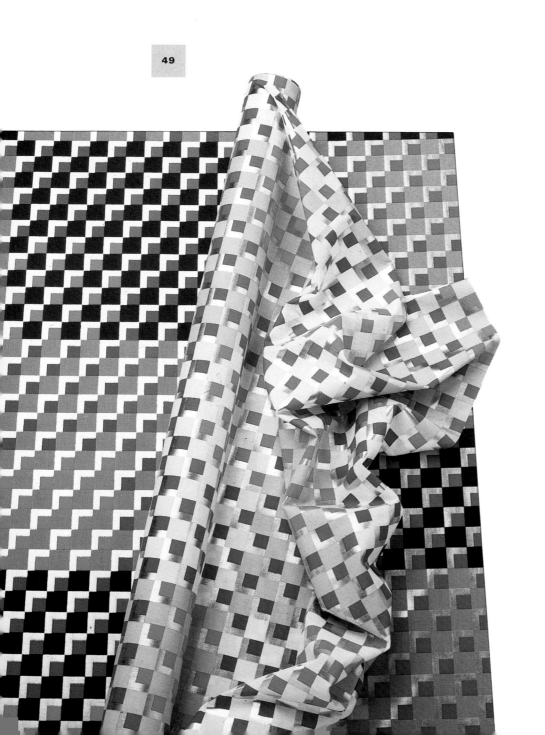

Verner Panton
Fabric, Cubus Collection
100 per cent cotton
A printed furnishing fabric based on a
square grid with a three-dimensional
appearance.
Manufacturer: Mira-X, Switzerland

Silvia Gubern
Fabric, Harare
100 per cent cotton
A cotton fabric suitable for tapestry or as
a furnishing fabric.
W160 cm (63 in)
Manufacturer: Transtam, Spain

53 A native of Barcelona, Javier Mariscal is now well-known as a graphic artist and designer; his drawing of a dog has been accepted as the logo for the city's 1992 Olympic Games. His textile designs retain the vigour of free-hand sketching, seeming as if executed with painterly brush-strokes, while actually having been printed by modern mass-production methods. Most of his work in some way pays tribute to the past, but always achieves a freshness and individuality. Birds on an earlier fabric, *William Morris,* have overtones of Miró as much as Morris.

Javier Mariscal
Fabric, El Palmar
100 per cent cotton
W160 cm (63 in)
Manufacturer: Marieta, Spain

51

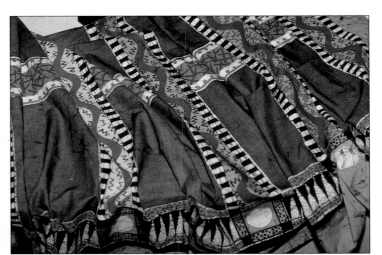

Dinah Casson and Roger Mann
India Fabric
100 per cent cotton
A fabric printed by the batik method.
Manufacturer: Dinah Casson and Roger
Mann, UK

52

Paul Burgess
Fabric, Man-Flag
Wool
Monoprint/silk-screened furnishing
fabric using acid dye on wool delaine.
One-off.
W137 cm (50 in). L300 cm (118 in)
Manufacturer: Paul Burgess, UK

Bunny Newth and Michael Newth
Fabric, Pigalle
100 per cent cotton
A furnishing fabric available in three
colourways. Limited batch production.
W137 cm (54 in)
Manufacturer: Tempera Fabrics, UK

Yoshiki Hishinuma
Fabric, Dance
Polyester
Limited batch production
Manufacturer: Hishinuma Associates,
Japan

57

Jasia Szerszynska
Fabric
75 per cent cotton, 25 per cent silk
Pigment-printed textile hanging.
One-off.
W120 cm (47¼ in). L400 cm (157½ in)
Manufacturer: Jasia Szerszynska, UK

Yoshiki Hishinuma
Fabric, Gaikotsu
Nylon, cotton
Limited batch production
Manufacturer: Hishinuma Associates,
Japan

58

Hiroshi Awatsuji
Fabric, Ishi
100 per cent cotton
W120 cm (47¼ in)
Manufacturer: Fujie Textile, Japan

59

Rouquart Veerle
Fabric, Baccara 4299
Polyacryl-PC
A velvet furnishing fabric.
W140 cm (55⅛ in)
Manufacturer: Van Houtte, Belgium

60

61

Etamine
Fabric, Anka 6024/50
100 per cent cotton
Furnishing fabric with a design inspired
by the wax-dyed fabrics of Mali.
W146 cm (57½ in)
Manufacturer: Etamine, France

62

Jasia Szerszynska
Fabric
100 per cent cotton
Printed and hand-painted cotton velvet.
Limited batch production.
W120 cm (47¼ in). L300 cm (118 in)
Manufacturer: Jasia Szerszynska, UK

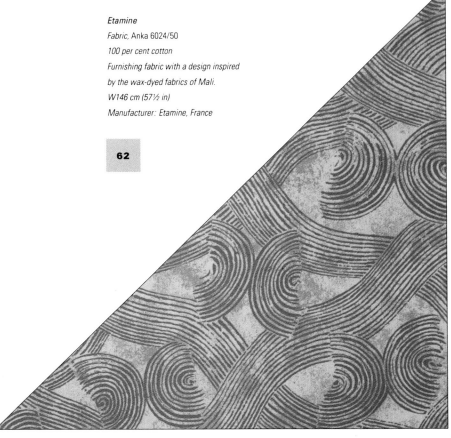

5

Industrial designers used to be nameless. Now more manufacturers rely on designers and designer labels to market their products. Architects, too, are becoming contributors to brand images, designing items from kettles to clocks. Some products are pertinent social commentaries: the *Factory* from Japan is for business travellers; the stainless-steel fob watch, *Momento*, which doubles as a wrist watch, reflects fashion trends; and the briefcase by Hertzberger exploits many professionals' preference for cycling to work. ■ Honest workmanship, fitness for purpose and truth to materials are the worthy criteria generally applied to pieces of industrial design. To these ends, late twentieth-century designers harness new power sources. Liquid crystals allow a TV to fit into a back pocket. Quartz movements now keep time behind watchfaces adorned with diamonds. Products need more than just a pretty face to compete in the marketplace. Behind many a plastic-moulded casing, stainless-steel front or silver and gold frame, there lies a piece of microchip technology. ■ Some products rely on user familiarity to sell. Purchasers of the latest computer terminals are accustomed to earlier keyboards; those who travel widely appreciate lightweight, resilient luggage; the angler values flexible tackle, the rower a fold-up ergometer for fitness training. Judgments on new buys benefit from established attachments. ■ There are products which are truly inventive. The *Datashow* by Reibl at Kodak projects computer graphics and text on a wide screen. The *Phonebook* by Krohn with Viemeister combines a telephone with an answering machine in a slim plastic volume. Other successes are based on evolution, not revolution, such as the *Apple IIGS* personal computer, or the Polaroid *Onyx* which allows the photographer to see the printing process. Some, such as the *Phonebook* and Montgomery's *Picture Phone,* are still in prototype. Product designers mostly offer lucid explanations of what it is they set out to resolve and to achieve before embarking on full-scale production.

Lisa Krohn with Tucker Viemeister /
Smart Design
Telephone and answering machine,
Phonebook
Plastic
A machine that combines the functions
of both a telephone and a telephone
answering machine. The prototype,
produced by Neste, Finland, won first
prize at the international "Forma
Finlandia" plastic design competition.
H5 cm (2 in). W20 cm (7⅞ in).
L30 cm (11⅞ in)
Manufacturer: Smart Design, USA

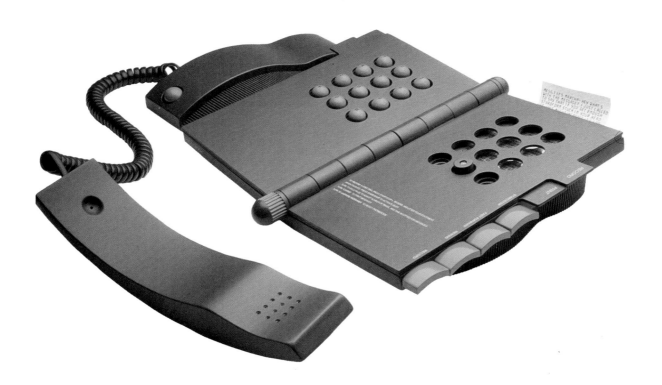

1

Arata Isozaki

Watch

Gold, sapphire glass

Waterproof watchcase handmade in
18 carat gold and crowned with a double
layer of sapphire glass. Dial in gold with
eleven diamonds and a sapphire.
Movement handmade and mounted by
Piguet-SA le Brassus, Switzerland.
Signed and numbered limited batch
production.
Manufacturer: Cleto Munari, Italy,
for Unum, Italy

2

Hans Hollein

Watch

Gold, sapphire glass, enamel

Waterproof watchcase in 18 carat gold
crowned with sapphire glass. Handmade
and fully articulated between watchcase
and strap. Dial in white enamel with gold
pointers and hands. Quartz movement.
Signed and numbered limited batch
production.
Manufacturer: Cleto Munari, Italy,
for Unum, Italy

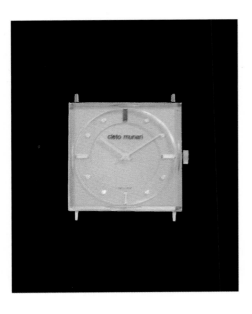

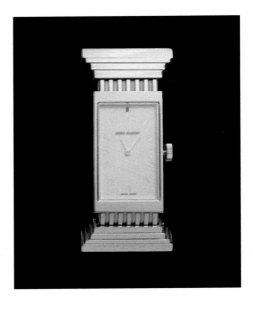

3

In 1985 Cleto Munari opened a jewellery workshop, commissioning twenty of
the world's top designers to draw pieces of jewellery for his influential avant-
garde collection. The Watches of Cleto Munari, each numbered and signed, are
the work of four leading designers/architects. They are in the permanent
collection of the Metropolitan Museum of Art, New York.

Ettore Sottsass
Watch
Gold
A waterproof watch with a handmade 18
carat gold case and porcelain gold dial.
The movement is handmade and
mounted by Piguet-SA Le Brassus,
Switzerland. Signed and numbered
limited batch production.
Manufacturer: Cleto Munari, Italy, for
Unum, Italy

5

4

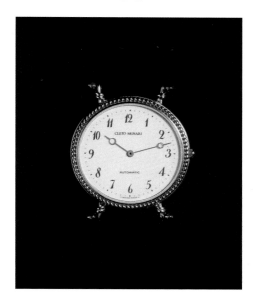

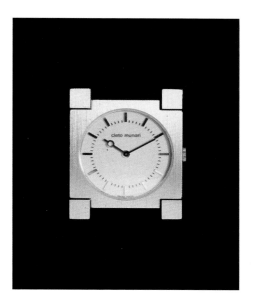

Michael Graves
Watch
Gold, sapphire glass, enamel
Waterproof watchcase in antique 18
carat gold crowned with sapphire glass
and decorated with four green agates.
Dial of enamel. Handmade and mounted
by Piguet-SA Le Brassus, Switzerland.
Signed and numbered limited batch
production.
Manufacturer: Cleto Munari, Italy,
for Unum, Italy

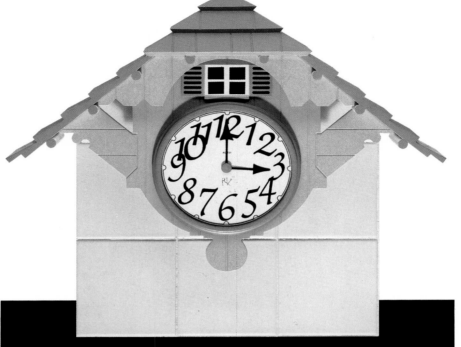

6

Robert Venturi

Cuckoo Clock

Wood, cast iron

A cuckoo clock in enamelled wood with
painted cast-iron weights. Mechanical
movement with a pendulum regulator.
The cuckoo melody is bellows-operated.
H28 cm (11 in). W41 cm (16⅛ in).
D12 cm (4¾ in)
Manufacturer: Alessi, Italy

Aldo Rossi

Watch, Momento

Stainless steel, sapphire glass

A water-resistant wrist watch with a
black silicone-treated leather strap and/
or pocket watch with a chain of nickel-
plated brass. Quartz movement.
H0.6 cm (¼ in). Di3.2 cm (1¼ in)
Manufacturer: Alessi, Italy

"Steel with style" is the phrase Alessi use to market their designer household wares around the world. Their first collection of watches and clocks begins with a commission for Aldo Rossi. His *Momento*, with its Arabic numerals on an enamelled face, has a dual role: it is both a wrist watch on a leather strap and a pocket watch on a chain, unclipping easily from either setting to fit immaculately into the other. The rational functionality which informs so many Alessi products is applied in a very different way with the intentional irony of Robert Venturi's *Cuckoo Clock*, a caricature of the traditional Black Forest clocks. The door swings open, whereupon a bellows-operated cuckoo sings.

7

Marcello Morandini

Watch, Orologio da Polso

Gold, steel, sapphire glass

H0.6 cm (¼ in). Di3.2 cm (1¼ in)

Manufacturer: Girard-Perregaux,
Switzerland

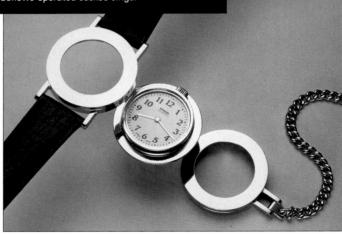

8

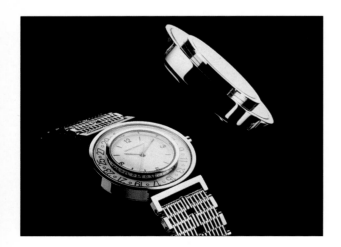

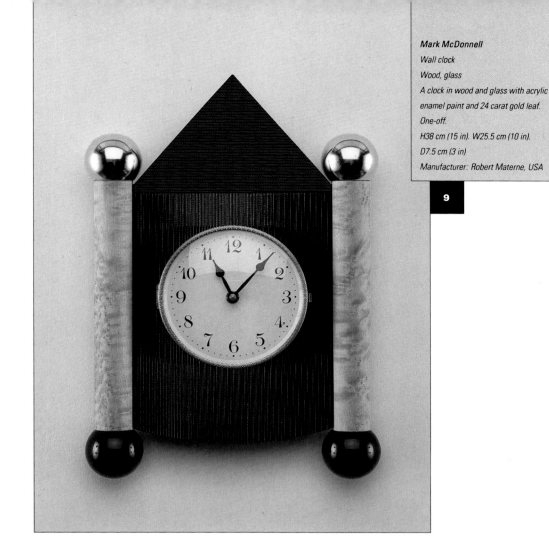

Mark McDonnell
Wall clock
Wood, glass
A clock in wood and glass with acrylic
enamel paint and 24 carat gold leaf.
One-off.
H38 cm (15 in). W25.5 cm (10 in).
D7.5 cm (3 in)
Manufacturer: Robert Materne, USA

9

Pio Manzù
Clock, Cronotime
Stainless steel or ABS
A table clock with quartz movement,
originally designed in 1966 and now
included in the Permanent Design
Collection of the Museum of Modern Art,
New York.
H8.5 cm (3⅜ in). Di7 cm (2¾ in)
Manufacturer: Alessi, Italy

Joe Colombo
Clock, Optic
ABS
A table alarm clock with quartz
movement.
H8 cm (3⅛ in). W8 cm (3⅛ in).
D8 cm (3⅛ in)
Manufacturer: Alessi, Italy

10

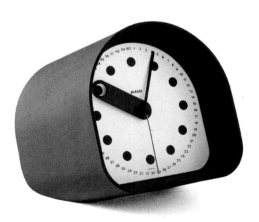

Alessi have also revived two earlier clock designs. The *Optic* alarm clock in ABS was designed by architect and interior designer Joe Colombo in 1970, the year of his death. Car designer and researcher Pio Manzù, who died in 1969, designed *Cronotime,* another table clock, in 1966. Housed in ABS or stainless steel, appropriately it is reminiscent of a car dashboard fitting.

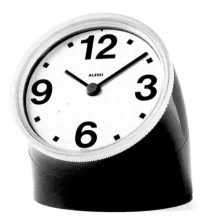

11

12

John Betts / Henry Dreyfuss
Associates
Fishing rod handles, 1000 Series
Lexan, graphite, epoxy
A fishing rod with an EVA foam handle
and a lexan sleeve that transmits
vibrations to the user.
L142 cm (56 in). Di3.8 cm (1½ in)
Manufacturer: Abu Garcia Produktion,
Sweden

Professional fishermen are capable today of winning as much as fifty thousand dollars in a single tournament – a level of competition that prompted Sweden's Abu Garcia to commission new rods and reels from Henry Dreyfuss Associates. Three years later the programme consists of fifteen product series (124 rods and reels), the latest being John Betts' new rod handles and baitcasting reel. Fishing equipment must be lightweight and flexible, capable of careful balance to avoid scaring away the fish yet strong enough to cope with very varied water and weather conditions. The *1000 Series* has a foam handle which is held when casting. The grip underneath the reel seat is bonded to the top part of the rod and covered with a lexan sleeve that transmits vibrations directly from the rod to the hand. The *Ambassadeur 1021* baitcasting reel, which fits on top of the grip, is designed to increase control, accuracy and comfort for experienced fishermen. It has an injection-moulded frame carefully contoured for "palming," a bayonet cap which allows the spool to be rapidly removed and replaced when different line weights are required, rubber crank handles, speed adjustment and a brake.

13

John Betts / Henry Dreyfuss
Associates
Baitcasting reel, Ambassadeur 1021
Graphite and polyamide composite
An ergonomically designed reel.
H5.3 cm (2⅛ in). W7 cm (2¾ in). L9.6 cm
(3¾ in). Di spool 3.6 cm (1⅜ in)
Manufacturer: Abu Garcia Produktion,
Sweden

14 Not unexpectedly for a very flat country, The Netherlands has a great many cyclists. Anyone who cycles would find Dutch designer Titus Hertzberger's briefcase useful, whether for business documents or as a rucksack; it is light and portable, but also strong. Its plexiglass ends unashamedly reveal its contents. Hertzberger's idea is a social commentary on the increasing number of people worldwide who, though well-paid professionals, still prefer to cycle to and from work.

Titus Hertzberger
Briefcase
Aluminium, plexiglass
Prototype of a briefcase that can also
be used as a rucksack.
H32 cm (12½ in). W40 cm (15¾ in).
D9.5 cm (3¾ in)
Manufacturer: Titus Hertzberger,
The Netherlands

Matsushita Electric Design Room,
Home Appliance Sector
Steam iron
ABS resin
H15.8 cm (6¼ in). W10.2 cm (4 in).
D6.1 cm (2⅜ in)
Manufacturer: Matsushita Electric,
Japan

15 No longer than a suitcase handle, with the circumference of a cylindrical torch, this electric steam iron works vertically as well as horizontally; so curtains, or a jacket hanging up, can be pressed without moving them or setting up a conventional ironing board, which in many situations is difficult to manage.

Issey Miyake
Suitcase, Issey Miyake Carry Line
Nylon
A new range of cases designed to
be fashion accessories as well as
practical items.
H49 cm (19¼ in). W74 cm (29 in).
D11 cm (4⅜ in)
Manufacturer: Matsuzaki, Japan

**Douglas Paige / Ron Loosen
Associates**
Suitcase, Aerospace
Polycarbonate, Xenoy "GE," polyester
blend
High-impact, waterproof, air-tight
luggage.
H46 cm (18 in). W71 cm (28 in).
D23 cm (9 in)
Manufacturer: Andiamo, USA

Luigi Colani
Case, Colani Air-Pal
Xyron
One of a series of ergonomic suitcases
for air travel made from a recently
developed material that is both light
and strong. The handle and case are
shaped to be carried comfortably and the
smallest case can be used as hand
luggage.
H35 cm (13¾ in). W48 cm (18⅞ in).
D12 cm (4¾ in)
Manufacturer: Matsuzaki, Japan

Matsushita Electric Design Room,
Bicycle Division
Funny Bike
A road bicycle with an aeroframe.
H95 cm (37½ in). W40 cm (15¾ in).
L156 cm (61⅜ in)
Manufacturer: National Bicycle
Industrial, Japan

19

Design Central
Hairdryer, Heatwave
Plastic, metal
Prototype of a hairdryer which can be
hand-held or wall-mounted. The metal
screen can be changed to suit different
personalities.
H14 cm (5½ in). W18 cm (7 in). D2.5 cm
(1 in). Di screen 12.5 cm (5 in)
Manufacturer: Design Central, USA

22

Sohrab Vossoughi / Ziba Design
Exercise machine, Tailwind
Steel, extruded aluminium, plastic
A cycling ergometer.
H91.4 cm (36 in). W40.6 cm (16 in).
D81.3 cm (32 in)
Manufacturer: Proform, USA

20

21

Sohrab Vossoughi / Ziba Design
Exercise machine, Regatta
Steel, plastic, metal
A rowing ergometer made of steel
tubing, plastic and sheet metal which
folds for storage.
H48.5 cm (19 in). W56 cm (22 in).
D137 cm (54 in)
Manufacturer: Proform, USA

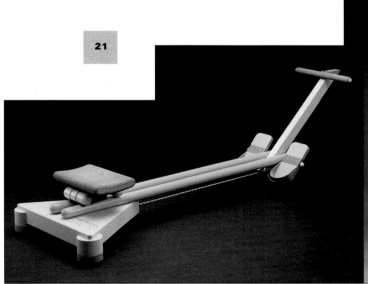

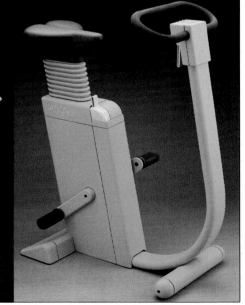

Ergometers not only simulate, as nearly as possible, the feel of rowing a boat, for the purposes of exercise; they also enable the assessment of performance, allowing results to be measured exactly. Normally they are cumbersome, and need to be fixed to the gymnasium floor, but *Regatta* – which gives a digital read-out of performance (calories expended, distance covered and speed) – folds up. *Tailwind* is an attractive cycling ergometer with a "step-through" frame and a fluid-filled seat for extra comfort.

23 Computer-generated information, both text and graphics, can now be projected in a large auditorium using liquid crystal display rather than video beam. The Kodak *Datashow* computer data projector incorporates a liquid crystal display panel with an integrated projection system that enables images to be projected on to a large screen. This is easy to set up, six times brighter than video beamers, and has more stable monochromes than they do. It is also more versatile, capable of projecting at distances up to 50 feet/16 metres. Images captured on disc are presented via a link-up to IBM personal computers or to 100 per cent IBM-compatible personal computers with a colour graphics adaptor. The housing is suitably rugged and portable for *Datashow* to be taken on the road.

Michael Reibl / Kodak
Design Department
Computer data projector, Datashow
Metal, plastic
A projector using a miniature liquid
crystal display to project computer-
generated information.
LCD H7.6 cm (2⅞ in). W9.2 cm (3⅝ in)
Projector H16.5 cm (6½ in). W35.5 cm
(14 in). D64.5 cm (25⅜ in)
Manufacturer: Kodak, West Germany

Design Central
Personal electronic terminal
Plastic, glass
Prototype of an electronic terminal for
use in word-processing, data and office
communication.
H28 cm (11 in). W42 cm (16½ in)
Manufacturer: Design Central, USA

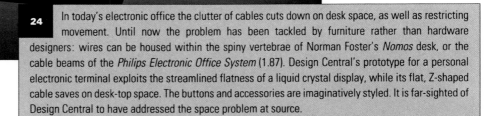

24 In today's electronic office the clutter of cables cuts down on desk space, as well as restricting movement. Until now the problem has been tackled by furniture rather than hardware designers: wires can be housed within the spiny vertebrae of Norman Foster's *Nomos* desk, or the cable beams of the *Philips Electronic Office System* (1.87). Design Central's prototype for a personal electronic terminal exploits the streamlined flatness of a liquid crystal display, while its flat, Z-shaped cable saves on desk-top space. The buttons and accessories are imaginatively styled. It is far-sighted of Design Central to have addressed the space problem at source.

James M. Conner / Henry Dreyfuss
Associates

Cameras, Spectra and Onyx
Polycarbonate, ABS, silicone rubber
Polaroid's "Image System" features
sonar autofocus, a built-in programmed
flash and automatic exposure control,
picture ejection and film advance. The
Onyx version has a transparent onyx-hue
top.
H7.5 cm (3 in). W14 cm (5½ in).
D16.5 cm (6⅜ in)
Manufacturer: Polaroid, USA

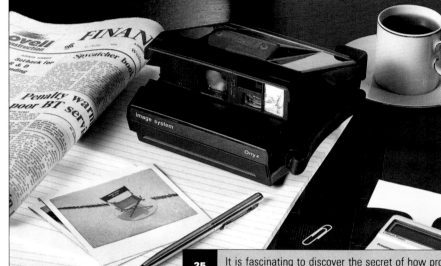

25 It is fascinating to discover the secret of how products work. Quick to realize the voyeuristic appeal of perspex, James Conner has opened up the intricacies of Polaroid's *Spectra* camera by inserting a transparent panel on top, and re-naming it the *Onyx*. The circuitry – which prints out instant pictures, making more than thirty complex focusing and exposure decisions within one-twentieth of a second – is thus revealed. Everything is automatic: focus, exposure control, picture ejection and film advance. The flash re-charges in a fifth of a second, while chimes warn the amateur that he is out of film or about to make a mistake. Creative photographers can over-ride automatic functions, and can even take their own portraits by switching on the self-timer, which gives twelve seconds for the dash from behind the lens to composure in front of it; a print is produced just fifteen seconds later.

Sony Design Team
Handycam CCD-M7
*A lightweight video camera powered by
three alkali batteries.*
H11.2 cm (4⅜ in). W9.3 cm (3⅝ in).
D24.2 cm (9½ in)
Manufacturer: Sony Corporation, Japan

26

***Moggridge Associates / John
Stoddard***
Computer, Archimedes
Steel, injection-moulded ABS
*Desk-top high-performance personal
computer consisting of processor unit,
keyboard and monitor. Capable of
executing 4 million instructions per
second. Winner of the British 1987
Microcomputer of the Year Award.*
*H9.7 cm (3⅞ in). W36.2 cm (14½ in).
D40.6 cm (15⅞ in)*
Manufacturer: Acorn Computers, UK

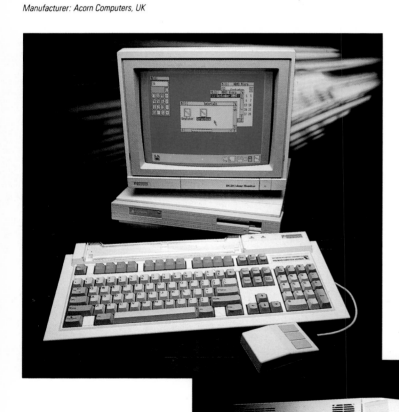

Braun Product Design / Dietrich Lubs
Calculator, ETS 77
Plastic, metal
A calculator using solar cell energy.
H13.7 cm (5⅜ in). W7.5 cm (3 in).
D1 cm (½ in)
Manufacturer: Braun, West Germany

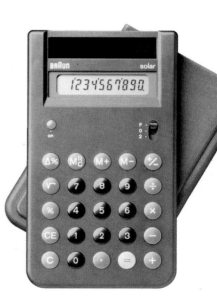

28

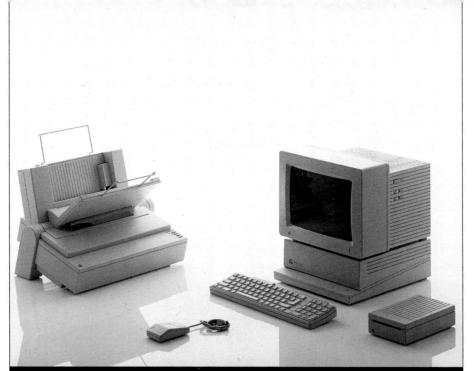

Frogdesign / Hartmut Esslinger
Computer, Apple IIGS
A personal computer in the Apple II
family. It runs programs three times
faster than its predecessors. It has 5000
colours and a 32-oscillator synthesizer,
with separate disc drive and a Laser
Writer printer.
Monitor / box H40 cm (15¾ in).
W62.8cm (24¾ in). D75 cm (29½ in)
Manufacturer: Apple Computer, USA

The original *Apple II* computer won the hearts of a user group whose loyalty long outlasted new developments in the industry. Apple, however, have brought new life to the *Apple II* by giving it a faster and more powerful microprocessor, which retains a high degree of compatibility with the original *Apple II*; the sixteen-bit 65C816 microprocessor has 256K RAM and 128K ROM as standard. But its real appeal to a new generation of followers lies in the letters "GS," "graphics/sound." Designed specifically for music applications, it has an Ensoniq sound chip with its own 64K of RAM which enables the GS to handle sixteen voices or instruments simultaneously.

29

30

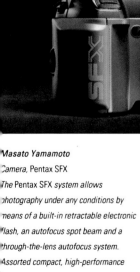

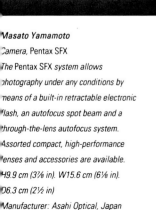

Ricoh Industrial Design Center
Copier, Cuvax MC50
ABS resin
A digital photocopying machine.
H4.8 cm (1⅞ in). W15.7 cm (6⅛ in).
D30.5 cm (12 in)
Manufacturer: Ricoh Company, Japan

Masato Yamamoto
Camera, Pentax SFX
The Pentax SFX *system allows*
photography under any conditions by
means of a built-in retractable electronic
flash, an autofocus spot beam and a
through-the-lens autofocus system.
Assorted compact, high-performance
lenses and accessories are available.
H9.9 cm (3⅞ in). W15.6 cm (6⅛ in).
D6.3 cm (2½ in)
Manufacturer: Asahi Optical, Japan

31

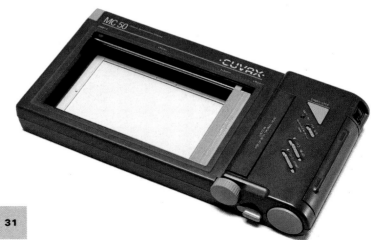

One has only to remember past dramas enacted over the telephone to wonder whether the *Picture Phone* prototype could be the realization of everyone's worst fears. However, its real purpose is to transmit documents via the detachable camera lens. The camera mimics the eye, with a lid that can be closed to block visual transmission. Lift the lid, and the graphics panel engages. Dialling out necessitates using the touch-screen key pad or electronic directory (both appear in the lower right quadrant of the screen). A thumbwheel control scrolls off the directory, while a triangular button protruding from the screen acts as a marker and call initiator. Paul Montgomery of Frogdesign says that it was shaped by three influences: window/picture-frame imagery, human facial and head structure – "anthropometrics" is the term he uses of the curves and dimensions of the handset – and Synthetic Cubism (the synthetics being injection-moulded plastics for the housing, and rubber for the ear-piece and structural ribbon cable).

Jacob Jensen / B & O Design Team
Beocenter 9000
Glass, metal, plastic
A music system comprising FM/AM
radio, cassette tape recorder and
compact disc player.
H11 cm (4⅜ in). W76 cm (30 cm).
D34 cm (13⅜ in)
Manufacturer: Bang & Olufsen,
Denmark

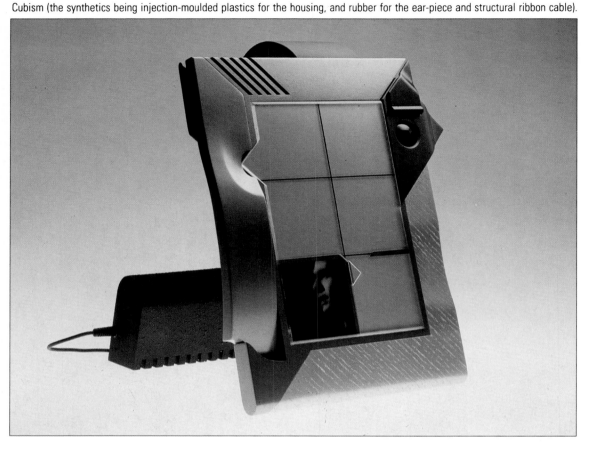

Paul Montgomery
Picture Phone
Injection-moulded ABS, rubber
Prototype of a telephone that
transmits a digital image using fibre-
optic technology and functions as a
conventional telephone when the lens
cover is down. Calls can be made using
the touch-screen key pad or the
electronic directory.
H30.5 cm (12 in). W15 cm (6 in).
D15 cm (6 in)
Manufacturer: Paul Montgomery, USA

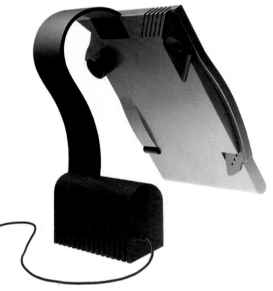

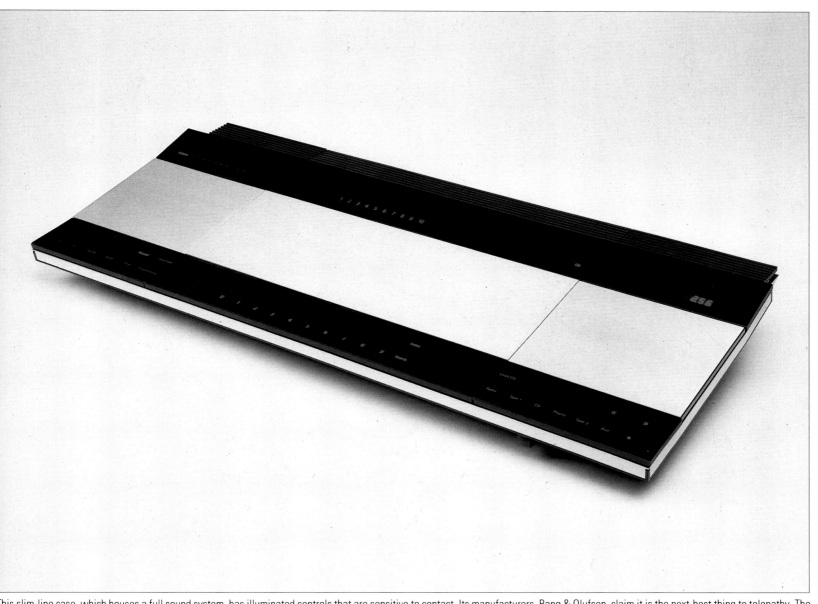

This slim-line case, which houses a full sound system, has illuminated controls that are sensitive to contact. Its manufacturers, Bang & Olufsen, claim it is the next-best thing to telepathy. The instruction manual appears on the display when summoned by touching the "sensi-touch" areas; there is also a hand-held remote control. This micro-computer technology, employed by Jacob Jensen with the intention of freeing the design from obtrusive dials and switches, also allows for the pre-programming of tape and radio facilities, and auto-tracking on tape and compact disc.

Matsushita Electric Design Room,
Television Sector
Television, TR-3LT4
ABS resin
Portable liquid crystal colour TV with a
backlit screen and built-in battery.
H10.8 cm (4¼ in). W9 cm (3½ in).
D3.9 cm (1½ in)
Manufacturer: Matsushita Electric,
Japan

The speaking book for View-Master relies on the latest microchip technology. Capable of telling stories and turning pages, the machine responds to a programmed chip in an accompanying book. A voice-over "reads" a story while the child follows the tale through the printed pictures. Design Logic was formed by two young men, David Gresham from Cranbrook Academy of Art in America and Martin Thaler from the Royal College of Art in England. Their broadsheet explains: "We approach our work via the avenue of product semantics, imparting historical, contextual or functional messages to product form in order to achieve emotional or symbolic interaction between the product and its user." With the speaking book, they certainly believe in catching their users young.

Design Logic / D.M. Gresham,
James N. Ludwig
and Martin Thaler
Children's book reader
High-impact styrene
A computerized storyteller. The green
button is for on/off power, the yellow is
for volume control and the three
magenta buttons are for questions and
answers.
H40 cm (15¾ in). L30 cm (11⅞ in).
D2.5 cm (1 in)
Manufacturer: View-Master Ideal
Group, USA

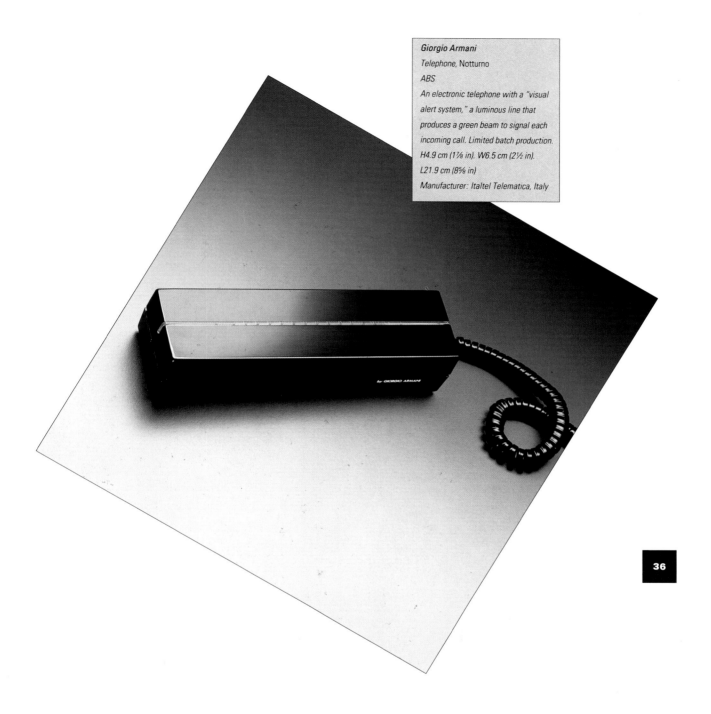

Giorgio Armani

Telephone, Notturno

ABS

An electronic telephone with a "visual
alert system," a luminous line that
produces a green beam to signal each
incoming call. Limited batch production.
H4.9 cm (1⅞ in). W6.5 cm (2½ in).
L21.9 cm (8⅝ in)
Manufacturer: Italtel Telematica, Italy

36

Giorgio Armani's fashion designs are applauded on the catwalks of the world; in 1988 he received the Cristobal Balenciaga Award for best international fashion designer. So his first product design is bound to arouse curiosity. *Notturno's* luminous green line, a beam that lights up to signal a call, runs along its slender black case like an elegant zipper. The batteries that feed the light sit in the rectangular base on which the push-button receiver rests. The telephone also sounds, and can be volume-controlled.

Sharp Corporate Design Center

Television, 3C-E1

A flat-screened liquid crystal display
colour television.
H8.3 cm (3¼ in). W9.8 cm (3⅞ in).
D4 cm (1½ in)
Manufacturer: Sharp Corporation, Japan

Matsushita Electric Design Room,
Television Sector

Television, TH-33F1D
Polystyrene resin, vinyl chloride sheet
Stereo colour television in a console-
type cabinet.
H105.5 cm (41½ in). W79.2 cm (31⅛ in).
D58.3 cm (22⅞ in)
Manufacturer: Matsushita Electric,
Japan

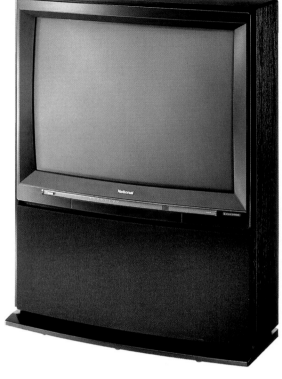

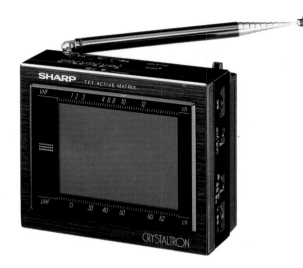

37

38

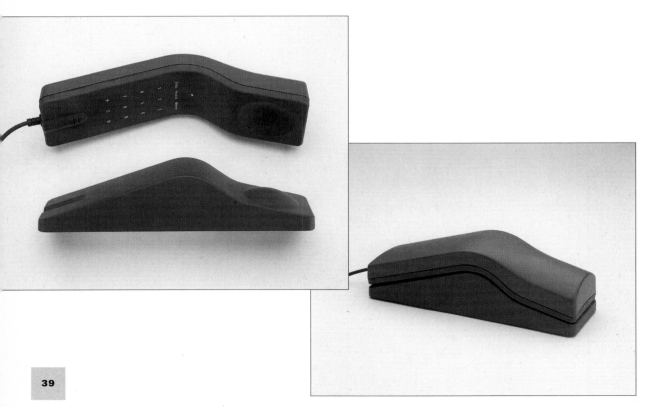

Eric Chan

Telephone, Becker EC Phone
Santoprene, ABS
An ergonomically designed telephone
with a rubber-lined handset, a rubber-
covered keyboard for water and dirt
resistance and a magnetic on/off switch.
Other features include last number re-
dial, ten-number memory and ringer
volume control. Limited batch
production.
H6.5 cm (2½ in). W5.7 cm (2¼ in).
L20.5 cm (8 in)
Manufacturer: Becker, USA

39

Corporate Industrial Design (CID)

Roller 2 Sound Machine, D 8017

Edistir polystyrene

A stereo radio and cassette recorder.

H20.5 cm (8 in). W41.8 cm (16⅜ in).

D14.5 cm (5¾ in)

Manufacturer: Philips NV,

The Netherlands

Corporate Industrial Design (CID)

Television, 3 LC 1000

Anodized pressed aluminium

A pocket colour TV with an active-matrix,

high-resolution liquid crystal display in a

compact design.

H16 cm (6¼ in). W8.8 cm (3⅜ in).

D2.5 cm (1 in)

Manufacturer: Philips NV,

The Netherlands

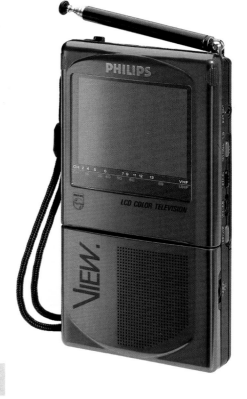

40

41

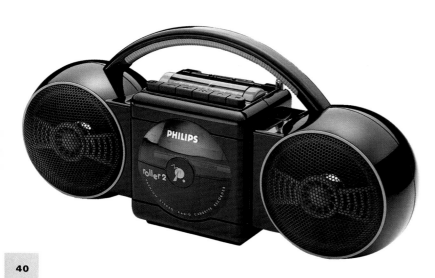

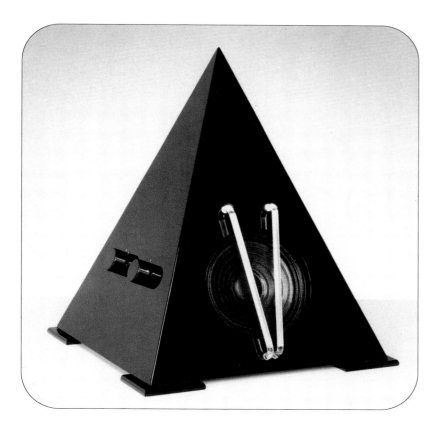

Harvey J. Mackie

Radio, Pyramidio

Perspex, MDF

A mains-operated three waveband AM/

FM radio. The V-shaped bars of the

speaker grille light up when switched on.

Tone control and socket for an external

FM aerial are at the rear. Limited batch

production.

H30.5 cm (12 in). W27.5 cm (10¾ in).

D27.5 cm (10¾ in)

Manufacturer: Colorado, UK

42

43

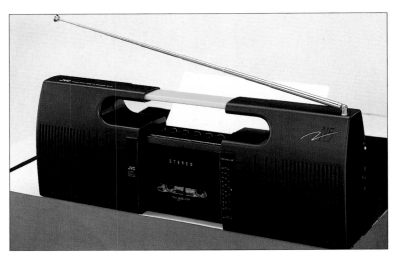

JVC Design Team
Radio cassette, RC-N5
Plastic
A lightweight stereo radio cassette
recorder that slides shut for easier
carrying.
H16.5 cm (6½ in). W33 cm (13 in).
D7.7 cm (3 in)
Manufacturer: JVC / Victor Company
of Japan, Japan

Corporate Industrial Design (CID)
Compact disc player, CD 15
ABS
A portable compact disc player.
H4.5 cm (1¾ in). W21.5 cm (8½ in).
D15 cm (6 in)
Manufacturer: Philips NV,
The Netherlands

44

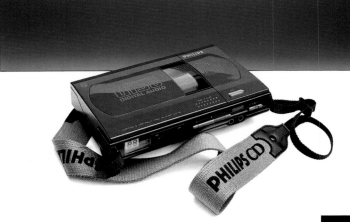

Sony Design Team
Compact disc player, Discman D-600
A lightweight CD player with a
contoured shape, suitable for the car
or home stereo system. With a simple
one-touch operation – Play/Pause/
AMS/Search.
H4.8 cm (1⅞ in). W15 cm (6 in).
D17.5 cm (6⅞ in)
Manufacturer: Sony Corporation, Japan

46

45

Matsushita Electric Design Room,
General Audio Division
Music system, RX-FD55
Polystyrene resin, ABS resin, punched
SPCC
A portable radio cassette recorder with a
compact disc player.
H17.3 cm (6¾ in). W60.5 cm (23⅞ in).
D17.6 cm (6⅞ in)
Manufacturer: Matsushita Electric,
Japan

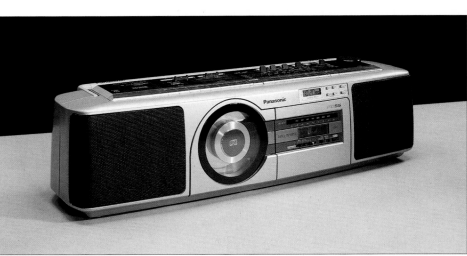

47

Plumb Design Group / Sharp
Corporate Design Center
Radio cassette, QT-F40X
A battery AC/DC stereo tape recorder
with AM/FM radio with top cover and
shoulder strap. Available in four colours.
H16 cm (6¼ in). W6.8 cm (2⅝ in).
L33 cm (13 in)
Manufacturer: Sharp Corporation, USA

Jacob Jensen / B & O Design Team
Beosystem 5500
Plastic moulding, glass, metal
A music system consisting of four units
operated by a master control panel
through infra-red two-way
communication: Beomaster 5500 *hi-fi*
quality 2 x 60W tuner/amplifier; Beocord
5500 *tape recorder;* Beogram 5000
tangential arm record player; CD 5500
compact disc player.
Each unit H7.5 cm (3 in). W42 cm
(16½ in). D32.5 cm (12¾ in)
Manufacturer: Bang & Olufsen,
Denmark

48

Charles Rozier
Loudspeaker, Snell Type E
Chiplore, veneer, fabric
Variation on a standard Snell
loudspeaker with black ebonized finish,
decorated with paint. One-off.
H33 cm (13 in). W35.5 cm (14 in).
D28 cm (11 in)
Manufacturer: Charles Rozier, USA

49

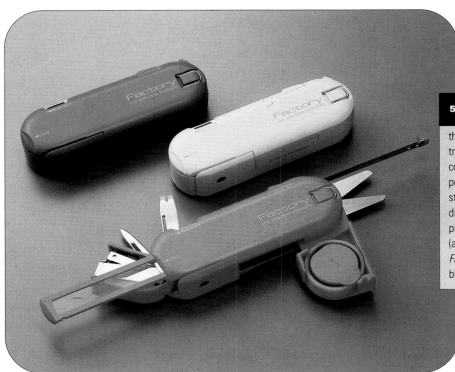

Plus Design Team

Desk tool, Factory

ABS resin

An all-in-one tool consisting of scissors, hole punch, magnifying lens, stapler, tape measure, carton opener, pin box, staple remover and tape dispenser.

H11.2 cm (4⅜ in). W3.7 cm (1⅜ in).

D2.7 cm (1⅛ in)

Manufacturer: Plus Corporation, Japan

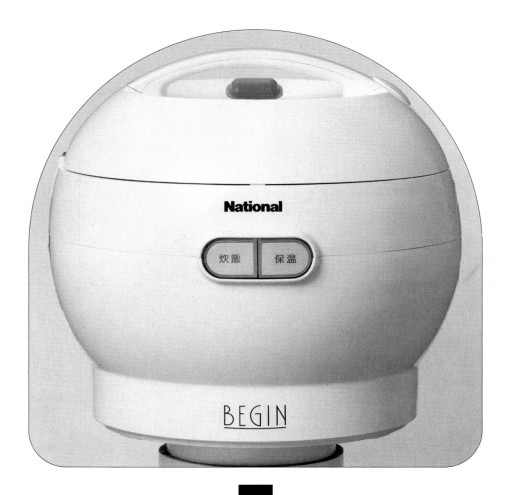

Matsushita Electric Design Room,

Home Appliance Sector

Rice Cooker

Polypropylene

A simple compact rice cooker.

H21 cm (8¼ in). L25 cm (9⅞ in).

D23 cm (9 in)

Manufacturer: Matsushita Electric, Japan

51

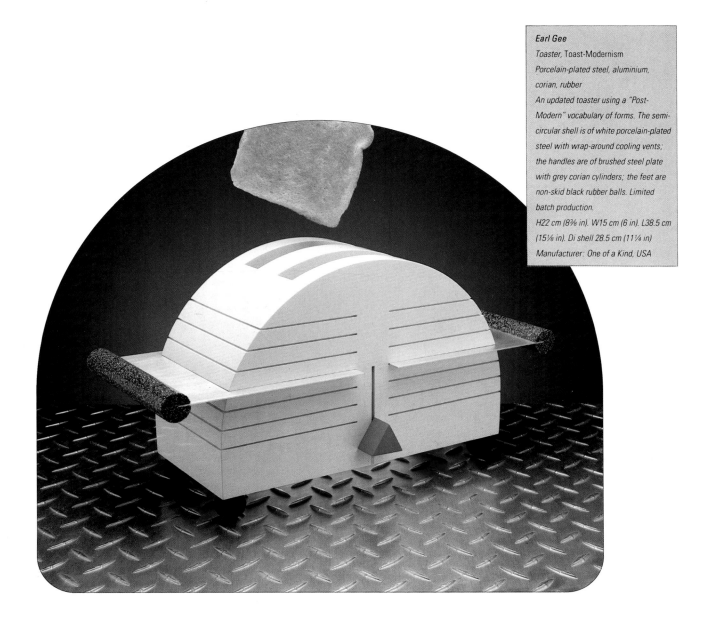

Earl Gee

Toaster, Toast-Modernism

Porcelain-plated steel, aluminium,
corian, rubber

An updated toaster using a "Post-
Modern" vocabulary of forms. The semi-
circular shell is of white porcelain-plated
steel with wrap-around cooling vents;
the handles are of brushed steel plate
with grey corian cylinders; the feet are
non-skid black rubber balls. Limited
batch production.

H22 cm (8⅜ in). W15 cm (6 in). L38.5 cm
(15⅛ in). Di shell 28.5 cm (11¼ in)
Manufacturer: One of a Kind, USA

52 *Toast-Modernism* is a flippant commentary on Post-Modern architectural trends. Its geometric elements – the ball feet and triangular controls – fulfil specific functions, while the porcelain finish and grey marble look-alike handles manage to give this everyday piece of household equipment a monumental façade. As interesting as its title is its method of production. One of a Kind is a group that acts as a showcase for innovative limited editions, all hand-signed; unlike most other toasters one can think of, the piece has been created far from the mainstream, commercial, fast-track production system.

53

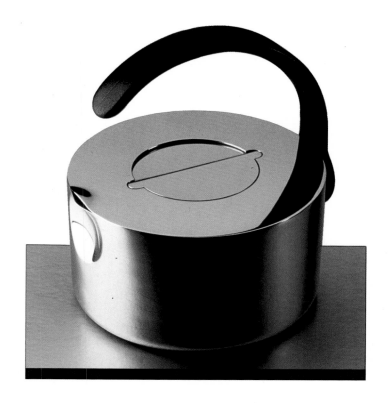

V. Lorenzo Porcelli
Kettle
Stainless steel, phenolic plastic
Kettle with 1.9 litre capacity with a
counterbalanced pivoting lid that
opens with the pressure of water. The
"spout" is a debossed lip with an
eyelid opening.
H20.5 cm (8 in). W18 cm (7 in).
Di18 cm (7 in)
Manufacturer: Dansk International
Designs, USA

54

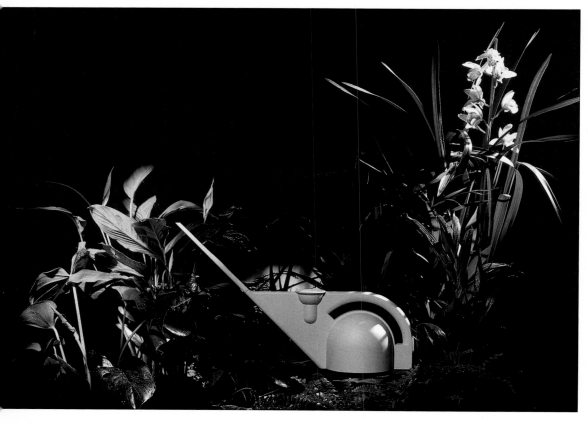

Moggridge Associates / Hedda
Beese, Design Drei
Watering can
Blow-moulded plastic
Prototype of a watering can that can
be easily manoeuvred at all angles. The
water flows through the central spine
and handle and the narrow spout is
detachable. The funnel-shaped opening
at the top is for easy filling and allows
observation of the water level.
H20 cm and 50 cm (7⅞ in and 19⅝ in).
L55 cm (21½ in). Di16 cm (6¼ in)
Manufacturer: IDM Modelmakers, UK

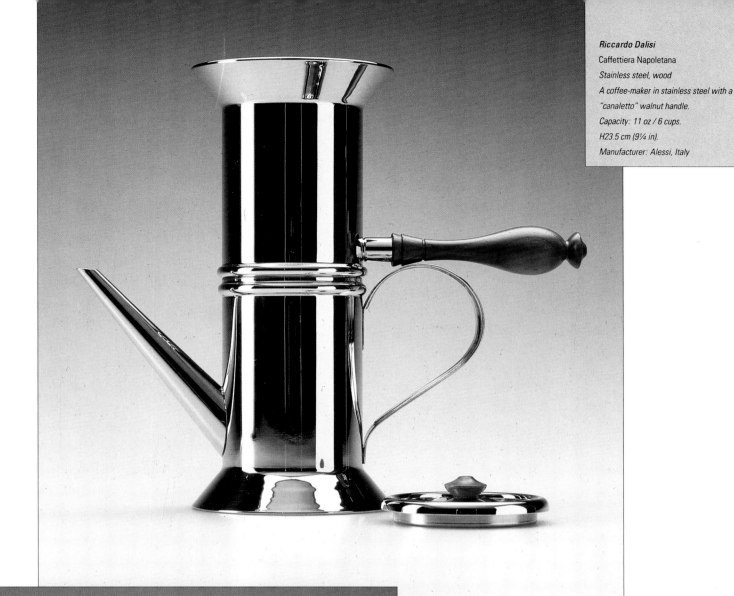

Riccardo Dalisi
Caffettiera Napoletana
Stainless steel, wood
A coffee-maker in stainless steel with a
"canaletto" walnut handle.
Capacity: 11 oz / 6 cups.
H23.5 cm (9¼ in).
Manufacturer: Alessi, Italy

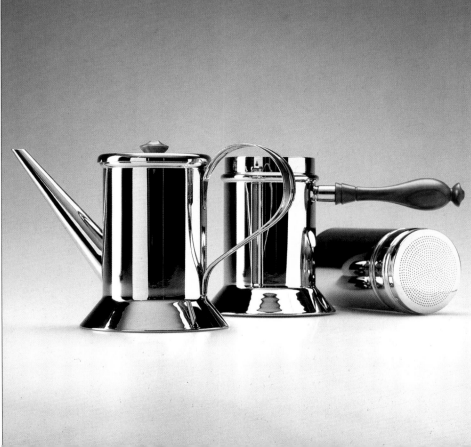

55 Architect Riccardo Dalisi often overturns our expectations about familiar objects; his coffee-pot is placed one way up for heating, and the other way for pouring. It is his most recent reworking of the time-honoured shape of the Neapolitan tin coffee-maker, with its slender wooden handle and the long diagonal spout into which a twist of paper is traditionally stuck to prevent the aroma escaping. Dalisi has been working on the theme of Neapolitan coffee-pots for some years, combining high-tech research with the popular culture and traditions of southern Italy. A Neapolitan in all but place of birth, Dalisi is credited with playing a large part in regenerating design and research in southern Italy.

56

Josep Lluscà
Pressure cooker, Splendid
Stainless steel
A pressure cooker with all the controls
integrated in the handle, which operates
three times as fast as an ordinary
pressure cooker, saving about 70
per cent on energy. Available in three
sizes – 4, 6 or 7 litres.
6 litre capacity H16 cm (6¼ in).
Di22 cm (8⅝ in)
Manufacturer: Radar (Group Fagor),
Spain

57

Sanyo Design Team
Electric heater, R-CR1
Resin, chrome-plated steel
"Old-fashioned" electric heater with a
resin base and chrome-plated steel body
that heats a room faster than a
conventional heater. Limited batch
production.
H35 cm (13¾ in). W39 cm (15⅜ in).
D18 cm (7 in)
Manufacturer: Sanyo Electric, Japan

Matsushita Battery Industrial Co.

Design Team

Letter opener

ABS

A battery-powered letter opener.

H8.5 cm (3⅜ in). W11.9 cm (4⅝ in).

D5.3 cm (2 in)

Manufacturer: Matsushita Battery

Industrial, Japan

58

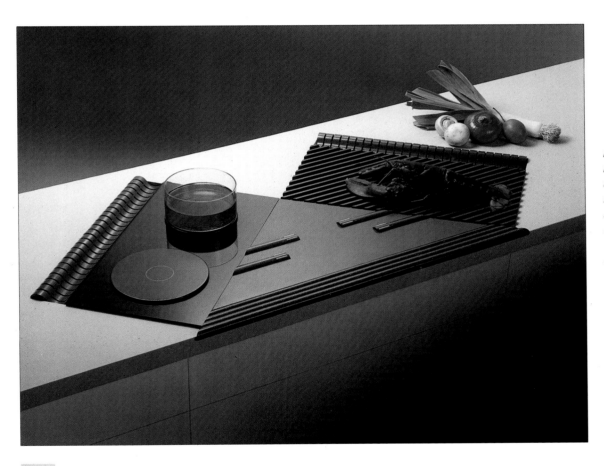

59

Design Central

Electronic cooktop

Glass, metal, plastic

Prototype of a cooktop with surfaces

oriented towards the user. It has a digital

electronic display through glass.

W116.8 cm (46 in). D56 cm (22 in)

Manufacturer: Design Central, USA

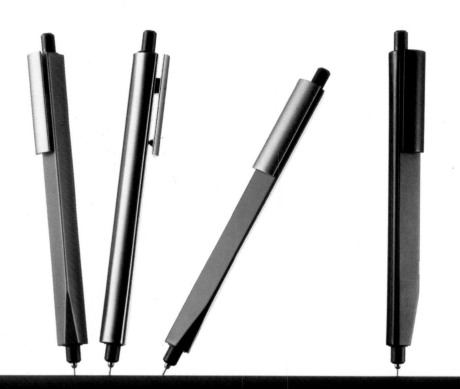

Masayuki Kurokawa
Pencils, Archi Version K
Aluminium alloy
Mechanical pencils.
W1.3 cm (½ in). L14.7 cm (5¾ in).
D1.6 cm (½ in)
Manufacturer: Sakura Color Products,
Japan

60

Kazuo Kawasaki
Scissors, X & I
Stainless steel
Forged in the traditional method with
fire, the scissors open and shut by means
of a flat spring. A plate spring at the
fulcrum joint increases accuracy. With
safety carrying case.
W0.8 cm (⅜ in). L14 cm (5½ in).
D0.8 cm (⅜ in)
Manufacturer: Takefu Knife Village,
Japan

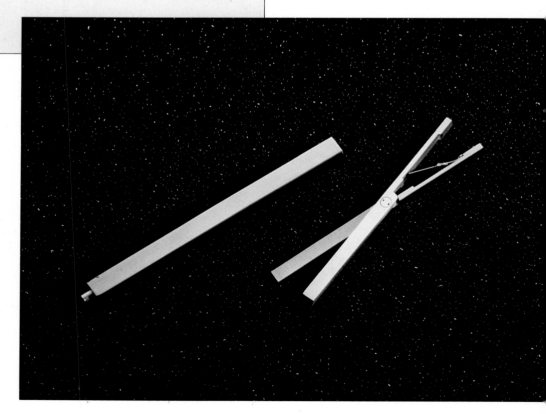

61

62

*Davide Mercatali and Paolo
Pedrizzetti*
Can-opener, Safety
Hostaform
*A can-opener that leaves no sharp
edges on the lid or rim and that has no
contact with the contents of the can.*
L16 cm (6¼ in)
Manufacturer: Icom, Italy

63

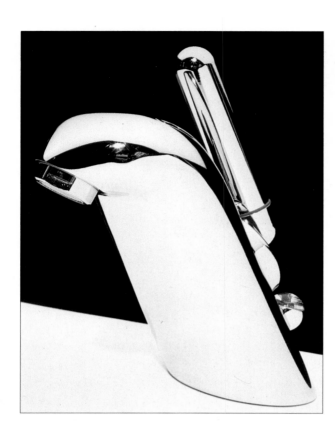

Mario Bellini
Taps, Class
Brass
A series of taps for the bathroom,
chromium-plated or gilt, with a single-
control mixer for handbasins.
H16.5 cm (6½ in). W17.5 cm (6⅞ in).
Di7.5 cm (3 in)
Manufacturer: Ideal Standard, Italy

64

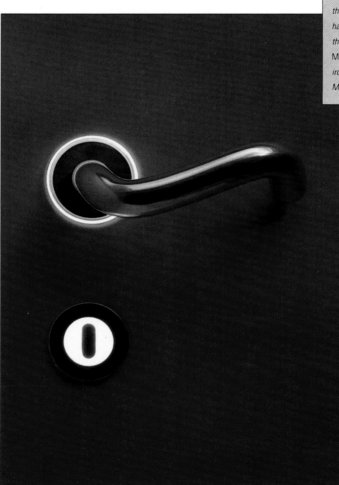

65

Mark Bayley
Shell Door Handle
Epoxy resin
Limited batch production
Di20 cm (7⅞ in)
Manufacturer: Mark Bayley,
UK

66

Makoto Komatsu
Handles, Soyushi
Metal
Handles in metal in two styles – modern
and classic – with a variety of grips
that can be changed as desired. The
grips are finished in materials such as
rubber, plastic, wood, stone, porcelain
and lacquered wood.
L12.4 cm (4⅞ in). Di2.4 cm (1 in)
Manufacturer: OHS, Japan

67

217

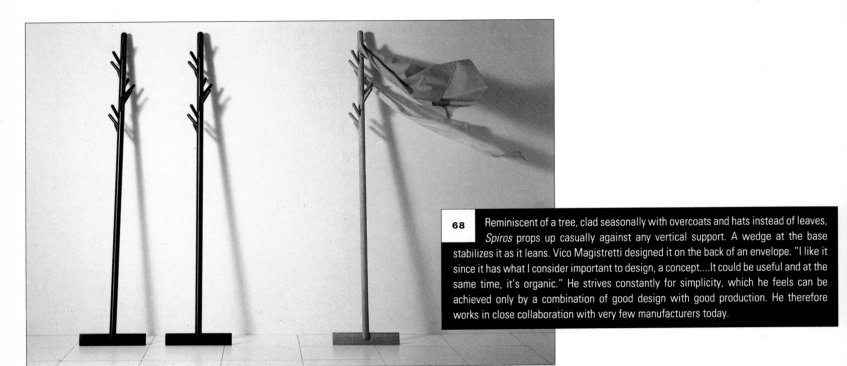

68 Reminiscent of a tree, clad seasonally with overcoats and hats instead of leaves, *Spiros* props up casually against any vertical support. A wedge at the base stabilizes it as it leans. Vico Magistretti designed it on the back of an envelope. "I like it since it has what I consider important to design, a concept....It could be useful and at the same time, it's organic." He strives constantly for simplicity, which he feels can be achieved only by a combination of good design with good production. He therefore works in close collaboration with very few manufacturers today.

Vico Magistretti

Coat stand, Spiros

Wood

A portable coat stand that leans against the wall and can be easily dismantled. In black opaque lacquered wood or natural oak.

H200 cm (78¾ in). W base 40 cm (15¾ in)

Manufacturer: Morphos / Acerbis International, Italy

Achille Castiglioni

Drinks cooler, Servino

ABS, steel

A stand holding a wine/drinks cooler. It has a black ABS base, stove-enamelled steel support rod and chromium-plated steel support spring. The cooler holds shells in puffed polythene containing non-toxic cooling liquid which, when taken from the freezer, reduces the temperature of a bottle from 22 to 13 degrees centigrade in thirty minutes.

H125 cm (49¼ in). W20 cm (7⅞ in). D24 cm (9⅜ in)

Manufacturer: Zanotta, Italy

69 Like all designs by Castiglioni, this one seems obvious and simple, and yet it is quite new. The *Servino,* a wine and drinks cooler, in outline looks faintly like an attentive but anorexic waiter; it supports an ice-bucket without occupying space on the table. Capable of cooling drinks fast, it is invaluable in restaurants and at home.

fonso Crotti
ent servant, Iago
n, copper
a illuminated clothes stand made of
n plates with copper rivets. Limited
tch production.
75 cm (68⅞ in). W52 cm (20½ in).
anufacturer: Attilio Bordignon, Italy

70

A selective survey of some of the new
designs that are in prototype or
production in 1988.

1
Philippe Starck
Chair, Lola Mundo
A folding chair.
To be produced by Driade, Italy

2-4
Philippe Starck
Cutlery
To be produced by
Sasaki, Japan

5
Philippe Starck
Mirror

6
Aldo Rossi
A coffee-pot and a folding chair,
both in steel.
To be produced by Alessi, Italy

7
K. Munshi
Decorative lamp
Prototype of a table lamp for soft
lighting, made of aluminium tube
and wood, for limited batch
production.

8, 11
Andrée Putman
Bureau Ministre des Finances
An award-winning desk.

9
Andrée Putman
Storage system
A movable storage system for
clothes etc, with shelves.
To be produced by Les 3 Suisses,
France

10
Andrée Putman
Table
A circular table with two flaps.
To be produced by Les 3 Suisses,
France

1

2

3

4

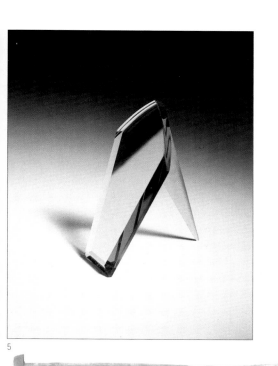

5

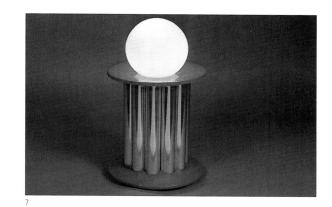

7

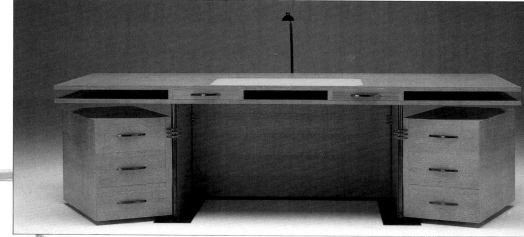

8

6

9

11

10

12

Braun Product Design Department

Lady shaver
A cord version of the Lady shaver which automatically adjusts to any voltage 110-240V.
To be produced by Braun, West Germany

13

Braun Product Design Department

Aromaster compact
A space-saving coffee-machine. The filter pivots for filling and unhinges for cleaning. The "drip stop" allows coffee to be poured before the brewing process is complete.
To be produced by Braun, West Germany

14-16

Richard Ginori

Tableware, La
A cup and saucer, plates and sugar bowl from the La service.
To be produced by Richard Ginori, Italy

17-23

Design Logic / D.M. Gresham, Martin Thaler, James N. Ludwig

Telephone answering machines
Semantic studies of digital answering machines produced for Sandor F. Weisz of Dictaphone, USA. The design in 17-18 is based on the conventional flat model; that in 19-21 is a Constructivist view of the human face; and that in 22-3 is based on the design of the US mailbox.

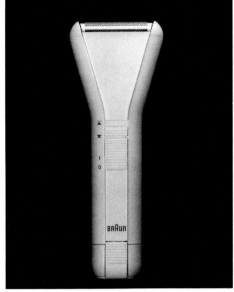

12

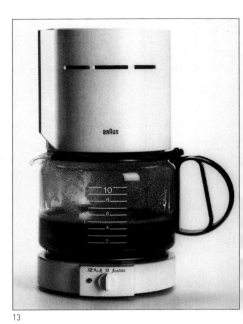

13

14

15

16

17

18

20

21

19

23

22

223

24-6

*Moggridge Associates /
Brian Stewart*

Picture frames

A system of elements, consisting of
backgrounds, borders and feet in
different shapes, sizes and colours,
which can be clipped together to
make formal or informal frames.

27

*Moggridge Associates /
Brian Stewart*

Light

A design concept model of a
halogen light to be used wherever a
flexible light source is needed. The
lamp holder can be rotated and slid
up and down the support to provide
direct or indirect light.

28-33

Paolo Tilche

China sanitary fixtures, Ti-Uno

To be produced by Pozzi Ginori, Italy

24

25

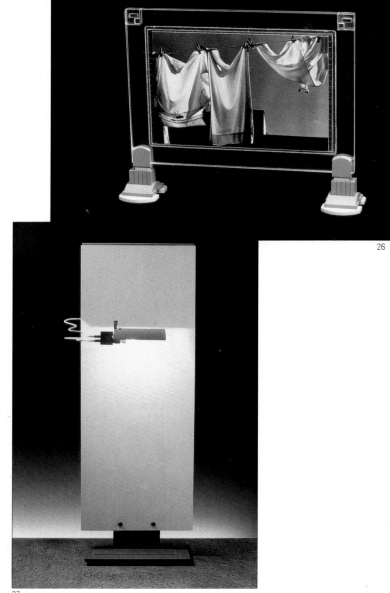

26

27

28-33

Every effort has been made to obtain details about each designer whose work is represented in the book, but in some cases information was not available. The figures following each entry refer to the illustrations in which the designer's work is represented (the number before the full point indicates the chapter number).

Alvar Aalto was born in Kuortane, Finland, in 1898. He studied architecture at Helsinki Polytechnic and opened his own office in 1923. His sanatorium at Paimio (1929-33) was one of the great monuments of the Modern style. With his wife Aino, in 1935 he founded Artek to produce his designs – which it still does. From 1946 to 1948 he was a professor at the Massachusetts Institute of Technology. He became a member of the Academy of Finland in 1955. Its President from 1963 to 1968, he received awards from all over the world. He died in 1976. *(1.61, 3.69)*

Robert Adam is a British architect with a reputation as a leading exponent of contemporary classicism. His designs for shops, factories and houses apply classical architectural language to commercial and domestic requirements. *(1.51)*

Tom Ahlström was born in Stockholm in 1943. In 1968 he founded A & E Design with *Hans Erich*. Their work has received a number of design awards and their products are exhibited in various museums around the world. In 1987 they received the Swedish Industrial Designer of the Year Award. *(2.53)*

Alan Tye Design is a British industrial (product) design practice founded eighteen years ago by Alan Tye, a qualified architect who was awarded the title of Royal Designer for Industry in 1986. The practice has won over seventy awards and more than 10 million Alan Tye Design products have been sold worldwide. *(5.65)*

Nick Allen studied Fine Art at Epsom, UK. He has worked with environmental groups designing low-impact housing and tools for the Third World. In 1983 he founded Inventive Design, since when his work has mainly been concerned with furniture. *(1.59)*

Kyrre Andersen was born in 1958 and educated at the National College of Art and Design in Oslo where he now teaches from time to time. Most of his work is concerned with lighting and clocks. He has exhibited throughout Scandinavia and has pieces in several Norwegian museums. He has worked with Trikk since 1983. *(2.23-24)*

Ron Arad was born in 1951 in Tel Aviv, Israel. He studied at the Jerusalem Academy of Art and at the Architectural Association, London, graduating in 1979. He founded the design company One Off Ltd in 1981. He has exhibited widely – in 1987 in Geneva, Shibuya, Paris, Barcelona, Kassel, London and Milan – and designs furniture, products and interiors. He has contributed to furniture collections for Vitra and Aram Design Ltd. *(1.2-5, 2.34)*

Junichi Arai is a Japanese textile designer. He has supplied *Issey Miyake* and Comme des Garçons, among other leading Japanese designers. In 1987 he was made an Honorary Member of the Faculty of Royal Designers for Industry, UK. *(4.28-32)*

Zeev Aram was born in Clausenburg in 1931. He studied at the Central School of Art, London. He founded Zeev Aram Associates in 1963. In the following year Aram Design Ltd began producing his own work as well as that of modern British designers and re-editions of classics by designers such as *Eileen Gray* and Le Corbusier. He also designs commercial interiors, exhibitions and products. *(1.77)*

Giorgio Armani was born in Piacenza, Italy, in 1934. From 1964 to 1970 he worked with Hitman (Cerruti men's fashion company), at the end of which time he began to work freelance for several companies. In 1975 he founded Giorgio Armani SPA which has expanded to include lines for children's fashion, underwear for men and women, accessories for men and women, jeans and perfume. He has received numerous awards, most recently the Gran Cavalière from the Italian government and a Lifetime Achievement Award from the Council of Fashion Designers of America, both 1987, and in 1988 the Cristobal Balenciaga Award, Madrid, for the best international designer. *(5.36)*

Sally Armfield was born in Australia in 1960. In 1985 she completed a degree in Textile Design at the Royal Melbourne Institute of Technology. Since 1987 she has been working as a freelance fabric designer specializing in furnishing fabrics. *(4.36)*

Pietro Arosio is an Italian designer, born in 1946 in Lissone. He works both as an industrial designer and as an art director for furniture companies. He won the Casaviva d'Oro in 1983 for his kitchen, *Agrodolce*. In 1982 his *Arco* desk, produced by Ciatti, was selected by the Victoria and Albert Museum, London. *(1.86)*

Sergio Asti is an Italian architect who has designed the furnishings and interiors of several flats, shops and exhibitions. He has lectured and exhibited extensively, and has sat on a number of award juries since he completed his studies at the Milan Polytechnic in 1953. In the mid-1960s he studied glass techniques in Murano, Italy. Many of his designs from this period are now being produced for the first time by Vistosi. His designs have won many awards and have been displayed in several Venice Biennale exhibitions as well as in permanent museum collections. *(3.60)*

Gae Aulenti graduated from Milan Polytechnic in 1954. As well as architectural projects, she has designed stage sets and costumes for opera and drama, lectured extensively on architecture, had exhibitions throughout the world and received many awards. She was responsible for the Musée National d'Art Moderne at the Centre Georges Pompidou and for the interior architecture of the Musée d'Orsay, both in Paris. In September 1987 President Mitterrand conferred on her the title of Chevalier de la Légion d'Honneur. *(1.58)*

Hiroshi Awatsuji was born in Kyoto in 1929 and graduated from the Kyoto Municipal College of Fine Arts, establishing his own design studio in 1958. Since 1964 he has collaborated with the Fujie textile company. His commissions in Japan include textiles for the government pavilion at Expo 70, and tapestries for the Keio Plaza and Ginza Tokyu hotels. He exhibited at the Victoria and Albert Museum's Japan Style exhibition in 1980, and at the Design Since 1945 exhibition in Philadelphia. *(4.58)*

Philip Baldwin was born in New York in 1947. He has a degree from the American University, Washington DC. In 1979-80 he studied at the Orrefors Glasskolan in Sweden and with Ann Wolff and Wilke Adolfsson. With *Monica Guggisberg* he started a glass studio in Nonfoux, Switzerland, in 1982. Their work includes industrial and one-off pieces for galleries and museums. *(3.66)*

Roberto Barazzuol was born in Italy in 1958. A graphic designer, he currently lives in California and works for Esprit in San Francisco. *(4.41)*

Luciano Bartolini was born in Fiesole in 1948. He held his first solo show in Milan in 1975 and since then has exhibited in Cologne, Paris, New York, Zurich and Munich among other places. In 1983-4 he had a ten-year retrospective exhibition in Munich. In 1988 he has solo shows in Paris, Chicago and Milan. *(4.6)*

François Bauchet lives in Paris. He has been designing furniture since 1981. He has recently exhibited at the Neotu Gallery, Paris, the Octobre des Arts, Lyon, and the Documenta Kassel. *(1.143)*

Mark Bayley is a British photographer and interior designer. He studied graphic design at the London College of Printing and photography at the Royal College of Art, London, graduating in 1984. He began work as a freelance photographer, specializing in portraits and fashion photography. His work in lights and interior design was stimulated by creating props for his photographic assignments. He now also undertakes private commissions for interiors and lamps. *(2.14, 5.66)*

Hedda Beese was born in 1944 in Germany and educated in Berlin and at the Central School, London. Previously the joint managing director of the London office of *Moggridge Associates*, she is now establishing the company's German office, Design Drei. *(5.54)*

Mario Bellini was born in Milan in 1935 and graduated in architecture from the Milan Polytechnic in 1959. He works in architecture and industrial design for firms such as Artemide, B & B Italia, Cassina, Erco, Ideal Standard, Poltrona Frau and Rosenthal. Since 1965 he has been a consultant with Olivetti, and is now editor of *Domus*. Recently he has produced a new office seating range for Vitra. He has won several awards including the Compasso d'Oro in 1986. *(1.62, 2.4, 3.10, 3.71, 5.64)*

Guen Bertheau-Suzuki was born in Paris in 1956 and has a diploma from the Institute of Architecture in Tournai, Belgium, and a Master's degree from Tokyo University. An industrial and graphic designer, Bertheau-Suzuki has worked in Paris, Brussels and Tokyo. *(1.96)*

John Betts is a senior designer with Henry Dreyfuss Associates in New York where he has worked since 1984. His clients include Falcon Jet, Polaroid and Abu Garcia. In 1986 he founded the Inventors Club with Dennis Traut, Chuck Yuen and Eve Warmflash. *(5.12-13)*

Leo Blackman, an architect and industrial designer, was born in New York City in 1956. He graduated in architecture from Columbia University, New York, in 1981. He designs furniture and light fixtures. His work has appeared in galleries and exhibitions and has been purchased by the Brooklyn Museum for its permanent collection. Some of his work is undertaken in collaboration with *Lance Chantry*. *(2.33)*

Peter Blake was born in Dartford, Kent, UK, in 1932. Best known as an artist he has exhibited widely. A retrospective exhibition of his work was held at the Tate Gallery in London in 1983. *(1.124, 2.15)*

Ricardo Blanco was born in Buenos Aires in 1940 and has a degree in architecture from Buenos Aires State University. Professor of Industrial Design at the universities of La Plata, Cuyo and Buenos Aires, he specializes in furniture, lighting and graphic design, and has won numerous awards. *(1.19)*

Pauli Ernesti Blomstedt, one of the leading Functionalists in Finland, was born in 1900 and died in 1935. In 1986 Adelta OY began producing re-editions of his furniture designs from the early 1930s and in 1988 presented his *Post Deco* collection of desks, tables and entrance-hall furniture. *(1.68)*

Marilena Boccato, *Gian Nicola Gigante* and *Antonio Zambusi* studied architecture at Venice University in the 1960s. They have worked together as architects and interior and industrial designers. They won the Palladio prize in 1969 and the Macef prize in 1966. Their work has been shown at the Museum of Modern Art in New York and the Museum of Contemporary Art in Chicago. *(2.44)*

Cini Boeri graduated from the Milan Polytechnic in 1951 and worked at the Zanuso Studio from 1952 to 1963. Since then she has managed her own studio in Milan, working in civil and interior architecture. She has lectured and written widely and taken part in several competition juries. Her work has won many awards, including the Compasso d'Oro (1970), and a number of her works are in the collection of the Museum of Modern Art, New York. *(1.25)*

Jonas Böhlin, a Swedish designer living in Stockholm, was born in 1953. He graduated as an architect in 1981. He concentrates on interior architecture, stage and exhibition design and furniture design. His work is exhibited in the National Museum of Art, Stockholm, and the Rhösska Museum of Artcrafts, Gothenburg. He has exhibited at the ASF Gallery and Queens Museum, New York. *(1.127)*

Mattia Bonetti was born in Lugano in 1952. He is now a photographer living in Paris, and has collaborated with Gerard and *Elisabeth Garouste* since 1980, exhibiting in Bordeaux, Barcelona, New York, Paris and Copenhagen. Recently they designed a showroom for Christian Lacroix. *(1.40)*

Mario Botta was born in 1943 in Mendrisio, Switzerland. He attended the Academy of Fine Arts in Milan, then graduated in architecture from the University of Venice. He gained practical experience in Le Corbusier's studio, and established his own architectural practice in Lugano in 1969. He has completed a number of buildings in Switzerland generally categorized as "rationalist." Since 1982 he has also designed furniture for Alias. Two of his chairs are in the "Study Collection" of the Museum of Modern Art in New York. *(1.92, 2.52)*

Maryse Boxer was born in Tunis, studied at art schools in Tunis and Paris, and lived in Los Angeles and New York City before moving to London. She is a stylist and colourist for international textile and cosmetic companies. In London she became involved in creating a versatile tableware collection. Her work has been published in design magazines internationally and exhibited in Paris and London. *(3.12)*

Constantin Boym was born in Moscow in 1955. He attended the Moscow Architectural Institute and in 1981 emigrated to the USA. In 1984-5 he attended the Domus Academy in Milan. In 1986

with *Lev Zeitlin* he founded Red Square Design in New York, a studio working in furniture, products, interiors and graphics. *(1.117-118)*

Andrea Branzi was born and educated in Florence. He is both a designer and an editor and has consistently been a representative of the radical tendency in Italian design. Until 1974 he was with Archizoom Associati, the first avant-garde Italian group. He was involved in the establishment of Studio Alchimia, the Milan-based group who have created pieces that are closer to artworks than to conventional pieces of design. Since 1981 he has been involved with the Memphis group, collaborating with *Ettore Sottsass*. He is educational director of the Domus Academy. *(1.22)*

Braun Product Design Team, under the directorship of Professor Dieter Rams, is responsible for the design of all Braun products. The team includes Dietrich Lubs. *(5.28)*

Anne Breckenfeld is a graduate of the Pratt Institute, New York. She worked for Smart Design, New York, from 1985 to 1987 in both product and graphic design, and is currently a freelance designer living in Seattle, Washington. *(5.62)*

Bruni Brunati was born in 1954 and studied at the University of Architecture in Venice. Now he works mainly in town planning with special emphasis on landscape and urban design. Since 1982 he has collaborated with *Carlo Zerbaro*. *(1.104)*

Tracey Bullen is an English textile designer and printer working mainly with furnishing fabrics. As Chameleon Textiles she has participated in trade and design fairs in London and abroad. Her projects include domestic bedroom and living interiors, interiors for offices, and nightclub interiors. *(4.48)*

Paul Burgess was born in Swindon, UK, in 1961. He studied printed textiles at the Camberwell School of Art and at the Royal College of Art, both in London. His commissions include collections for Extravert Ltd and Extetique/Amescote Ltd and print designs and window displays for Next plc. In 1986 he won the Drapers Record Award at Texprint 86, London. *(4.54)*

Scott Burton was born in Greensboro, Alabama, in 1933. A sculptor, he now lives in New York where his work is concerned with the relationship between art and public life. His chairs are often minimalist sculptures in stone. *(1.121)*

Niall D. Campbell was born in London in 1953. At the age of twenty he emigrated to Australia. He graduated from the Tasmania Art School in 1986 and was awarded the Mt Nelson Prize for Art by the University of Tasmania. In 1987 he was commissioned by the Tasmanian government to design and build a sculptural playground for a primary school. He is currently working as a freelance designer and furniture-maker. *(1.28)*

Dinah Casson trained at the Hornsey College of Art and the Ravensbourne College of Art and Design, both in London. She has been in private practice since 1971, working in partnership with *Roger Mann* since 1984. Her furniture design includes desk chairs for Ryman and Vickers, a chair for the Cooper-Hewitt Museum of Decorative Arts and Design, New York, and she is currently working on stoves for the National Coal Board, UK. She is also an interior designer and a member of various design committees. *(2.36, 4.52)*

Lola Castello Colomer was born in Valencia where she studied interior design at the School of Applied Arts. She began her professional career in 1971 and in 1980 established the company Punt Mobles with *Vicent Martinez*. Her work has been shown at furniture fairs in Milan, Cologne, Paris and Valencia. She is a member of the Professional Designers' Association of Valencia. *(1.72)*

Achille Castiglioni was born in Milan in 1918. He began his work as a designer in partnership with his brothers, Livio and Pier Giacomo Castiglioni, specializing in interiors, furniture and lights. He is particularly well known for the latter, notably the *Toio* uplighter. Castiglioni has been honoured no less than seven times by the Compasso d'Oro, as well as having six of his pieces selected for exhibition at the Museum of Modern Art, New York. *(1.91, 2.45, 5.69)*

Piero Castiglioni was born in Lierna, Italy, in 1944. He graduated in architecture and since 1980 he has been working for Fontana Arte. He collaborated with his father, *Achille Castiglioni*, on the *Scintilla* system which Fontana Arte has been producing since 1983. With *Gae Aulenti* he set up the Musée d'Orsay in Paris. He is currently trying to solve the problems of Palazzo Grassi in Venice and of the museum in Prato. He is also working on structures for the Olympic Games in Barcelona in 1992. *(2.7, 2.22)*

Eric Chan is a partner in the New York firm of Chan + Dolan Industrial Design Inc. He has a Higher Diploma with distinction from the Industrial Design Department of the Hong Kong Polytechnic and a Master's degree in Fine Art from the Cranbrook Academy of Art, Michigan, USA. He is the holder of several US design patents and has won several awards in the USA, Japan and Hong Kong. He has worked for the Hong Kong Trade Development Council, the Plumb Design Group, Henry Dreyfuss Associates and Emilio Ambasz and Associates. *(5.39)*

Lance Chantry was born in Chicago in 1954. He now works for major electronics firms, using robotics and advanced electronics in product design and lighting. He collaborated with *Leo Blackman* on the *Quahog* lamp. *(2.33)*

Hans Amos Christensen was born in Denmark in 1949. He was educated in Copenhagen, and has a Master's degree from the Royal Academy of Fine Arts. He has collaborated with architects including Knud Holcher and Nils Fagerholt. *(1.105)*

Antonio Citterio was born in Italy in 1950. He studied at the Milan Polytechnic, and has done industrial and furniture design since 1967. He opened a studio with Paolo Nava in 1973. They have worked for B&B Italia, Flexform and others. In 1979 they were awarded the Compasso d'Oro. *(2.49)*

Lucy Clegg is a British designer and maker of rugs. She studied at High Wycombe College of Further Education and at the Camberwell School of Arts and Crafts where she took a degree in ceramics. In 1986 she set up her own studio and her work was exhibited in London in 1987. *(4.12)*

Clodagh was Ireland's leading fashion designer for ten years. She then moved to Spain where her interior design work included residential homes, apartments and hotels. She now heads Clodagh Inc., a New York interior design firm, and is a partner in Clodagh, Ross and Williams. Her interiors have won awards and much critical acclaim. *(1.95)*

Luigi Colani is a German designer who was born in 1928 and educated in Berlin and Paris. His designs draw on organic and sculptural influences. Colani has produced ceramics for Rosenthal and Melita, and has worked extensively in Japan. *(5.18)*

Joe Colombo was born in Milan in 1930. He studied architecture at the Milan Polytechnic but gave up his studies to manage his father's company. He returned to architecture during the 1950s. In 1964 he won the In-Arch Prize for his design of the interior of a Sardinian hotel and was also awarded gold medals for objects exhibited at the XIIIth Triennale. He was twice awarded the Compasso d'Oro and in 1968 received the Design International Award in Chicago. His work has been exhibited throughout the world. He died in 1970. *(5.11)*

Laslo Čonek was born in Srbobran, Yugoslavia, in 1954 and graduated from the School of Design in Novi Sad in 1979. He now lives in Italy and since 1985 has worked as a freelance designer and consultant to a number of companies. *(2.20)*

James M. Conner is a senior partner at Henry Dreyfuss Associates, New York, having been with the firm since 1952. His clients include NASA, Honeywell, Lockheed and AT&T. His major design work in recent years has been in farm, industrial and consumer equipment for John Deere and in cameras for Polaroid. *(5.25)*

Corporate Industrial Design (CID) is the design team for the multinational electronics organization Philips. Headed by Mr R. Blaich, CID consists of 115 designers based in Eindhoven in The Netherlands as well as an additional 110 designers worldwide. *(1.87, 2.9, 5.40-41, 5.45)*

Scott Crolla is one of Britain's most acclaimed fashion designers. His London shop is known as a unique source of contemporary fashion. His *Cathedral Chair* is part of the first Alma collection which brings together talents from the disciplines of architecture, interiors and clothes design. *(1.41)*

Alfonso Crotti was born in Milan in 1959. He has a degree in architecture from the Milan Polytechnic. His architectural work is often in collaboration with Alberto Montesi and his product design with *Roberto Marcatti*. *(2.42, 5.70)*

Titi Cusatelli was born in Milan in 1956 and graduated from the Istituto Europeo di Design in 1986. He is an assistant to *Davide Mercatali* and *Paolo Pedrizzetti*, and designs for Noto in collaboration with *Roberto Marcatti*. *(3.44)*

Riccardo Dalisi was born in Potenza, Italy, in 1931. Since 1962 he has been conducting experiments on architectural form using light and geometry, and taking part in competitions connected with building construction at an academic level. He has written a number of books and teaches at the University of Naples. In recent years he has been developing the theme of the Neapolitan coffee-pot for which he won the Compasso d'Oro in 1981. He has been described by *Alessandro Mendini* as "the brains behind design in the South." *(5.55)*

Paulo Mendes da Rocha was born in Vitória, Espírito Santo, Brazil, in 1928. He graduated in architecture from the University of São Paulo in 1954. His major projects include the Brazilian pavilion at the Expo 70 world fair in Osaka, Japan; first prize in the Museum of Ecology and Sculpture Design Competition for a design which was built in 1986; the Calux Kindergarten at São Bernardo do Campo, São Paulo, 1978. He is Professor of Architectural Design in the School of Architecture and Urbanism in the University of São Paulo and has a private practice in that city. The executive version of the *Paulistano* chair won first prize for industrial design awarded by the Museo da Casa Brasileira. *(1.83)*

Philip Davies joined *Moggridge Associates* in 1986 where he is involved in consumer and medical product design, packaging, exhibition and graphic design. He was born in Wales in 1959 and studied at Teeside Polytechnic and at the Royal College of Art in London. He won an RSA Philips Electronics Bursary award in 1981 and a British Telecom postgraduate design award for communication in 1984. *(2.16)*

Paolo Deganello was born in Este, Italy, in 1949. He studied in Florence and from 1963 to 1974 worked as a town planner for the Florence municipality. In 1966 he founded, with *Andrea Branzi*, Gilberio Corretti and Massimo Morozzi, the then avant-garde group Studio Archizoom. In 1975, with Corretti, Franco Gatti and Roberto Querci he founded the Collettivo Tecnici Progettisti. He has taught widely, and has published several books and articles. He has designed products for Marcatre, Vitra, Driade and Cassina and has taken part in many international exhibitions and competitions. *(1.14)*

Corrado Dell'Orso was born in Thurgau, Switzerland, in 1957. He began work as an upholsterer and decorator. In 1982 he founded Dell'Orso Design Zurzach which designs and executes the interiors of yachts and cars, works with leather goods and designs and constructs seating. *(1.84)*

Michele De Lucchi was born in Ferrara, Italy, in 1951. He studied first in Padua and then at Florence University, where he founded the Gruppo Cavat, which produced avant-garde and radical architecture projects, films, texts and happenings. He obtained his degree in architecture from Florence University in 1975 and subsequently became assistant professor to *Adolfo Natalini* at the Faculty of Architecture there, as well as at the International Art University of Florence. In 1978 he left teaching and moved to Milan, where he began a close collaboration with *Ettore Sottsass*. He worked and designed for Alchimia until the establishment of the international group Memphis in 1981. For Memphis he designed and carried out some of their best-known products. In 1979 he became a consultant for Olivetti Synthesis in Massa and in 1984 for Olivetti SPA in Ivrea. Under the supervision of Sottsass he designed Olivetti's *Icarus* office furniture. At the same time, with Sottsass Associati, he designed both the interior decoration and the image of more than fifty Fiorucci shops in Italy and abroad. A series of his household appliances for Zirmi was shown at the Milan Triennale of 1979. He is designing for a wide range of important furniture manufacturers: Acerbis, Artemide, Vistosi, RB Rossana and Fontana Arte. *(1.134)*

Design Central is an industrial design company based in Columbus, Ohio. It was founded in 1985 by Gregg M. Davis, Deborah Davis-Livaich, Paul P. Kolada and Rainer B. Tuefel and now consists of eight designers. The company specializes in industrial design, product design, graphic

communication, package design, exhibition design, 3D modelling and design-related market research. *(5.20, 5.24, 5.59)*

Design Logic was formed in 1985 by David Gresham and Martin Thaler who had previously worked together at ITT Corporate Design Center. David Gresham has a Master of Fine Arts degree from Cranbrook Academy of Art, Michigan. He has taught courses in furniture and product design at the Illinois Institute of Technology in Chicago and has lectured internationally on design. Martin Thaler has a Master of Fine Arts degree from the Royal College of Art, London. Design Logic is based in Chicago. Their projects range from computer equipment and furniture to toys and china. James N. Ludwig is also a member of Design Logic. *(5.35)*

Thomas Dixon is a British sculptor and designer, born in 1959. He produces one-off furniture pieces and fixtures such as chandeliers, generally in response to specific commissions. *(1.29)*

Donghia Design Studio is based in New York City. *(1.43)*

André Dubreuil was born in France in 1951. He studied architecture in Switzerland and design at the Inchbald School of Design in London. He worked as an interior designer and muralist before developing his wrought-iron furniture. He currently lives in London. *(1.135)*

Christian Duc is a French designer living in Paris. After studying, he lived in Amsterdam and then Berlin. He returned to Paris in 1979 and set up DCA Co. which produces his own furniture and tableware designs. He also works as an interior designer, recently for a Paris shop and restaurant. In 1985 he won the interior design prize at the Decorative Artists' Exhibition, Paris. *(4.8)*

Andrzej B. Duljas was born in Poland in 1958. He studied laser microanalysis and researched powders metallurgy before moving to the areas of Fine Arts and design. In the USA he spent two years with the lighting firm of Louis Baldinger and Sons and in 1987 left to join the Koch + Lowy Design Team. He is currently developing his expertise with space metal technology and working on dining tables, wall sconces and lighting accessories. *(2.43)*

Nikodemus Einspieler was born in Klagenfurt/Kaernten, Austria, in 1959. He studied electronics and law. He is also a sculptor and painter, producing furniture and lamps since 1984. *(2.19)*

Thomas Eisl was born in Austria in 1947 and has lived in England since 1969. He was educated at the Central School of Art, London, graduating in Fine Arts in 1977. Since 1981 he has been designing lights, mainly one-offs. *(2.31-32)*

Hans Erich was born in 1942. With *Tom Ahlström* he is the founder of A & E Design, Stockholm, Sweden. *(2.53)*

Etamine began as a boutique in Paris in 1977 selling fabrics and wallpaper and in 1981 expanded to include wholesaling and design activities. All designs are developed by Francine Royneau, Françoise Dorget and Marilyn Gaucher. They now have two boutiques in Paris as well as a trade showroom and a warehouse in Chartres. *(4.62)*

James Evanson is an American, born in 1946. He trained as an architect at the Pratt Institute, New York, and the Art Center College of Design, New

York, and has worked as an artist exploring the boundaries between art and design. *(1.10, 4.22)*

Luciano Fabro was born in Turin, Italy, in 1936 and now lives in Milan. Since 1960 he has been involved in research and design in the fields of sculpture, products, staging and texts. He is linked with the artistic movement known as Arte Povera. He has held solo exhibitions in Milan, Rome, Cologne, Rotterdam and Los Angeles. *(4.37)*

Terry Farrell is one of Britain's best-known architects. With *Doug Streeter*, the Terry Farrell Partnership is responsible for the TV-am building in London and the Henley Boathouse. They are currently working on a site at London Wall and on London's South Bank. *Canterbury* was commissioned for the Alma collection. *(1.47)*

David Field, a British designer, was born in 1946. He studied mechanical engineering and industrial design before graduating from the Royal College of Art, London, in 1972. He teaches at the RCA and at the London College of Furniture. He has designed furniture and one-off commissions for a number of manufacturers and designers, and has exhibited at the Victoria and Albert Museum, London, and the Grand Palais, Paris. *(1.75)*

Norman Foster, the British architect, was born in Manchester in 1935 and studied architecture at the universities of Manchester and Yale. He started in practice as an architect with Richard Rogers in 1965. Since 1969 he has worked independently as Foster Associates. His major buildings include the Sainsbury Centre, Ipswich, and the Hong Kong and Shanghai Bank, Hong Kong. In 1985 Foster began work on a furniture system for Tecno, known as *Nomos*. Foster is a winner of the Royal Gold Medal for Architecture, and many other awards for his buildings. His work has been exhibited at the Museum of Modern Art, New York, and the Royal Academy, London. *(1.46)*

Gianfranco Frattini, an architect and designer of exhibitions, interiors and furniture, was born in Padua, Italy, in 1926. He studied architecture at the Milan Polytechnic, graduating in 1953. He worked for *Gio Ponti* until 1957, when he left to establish his own studio. Since then he has worked for most of the major Italian furniture and lighting manufacturers, including Cassina, Artemide and Arteluce. He has won the Compasso d'Oro six times as well as many other medals and awards, and his work is exhibited throughout Europe and America. *(1.79, 2.51)*

John French was born in England in 1942 and educated at Leeds College of Art. From 1966 to 1977 he practised as a sculptor and since then he has been designing and making wall-hangings and carpets. He has worked in the UK, USA, France, Germany, Scandinavia and the Middle East. He is also a design consultant to the United Nations. *(4.13)*

Dan Friedman was born in the USA in 1946 and educated at the Carnegie Institute of Technology, Pittsburgh, the Hochschule für Gestaltung, Ulm, and the Allgemeine Gewerbeschüle, Basel. He taught art and design at Yale University School of Art and Architecture and at the State University of New York. Since 1975 he has been a freelance artist and designer. *(1.133)*

Frogdesign was established by Hartmut Esslinger, a West German designer born in 1945.

Esslinger studied electrical engineering at the University of Stuttgart and the Fachochschüle für Design in Gmund. Frogdesign is a consultancy with offices in West Germany, America and Japan. It has produced designs for consumer electronics, furniture, hi-fi and TV equipment. *(5.30)*

Derek Frost set up his own design consultancy in London in 1984, having previously trained and worked with Mary Fox Linton. His interior design projects, both commercial and residential, are wide-ranging. He also has an interest in one-off furniture design and works with some of Britain's best cabinetmakers and craftworkers. *(1.33-34)*

Olivier Gagnère was born in Paris, where he still lives and works, in 1952. In 1981 he collaborated with Memphis in Milan and had a solo exhibition at Galerie Détails in Paris. His work has been exhibited at galleries and museums throughout Europe and is in permanent collections, including those of the Musée des Arts Décoratifs, Paris, and the Museum of Modern Art, San Francisco. *(3.1, 3.26)*

Jorge Armando Garcia Garay was born in Buenos Aires, Argentina, and has been working in Barcelona since 1979 where he heads Garcia Garay Design. His work in 1987 included a series of tables, an umbrella stand and a wall lamp. For 1988 his work includes the *Fenix* floor and suspension lamp. *(2.40)*

Elisabeth Garouste see *Mattia Bonetti*. *(1.40)*

Bruno Gecchelin is an Italian architect, born in Milan in 1939. He studied architecture at the Milan Polytechnic and began his career in 1962, working with many major companies. *(2.5)*

Earl Gee was born in Los Angeles, USA, in 1960. He studied graphics and packaging design at the Art Center College of Design, graduating in 1983. In 1984 he joined Mark Anderson Design in Palo Alto, California, a multi-disciplinary consultancy. He has received numerous awards for his designs. *(5.52)*

Frank O. Gehry, a principal of Frank Gehry and Associates, Los Angeles, was born in Toronto, Canada, in 1929. He has won many awards and is a Fellow of the American Institute of Architects. His designs have been widely published and exhibited, in particular at the Museum of Modern Art, New York, and at the Louvre, Paris. *(1.8)*

Keith L. Gibbons was born in 1946 in London where he attended the Royal College of Art. Since 1972 he has been designing and manufacturing furniture and lighting for small batch production. Recently he has specialized in one-offs. *(1.73)*

Gian Nicola Gigante see *Marilena Boccato*. *(2.44)*

Ernesto Gismondi is an Italian designer, engineer and industrialist. He was born in San Remo in 1931 and studied aeronautical engineering at the Milan Polytechnic and the School of Engineering, Rome. He established the lighting company Artemide in 1959, initially producing lamps in small quantities using handcraft techniques and later working on the lighting of large areas for institutional customers. As well as employing some of the world's foremost designers to work for Artemide, Gismondi has himself produced successful lights for his company. He is also managing director of Reglar, a company involved in the production and moulding of SMC (sheet moulding compound), a

thermoplastic suitable for use in the production of furniture and industrial articles, which Gismondi himself developed in 1966. *(2.30)*

Robly A. Glover Jr received a degree in Fine Arts from Indiana State University in 1987. He is a freelance designer and craftsman. *(2.46)*

Sue Golden is a British artist. After an art-school training in London, she began to produce small, one-off sculptural work, drawing on tribal art: mirrors, vases and, in 1987, the *Shield Chair*. *(1.18)*

Piers Gough is a British architect, born in Brighton, England, in 1946. He practised with Wilkinson Calvert and Gough, 1968-72, as Piers Gough, 1972-5, and now with Campbell Zogolovitch Wilkinson and Gough. His *Chaise Langue* was commissioned by Aram Design Ltd. *(1.27)*

Michael Graves, the Princeton architect, famed for his Post-Modern classicism, was born in 1934. His work, which has received numerous awards, includes the Newark Museum, the Whitney Museum, a library in San Juan Capistrano, the Humana Headquarters in Louisville and a winery in Napa Valley. His painting and murals are in several major museums and he has designed furniture for Memphis and Sawaya & Moroni and products for Alessi and Swid Powell. *(2.28, 5.4)*

Eileen Gray was born in Enniscorthy, Ireland, in 1878. She studied at the Slade School of Art in London (she was one of the first women to be admitted) and in Paris. Pursuing her interest in Japanese lacquer, she studied with the Japanese craftsman Sugawara. In 1907 she bought an apartment in Paris where she lived until her death in 1976. During the 1920s and 1930s, working in architecture and interior design, she became a leading exponent of the revolutionary new theories of design and construction and worked with outstanding figures of the modern movement, including J.J.P. Oud and Le Corbusier. In the 1960s her work was "rediscovered" and revived. In 1972 she was appointed a Royal Designer to Industry. *(1.63)*

Laura Griziotti is a graduate of the Milan Polytechnic and works as an architect and industrial designer. She has been a member of several juries and has received a Compasso d'Oro and the Lubiana Gold Medal. *(3.63)*

Maty Grunberg is a sculptor. Born in 1943, he studied at the Bezalel Academy of Arts in Jerusalem and the Central School of Arts and Design, London. He has had several exhibitions in the UK and abroad. His *D-Table* for Aram Design Ltd was inspired by a formula by the nineteenth-century mathematician Henry Ernest Dudeney – the conversion of a triangle into a square and vice versa. *(1.122)*

Silvia Gubern studied art and graphic design at the Elisava School, Spain, but decided to paint. She now lives and teaches in Barcelona and works in graphic, interior, industrial and textile design. *(4.51)*

Monica Guggisberg was born in Bern in 1955 and studied at Orrefors Glasskolan, Sweden, from 1979 to 1981. Since 1982 she has collaborated with *Philip Baldwin* in Nonfoux, Switzerland. *(3.66)*

Gwathmey Siegel is a well-known New York architectural firm which has won many design awards, including the American Institute of Architects' highest honour, 1982, and the AIA Gold Medal in 1983. Charles Gwathmey was born in 1938.

He received a Master's degree from Yale in 1962 and since 1964 has taught architectural design at Yale, Princeton, Columbia and Harvard. In 1981 he became a Fellow of the AIA. *See also Robert Siegel. (3.6)*

Zaha Hadid was born in Baghdad, Iraq, in 1950. She graduated from the Architectural Association, London, in 1977 and in the same year joined the Office of Metropolitan Architecture. In 1982 she was awarded a gold medal in the *Architectural Digest* British Architecture Awards for an apartment conversion in London and in 1983 she won first prize in the Peak International Competition, Hong Kong. She lives in London and is currently at work on projects in Germany and Tokyo. *(1.112-115)*

Dorothy Hafner was born in 1952 in Woodbridge, Connecticut, and studied art at Skidmore College, New York. Her hand-painted porcelain is in numerous collections, including the Smithsonian Institute, Washington DC, and the Victoria and Albert Museum in London. Her dinnerware has featured in many exhibitions and she has held solo shows throughout the USA and Europe. In 1982 she began her first porcelain collection for the Rosenthal Studio Line in West Germany, the first American woman to do so. *(3.14)*

Celia Harrington is a British textile designer. She studied in London at Goldsmiths College and then at the Central School of Art and Design. She undertakes commissions worldwide. *(4.20)*

Niels Jørgen Haugesen trained as a cabinetmaker and completed his studies at the School for Arts and Crafts, Copenhagen, in 1961. He worked for Arne Jacobsen until 1971 when he opened his own design office. Since 1973 he has also taught furniture design at the School for Arts and Crafts. His furniture has won many prizes and been exhibited. In 1987 the *Haugesen Table* won the Danish Design Council's ID Prize. *(1.102)*

Robert and Trix Haussmann studied architecture in Zurich and began a practice together in 1967. Their work covers interior design, restoration work, textiles, furniture and ceramics. *(3.49)*

John Hejduk was born in New York in 1929. He studied at the Cooper Union School of Art and Architecture, New York, the University of Cincinnati and at the Harvard Graduate School of Design. He studied under Pier Luigi Nervi at the University of Rome. He has worked with various architectural practices in New York and since 1975 has been Dean of the School of Architecture, Cooper Union, New York. *(1.120)*

David Hertz studied at the Southern California Institute of Architecture. He has worked for *Frank O. Gehry* and Associates, John Lautner and G.M. Shaw Design. His work has been exhibited throughout the USA and in Japan. His commissions include concrete tables and bars for a restaurant, sculptural seating pieces for employees and public spaces at the General Telephones corporate headquarters in Los Angeles, display tables for clothing stores, and counter, displays and retail vases for a Los Angeles flower shop. His work has been featured in journals and newspapers worldwide. *(3.19)*

Titus Hertzberger was born in 1965 and is studying industrial design at the University of Delft, The Netherlands. *(5.14)*

Chris Hiemstra *see Lumiance Design Team.* *(2.6)*

Matthew Hilton, born in 1957, is a British designer. He studied furniture design at Kingston Polytechnic and then worked with the product-design consultancy CAPA for five years on a variety of high-technology products. He became an independent furniture and interior designer in 1984, producing lights as well as furniture. In 1986 he designed a range of furniture for Sheridan Coakley which was shown in Milan, and in 1987 exhibited in Tokyo with *Jasper Morrison. (1.2, 1.15, 3.34-36)*

Yoshiki Hishinuma, a textile designer, was born in Sendai Prefecture, Japan, in 1958. He worked for the Miyake Design Studio in 1978, and is now a freelance fashion, textile and bag designer. In 1984 he established the Hishinuma Design Institute and introduced his first collections. *(4.55, 4.57)*

Diana Hobson was born in 1943 in Stoke on Trent, UK. She worked briefly for Clarisse Cliff before studying ceramics at Stoke on Trent School of Art and then silversmithing at the Royal College of Art, London, where she graduated in 1976. Since 1979 she has taught at the Camberwell School of Art, London, and has worked in glass since 1983. Her work is in the collections of the Victoria and Albert Museum, the Crafts Council and the Tate Gallery, London, the Cooper-Hewitt Museum of Decorative Arts and Design and the Corning Museum of Glass, New York, the Musée des Arts Décoratifs in Paris, Der Vest, Coburg, West Germany, the Museum für Kunst und Gewerbe, Hamburg and the Ulster Museum, Belfast. *(3.64)*

Jochen Hoffmann was born in Germany in 1940. He studied industrial design at the Hochschüle für Bildende Kunste in Braunschweig. Since 1970 he has worked as a freelance designer in Bielefeld, Germany, and has won several awards. *(1.82)*

Steven Holl is an American architect who was born in Bremerton, Washington, in 1947. He studied at the University of Washington and at the Architectural Association, London. He heads Steven Holl Architects in New York and is Adjunct Professor of Architecture at Columbia University Graduate School of Architecture and Planning, New York. His furniture designs are included in the Whitney Museum of American Art's Twentieth Century Design Exhibition and his drawings have been shown throughout America and Europe. *(1.89)*

Hans Hollein was born in Vienna, Austria, in 1934. He received his diploma from the Academy of Figurative Arts in Vienna, attended the Illinois Institute of Technology in Chicago and obtained a Master's degree in architecture at Berkeley University. He has received numerous awards and is a member of various committees and juries. He has undertaken design projects for companies such as Herman Miller, Cleto Munari, Alessi, Memphis, Poltronova, Knoll International, Baleri and Swid Powell. Since 1978 he has been the Austrian Commissar for the Venice Biennale. *(5.3)*

Ullrich Höreth was born in Munich, West Germany, in 1957 and studied visual communication in Würzburg. A designer and commercial artist, he now lives in Vienna, Austria. *(2.41)*

Bev Houlding, a British designer, trained at Goldsmiths College, London. With painter and print-maker Mark Houlding, she established the Screens Gallery Workshops in 1984 to produce commissioned one-off screens and limited batch runs. She has exhibited throughout the UK. *(1.20)*

Thomas Hucker was born in the USA in 1955. He graduated in furniture design from Boston University. In 1982 he was artist-in-residence at the Tokyo University of Fine Arts. Since 1983, as Thomas Hucker Design, he has been a furniture designer and maker, winning several awards. *(2.54)*

Anthony Hunt is a structural engineer. He was born in the UK in 1932 and studied at Westminster Technical College, London. He is senior partner and founder, in 1962, of Anthony Hunt Associates, Consulting Engineers. *(1.85)*

The Imperial Woodworks, a group of craftsmen, furniture-makers and designers, was established in 1980 by Brian James (who trained at St Martin's School of Art, London and the Royal College of Art, London) and David Davies (who trained as an engineer at Luton). Imperial Woodworks have exhibited in galleries in the UK and have produced pieces for American and West German collectors and interior designers. *(1.54)*

Massimo Iosa-Ghini is an Italian designer working in furniture, textiles, fashion and advertising. Born in 1959 in Borgo Tossignano, he studied in Florence and graduated in architecture in Milan. In 1981 he joined the group Zak-Ark, and from 1984 has collaborated with the firm AGO. Since 1982 he has worked on a number of discotheques, video projects and magazines. In 1986 he took part in the Memphis group's "12 New" collection and has continued to design pieces for Memphis. *(1.13)*

Fujiwo Ishimoto was born in Ehime, Japan, in 1941 and studied design and graphics in Tokyo. From 1964 to 1970 he was a commercial artist, from 1970 to 1974 a designer at Decembre and from 1974 onwards a printed textile designer for Marimekko, Finland. In 1983 he was awarded both the Roscoe Prize and an honourable mention at the Finland Designs Exhibition. *(4.43)*

Arata Isozaki was born in Kyushu in 1931 and studied at the University of Tokyo. He founded his own studio in 1963 and continued to collaborate with other architects and studios as well. Among his projects are the Gunma Prefectural Museum of Modern Art at Takasaki (1971-2), the Kitakyshu City Museum of Art (1972-4), the Shukosha Building at Fukoka (1975), the Fujimi Country Clubhouse at Oita (1972-4), the City Hall in Tokyo and the Museum of Contemporary Art in Los Angeles (both 1986). *(5.2)*

Elizabeth Browning Jackson, the American artist and designer, was born in 1948 and educated at San Francisco Art Academy, the University of New Mexico and Capella Gardin, Sweden. Her work has been shown at the Gallery of Applied Arts, San Francisco, Art et Industrie, New York, Arqitectonica, Miami, Grace Designs, Dallas, and Axis, Tokyo. *(4.18)*

Charles Jencks was born in Baltimore, USA, in 1939. He teaches at the Architectural Association, London, and at California University, Los Angeles. He is widely known for his writings on architecture and his designs have been most influential. *(1.65)*

Jacob Jensen was born in Copenhagen in 1926. He was educated at the School for Handicrafts, specializing in industrial design. From 1952 to 1959 he was Count Bernadotte's chief designer and moved to the USA where he taught at the University of Chicago. In 1961 he returned to Denmark and started his own company. He has designed over 200 industrial projects, many for Bang & Olufsen. Twelve pieces have been selected by the Museum of Modern Art in New York. He has received nearly one hundred prizes worldwide. *(5.33, 5.49)*

Eva Jiricna is an architect and interior designer who was born and educated in Prague and who has lived and worked in London since 1968. After working for a number of architects in London, notably Richard Rogers, she established her own practice, Jiricna Kerr Associates, with Kathy Kerr in 1984. They have worked on a number of interiors in London, notably for Harrod's and Lloyds. *(1.42)*

Allen Jones RA is a British artist born in Southampton, England, in 1937. He has exhibited extensively and is represented in numerous public and private collections around the world. His *Love Seat* was designed on the invitation of Aram Design Ltd, London. *(1.17)*

Christoph Jünger was born in Munich, West Germany, in 1956. From 1978 to 1981 he was an apprentice silversmith and in 1984 began studying at the Munich Academy of Art. In 1985 he taught as a guest lecturer at Rhode Island School of Design, USA, and in 1986 returned to Munich. *(3.68)*

Shiu Kay Kan is a British designer living in London. He studied architecture at the Architectural Association and at the Polytechnic of Central London. He started SKK Lighting in 1978 and his first design was the *Kite Lite*; the *Stickleback*, featured here, is his most recent piece, designed in conjunction with Jon Cole. *(2.35)*

Tomu Katayanagi was born in Tokyo in 1950 where he studied architecture and design. From 1972 to 1977 he worked in Italy with *Cini Boeri*, returning in 1981 from Ikeno's architectural studio in Tokyo. He was awarded the Medaglia d'Oro at the Triennale in 1973 and the Casa Amica prize in 1974. *(1.25)*

Motomi Kawakami was born in Hyogo Prefecture, Japan, in 1940. He graduated from the Tokyo National University of Arts in 1966 and worked in a Milan architectural practice. In 1970 he began to give lectures in design at the Faculty of Fine Arts, Tokyo National University, and in 1971 established the Kawakami Design Office. He has had several exhibitions and won the IF Design Award, West Germany, in 1981 and 1982 and the Grand Prize of the Package Design Award in Japan in 1985. *(1.106)*

Rei Kawakubo is a Japanese fashion designer. She graduated in Fine Arts from the Keio University, Tokyo. After two years working for a textile manufacturer, she started to work as a freelance stylist, establishing her own fashion company, Comme des Garçons, in 1973, an enterprise which has been, with *Issey Miyake* and Yamamoto, responsible for giving avant-garde Japanese fashion a leading world role. Kawakubo has designed furniture and products, and in 1986 established a product-design studio in Tokyo to concentrate on such projects. *(1.94)*

Kazuo Kawasaki was born in Fukui City, Japan, in 1949. He graduated in industrial arts from the Kanazawa University of Arts in 1972. Until 1979

he was creative director for product planning at Toshiba. In 1979-80 he practised as a freelance designer and since 1980 he has been president of Ex-Design Co. He lectures in architectural design at Fukui University and is a part-time instructor at the Kanazawa University of Arts, as well as the Technical Advisor for the Fukui Prefecture. *(5.61)*

Perry A. King was born in London in 1938 and studied at the School of Industrial Design, Birmingham. He later moved to Italy to work as a consultant to Olivetti, designing among other things the *Valentine* typewriter in collaboration with *Ettore Sottsass*. For the last thirteen years he has worked in collaboration with *Santiago Miranda* from their office, King Miranda Associati, in Milan, in the fields of industrial design, furniture and interior design, lighting design and graphics. Their work has received several awards and has been exhibited and published in Italy and abroad. *(1.9)*

Rodney Kinsman was born in London in 1943. He has a degree in furniture design from the Central School of Art, London. In 1966 he founded OMK Design Ltd to produce and promote his own designs. OMK now has licensing and marketing links worldwide. In 1983 he received a Fellowship from the Society of Industrial Artists and Designers (now the Chartered Society of Designers). He is also the chief design consultant to Kinsman Associates, specializing in design work commissioned internationally from independent companies. *(1.111)*

Toshiyuki Kita was born in 1942 in Osaka, Japan. He graduated in industrial design in 1964. Since 1969 he has divided his time between Osaka and Milan, working on furniture and accessories for many of the major manufacturers. He has received the Japan Interior Design Award, the Kitaro Kunii Industrial Design Award and the Mainichi Design Award. The *Wink* armchair and *Kick* table for Cassina are in the collection of the Museum of Modern Art, New York. In 1987 he took part in the celebrations for the tenth anniversary of the Centre Georges Pompidou in Paris. *(1.136)*

Setsuo Kitaoka was born in Kouchi Shikoku, Japan, in 1946. In 1974 he graduated from the Department of Living Design at the Kuwazawa Design Institute and joined Yamaguchi Co. Ltd. In 1977 he established the Kitoaka Design Office in Tokyo. *(1.78, 2.37)*

Liz Kitching is a London-based designer and maker of hand-tufted rugs. She works for architects, designers and private clients. *(4.19, 4.21, 4.23)*

Johannes Peter Klien was born in Austria in 1946. He graduated from the College of Applied Arts in Vienna. From 1973-9 he worked in Paris, first with Christian Hunziker and then with Formes Industrielles. In 1979 he opened his own office, Design Form Technik, in Vaduz, Liechtenstein. His work has been exhibited in Germany and Austria; in 1984 he won the Golden Sound Award, Japan. *(2.11)*

Makoto Komatsu was born in 1943 in Tokyo. He graduated from art school there, then went to work for the Swedish glass-maker Gustavsberg. After returning to Japan he began working as an independent designer. His work is in the permanent collections of the Museum of Ceramics, Faenza, the New York Museum of Modern Art and the Victoria and Albert Museum, London. *(5.67)*

Geert Koster was born in Groningen, The Netherlands, in 1961 and graduated from the School of Interior Design, Minerva Academy of Art, in 1984. In 1984-5 he studied at the Domus Academy in Milan. Since 1978 he has been a consultant for Vorm-Martini, The Netherlands, and since 1985 he has collaborated with *Michele De Lucchi* as part of Solid, eight young designers including *Angelo Micheli*, who produce small but essential items for the home, launched in 1986. *(3.37)*

Lisa Krohn graduated in studio art and art history from Brown University, USA, in 1985. She also studied industrial design at the Rhode Island School of Design. She has worked as a freelance designer in New York for Walker Group/CNI, the Richard Penney Group and Smart Design. In 1986 she entered the MFA programme at the Cranbrook Academy of Art. Her *Phonebook*, designed with *Tucker Viemeister*, won the 1987 Forma Finlandia International Design Competition among other accolades. She is editor of the newsletter of the New York chapter of the Industrial Designers' Society of America. In her spare time she produces and markets her jewellery designs. *(5.1)*

Otto Krüger was born in 1868. He became manager of the Munich-based firm of Vereinigte Werkstätten which was founded in 1898. He opened his own arts and crafts studio in Munich in 1912 and became director of a workshop for the study of colour in 1920. He died in 1938. *(2.17)*

Yrjö Kukkapuro was born in Wyborg, Finland, in 1933 and studied at the Helsinki Institute of Crafts and Design. He opened Studio Kukkapuro in 1959. He has taught in the Department of Architecture, Helsinki Polytechnic and was a professor and then the Rector of the University of Industrial Arts, 1974-80. He has held solo exhibitions of his work in Milan, Amsterdam, London, Vienna, Oslo and Lahti and won prizes in Scandinavia and the USA. His work is in the collections of museums in New York, London, Helsinki, Hamburg and Copenhagen. *(1.126)*

Shiro Kuramata was born in Tokyo in 1934. He started an independent practice as a furniture designer in 1965, having served an apprenticeship in cabinetmaking. Apart from his celebrated glass armchair of 1976, and other pieces of furniture, Kuramata has designed interiors for *Issey Miyake* and for the Seibu stores. In 1981 he received the Japan Cultural Design Prize. *(1.32, 1.88, 1.90)*

Masayuki Kurokawa was born in Nagoya, Japan, in 1937. He graduated from the Department of Architecture at the Nagoya Institute of Technology in 1961 and completed his training in the Graduate School of Architecture at Waseda University in 1967. That same year he established Masayuki Kurokawa Architect and Associates. In 1970 he won first prize in the International Design Competition for a mass-production house, in 1973 he won first prize in the Competition for Interior Vertical Element of House, and in 1976 he won the annual prize of the Japan Interior Designers Association for a series of interior elements. He has won six IF prizes for his designs of tables and lighting fixtures. *(2.1, 5.60)*

James Kutasi was born in Sydney, Australia, in 1955. He studied architecture at Sydney University and cabinetmaking at the London College of Furniture, 1982-3, and Sydney Technical College,

1984. His work has been exhibited in London and Sydney and in 1987 he won the Australian Wilsonart Design Award for the chair featured here. He lives and works in New South Wales. *(1.141)*

Willie Landels was born in Venice in 1928 and has lived in London since 1951. He was editor of *Harpers & Queen* and is currently art director of *Departures* magazine. *(1.55)*

Danny Lane was born in 1955 in the USA. He went to Britain in 1975 to work with the stained-glass artist Patrick Reyntiens, and then studied painting at the Central School of Art, London, until 1980. The following year he set up his first studio in London's East End. In 1983 he established Glassworks, using glass in one-off pieces, furniture and interiors. In 1986 his studio was equipped to handle large-scale architectural installations. Since 1985 he has frequently been invited to exhibit in the UK and abroad. Recently he has been working on glass and forged steel constructions. *(1.26)*

Jürgen Lange was born in 1940 in Ratzeburg, West Germany. He trained as a cabinetmaker then studied industrial design in Braunschweig. In 1968 he established his own design studio in Grafenau, Würtemberg. From 1981 to 1986 he was Professor of Furniture Design at Offenbach. He is a member of many international design juries. *(1.16)*

Jack Lenor Larsen, the American textile designer, was born in 1927. He trained at the University of Washington, Seattle, and at the Cranbrook Academy of Art, Michigan, graduating in 1951. The next year he opened a studio in New York. His first major commission was for textiles for the new Lever Building, and this led to other large-scale projects such as upholstery for Pan Am and Braniff, quilted-silk banners for the Sears Bank in the Sears Tower, Chicago, and upholstery collections for Cassina (1981) and Vescom. Larsen Carpet and Larsen Leather were established in 1973 and Larsen Furniture in 1976. Larsen has received numerous honours and awards including a gold medal at the 1964 Milan Triennale and a nomination as a Royal Designer for Industry in 1982. *(4.44-45)*

Peter Layton was born in Prague in 1937. He has a diploma in ceramics from the Central School of Art, London, and taught for ten years from 1965 in art schools in the UK and the USA. In 1976 he established the London Glassblowing Workshop. He was chairman of British Artists in Glass, 1982-4. His work has been exhibited widely. *(3.62)*

Jennifer Lee was born in 1956 in Aberdeenshire, Scotland. She studied at the Edinburgh College of Art and at the Royal College of Art, London. In 1979-80 she was awarded an Andrew Grant Travelling Scholarship to the USA. Her hand-built pots have been exhibited in the UK, USA and throughout Europe and are in the collections of the Victoria and Albert Museum, London, the Royal Scottish Museum, Edinburgh, Hawkes Bay Gallery and Museum, Napier, New Zealand, and the Los Angeles County Museum of Art. *(3.15-18)*

Peter Leonard was born in Suffolk, England, in 1954. He studied at the Cambridge College of Arts and Technology, Kingston Polytechnic and at Northwestern University, Chicago. He worked as an interior designer with Frederick Gibbert, then with Conran Associates before establishing his own design consultancy in

1981. In 1986 he opened Soho Design Ltd, a furniture and accessories shop in London. *(1.36-37, 2.48)*

Max Leser, a Canadian designer, was born in London, UK. He studied ceramics at the Banff School of Fine Arts, Alberta, and glass-working at Georgian College, Barrie, Ontario, the Sheridan School of Design, Mississauga, Ontario, the Alberta College of Art and the Pilchuck Glass Center, Stanwood, Washington. In 1984 he was commissioned by the city of Toronto to create a limited edition sculpture for the Gardiner Award, and in 1986 he was commissioned to create a transparent time capsule for the lobby of the new North American Life tower in Toronto. His work has been exhibited worldwide and is in permanent collections in Canada and the USA. He currently lives in Toronto where he is president of Leser Design Inc. which specializes in modern glass products. *(1.107, 3.54-59)*

Vittorio Livi is inextricably linked with the Italian company Fiam which was founded in 1974 and which specializes in producing designs in curved crystal. Livi has been refining techniques for working with crystal since the 1960s and the creation of Fiam marked a turning point in his career. *(1.110)*

Josep Lluscà was born in Barcelona in 1948. He studied design at the Escola Eina, Barcelona, and the Ecole des Arts et Métiers, Montreal. He was vice-president of the Industrial Designers' Association 1985-7 and a member of the Design Council of the Catalonian government. He is a professor at the Escola Eina. He has won several awards and taken part in international conferences and exhibitions. *(5.56)*

Steven Lombardi has designed numerous residential and commercial buildings, but since 1979 the design of furniture and lighting and Fine Art have also played an important part in his working life. His pieces include stainless- steel clocks, modular seating and whimsical robots. His work has been exhibited in Italy and abroad. *(2.50)*

Dietrich Lubs see Braun Product Design Team. *(5.28)*

Paul Ludick was born in Ohio, USA, in 1957. He studied Fine Arts at Kent State University and in 1981 moved to New York and worked in carpentry. He began to exhibit his artworks in 1983 and has subsequently been featured in several publications. His work includes set designs for rock music videos, multi-media sculpture and performance art. *(1.39)*

Lumiance Design Team is based in Haarlem, The Netherlands, under the direction of Chris Hiemstra, head of the research and design department. Born in 1942, Hiemstra studied graphic, interior and industrial design and was co-owner of Hiemstra/ Swaak, an industrial design office, before joining Lumiance in 1970. *(2.6)*

Margaret McCurry see Stanley Tigerman. *(3.5)*

Mark McDonnell is an American designer, born in Egypt in 1954. He was educated at the Rhode Island School of Design, graduating in 1979. McDonnell designs and makes one-off objects, which are in of the Musée des Arts Décoratifs, Paris, the Corning Museum of Glass, New York, the Haaretz Musuem, Tel Aviv, the Glasmuseum, Ebeltoft, Denmark, the Museum of Applied Arts,

Helsinki, the Museu de Art, São Paulo, and the Museum of Fine Arts, Boston. He is chairman of the Glass Program at California College of Arts and Crafts, Oakland. *(5.9)*

Chris McElhinny is an Australian designer and furniture-maker, born in 1958. He studied at the John Makepeace School for Craftsmen in Wood and from 1982-4 was craftsman-in-residence at Cuppacumbalong Tharwa, ACT. Since 1984 he has lectured in wood and design at Canberra School of Art. *(1.74)*

Daniel Mack Rustic Furnishing is based in New York City. Mack believes that "Rustic furniture is becoming part of the grammar of American design" and his workshop is filled with branches, logs and sticks. His work has been exhibited throughout America and featured widely in magazines and newspapers. *(1.52)*

Harvey John Mackie was born in London in 1952. He has qualifications in electronics, was a commercial photographer from 1974-9 and a musician from 1979-82. In 1982 a venture making 1930s-inspired radios was a critical but not commercial success. Using a more design-oriented approach he has now produced a range of witty pieces from Colorado, his north London workshop. *(2.25, 5.42)*

Charles Rennie Mackintosh was born in Glasgow in 1868 and died in London in 1928. He established an international reputation in the late 1890s through the publication of illustrations of his work in the *Studio*. His reputation was further enhanced by a portfolio of his competition designs for the House of an Art Lover *(Haus eines Kunstfreundes)* which was issued by Alexander Koch of Darmstadt in 1902. His Glasgow School of Art (1897-1909), which was little publicized at the time, is now considered to be one of the most brilliant of proto-Modern Movement buildings. He was a prolific designer of furniture, textiles and graphics, as well as an accomplished watercolour artist. *(1.69-70)*

Vico Magistretti was born in Milan in 1920. He took a degree in architecture in 1945 and subsequently joined his father's studio. Until 1960 he was mainly concerned with architecture, town planning and interiors. He began designing furniture and household articles for his buildings in the 1960s and collaborates closely with the companies, e.g. Alias, Artemide, Cassina, Conran Habitat, De Padova, Knoll International, O-Luce, which produce his designs. He has participated in nearly all the Triennale since 1948 and has won numerous awards. Fifteen pieces are in the collection of the Museum of Modern Art in New York. *(2.21, 5.68)*

Roger Mann was born in London in 1959 and has a degree in interior design from Kingston Polytechnic. In 1982-3 he worked as a freelance for Beardsmore Yauner Architects, John Herbert Design Associates and Arup Associates, winning a Royal Society of Arts Travel Bursary. He has worked with *Dinah Casson* since 1984. *(2.36, 4.52)*

Pio Manzù was born in Bergamo, Italy, in 1939. He studied at the Hochschule für Gestaltung, Ulm. In 1962, together with Michael Conrad, he won an international competition held by *Revue Automobile* for the design of a new coupé body for an Austin Healey 100 chassis. He became a consultant to Centro Stile Fiat in 1968, devoting his research to small powered cars. He died in 1969 in a road accident at Brandizzo on the motorway to Turin. *(5.10)*

Roberto Marcatti was born in 1960 in Milan. He graduated in architecture from the Milan Polytechnic and has since designed lights for the Milan-based firm Zeus. He also collaborates with Maurizio Peregalli, *Titi Cusatelli* and *Alfonso Crotti*. With *Frank O. Gehry* and Claes Oldenburg he worked on a project for Venice. *(2.42, 3.44)*

Gualtiero Marchesi is a leading Italian chef who has three stars in the *Michelin Guide*. His concern for the presentation as well as the preparation of food led to the development of the *Gualtiero Marchesi Idea* featured here. *(3.8)*

Javier Mariscal, a Spanish designer, was born in 1950. He trained as an artist and graphic designer and worked on the Memphis collection of 1981. He has designed lights with Pepe Cortés for BD, textiles for Marieta and carpets for Nani Marquina. *(4.11, 4.53)*

Nani Marquina was born in Barcelona in 1952. She studied design at the Escola Massana. She designs interiors and textiles and, with Pep Feliu, started her own company, based in Barcelona. Among the designers whose work she produces are *Javier Mariscal, Eduard Samso* and *Peret*. *(4.17)*

Vicent Martinez is a Spanish designer, born in Valencia in 1949. He studied drawing, clay modelling and graphic design at the Escuela de Artes Aplicadas in Valencia and went on to further studies at the Escola Massana in Barcelona. He started his career in graphic design, then in 1972 set up his own design studio specializing in industrial design and furniture. In 1980 he established the firm Punt Mobles. Since then he has received several design awards and in 1986 took part in the Design Day exhibition at the Museum of Contemporary Art, Mallorca. *(1.97)*

Lars Mathiesen was born in Denmark in 1950. After architectural studies he was employed by Box 25, Architects, and by Vast-Kyst Stugan. In 1978 he established Pelikan Design with Niels Gammelgaard. He has won several prizes and teaches at the Royal Academy of Fine Arts, Copenhagen. *(1.57)*

Ingo Maurer was born in West Germany in 1932. After training as a typographer and graphic artist in Germany and Switzerland, he emigrated to America in 1960. He moved back to Europe in 1963 and started his own lighting design firm, Design M, in 1966. His work has been collected by museums in Israel and Japan, by the Museum of Modern Art, New York, and by the Neue Sammlung, Munich. *(2.2-3)*

Sigi Mayer is the creative director at Franz Schatzl Design Werkstätten where he collaborated with *Wolfgang Schatzl* on jewel boxes. He was born in Bad-Goisern, Austria, in 1950 and attended the Academy of Art in Vienna. He has worked in advertising and product design. *(3.22-25)*

Richard Meier was born in the USA in 1934. He founded Richard Meier and Partners Architects in New York in 1963. He has taught at the Cooper Union School of Art and Architecture, New York, and at Yale and Harvard universities. Recent works include the High Museum in Atlanta, the Museum for the Decorative Arts in Frankfurt, the J. Paul Getty Center in Los Angeles and a new city hall for The Hague in The Netherlands. He also designs ceramics and silverware for Swid Powell. *(3.46-47, 3.50)*

Shari M. Mendelson studied jewellery and metalsmithing at Arizona State University and Suny, New Paltz, New York. Her one-off bowls and vessels have been exhibited throughout the USA and she was awarded a Prize for Excellence in 1986 at the Designer Craft Council Show at the Schenectady Museum, New York. She is an instructor in metals and holds workshops and seminars. *(3.28)*

Alessandro Mendini was born in Milan in 1931. He was a partner of Nizzoli Associates until 1970, and a founder member of Global Tools. He then edited *Casabella* and *Modo* and, until 1985, *Domus*. He has collaborated with a number of companies, and received the Compasso d'Oro in 1979. *(2.29)*

Davide Mercatali was born in Milan in 1948. After receiving a degree in architecture in 1973, he worked as an illustrator and graphic designer. His first industrial designs were decorations for materials and tiles. In 1978 he and *Paolo Pedrizzetti* designed *I Balocchi*, a collection of coloured taps and bathroom accessories produced by Fantini. Since then he and Pedrizzetti, with whom he formed a design partnership in 1982, have designed household goods, electrical appliances, interior decoration, lighting fixtures, accessories and building components and tools. They have twice won the Compasso d'Oro. *(5.63)*

Bruce Metcalf has a Master's degree from the Tyler School of Art, USA. He is currently Associate Professor of Art at Kent State University, Ohio. Since 1971 he has held twenty-four solo and two-person exhibitions and taken part in over 130 competitive and invitational exhibitions. *(3.33)*

Angelo Micheli was born in Cremona, Italy, in 1959. He studied architecture and design at the Milan Polytechnic. He has worked at *Michele De Lucchi*'s studio in Milan since 1984 and participated in the "12 New" Memphis collection in 1986. With *Geert Koster*, he is a member of Solid, a new group of eight young designers. *(3.48)*

Santiago Miranda is a Spanish designer, born in Seville in 1947. He trained at the Escuela de Artes Aplicadas in Seville before moving to Italy where he has worked ever since with *Perry A. King*. *(1.9)*

Carlos Miret is a Spanish architect born in 1950. He designs furniture for Amat Meubles and works in the Zaragoza area of Spain. *(1.101)*

Issey Miyake was born in Hiroshima, Japan, in 1938. He graduated from Tama Art University in 1964. From 1965-70 he was a fashion designer in Paris and in 1970 he established the Miyake Design Office, Tokyo. The leading Japanese fashion designer, he is now exploring other design areas. *(5.16)*

Eiji Miyamoto was born in 1948 near Tokyo and graduated from Hosei University in 1970. Miyamoto began developing and designing fabrics in 1975 and now supplies leading Japanese fashion designers, including *Issey Miyake*. *(4.33-35)*

Moggridge Associates was established by Bill Moggridge, a British industrial designer, in London in 1969. ID Two, a Californian offshoot, was established in 1979, and a third office, Design Drei, in West Germany in 1987. *See also Hilda Beese, Philip Davies* and *John Stoddard*. *(2.16, 5.26, 5.54)*

Mondo SRL is the name of an Italian design company set up in 1987 by Giulio Cappellini, Paola Navone and Rodolfo Dordoni. *(1.35)*

Paul Montgomery studied at North Carolina State University, the University of Georgia in Cortona, Italy, and Cranbrook Academy of Art, Michigan, where he received his Master's degree in Fine Arts in 1987. He has designed products such as computer systems, televisions, medical products, luggage, typewriters and office furniture and has worked for Texas Instruments in Austin, Texas, PA Technology in Princeton, NJ, and Frogdesign in California. His most recent awards (1987) were for his digital still camera, from the Industrial Designers' Society of America, "Designers' Choice" from *ID* Magazine and Frogdesign's *frogjunior* award. *(5.32)*

Marcello Morandini was born in Mantua in 1940 and has lived in Varese since 1947. He was educated at the Brera Academy in Milan. In 1963 he opened his own studio and exhibited his first three-dimensional structures in Genoa in 1965. He has subsequently had many exhibitions in Italy and throughout the rest of the world. In 1979 he was invited to Sydney, Australia, and lived and worked for a short time in Singapore. He has been designing ceramics for Rosenthal for several years and was commissioned by them to design the façade of their new offices in Selb, West Germany. *(3.9, 5.7)*

Masahiro Mori was born in 1927 in Saga-Ken, Japan. A ceramics and industrial designer, he has won the gold medal of the International Competition of Contemporary Art Ceramics, Faenza, Italy, in 1975 and the Grand Prix of the 13th Annual Industrial Design Competition, Valencia. *(3.2-3)*

Jasper Morrison is a British furniture designer, educated in New York, Frankfurt and England. He graduated from the Royal College of Art, London, in 1985. Since then he has designed and made small-batch production pieces. In 1986 he started on his own and took part in Zeus's exhibition in Milan. He has also designed projects for SCL Ltd, London, and, in 1988, Idée, Japan. *(1.144, 4.7)*

Pascal Mourgue began working as an interior designer at the end of the 1960s. Since 1982 he has been concentrating on furniture designs although he also designs carpets, tableware and even trimarans. He was named French Designer of the Year in 1984, and in 1986 won the Grand Prix de la Critique du Meuble Contemporain. He lives in Paris. *(1.100)*

Thomas Muller studied architecture at the Staatliche Akademie der Bildenden Kunste in Stuttgart. From 1985 to 1987 he studied at the Department of Furniture Design at the Royal College of Art, London. He currently lives in Berlin. *(2.39)*

K. Munshi is a professor at the Industrial Design Centre, Indian Institute of Technology (IIT), in Bombay. He has a degree in mechanical engineering and studied industrial design at IIT and at the Royal College of Art in London. As well as his teaching work, with *Kirti Trivedi* he is active as a design consultant in many organizations in India. *(2.12)*

Adolfo Natalini was born in Pistoia, Italy, in 1941. He studied architecture in Florence and in 1966 established an avant-garde group called

Superstudio. His work is in town planning and architecture, since 1981 he has been a professor of architecture at the University of Florence. For Volumina he worked with *Guglielmo Renzi*. *(1.45)*

Leah Nelson, an American designer living in Chicago, has been working with rugs, carpets and wall-hangings for fourteen years. She manufactures her designs in limited batches or creates custom rugs for both residential and commercial clients. *(4.15)*

Ugo Nespolo was born in Mosso S. Maria, Italy, in 1941 and lives in Turin. He is a painter, sculptor, avant-garde film-maker and designer. He has exhibited in Turin, Cologne, New York, London, Tokyo, Helsinki, Paris, Venice and Milan. In 1987 he completed seven handmade carpets for Elio Palmisano. *(4.14, 4.16)*

Marc Newson was born in Sydney, Australia, in 1963. He graduated from Sydney College of the Arts in 1984. He first exhibited in 1986 and in 1987 designed prototypes of furniture for Idée in Tokyo. *(1.81)*

Bunny Newth and Michael Newth design and produce hand-printed fabrics for furnishings and interiors. They trained as fine artists in painting and print-making at colleges in Canterbury and London. Two years ago they founded Tempera Fabrics in Canterbury and began designing and hand-printing fabrics for interiors. Many of their designs are taken from their own paintings, etchings and lino cuts and printed in bold, rich colours. *(4.56)*

Jean Nouvel, one of France's best-known contemporary architects, was born in 1945. In 1987 he was awarded the Equerre d'Argent for the most outstanding French building of the year (the Institut du Monde Arabe in Paris, for which he also designed the interior of the museum and the furniture for the reception rooms). In 1987 also, the Salon International du Meuble nominated him "Designer of the Year" for his furniture. He is now working on low-cost housing for Nîmes and has a life-long interest in theatre and set design. *(1.128-130)*

Gabriel Ordeig was born in London in 1954. In 1960 he moved to Barcelona. He returned to the UK to study art, at East Ham College, London, and at Cardiff Art School, graduating in 1978. He returned to Barcelona where his work includes the lighting of bars and nightclubs, as well as the design of interiors. He is the chief executive officer of Santa & Cole which was established in 1985. *(2.26-27)*

John Outram is a British architect whose works include warehouses and factories and, recently, a country house in Sussex. He is currently building a pumping station for the London Docklands Development Corporation. *(1.123)*

Douglas Paige was born in the USA in 1959. He studied design at the Cleveland Institute of Art, graduating in 1982. He is currently a senior designer with Ron Loosen Associates, an industrial design consultancy in Los Angeles, California. *(5.17)*

Paolo Pallucco is an Italian furniture designer, architect and manufacturer born in 1950 in Rome. He established Pallucco in 1980, producing new designs and re-editions of modern classics as well as his own creations. In 1984 he started Pallucco Design to work on designs independently of Pallucco. He collaborates with *Mireille Rivier*. *(1.119)*

Roberto Pamio is an Italian architect, born in 1937. He studied architecture at the University of Venice. He established an architectural practice in Scorzè in the Veneto after working as an industrial designer for Zanussi. Present clients include Arflex, for whom he designs upholstered and office furniture, and Leucos, where he works on light fittings and glassware. In 1986 he received a Product Design Award from the Institute of Business Designers and *Contract Magazine*, Chicago. His designs have been exhibited in the Museum of Modern Art, New York, and the Centre Georges Pompidou and the Louvre in Paris. *(2.8)*

Verner Panton was born on the Danish island of Funen in 1926. After completing his studies at the Copenhagen Royal Academy of Fine Arts in 1955, he worked as a freelance architect and designer in several European countries. Since 1969 he has been working for Mira-X in Suhr, Switzerland, developing floor coverings, furnishing fabrics and upholstery weaves. He also designs exhibitions, furniture and lights and has won many prizes for his work. *(1.76, 4.49)*

Eduardo Paolozzi RA was born in Leith, Scotland, in 1924. He studied at the Edinburgh College of Art and at the Slade School of Art in London. He is currently a tutor in the ceramics department of the Royal College of Art, London, and Professor of Sculpture at the Academy of Fine Arts in Munich. He has had several major solo exhibitions in the UK and abroad. He was recently appointed HM Sculptor in Ordinary for Scotland for life. *(1.132)*

Suku Park was born in Seoul, South Korea, in 1947. He studied at the College of Fine Art, Seoul National University, and at the Swedish State School of Design and Crafts, Stockholm. His work has been exhibited in London and throughout Scandinavia and is in the collection of the National Museum, Stockholm, and many others. From 1984-7 he was art director at Pentik Novis, a ceramics firm in Posio, Lapland. He now has his own studio in Helsinki, working mainly with porcelain and wood. *(3.20-21)*

Paolo Pedrizzetti studied architecture at Milan Polytechnic, graduating in 1973. He worked in building design and building-site management until 1978, when he turned to product design. Pedrizzetti is also a journalist for Italian and foreign newspapers and magazines. *See also Davide Mercatali*. *(5.63)*

Peret (Pedro Torrent) was born in Valencia in 1950 and began his professional career as an illustrator and graphic designer. In 1970 he became art director of Prisunic and Delpire-Advico in Paris. Later he opened his own studio, working for *L'Express, Marie-Claire*, Air France and Citroën, among others. In 1978 he moved his studio to Barcelona where he designs books, magazines, record sleeves and posters as well as lamps, carpets, porcelain and table linen. He has recently designed a silkscreen print lampshade for Santa & Cole and rugs for Nani Marquina, both in Barcelona. *(4.3)*

Gaetano Pesce, artist and designer, is constantly researching into new materials made possible by technological advances. His projects have been exhibited worldwide and many are in permanent museum collections. Born in 1939 he trained as an architect at Venice University. His works include the doughnut-like polyurethane foam Up 1 armchair in 1969, and a cave-like commune for

twelve people shown in 1972. He has lectured world-wide and in 1987 was a visiting professor at the School of Architecture in São Paolo, Brazil. *(1.12)*

Paolo Piva was born in Milan in 1954 and qualified as an architect in 1979, having studied at the Milan Polytechnic. In 1978 he became a partner of Studiodada Associati and has worked for companies such as Felice Rossi, Egoluce, Idea Italia and Stilnovo. *(2.47)*

Plumb Design Group is celebrating its twenty-fifth anniversary in 1988. Founded by William Lansing Plumb, it now consists of about fifteen designers. Plumb is a communications company, committed to strong visual solutions to business problems, designing consumer and technical products and creating environments from trade exhibits to office lobbies and retail store interiors as well as corporate identity systems. *(5.47)*

Gio Ponti was born in Milan in 1891 and studied architecture at the Milan Polytechnic, opening a studio in Milan with other architects in 1921. Having worked mainly as a painter, from 1923-30 he designed ceramics for the Richard Ginori factory. He also practised as an architect and designed tableware and furniture, and in 1928 founded *Domus* magazine which he edited until his death in 1979. *(1.60)*

Vincenzo Lorenzo Porcelli, an American industrial designer, is president of Porcelli Associates Inc., based in New York. His work is represented in the Museum of Modern Art and the Cooper-Hewitt Museum of Decorative Arts and Design, New York, the Staatliches Museum, Munich, and the Brussels Design Centre. In 1984-5 he was chairman of the New York chapter of the Industrial Designers' Society of America. *(5.53)*

Ferdinand Alexander Porsche was born in West Germany in 1935. He studied at the Ulm Design School, then worked in an engineering company before joining the family car-making business. He was responsible for two sports models including the classic *911*. In 1972 he established his own product-design consultancy, Porsche Design, in Zell-am-Zee in Austria, working on wrist watches and sunglasses, marketed under the Porsche Design label, as well as furniture, lighting and electrical equipment for other firms. *(1.71)*

Stephen Povey, a British designer, graduated from the Royal College of Art, London. He established his own design and manufacturing company, Diametric, in 1986. *(1.108)*

L. Suzanne Powadiuk graduated from the University of Toronto in 1979 with a degree in art and architectural history. She also has a degree in environmental design from the Parsons School of Design. She works in both New York and Toronto in architecture, interior and furniture design. The *Arc Light* was a winning design in the Canadian Virtu Furniture competition. *(2.38)*

Ambrogio Pozzi was born in Varese, Italy, in 1931. While studying he began work for his family's firm, Ceramica F. Pozzi of Gallarate. As Ambrogio Pozzi Design he has worked for Riedel, Pierre Cardin, Alitalia, Rosenthal, iGuzzini and Rossi. He is a member of the Italian Association for Industrial Design and has won awards worldwide. *(3.11)*

Andrée Putman was born in Paris. She

studied the piano at the Paris Conservatoire under François Poulenc. After several years as a journalist she moved into industrial design and in the 1970s was co-founder of Créateurs et Industriels, bringing together designers such as *Issey Miyake* and *Castelbajac*. In the mid-1970s her interest in the work of *Eileen Gray* led to the reproduction of previously forgotten twentieth-century furniture designs. In 1978 she founded Ecart International, specializing in re-editions, and began her own interior designs. *(3.4, 4.9-10)*

Michael Reibl was born in Budapest, Hungary, in 1933. He trained first in precision engineering and then as a design engineer. Since 1975 he has worked as an industrial designer for Kodak AG in Stuttgart. He has won awards from Gute Industrieform, Hannover, and the Design Centre, Stuttgart. *(5.23)*

Guglielmo Renzi was born in Florence where he now lives and works. He graduated in architecture in 1980, having studied with *Adolfo Natalini*. He is now working on an ambitious secret project. *(1.45)*

Daniel Reynolds was born in Caracas, Venezuela, in 1961 and moved to London in 1970. He studied at Kingston, Brighton and Middlesex polytechnics. His furniture, described by one magazine as "weighty but elegant, primitive but intriguing," has been exhibited in London, toured the UK with the Crafts Council's The New Spirit in Craft and Design exhibition, and in 1988 appears at the Craft and Folk Art Museum, Los Angeles. *(1.38)*

Mireille Rivier was born in 1959 in Lyon, France. She graduated in architecture at the Polytechnic of Lausanne before moving to Rome where she works with *Paolo Pallucco*. *(1.119)*

Franz R.R. Romero was born in Zurich in 1951. He studied architecture at the Winterthurer Technical College, the Federal Institute of Technology, Zurich, and the Institute of Architecture and Urban Studies, New York. He now runs his own architectural office in Zurich. He regards furniture design as "micro-architecture;" the *DS-57* is the first furniture designs to be mass produced. *(1.49)*

James Rosen was born in New York and currently lives in Los Angeles. He has a BFA degree in environmental design from the Parsons School of Design and began his professional career working for *Steven Holl*. He has also worked as a model-maker for Skidmore, Owings & Merrill. He now designs furniture for the Pace Collection and works as showroom co-ordinator for Pace. *(1.109)*

Aldo Rossi was born in Milan in 1931. In 1956 he began his career working with Ignazio Gardella and later with Marco Zanuso. From 1955 to 1964 he was editor-in-chief of *Casabella-Continuita*. Since 1975 has held the chair of Architectural Composition at Venice University. He has taught at the Federal Polytechnic of Zurich, and has collaborated with the principal American universities since 1976. In 1983 he was named director of the architecture sector of the Venice Biennale. He has designed many award-winning buildings. *(5.8)*

Michael Rowe was born in 1948 in High Wycombe, England. He graduated from the Royal College of Art, London, in 1972 and set up his own metal-working studio in the same year. He became head of department of metalwork and jewellery at

the RCA in 1984. Rowe's work is in the British Crafts Council, the municipal galleries of Birmingham and Leeds, the Victoria and Albert Museum, London, the Karlsruhe Museum, West Germany, and the Art Gallery of Western Australia. *(3.39)*

Charles Rozier was born in the USA in 1951. He studied engineering at Brown University and has a degree from Cranbrook Academy of Art, Michigan. He has received three Designers' Choice awards and in 1977 won the Braun Prize. He is the principal of Charles Rozier Design, New York, specializing in consumer products and office furniture. *(5.48)*

Toby Russell was born in London in 1963 and studied 3D design, silversmithing and metalwork at the Camberwell School of Arts and Crafts. He now has his own workshop and has exhibited in London, Paris and throughout the UK. *(3.38)*

Eliel Saarinen was born in Finland in 1873 and died in 1950, a naturalized American citizen. Saarinen trained as an architect and a painter in Helsinki. After a distinguished career in Finland, working in a romantic, nationalistic interpretation of Classicism, Saarinen moved to America in 1923 after a well-received submission in the *Chicago Tribune* Tower Competition. In 1924 he became visiting professor of architecture at the University of Michigan and in 1925 was asked by the proprietor of the *Detroit News* to develop his Cranbrook education centre at Bloomfield Hills, Michigan. The Cranbrook Foundation was set up in 1927 and in 1932 Saarinen became President of the Cranbrook Academy of Arts. He continued his independent architectural practice, in the years after 1945 with his son Eero. *(1.64-67, 4.25-26)*

Loja Saarinen, *née* Gesellius, was a sculptor and weaver. She married *Eliel Saarinen* in 1904 and designed and executed rugs and textiles at Cranbrook. *(4.25)*

Lino Sabattini is an Italian silversmith, born in 1925. His metalwork first attracted international attention in 1956 when it was exhibited in Paris at a show organized by the architect *Gio Ponti*. Since then Sabattini has continued to be closely associated with a simple, sculptural approach to metal and glassware, working for companies such as Rosenthal and Zani. He exhibits at the Milan Triennale and other major exhibitions. In 1979 he was awarded the Compasso d'Oro. His work is in the Museum of Modern Art, New York, the Cooper-Hewitt Museum of Decorative Arts and Design and the British Museum, London. *(3.42-43)*

John Saladino was born in Kansas City, USA. A graduate of the Yale School of Art and Architecture, he worked in Rome with the architect Piero Saratoga before returning to the USA in 172 to open his own design practice in New York. John F. Saladino Inc. is now an architectural and interior design organization with a staff of twenty-five. In 1986 he started Saladino Furniture Inc. and opened a showroom the following year to critical acclaim. He has won numerous interior design and furniture awards and has served as a board member for a number of organizations, including Formica, the Parsons School of Design and Steuben Glass. *(1.44)*

Astrid Sampe, Hon. RDI, was born in Stockholm, Sweden, in 1909. She studied at Konstfackskolan, Stockholm, and at the Royal College of Art, London. She ran the NK Textile Design Studio, Textilkammeren, from 1937 until 1971. Her work has been wide-ranging: she decorated Hinseberg, Sweden's only prison for women, and the Swedish Embassy in Tokyo, both 1959; she participated in the redecoration of Haga Castle, used by the Swedish government for state visits, 1966; and from 1966 to 1969 she decorated passenger ships for Swedish Lloyd. She has received the Gregor Paulsson statuette from the Swedish Society for Industrial Design, 1959, and His Majesty The King's medal in 1980. She is an honorary member of the Association for Swedish Craftsmen and Industrial Designers and of the Swedish Association of Textile and Clothing Designers. *(4.4)*

Eduard Samso, a Barcelona-based Spanish architect, was born in 1957. He has specialized in interiors for shops and bars in Barcelona. His most recent projects include furniture for the Spanish company Akaba and rugs for Nani Marquina. *(4.24)*

William K. Sawaya was born in Beirut in 1948 and graduated from the National Academy of Fine Arts, Beirut, in 1973. An architect, he is particularly interested in the definition of internal spaces and began his career in the Lebanon, subsequently working in the USA, France and Italy. He moved to Italy in 1978 and in 1984 he established Sawaya & Moroni together with Paolo Moroni. His work has been published in various magazines and newspapers throughout Europe and the USA. *(1.45)*

Wolfgang Schatzl was born in Neukirchen, Austria, in 1961. He graduated from the Technical College for Woodworking in Hallstatt and is junior manager of Franz Schatzl Design Werkstätte. With *Sigi Mayer* he designed a range of jewel boxes which won an award for good design in 1987. *(3.22-25)*

Luigi Serafini, an Italian artist, was born in Rome in 1949. He is active in the fields of art, architecture, cinema and literature. In 1981 he produced the *Codex Seraphinianus* which brought together the results of a series of artistic and philosophical speculations and was translated into several languages. His work has been exhibited worldwide. He designs furniture for the Milanese company Sawaya & Moroni. *(1.11)*

Kazuo Shinohara, a leading Japanese architect, was born in Shizuoka in 1925. Together with *Arata Isozaki* he was influential in the "New Wave" of Japanese architecture. He was educated at the Tokyo Institute of Technology where, since 1970, he has been Professor of Architecture. He began a private architectural practice in 1954 and established a studio at the Tokyo Institute in 1962. He has written several books and much has been written about him. *(1.103)*

Peter Shire was born in Los Angeles, California, in 1947. He has a degree in ceramics from Chouinard Institute of Art. He opened his own studio in 1972 and held his first solo show in a Hollywood gallery in 1975. His sculptural furniture designs attracted the attention of *Ettore Sottsass*; from 1981 he has been producing furniture for the Memphis group. *(1.21)*

Helen Shirk was born in Buffalo, New York, in 1942, and received a Master's degree from Indiana University in 1969. Her bowls and vessels are in the collections of, among others, the National Museum of Modern Art, Kyoto, the Minnesota Museum of Art, St Paul, and the University of Texas in El Paso. Her work is frequently exhibited in galleries and museums. She is currently Professor of Art at San Diego State University, California. *(3.27)*

Robert Siegel was born in 1939 in New York City. He graduated in architecture from the Pratt Institute, New York, in 1962 and received his Master's degree from Harvard University in 1963. With *Charles Gwathmey* he founded Gwathmey Siegel & Associates Architects. In 1979 he was elected vice-president of the New York chapter of the American Institute of Architects. *(3.6)*

Scot Simon received a BFA from San Francisco Art Institute in 1976 and in that year began creating collections of fashion accessories. In 1979 he began his own business, concentrating on the design of surfaces. He has created tabletop surfaces for Mikasa, developed light plastic laminates for Formica and embossing patterns for Vescom in The Netherlands. He has received three Roscoe awards and has participated in various museum exhibitions. He is now designing printed and textural wall-coverings for Lonseal Inc. and bedlinens for Martex as well as fabrics, carpets and tiles. *(4.1, 4.42)*

Bořek Šipek was born in Prague in 1949. He studied furniture design in Prague, architecture in Hamburg and philosophy at Stuttgart University. His works are included in the collections of the Museum of Modern Art, New York, the Museum of Decorative Arts in Prague, the Kunstmuseum, Düsseldorf, and PTT in Den Haag, among others. He now lives in Amsterdam and designs for various companies, including Sawaya & Moroni, Driade, Vitra and Cleto Munari. *(1.6-7, 1.116, 3.51-53)*

Ruth Skrastins is an Australian textile designer who studied fabric design at East Sydney Technical College. After teaching she began Ruth Skrastins Fabrics in Sydney in 1984. Her work has been exhibited throughout Australia, and in 1986 she won an award for the Best New Innovative Product at the National Interior Design Show. *(4.46-47)*

Nancy A. Slagle was born in the USA in 1958 and studied jewellery and metal art at Drake University, Des Moines, Iowa, and metalsmithing and jewellery design at Indiana University. She was a graduate assistant and then an assistant instructor at Indiana University. She has had several exhibitions, the first in Florence in 1978, and her work is in Evansville Museum of Arts and Science, Evansville, Indiana. She is married to *Robly A. Glover Jr* and lives in Bloomington, Indiana. *(3.45)*

Judy Smilow Design, New York, includes graphic, corporate, packaging and industrial design. Judy Smilow was born in New York in 1958 and has a BFA in communications design from the Parsons School of Design, New York. *(3.61)*

Diane E. Smith was born in Lismore, Australia, in 1952. She received a BA from Queensland University and an MA in anthropology from the Australian National University, Canberra, in 1981. She designs and makes furniture and from 1985 to 1987 attended the wood workshop at the Canberra School of Art. *(1.53)*

Nathaniel Smith was born in the USA in 1955. He studied art at the University of Massachusetts in Boston and in 1981 moved to Denmark and attended the School of Applied Arts in Copenhagen. He still lives in Copenhagen and is co-founder of Ark Design Studio, creating industrial designs, interiors and one-off and mass production tableware. *(3.65)*

Snowdon is a British photographer and designer. *(1.131)*

Ettore Sottsass was born in Innsbruck, Austria, in 1917. He graduated as an architect from Turin Polytechnic in 1939, and opened an office in Milan in 1946. Since 1958 he has been a design consultant for Olivetti but is also active in fields as various as ceramics, jewellery, decorations, lithographs and drawings. He has taught and exhibited widely. In 1980 he established Sottsass Associati with some other architects, and has designed many pieces of furniture that are part of the Memphis collection. *(1.23, 1.25, 3.7, 5.5)*

George G. Sowden was born in Leeds, UK, in 1942. He studied architecture at Cheltenham College of Art from 1960-8, and in 1970 moved to Milan to work in the Olivetti studio with *Ettore Sottsass*, particularly in information technology. He is a founder member of the Memphis group, and has produced furniture for its collections, as well as continuing in a consultancy role and collaborating independently with Nathalie du Pasquier. *(1.48, 3.40)*

Philippe Starck was born in Paris in 1949 and works as a product, furniture and interior designer. In Paris he was commissioned by President Mitterrand to give a new look to part of the Elysée Palace and designed the Café Costes, together with a number of fashion shops. In New York he remodelled the interior of the Royalton Hotel, and in Tokyo he has designed two restaurants and is currently working on a number of other buildings. His furniture design includes projects for Disform, Driade, Baleri and Idée. Among his industrial-design projects are a cutlery line for Sasaki, clocks for Spirale and mineral-water bottles for Vittel. *(1.1, 1.93)*

John Stoddard is joint managing director of the London office of *Moggridge Associates*. He was born in 1948 and educated at the Royal College of Art, London. *(5.26)*

Doug Streeter *see Terry Farrell*. *(1.47)*

Jasia Szerszynska is a British designer of printed textiles and one-off wall-hangings. She also undertakes commissions for furnishing fabrics which are printed in quantity. Recent work includes the design and manufacture of twelve festive banners for the new offices of the *Terry Farrell* Partnership, London. *(4.59-60)*

Matteo Thun was born in Austria in 1952 and graduated from Florence University. He was a founding member of the Memphis design group and established his own design company in Milan in 1984. His work has been shown in Berlin, Hannover, Düsseldorf, Vienna, Los Angeles and at the 1983 Milan Triennale. He is a professor of product design and ceramics at the Academy of Arts, Vienna. *(3.70)*

Stanley Tigerman was born in 1930. He studied at the Yale School of Architecture and is now a principal in Tigerman, Fugman, McCurry in Chicago. With *Margaret McCurry* he explores the humorous as well as the solemn side of design. His work has been awarded numerous prizes. *(3.5)*

Peter Ting was born in Hong Kong in 1959 and moved to the UK in 1976. He studied at the West Surrey College of Art and Design and at the South Glamorgan Institute of Higher Education. In 1984-6 he researched eighteenth- and nineteenth-century creamware at North Staffordshire Polytechnic, Stoke-on-Trent, where he designed a creamware tea/coffee service. He had his first major solo show in Hong Kong in 1987, exhibiting some 200 pieces, and in 1988 exhibitions in the UK and Japan. His workshop, Tingware, produces decorative items, manufactures limited editions of bone china tableware and undertakes one-off commissions. *(3.13)*

David Tisdale is the president of David Tisdale Design Inc., New York. He was educated at the University of California and has a Master's degree in art from San Diego State University, California. His work has been exhibited throughout the USA and Canada and is in the Cooper-Hewitt Museum of Decorative Arts and Design, New York, the Virginia Museum of Fine Arts, Richmond, Virginia, and museums in Berlin and Trondheim, Norway. His most recent work has used anodized aluminium and he has produced collections for Sasaki. *(3.29-32)*

Kirti Trivedi is a professor at the Industrial Design Centre, Indian Institute of Technology (ITT), Bombay. After taking a degree in mechanical engineering he studied industrial design at ITT, where he met *K. Munshi*, and then at the Royal College of Art, London, where he won the Pye Design Award for consumer electronic products. He was awarded a UNESCO fellowship to study and work in Japan. Besides teaching, he is as a graphic designer and a product designer for clients throughout India. *(1.80, 2.12)*

Oscar Tusquets Blanca was born in Barcelona in 1941. He attended the Escuela Técnica Superior de Arquitectura, Barcelona and in 1964 he established the Studio PER with Lluis Clotet, with whom he collaborated on most projects until 1984. He has been a guest professor and lecturer at universities in Germany, France and the USA, and his work has been exhibited in many parts of Europe and the USA. He has received many awards both as an architect and as a designer. *(1.50, 4.2-3)*

Attilio Urbani was born in Gemona del Friuli, Italy, in 1945. He studied design at the Instituto d'Arte in Udine and then entered the family firm of Polflex of which he is currently the managing director and chief designer. Three of his designs won second place in the Resources Council Competition, USA. The *Polfex 713* chair featured here was part of an exhibition of modern design at the Museum of Modern Art, Los Angeles. *(1.142)*

Michael Vanderbyl established Vanderbyl Design in San Francisco in 1973. His clients include Esprit, Hickory Business Furniture, IBM, the American Institute of Architects and the San Francisco Museum of Modern Art. He is Dean of the School of Design at the California College of Arts and Crafts, Oakland. His work is in the collections of the Cooper-Hewitt Museum of Decorative Arts and Design and the Library of Congress. His graphic work has appeared in many publications and he is one of the forty-six American members of the Alliance Graphique Internationale, based in Zurich. He has received many awards for his graphic design and his showroom designs. *(1.137)*

Marc Van Hoe was born in Zulte, Belgium, in 1945. He studied industrial design, Fine Arts and textile history. In 1975 he opened a workshop. He now teaches and is a freelance designer and technical researcher in industrial textiles and fibre art. His work is part of several permanent collections and has been exhibited in Belgium, The Netherlands, France, Switzerland, Poland, Hungary and the UK. *(4.39-40)*

Mart A.A. Van Schijndel was born in Hengelo, The Netherlands, in 1943. He has worked as a carpenter, building engineer, interior designer, product designer, architect, teacher and university lecturer. Since 1969 he has run an architectural office in Utrecht. His interior designs and products have been used in the railway station, museum and Chamber of Commerce in Utrecht, and in offices, houses, shops, factories, restaurants and cultural and educational centres. He won awards in the Arango International Design Competition in 1985 and 1986. His work has been exhibited widely. *(3.67)*

Rouquart Veerle was born in Ghent, Belgium, and studied textile design and tapestry. She designs textiles for Van Houtte in Belgium. *(4.61)*

Robert Venturi, considered one of the greatest theorists of contemporary American architecture, was born in Philadelphia, USA, in 1925. A graduate of Princeton University and the American Academy of Rome, he lived in Italy from 1954-6. He is a professor at several universities and head of architectural design at Venturi, Rauch and Scott Brown in Philadelphia. His projects have been exhibited worldwide. In recent years he has become interested in industrial design, collaborating in particular with Knoll International and Alessi. *(5.6)*

Vicenç Viaplana was born in Granollers, Spain, in 1955. He studied psychology at Barcelona University but then became one of the artists of the G Art Gallery group. His paintings have been widely exhibited, earning critical acclaim. In 1982 he received a grant from the Spanish Ministry of Culture. In 1985 he painted murals in the Otto Zutz Club in Barcelona and became curator of the Museum of Contemporary Art in Granollers. He is the creative director of an advertising agency in Barcelona. Recently he has designed furniture and the lampshade featured here for *Gabriel Ordeig's La Bella Durmiente*. *(2.26)*

Tucker Viemeister founded Smart Design in New York City with David Stowell in 1985. After graduating from the Pratt Institute in 1974 he taught industrial design in Portugal. He worked for three years on environmental graphics, symbols, typography and street furniture for Washington DC's zoo and the National Mall. He has lectured at various colleges and his work was selected for the Presidential Design Achievement Award (1984) and for *ID* Magazine's Design Review in 1983, 1985, 1986 and 1987. His products are in the Cooper-Hewitt Museum of Decorative Arts and Design. He is the co-designer, with *Lisa Krohn*, of *Phonebook*. *(5.1)*

Mario Villa was born in Nicaragua and now lives in New Orleans, USA. He has a degree in architecture from Tulane University and in 1981 formed Graphic Editions, retailing as well as publishing fine art editions. He designed his first collection of furniture in 1984. He is now head designer and president of Mario Villa Inc. and consultant for a number of other projects such as Saks Fifth Avenue, Restaurant de la Tour Eiffel and Cave Canem in New York City. In 1987 he launched a furniture collection at the Gallery of Applied Arts, New York. *(1.31, 2.13)*

Sohrab Vossoughi was born in Tehran, Iran, in 1956 and moved to the USA in 1971 where he was educated at San Jose State University, graduating in 1979. He worked for Hewlett-Packard and began doing design consultancy work. In 1982 he established Ziba Design in Oregon. His clients include Nike, Intel Corp. and Dow Chemical Co. He has received many patents and design awards. His work ranges from furniture to computers, from fitness equipment to household appliances, and from consumer electronics to office systems. *(5.21-22)*

Kevin Walz, an interior designer, was born in 1950 in Rochester, New York. He studied Fine Arts at the Pratt Institute in Brooklyn and painting at the New York Studio School. In 1982 he established Walz Design Inc. in New York, undertaking residential design, loft conversion, office and retail work and furniture design. His first furniture collection was produced in 1987 by Arc International. *(1.139-140)*

Rupert Williamson has been designing and manufacturing one-off pieces of furniture from his workshop in Milton Keynes, UK, since 1975. His work is in several permanent collections including those of the Victoria and Albert Museum, London, and the Royal Museum of Scotland, Edinburgh. *(1.30)*

Jean-Michel Wilmotte opened his own design studio in Paris in 1975 specializing in interior architecture, furniture, lighting, fabric, carpet and product design. Then he founded Academy to produce and sell his own designs and in 1987 opened an office in Japan. He has designed interiors at the Elysée-Palace and for the French ambassador in Washington and has designed and renovated many public buildings in Nîmes. He has designed boutiques and stores throughout France as well as in Japan and the USA, and furniture and fabrics for Mobilier International and Toulemonde Bochart. *(1.99)*

Frank Lloyd Wright, the American architect, lived from 1867 to 1956. He is generally credited, along with Le Corbusier, Mies and Gropius, as being one of the founding fathers of the modern movement in architecture. Trained in the offices of Louis Sullivan, Wright established his own firm in 1889, beginning with a series of highly individualistic houses characterized by spatially dynamic plans. For Wright, architecture embraced all aspects of a building, and he produced a wealth of original detail for interiors, and a great deal of furniture. For the Larkin Building in Buffalo (1904), he designed the first metal office furniture. Major buildings include the Imperial Hotel, Tokyo (1916), the Johnson Wax Building, Racine (1936), and the Guggenheim Museum, New York, completed in 1960. *(3.41)*

Kiyoshi Yamamoto was born in 1949 in Tokyo. He graduated in textile design in 1973, working with *Hiroshi Awatsuji*. He has worked freelance since 1976, mainly on textiles, employing natural patterns and developing an interest in printing techniques. *(4.38, 4.50)*

Masato Yamamoto graduated from the Mechanical Engineering department of Hohsei University in 1973 and from the Kuwazawa School of Design, Japan, in 1975. He has worked for ROC Industrial Design Ltd, Tandy Co. Ltd and, since 1982, Asahi Optical Co. Ltd. His awards include Good Design Marks from the Ministry of International Trade and Industry, Japan, for the Pentax Motor Drive A in 1983, for the Pentax A3 Date in 1985 and the Pentax P50 Date in 1986. In 1987 he won the Design Forum Award of the Japanese Design Committee for the Pentax SFX. *(5.29)*

Helen Yardley, a British textile designer, studied at Plymouth and Manchester polytechnics and received an MA in textiles from the Royal College of Art, London, in 1978. Her work has been exhibited throughout the UK and in Germany and Czechoslovakia and her first solo exhibition is scheduled for March 1989. *(4.27)*

Antonio Zambusi *see Marilena Boccato.* *(2.44)*

Marco Zanuso Jr was born in Milan in 1954, the son of the distinguished Italian designer Marco Zanuso. He graduated in architecture from the University of Florence in 1978 and established his own office in 1980, working on exhibition design, architecture and industrial design. In 1981 he established Oceano Oltreluce, a lighting company. He has participated in many exhibitions. *(1.24)*

Lev Zeitlin was born in Moscow, USSR, in 1956. He studied at the Pratt Institute in New York and in 1982 joined Vignelli Associates. In 1986, with *Constantin Boym*, he founded Red Square Design in New York. *(1.117-118)*

Jürg Zeller was born in 1951. He studied at the Schule für Gestaltung in Basel, Switzerland, from 1976 to 1979 and founded Prototyp design studio in Basel in 1980. *(1.138)*

Carlo Zerbaro was born in 1956. He studied architecture in Venice, Italy, and participated in the Biennale. Since 1982 he has been working with *Bruni Brunati*, mostly in furniture design. Their works are in the Museum of Modern Art in Toronto and they have exhibited in Milan, Paris, Cologne and Copenhagen. They founded the Mastrociliegia Studio specializing in graphics and have worked on political campaigns as well as advertising. They also act as product and image consultants. *(1.104)*

Fullest possible details are given of suppliers of the designs featured here; the activities of some outlets and manufacturers however are limited solely to the place of origin of their work.

Abu Garcia Produktion 290 70 Svangsta, Sweden.

Academy SARL 5 Place de l'Odéon, 75006 Paris, France. *Outlets* Japan: Wilmotte Japon, Oishi Compound Building, 2-7-1 Shiroganedai, Minato-Ku, Tokyo 108. UK: Mary Fox Linton Ltd, 249 Fulham Road, London SW3 6HY. USA: Mirak Inc, 3461 West Alabama, Houston, TX 77027. West Germany: Reim Interline, 39 Liebzstrasse, 8000 Munich 22

Acerbis International Via Brusaporto 31, 24068 Seriate, BG, Italy. *Outlets* Australia: Arredorama International Pty Ltd, 1 Ross Street, Glebe, NSW 2037. France: Agences Générales Reuter, D915 Route de Paris, Domaine de la Pissotte, 95640 Marines. Japan: Atic Trading Inc, 2-9-8 Higashi, Shibuya-Ku, Tokyo. The Netherlands: Modular System, 73 Assumburg, 1081 GB Amsterdam, Buitenveldert. Scandinavia: Interstudio APS, 6-8 Esplanade, 1263 Copenhagen, Denmark. Spain: Axa International SA, 13, 5 Km, Llissa de Vall, Barcelona. UK: Environment Communication, 15-17 Rosemont Road, London NW3 6NG. USA: Atelier International Ltd, 235 Express Street, Plainview, NY 11803

Acorn Computers Ltd Cherry Hinton, Cambridge, UK. *Outlets* Australia: Barson Computers Australasia Ltd, 335 Johnston Street, Abbotsford, Victoria 3067. Canada: Olivetti Canada, 3190 Steeles Avenue East, Markham, Ontario L3R 1G9. Italy: G. Ricordi & Co SPA, Via Salomone 77, 20138 Milan. The Netherlands: Eeckhorn BV, Poortcenter Delft, 6-8 Poortweg, 2612 PA Delft. Norway: Sherlock A/S, 41 Asgerds Vej, 1454 Hellvik. Spain: Commercial de Servicos Electronicos, 37 General Varela, 28020 Madrid. Sweden: Ekorren Data AB, 3 Sjotullsgatan, 602 27 Norrkoping.

Adelta OY Tunturikatu 9A1, 00100 Helsinki, Finland. *Outlet* Europe/USA: FinlandContact GMBH, 3 Voigtelstrasse, 5000 Cologne 41, West Germany

Aidec Co Ltd 28 Mori Building, 16-13 Nishiazabu 4, Minato-Ku, Tokyo, Japan

Airon Via Don Sturzo 10, 20050 Triuggio, Italy

Akaba Calle Major, s/n, 20160 Lasarte, Gipuzkoa, Spain. *Outlets* France: Nestor Perkal, 8 Rue des Quatre Fils, 75003 Paris. Italy: Halifax, Via Prealpi 13, 20034 Giussano, MI. The Netherlands: Louis Goulmy Agenturen, Postbus 15, 2170 AA Sassenheim. Scandinavia: Teamprodukter, PO Box 30545, 20062 Malmö, Sweden. USA: Stendig International, 305 East 63rd Street, New York, NY 10021. West Germany: IMD AG BRD, 11 Flöthbruchstrasse 11, 4156 Willich 2, Anrath

Alessi SPA Via Privata Alessi 6, 28023 Crusinallo, Novara, Italy. *Outlets* Denmark: Gense A/S, 17 Maglebjergvej, 2800 Lyngby. France: Société Métallurgique Lagostina, 62 Rue Blaise Pascal, 93600 Aulnay-Sous-Bois. Japan: Italia Shoji Co Ltd, 5-4 Kojimachi, 1-Chome, Chiyoda-Ku, Tokyo 102. The Netherlands: Interhal BV, 8 Zoutverkoperstraat, 3330 CA Zwijndrecht. Sweden: Espresso Import, 10E Furasen, 42177 V. Frolunda. UK: Penhallow Marketing Ltd, 3 Vicarage Road, Sheffield S9 3RH.

USA: The Markuse Corporation, 10 Wheeling Avenue, Woburn, MA 01801. West Germany: Van Der Borg GMBH, 6 Sandbahn, 4240 Emmerich

Alias SRL Via Respighi 2, 20122 Milan, Italy. *Outlets* France: Roger von Bary, 18 Rue Lafitte, 75009 Paris. Japan: Casatec Ltd, 2-9-6 Higashi, Shibuya-Ku, Tokyo 150. The Netherlands: Kreymborg, 63 Minervalaan, 1077 Amsterdam. Scandinavia: Design Distribution, 38/A/1 Dobelnstan, 113 52 Stockholm, Sweden. UK: Artemide GB Ltd, 17-19 Neal St, London WC2H 9PU. USA: International Contract Furnishings Inc, 305 East 63rd Street, New York, NY 10021. West Germany: Peter Pfeifer Focus, 87 Leopoldstrasse, 40 Munich 8

G. & S. Allgood Ltd 297 Euston Road, London NW1 3AQ, UK

Alma Ltd 25 Sumner Place, London SW7, UK

Amat 8 Camino can Bros, D8760 Martorell, Barcelona, Spain.

Kyrre Andersen / Trikk Box 6818, St Olausplas, 0130 Oslo, Norway

Andiamo 11520 Warner Avenue, Fountain Valley, California, USA

Apple Computer Inc 1046 Brandeley Drive, Cupertino, CA 95014, USA

Arai Creations System 301 ESYC Heights, 5-16-8 Roppongi, Minato-Ku, Tokyo, Japan

Aram Designs Ltd 3 Kean St, London WC2, UK

Arc International 24 West 57th Street, New York, NY 10019, USA

Ark Design Studio 15D Nørre Søgade, 1370 Copenhagen, Denmark

Sally E. Armfield 71 John Street, Eltham, 3059 Victoria, Australia

Artek 3 Keskuskatu, 00100 Helsinki 10, Finland. *Outlets* Australia: Lightmakers Pty Ltd, 755-9 Botany Road, Rosebery, NSW 2018. Denmark: Paustian, 2 Kalkbränderilöbskaj, 2100 Copenhagen. France: Torvinoka, 4 Rue Cardinale, 75006 Paris. Italy: Finn Form, Viale Montesanto 4, 20124 Milan. Japan: Futaba Kogyo Co Ltd, Kawaramachi-dori, Nijo Minami, Kyoto 604. The Netherlands: I. Kreymborg BV, 63 Minervalaan, 1077 NR Amsterdam. Norway: Artinteriör AS, 57 Boks, Sköyen, 0212 Oslo 2. Sweden: Artek Showroom, 5 Kåkbrinken, 111 27 Stockholm. UK: Aram Designs Ltd, 3 Kean St, London WC2 4AT. USA: International Contract Furnishings Inc, 305 East 63rd Street, New York, NY 10021. West Germany: Firma Jörg Stoll Wohnbedarf, 60 Mauritiussteinweg, 5000 Cologne 1

Artemide SPA Via Brughiera, 20010 Pregnana Milanese, Milan, Italy. *Outlets* Australia: Artemide Pty Ltd, 69-71 Edward Street, Pyrmont, NSW 2009. France: Artemide SARL, 4 Rue Paul Cézanne, 75008 Paris. Japan: Artemide Inc, 1-5- 10 Sotokanda Chiyodaku, Tokyo 101. Scandinavia: Renzo d'Este, 1A Brodrevej, 2860 Søborg Copenhagen, Denmark. UK: Artemide GB Ltd, 17-19 Neal Street, London WC2H 9PU. USA: Artemide Inc, 528 Center One, 30-30 Thomson Ave, New York, NY 11101. West Germany: Artemide GMBH, 60 Königsallee, 4000 Düsseldorf

Art et Industrie 106 Spring Street, New York, NY 10012, USA

Asahi Optical Co Ltd 36-9 Maenocho 2-Chome, Italashi-Ku, Tokyo 174, Japan

Ateljé Lyktan AB PO Box 3, 29600 Århus, Sweden. *Outlets* The Netherlands: Fagerhult-Lyktan BV, 27 Lage Dijk, PB 319, 5700 AH Helmond. Scandinavia: Fagerhult-Lyktan AS, 47b Sinsenvn., PB 160, 0513 Oslo 5, Norway. West Germany: Fagerhult-Lyktan GMBH, 85-99a Borsteler Chaussée, 2000 Hamburg

Attilio Bordignon Via del Progresso 12, 20125 Milan, Italy

Avarte OY 16 Kalevankatu, 00100 Helsinki, Finland. *Outlets* Australia: Style Finnish (Vic) Pty Ltd, 83 Flemington Road, North Melbourne 3053. Denmark: Intercollection, 35 Pilestraede, 1112 Copenhagen K. France: Norday SARL, 220 Rue de Rivoli, 75001 Paris. Italy: FAI SRL International, Casella Postale 70, Via Garibaldi 6, 20033 Desio, MI. The Netherlands: Binnen, 31 Egelantiersgracht, 1015 RC Amsterdam. Norway: Finsk Interiørsenter, 22 Prinsessealléen 22, 0275 Oslo 2. Sweden: Avarte Svenska AB, 5 Kåkbrinken, Box 2039, 103 11 Stockholm. UK: Business Design Group Ltd, Lewins Mead, Bristol BS1 2NN. USA: Vecta, 1800 South Great Southwest Parkway, Grand Prairie, Texas 75051

A-Z Studios 3-5 Hardwidge Street, London SE1 3SY, UK

Bang & Olufsen AS 7600 Struer, Denmark. *Outlets* Australia: Bang & Olufsen (Aus) Pty Ltd, 136 Camberwell Road, East Hawthorn, Victoria 3123. Austria: Bang & Olufsen GesMBH, 137a Hietzinger Kai, 1130 Vienna. France: Bang & Olufsen France SA, 4 Rue du Port, 92110 Clichy. Italy: Dodi SPA, Via Enrico Fermi 1, 20090 Noverasco D'Opera, MI. Japan: Bang & Olufsen of Japan Ltd, Kudan-New Central Building, 4-5 Kudan-Kita 1-Chome, Chiyoda-Ku, Tokyo 102. The Netherlands: Bang & Olufsen Nederland BV, PO Box 36, 1243 ZG's-Graveland. Norway: Bang & Olufsen A/S, PO Box 1592. Assiden, 3001 Drammen. Sweden: Bang & Olufsen Svenska AB, PO Box 1324, 17125 Solna. UK: Bang & Olufsen Ltd, Eastbrook Road, Gloucester. USA: Bang & Olufsen of America Inc, 1150 Feehanville Drive, Mt Prospect, Illinois 60056. West Germany: Bang & Olufsen (Deutschland) GMBH, 8 Rudolf-Diesel-Strasse, 8031 Gilching bei Munich

Mark Bayley 67 Farringdon Rd, London EC1, UK

BD Ediciones de diseño 291 Mallorca, 08037 Barcelona, Spain. *Outlets* France: Nestor Perkal, 8 Rue des Quatre Fils, 75003 Paris. Italy: Dilmos, Piazza San Marco 1, 20100 Milan. Japan: Gallery Sanyo, 1F Ginza Ohno Building, 4-1-17 Tokio Tsukiji Chuo-ku. Scandinavia: Inside, 37 Galerien Hangatan, 10395 Stockholm, Sweden. UK: Inhouse, 28 Howe Street, Edinburgh EH3 6TG, Scotland. USA: Manifesto, 200 West Superior Street, Chicago, Illinois. West Germany: Fulvio Folci, 14 Dahlienweg, 4000 Düsseldorf

Becker Inc 501 Post Road East, Westport, CT 06880, USA. *Outlet* Italy: Eusgenius Marketing Group, Via P. L. da Palestrina 10, 20124 Milan

Bieffeplast SPA Via Pelosa 78, 35030 Caselle di Selvazzano, Padova, Italy. *Outlets* Austria: Pro Domo, 35-37 Flachgrasse, 1151 Vienna. Denmark: Interstudio, 6 Esplanaden, 1263 Copenhagen K.

France: Protis, 67-101 Avenue Vieux Chemin St Denis, 92230 Gennevilliers. The Netherlands: furniture – as Belgium; lighting – Interlinea, 49 Weeresteinstraat, 2182 Gr Hillegom. Spain: Idea Mueble, 185 Via Augusta, Barcelona. Sweden: Inside AB, PO Box 7689, 10396 Stockholm. UK: OMK Designs, 12 Stephen Buildings, Stephen Street, London WI. USA: Gullans International Inc, 227 West 17th Street, New York, NY 10011. West Germany: Andreas Weber, 79 Nymphenburger Strasse, 8000 Munich 19

Leo Blackman and Lance Chantry 374 13th Street, Brooklyn, NY 11215, USA

Bodùm (Schweiz) AG Kantonsstrasse, 6234 Triengen, Lucerne, Switzerland. *Outlets* France: Martin SA, 82-84 Rue de Dessous- des-Berges, 75013 Paris. Italy: Italtrade SA, 10-7 Piazza della Vittoria, 16121 Genoa. Japan: Zojirushi Vacuum Bottle Co, 20-5 Tenma, 1-Chome, Kita-Ku, Osaka 350. Scandinavia: Peter Bodum AS, 18 Nglegaardsvej, 3540 Lynge, Denmark. UK: Bodum (UK) Ltd, 7 Neal St, London, W2H 9PU. USA: Rosti (USA) Inc, 18 Sidney Circle, New Jersey 07033. West Germany: Peter Bodum, 6 Bochstrasse, 2358 Kaltenkirchen

Braun AG 145 Frankfurter Strasse, 6242 Kronberg, West Germany

Brent Kroghs Stålmøbelfabrik 5 Grønlandsvej 5, 8600 Skanderborg, Denmark

Bridgestone Corporation 1-10-1 Kyubashi, Chuo-Ku, Tokyo, Japan

Paul Burgess 73 Pascoe Road, London SE13, UK

Arnolfo di Cambio Viale Dei Mille 83, 53034 Colle Val d'Elsa, Siena, Italy. *Outlets* France: DMB Associés, 12 Rue Martel, 65010 Paris. Spain: Montorcier Cambra, 4 Calle de la Granja, 28100 Pol. Ind. Alcobendas. USA: Arteform, 1933 Broadway, Suite 967, Los Angeles, CA 90007

Niall Diarmid Campbell RSD 707 Petcheys Bay, Cygnet, Tasmania 7112, Australia

Casprini 52022 Cavriglia, AR, Italy

Cassina SPA PO Box 102, 20036 Meda, MI, Italy. *Outlets* Australia: Artes Studios – Arredorama, 1 Ross Street, Glebe, NSW 2037. Japan: Cassina Japan Inc, 2-9-6 Higashi, Shibuya-Ku, Tokyo 105. The Netherlands: Mobica, 31 Middenweg, 3401 MB Ijsselstein. Spain: Mobilplast SL, 40 Calle Milagro, 08028 Barcelona. USA: Atelier International Ltd, The International Design Center, 30-20 Thomson Avenue, Long Island City, NY 11101

Dinah Casson and Roger Mann 14 Cornwall Crescent, London W11 1PP, UK

Chameleon Textiles Unit OP5 Moniton Trading Estate, Basingstoke, Hampshire, UK

Lucy Clegg 42 Cross Tree Road, Wicken, Milton Keynes, Bucks MK19 6BT, UK

Clodagh Inc 365 First Avenue, New York, NY 10010, USA

Collection Källemo AB Box 605, 331 01 Värnamo, Sweden. *Outlets* France: Helene Mjörndahl, 38 Chemin du Tour-des-Bois, 78400 Chatou. Japan: Dag Klingstedt, 103 Oak Hills, Honcho 6-8-10, Nakano- Ku, Tokyo 164. Norway:

Lavi Projekt-inrredning, 11 Schwenckegt., 3015 Dramen. USA: Made in Sweden, 1771 Massachusetts Avenue, Cambridge, MA 02140

Colorado 30 Albion Avenue, London N10, UK

Comme des Garçons Co Ltd 5-11-5 Minami Aoyama, Minato-Ku 107, Tokyo, Japan

Laslo Čonek Via Poletti 90, 41100 Modena, Italy

Copco Wilton Enterprises 2240 West 75th Street, Woodridge, IL 60517, USA

Création Baumann 4900 Langethal 1, Switzerland

Dansk International Designs Ltd Radio Circle Road, Mt Kisco, NY 10562, USA. *Outlets* Japan: Suita Trading Corp, 3-6-15 Guibuya-Ku, Tokyo 150. The Netherlands: Laurent Imports, 141 Herngracht, 1015 BH Amsterdam. West Germany: Bestform, Postfach 1228, 5760 Arnsberg 1

Desede AG Oberes Zegli, 53l3 Klingnau, France: Robert Nissim, Résidence St Pierre A, 06700 St Laurent-du- Var. Italy: G. M. Mandrini, Via Cesare Battisti 3, 28040 Dormelletto. Japan: Mobilia Co, 2-3-5 Azabudai, Minato-Ku, Tokyo 106. The Netherlands: D. V. Luirink, 15 Korte Bergstraat, 3761 DR Soest. UK: Graham C. Walter, 42 High Street, Daventry NN11 4HU. USA: Stendig International Inc, 305 East 63rd Street, New York, NY 10021

The Design Cell 17-B Doshiwadi, LB Shastri Marg, Ghatkopan, Bombay 400 086, India

Design Central 181 Thurman Avenue, Columbus, OH 43206, USA

Design Form Technik AG 6 Buchenweg, 9490 Vaduz, Principality of Liechtenstein

Design Logic 500 North Clark Street, Chicago, IL 60610, USA

Design M Ingo Maurer GMBH 47 Kaiserstrasse, 8000 Munich 40, West Germany. *Outlets* France: Altras, 18 Rue Lafitte, 75009 Paris. Italy: Daverio SRL, Via Canova 37, 20145 Milan. The Netherlands: P. A. Hesselmans, 24 Korfgraaf, 4714 GM, Hellouw. Scandinavia (except Sweden): Finn Sloth, 1 Heilsmindevej, 2920 Charlottenlund, Denmark. Sweden: Sandklef, PO Box 4112, 421 04 V. Frolunda

Diametric Modern Furniture Ltd Mercantile House, 21 Victoria Wharf, All Saints Street, London N1 9RL, UK

Diseño + Diseño 1037 9 de Julio, 5500 Mendoza, Argentina

Thomas Dixon 28b All Saints Road, London W11, UK

Donghia Furniture 485 Broadway, New York, NY 10013, USA

Driade SPA Via Padana Inferiore 12, 29012 Fossadello di Caorso, Piacenza, Italy. *Outlets* France: Arturo Del Punta, 7 Rue Simon Lefranc, 75004 Paris. Japan: Arflex Trading Inc, 2-9- 8 Higashi, Shibuya-Ku, Tokyo 105. Scandinavia: Design Distribution, 38 A 1TR Doebelnsg., 11352 Stockholm, Sweden. USA: Modern Living, 4063 Redwood Avenue, Los Angeles, CA 90066. West Germany: Klaus Stefan Leuschel, 2 Beethovenstrasse, 6000 Frankfurt/Main 1

Ecart International 111 Rue St-Antoine, 75004 Paris, France. *Outlets* Europe: Ecart International, 111 Rue St- Antoine, 75004 Paris, France. Japan: Fugio Hasumi, 6 bis Rue Campagne Première, 75004

Paris, France. USA: Stendig International Inc, 305 East 63rd St, New York, NY 10021

Egoluce Via Privata Galeno 9, 20094 Corsico, MI, Italy

Thomas Eisl 3 Nimrod Passage, Tottenham Ct Road, London N1 4BU, UK

En Attendant les Barbares 25 Rue du Fg., Montmartre, 75009 Paris, France

Erco Leuchten GMBH 80-82 Brockhauser Weg, 5880 Lüdenscheid, West Germany. *Outlets* Australia: Spectra Lighting Pty Ltd, 17-19 Longford Court, Springvale, Victoria 3171. Canada: Emerson Electric Canada Ltd, PO Box 150, Markham, Ontario. Denmark: Skandia Havemann, 46 Vallensbaekvej, 2625 Vallensbaek. France: Erco Lumières SARL, 6ter Rue des Saints-Pères, 75007 Paris. Italy: Zumtobel Italiana SRL, Viale Berbera 49, 20162 Milan. The Netherlands: ERCO Lighting Nederland BV, 19 Minervalaan, 1077 NK Amsterdam. Norway: Perma Tekniske Artikler AS, 37 Østensjøveien, BP 6002, Etterstad, 0601 Oslo 6. Portugal: Omnicel, Tecnicas de Iluminacao Lda, 57-5 D Rua Castilho, 1200 Lisbon. Spain: Erco Illuminaciòn SA, Exposiciòn y Delegaciòn Cataluña, 1 Calle Tuset, Barcelona 6. Sweden: Aneta Belysning AB, PO Box 3064, 35003 Växjö. UK: Erco Lighting Ltd, 38 Dover Street, London WIX 3RB. USA: McPhilben Lighting Division of Emerson Electric Co, 270 Long Island Expressway, Melville, NY 11747

Esprit 900 Minnesota, San Francisco, CA 94117, USA

Etamine BP 256, Le Coudray, 28006 Chartres, France. *Outlets* Belgium/France: Etamine, 2 Rue Furstermberg, 75006 Paris. Italy: Il Posto delle Fragole, 60-62 Corso Magenta, 20123 MI. Japan: Fujie Textiles, 7-12-4 Chome, Sendagaya, Shibuya-Ku, Tokyo 151. Scandinavia: Green Apples, GT6 Bernt Ankers, Oslo 1, Norway. UK: Osborne and Little, 304 King's Rd, London SW3. USA: Boussai of France, 330 West 38th Street, New York, NY 10018. West Germany: Ardecora, 15 Maximillan Platz, Munich 2

James Evanson Associates 1 Bond Street, New York, NY 10012, USA

Fermob BP 48, 71102 Châlons-sur-Saône, France. *Outlets* Italy: Cidue, Via San Lorenzo 32, 36010 Carre, VI. Japan: Murata, Suite F4, Kitano Arms, 2-16-15 Kirakawacho Chiyodaku, Tokyo. The Netherlands: Roland Lap, 47 Eemmesserweg, Postbus 71, 1260 AB Blaricum. Scandinavia: Handelsaktiebolaget AB I, 78 Luntmakargatan, 11351 Stockholm. Spain: Scarabat, Ctra Benifesar/LS, La Senia, Tarragona. UK: King Easton Ltd, Green Station Road, Winchmore Hill, London N21 3NB. USA: Vecta Georges Beylerian, 305 East 63rd Street, New York, NY 10021. West Germany: Jean Luc Kleinmann, 226a Hauptstrasse, Postfach 2136, 7597 Rheinau 2

Fiam Italia SPA Via Ancona 1/13, 61010 Tavullia, PS, Italy. *Outlet* UK: Casa Bianchi, Roslyn House, Sun Street, Hitchin, Herts SG5 1AE

David Field Furniture Workspace, Barley Mow Passage, London W4 4PH, UK

Flos SPA Via Moretti 58, 25121 Brescia, BS, Italy

Fontana Arte SPA Alzaia Trieste 49, 20094 Corsico, Italy. *Outlets* Austria: Einrichtungs-Verkaufs GMBH Co KG, 27 Hagenstrasse, 4020 Linz. Canada:

Angle International, 296 St Paul West, Montreal. France: Giuseppe Cerutti, 1 Loc Grand Chemin, 11020 Aosta, Italy. The Netherlands: Silvera BV, Postbus 163, 1250 AD Laren. USA: Interna Designs Ltd, The Merchandising Mart, Space 6-168, Chicago, IL 60654. West Germany: Fr. Von Der Beck, 52 Bahnhofstrasse, 3472 Beverungen 1

John French Atelier Ltd 19-30 Alfred Place, London WC1E 7EA, UK

Freud 198 Shaftesbury Avenue, London WC2H 8JL, UK. *Outlet* Australia: Authentic Interiors, 26, Hercules Street, Ashfield, NSW 2131

Frogdesign 33 Grenzweg, D-727 Altensteig, West Germany. *Outlets* Japan Frogdesign, 204, 2-7-18 Tamagawa – Denenchofu Setagaya-Ku, Tokyo 158. USA: Frogdesign, 34 South 2nd Street, Campbell, CA 95008

Derek Frost Associates 5 Moreton Terrace Mews North, London SW1V 2NT, UK

Fujie Textile Co Ltd 4-7-12 Sendagaya, Shibuya-Ku, Tokyo 151, Japan

Fujii Living Ltd Interior Division, Nankaikaikan 8F, Nanba, Minami- Ku 542, Osaka, Japan

Furniture of the Twentieth Century 227 West 17th Street, New York, NY 10011, USA

Galerie Adrien Maeght 42 Rue du Bac, 75007 Paris, France. *Outlets* Italy: Edizioni Maeght, Piazza del Carmine 6, 20121 Milan. Japan: Producer Associates Co Ltd, 3- 4-30 Shiba-Koen, Minato-Ku, Tokyo. Spain: Galeria Adrien Maeght, 25 Calle Montlada, Barcelona 3

Garcia Garay Design 113 San Juan de Malta, 08018 Barcelona, Spain

Keith Gibbons Design and Production 23 Summerstown, London SW17, UK. *Outlet* USA: Viaduct Furniture Ltd, James Mair, 3 Royalty Studios, 105 Lancaster Road, London W11 1QF, UK

Richard Ginori SPA Via Pio La Torre 4-C, 20090 Vimodrone, Milan, Italy. *Outlet* UK: ICTC, Unit 2, Worton Industrial Estate, Fleming Way, Isleworth, Middlesex

Girard-Perregaux 1 Place Girardet, 2300 La Chaux-de-Fonds, Switzerland

Glassworks 55-60 Metropolitan Works, Enfield Road, London N1 5AZ, UK

Robly A. Glover Jr 2335 Winding Brook Circle, Bloomington, Indiana, USA

Sue Golden 33 Fitzroy Road, London NW1, UK

Zaha Hadid Studio 9, 10 Bowling Green Lane, London EC1, UK

Hakusan Porcelain Co Ltd Uchinomi, Hasami-Machi, Nagasaki-Ken, Japan

Fritz Hansens Eft AS 3450 Allerød, Denmark. *Outlets* Australia: Danish Design Centre, 69-71 Edward Street, Pyrmont 2009, NSW. Italy: Cappellini SPA, Via Cavour 7, 22060 Carugo. The Netherlands: Kreymborg BV, 63 Minervalaan, 1077 NR Amsterdam. Scandinavia: Ing-Marie Widell, Box 5076, 19405 Upplands Väsby 5. Spain: Sellex SA, Camino 6-3 Izpda-Loyola 4-10, Apartado 273, San Sebastian. UK: Scott Howard Furniture, 32 Broadwick Street, London W1. USA: Rudd International Corporation, 1025 Thomas Jefferson Street NW, Washington DC 20007. West Germany: Gert Klockgether, 169a Tegelweg, 2000 Hamburg 72

Celia Harrington Unit 330, 30 Great Guildford Street, London SE1 0HS, UK

Titus Hertzberger 68 II P. Aertszstraat, 1073 SR Amsterdam, The Netherlands

Hickory Business Furniture 900 12th St Drive NW, Hickory, North Carolina 28601, USA

Matthew Hilton 87 Shrubland Road, London E8, UK. *Outlet* Japan: Kiya Gallery, 9-2 Sarugaku-Cho, Shibuya-Ku, Tokyo, Japan

Hishinuma Associates 5-47-9 Jingumae, Shibuya-Ku, Tokyo 150, Japan

Hitex Sölvesborg, Sweden

Diana Hobson 7 Church Crescent, London E9 UK. *Outlets* France: Clara Scremini, 39 Rue de Charonne, 75011 Paris. USA: Kurland Summers Gallery, 8724 Melrose Ave, Los Angeles, CA 90069. West Germany: Gallery L, 31 Elbchaussee, Hamburg

Honiton Pottery Ltd Honiton, Devon, UK

Thomas Hucker Design 465 Medford St, Charlestown, Massachusetts 02129, USA

Icom SAS Via C. Battisti, 28040 Dormelletto, Novaro, Italy

Ideal Standard SPA Via Ampère 102, Milan, Italy

Idée 5-4-44 Minamiaoyama, Minato-Ku, Tokyo 107, Japan

IDM Modelmakers 7-8 Jeffreys Place, Jeffreys Street, London NW1 9PP, UK

Iguzzini Illuminazione SPA SS 77 Km 102, 62019 Recanati, Macerata, Italy. *Outlets* France: Oggi Design, 151 Avenue du Maine, 75014 Paris. The Netherlands: Accent, 150 Europaweg, 570044 Helmond. Sweden: Roshamn AB, 570 82 Malilla. UK: Forma Lighting Ltd, 85 Streatham Road, Mitcham, Surrey, CR4 2AP. West Germany: iGuzzini Deutschland, 5 Bunsenstrasse, 8033 Martinsried

Iittala Glassworks 14500 Iittala, Finland. *Outlets* Australia: Novo Industries Ltd, 60 Bay Street, Ultimo, NSW 2007. Austria: Fa. O. & S. Dunkelblum, 6-VII-3 Herrengasse, 1010 Vienna. Canada: Ahlstrom Iittala (Canada) Inc, 10217 Cote de Liesse Road, Dorval, Quebec H9P 1A3. Denmark: Erik Rosendahl A/S, 1C Lundtoftevej, 2800 Lyngby. France: AG Distribution SARL, 56 Rue de Paradis, 75010 Paris. Italy: Seambe SRL, Via Marchesi de Taddei 10, 20146 Milan. Japan: Matsuya Shoji Co Ltd, 2-20 Akashi-Cho, Chuo-Ku, Tokyo 104. The Netherlands: Indoor, 22-4 Paulus Potterstraat, 1071 DA Amsterdam. Norway: Carl F. Myklestad, Postbus 153, 91C Strömsvn, 1473 Skårer. Spain: Jocar Import, 91-5 Zamora, Barcelona 18. Sweden: Knut & Per-Åke Särnwald AB, 56 Kungsgatan, 411 08 Göteborg. UK: Storrington Trading Ltd, Eastmead Industrial Estate, Midhurst Road, Lavant, Chichester, West Sussex PO18 0DE. USA: Ahlström-Iittala Inc, 175 Clearbrook Road, Elmsford, NY 10523. West Germany: B. T. Dibbern GMBH & Co KG, 1 Heinrich-Hertz-Strasse, Postfach 1160, 2072 Bargteheide, Hamburg

The Imperial Woodworks Lower Farm Cottages, Happisburgh, Norfolk NR12 0QQ, UK

Innovations Inc 969 Third Avenue, New York, NY 10022, USA

Ishimaru Co Ltd 202 Maison Akashi, 7-3-24 Roppongi, Minato-Ku, Tokyo, Japan

Italtel Telematica Piazzale Zavattari 12,

20149 Milan, Italy. *Outlet* Switzerland: Autophon Telecom Ltd, 54 Bollingenstrasse, 3006 Bern

Carlos Jané SA PO Box 243, Poligono Industrial "Els Xops," 08080 Granollers, Barcelona, Spain

Erik Jørgensen Møbelfabrik AS Industrivaenget, 5700 Svendborg, Denmark. *Outlets* France: Bivex Collection, 157 Rue du Faubourg, 75008 Paris. Japan: T-Form, 8-19 Kozuchio Minami-Ku, Osaka. The Netherlands: F. & C. Morin, 40 Amsteldijk Noord, 1184 TD Amstelveen. UK: Scan-Q Ltd, 12 Fairway Drive, Greenford, Middlesex UB6 8PW. USA: Hans Fog, 7 Strandbyvej, 5953 Tranekaer, Denmark. West Germany: Peter Biehl, 46 Parkstrasse, 5262 Diez/Lahn.

Christoph Jünger 16 Gollierstrasse, 8000 Munich, West Germany

JVC (Victor Company of Japan) Ltd 4-8-14 Nihonbashi-Honcho, Chuo-Ku, Tokyo 103, Japan. *Outlets* France: JVC Video France SA, 102 Boulevard Heloise, 95104 Argenteuil, Cedex. Scandinavia: JVC Svenska AS, 3 Girorägen, 17562 Järfälla, Sweden. UK: JVC (UK) Ltd, JVC House, Eldonwall Trading Estate, 12 Priestley Way, London NW2 7BA. USA: US JVC Corp, 41 Slater Drive, Elmwood Park, New Jersey 07407. West Germany: JVC Deutschland GMBH, JVC Haus, Postfach 5404, 31-3 Mergenthaler Allee, 6236 Eschborn 1

Liz Kitching 22 Rastell Ave, London SW2, UK

Knoll International The Knoll Building, 655 Madison Avenue, New York NY 10021, USA

Koch + Lowy 21-24 39th Avenue, Long Island City, NY 11101, USA

Kodak AG Postfach 369, 7000 Stuttgart 60, West Germany

Kuramata Design Office 7-3-24 Roppongi, Minato-Ku, Tokyo, Japan

James Kutasi Building 119, 28 Lord Street, Botany 2019, NSW, Australia

Jack Lenor Larsen 41 East 11th Street, New York, NY 10003, USA. *Outlets* Austria: Böhm Gesellschaft MBH, 12 Richard-Strauss-Strasse, 1232 Vienna. Denmark: McNutt APS, 16 Rødtjørnen, 2791 Dragør. France: Suzy Langlois, 266 Boulevard Saint Germain, 75007 Paris. Italy: Mann & Rossi, Via Ariosto 3, 20145 Milan. The Netherlands: L Kreymborg, 63 Minervalaan, 1077 NR Amsterdam. Sweden: Ide Individuell/Helga Duell, 8 Norra Liden, 411 18 Göteborg. Switzerland: Pandora AG, 15 Am Schanzengraben, 8002 Zurich. UK: Clifton Textiles, 103 Cleveland Street, London WIP 5PL. West Germany: Jack Lenor Larsen, 14-18 Zimmersuhlenweg, 6370 Oberursel

Lavori in Corso Via Vigevano 8, 20144 Milan, Italy

Jennifer Lee 16 Talfourd Rd, London SE15, UK

Leser Design Inc 499 Adelaide Street West, Toronto, Ontario M5V 1TA, Canada

Leucos SRL Via Treviso 77, 30037 Scorzé, Venezia, Italy. *Outlets* Australia: Lidi Australia Pty Ltd, 67 Sheehan Road, West Heidelberg, Melbourne, Victoria 3081. France: Oggi Design, 151 Avenue du Maine, 75014 Paris. Japan: Casa Luce Inc, 1-4-2 Minamiaoyama, Tokyo 107. The Netherlands: Kreymborg BV, 63 Minervalaan, 1077 Amsterdam. Scandinavia: Unicum AB, PO Box 5, 14152 Thorburnsgatan, 400 20 Göteborg, Sweden. UK:

Forma Lighting Ltd, Business Design Centre, Unit 310-II, 52 Upper Street, London N1. USA: IPI Inc, 30-20 Center Two, Thomson Avenue, Long Island City, NY 11101. West Germany: Christian Robert GMBH, 5 Bunsenstrasse, Martinsried, 8033 Munich

J. & L. Lobmeyr 26 Kaerntnerstrasse, 1010 Vienna, Austria

London Glassblowing Workshop 109 Rotherhithe Street, London SE16 3NE, UK

Lonseal Inc 928 East 238 Street, Building A, Carson, CA 90745, USA

Lumiance BV 155 Oudweg, PO Box 6310, 2001 HH Haarlem, The Netherlands. *Outlets* Australia: Lumiance PTY Ltd, 53 Coppin Street, Richmond, Victoria 3121. Austria: Zumtobel AG, 8 Hochsterstrasse, PO Box 72, 6850 Dornbirn. Denmark: Uniline National AS, 10 Sankt Knudsvej, 1903 Copenhagen. France: Lumiance, 4 Rue Sadi Carnot, 93170 Bagnolet. Italy: Lumiance Italia, Via delle More 1, 24030 Presezzo, Bergamo. Norway: Lumiance Norge AS, 33 Vagsgt., 4300 Sandnes. Portugal: Tecnicon SARL, 40-A-40-C Avenue do Brasil, 1700 Lisbon. Spain: Ildo SA, 21 C de la Sofora, 28020 Madrid. Sweden: Marelco AB, 16 Askims Verksradsvag, PO Box 30070, 40043 Göteborg. UK: Lumiance, Tetbury Hill, Malmesbury, Wiltshire, SNI6 9JX. USA: Basic Concept, 141 Lanza Avenue, Garfield, New Jersey 07026. West Germany: Lumiance GMBH, 48 Feldheider Strasse, 4006 Erkrath 2

Chris McElhinny 101 Sherbrooke Street, Ainslie, Canberra, ACT 2601, Australia

Daniel Mack Rustic Furnishings 225 West 106th Street, New York, NY 10025, USA

Marieta Textil SA 15 Ballester, 08023 Barcelona, Spain. *Outlet* UK: Inhouse, 28 Howe Street, Edinburgh, Scotland

Marimekko 4 Puusepänkatu, 00810 Helsinki, Finland

Nani Marquina 3 C. Bonavista, 08012 Barcelona, Spain. *Outlets* France: Marie Bacou, 200 Rue La Fayette, 75010 Paris. Italy: Tisca, Via Donizetti 6, 24050 Lurano, Bergamo. Switzerland and West Germany: IMD, Franz Baars, 26 Eebrunnestrasse, 5212 Hausen, AG, Switzerland

Martech 329 Oudegracht, 3511 PC Utrecht, The Netherlands. *Outlets* France, Italy, Scandinavia, UK and USA: Carlo Wanna, 14 Houtkopersstraat, 3300 PC Utrecht, The Netherlands. West Germany: Teunen & Teunen, Postfach 36, 6222 Geisenheim 2

Robert Materne Inc PO Box 925, Bristol, RI 02809, USA

Matsushita Battery Industrial Co Ltd 1 Matsushita-Cho, Moriguchi, Osaka 570, Japan

Matsushita Electric Co Ltd 1-4 Matsuo-Cho, Kadoma City, Osaka, Japan.

Matsushita Electric Industrial Co Ltd Electric Iron Division, 3-14-43 Himejima, Nishiyodogawa-Ku, Osaka, Japan. Kitchen Appliance Division, 3-8-3 Himesato, Nishiyodogawa-Ku, Osaka, Japan. Television Sector, 1-1 Matsushita-Cho, Ibaraki, Osaka 567, Japan

Matsuzaki & Co Ltd 5-3 Kurame 1-Chome, Taito-Ku, Tokyo 111, Japan

Memphis SRL Via Olivetti 9, 20010 Pregnana Milanese, MI, Italy. *Outlets* Australia: Artemide Pty

Ltd, 69 Edward Street, Pyrmont, NSW 2009. Austria: Prodomo, 35-7 Flachgasse, 1150 Vienna. Canada: Artemide Ltd, 354 Davenport Road, Designers Walk, 3rd Floor, Toronto, MI5 RK5. France: Roger von Bary, 18 Rue Lafitte, 75009 Paris. The Netherlands: Copi, 90A Prinsestraat, 2513 CG, Den Haag. Scandinavia: Renzo d'Este, 1A Brodrevej, 2860 Søborg, Copenhagen, Denmark. UK: Artemide GB Ltd, 17-19 Neal Street, London WC2. USA: Memphis Milano, International Design Center, Center One, Space 525, 30-30 Thomson Avenue, Long Island City, NY 11101. West Germany: Agentur Brunnbauer, 51 Ehmckstrasse, 2800 Bremen 33

Shari M. Mendelson 119 South 2nd Street, Brooklyn, New York, USA

Bruce Metcalf c/o School of Art, Kent State University, Kent, OH 44242, USA

Minerva Co Ltd 1-10-7 Hiratsuka, Shinagawa-Ku, Tokyo, Japan

Mira-X AG Suhr Postfach, 5034 Suhr, Switzerland. *Outlets* Austria: Mira-X Österreich, 4-5 Ziehrerplatz, 1030 Vienna. France: Mira-X France SA, 4 Rue Barbette, 75003 Paris. Denmark: Mira-X Danmark, X-Design Studio A/S, 18 Thomas Helsteds Vej, 8660 Skanderborg. Italy: Modus SRL, Piazza Cadorna 9, 20123 Milan. The Netherlands: Mira-X Benelux, 330 Ginnekenweg, 4835 Breda. Norway: Mira-X Norge A/S, 28 Sagveien, 0458 Oslo 4. Sweden Mira-X Sweden, 32 Mariedalsvägen, 200 71 Malö. UK: Mira-X (UK) Ltd, 5 Guildford Rd, Westcott, Dorking, Surrey. USA: Kravet Fabrics Inc, 225 Central Avenue South, Bethpage, NY 11714. West Germany: Mira-X GMBH, 9 Maybachstrasse, 7022 Leinfelden-Echterdingen

Miyashin Co Ltd 582-11 Kitano-Machi, Hachioji-Shi, Tokyo 192, Japan

Mondo SRL Via Vittorio Veneto 1, 22060 Carugo, CO, Italy. *Outlets* France: Guiseppe Cerutti, 1 Loc Grand Chemin, 11020 St Christophe, AO, Italy. The Netherlands: Koos Rijkse Agency, 1 PR Christinalaa, 7437 XZ Bathmen. Scandinavia: Mobile Box AB, Hargs Sateri, 194 90 Upplands Varsey, Sweden. Spain: Jose Martinez Medina SA, Camino del Bony S/N, Catarroja, Valencia. USA: Interna Design Ltd, The Merchandise Mart, Suite 6-168, Chicago, IL 60654

Paul Montgomery 343 Holland Drive, Statesville, North Carolina 28677, USA

Jasper Morrison 16a Hilgrove Road, London NW6, UK

Thomas Muller 150 Kantstrasse, 1000 Berlin 12, West Germany

National Bicycle Industrial Co Ltd 13-3 Katayama-Cho, Kashihara, Osaka 582, Japan

Leah Nelson 110 West Kinzie, Chicago, IL 60610, USA

Neotu 25 Rue du Renard, 75004 Paris, France. *Outlets* The Netherlands: Eckhardt, 281 Spuistraat, 1012 VR Amsterdam. USA: Furniture of the Twentieth Century, 227 West 17th Street, New York, NY 10011

Nota Bene PO Box 30114, New York, NY 10011, USA

Noto Via Vigevano 8, 20144 Milan, Italy. *Outlets* Canada: Angle International, 296 Ovest, Rue St Paul, Montreal, Quebec H2Y 2A3. France: Altras, 24 Rue Lafitte, 75009 Paris. Italy: Arflex, Via Monterosa 27,

20051 Limbiate. Japan: Ambiente International, Sumitomo Seimei Building, 3-1-30 Minamiaoyama Minato, Tokyo. The Netherlands: Andrea Kok Agenturen, Bildersijkkade, 5HS 1052 RS Amsterdam. Scandinavia: Artelumina, 30 Sibyllgatan, 114 43 Stockholm, Sweden. Spain: Fernandez Casimiro, Urbanizacion Soto de Llanera, Casa 5, Pruvia, Llanera, Asturias. UK: One Off, 39 Shelton Street, London WC2. USA: Atmosphere, 176 2nd Avenue, New York, NY 10128. West Germany: Quartett GmbH, 30 Knochenhauerstrasse, D 3000 Hanover

Nucleon Oito Design Projs E Comércio de Móveis LTDA 1052 Al Ministro Rocha Azevedo, 01410 São Paulo, Brazil

OHS Co Ltd Kuono Building 1-23-9, Nishi-Shinbashi, Minato-Ku, Tokyo, Japan

O-Luce SPA Via Cavour 52, 20098 San Giuliano Milanese, Italy. *Outlets* France: Horas, 150 Rue Championnet, 75018 Paris. Japan: Arflex Trading, 2-9-8 Higashi Shibuya-Ku, Tokyo 150. The Netherlands: Carlo Wanna, 14 Houtkopersstraat, 3330 AJ Zwijndrecht. Norway: Martens, 18 Nobelsgate, Oslo 2. Sweden: Inside Gallerian, 37 Hamngatan, 10395 Stockholm. UK: London Lighting, 135 Fulham Road, London SW3 6RT. USA: Lighting Associates, 305 East 63rd Street, New York, NY 10021. West Germany: Floetotto Handelsagentur, 38-40 Ringstrasse, 4835 Rietberg

OMK Design Stephen Building, 30 Stephen Street, London W1, UK. *Outlets* France: Protis, 67-101 Ave Vieux Chemin, St Denis, 92230 Gennevilliers. Italy: Bieffeplast SPA, Via Pelosa 78, 35030 Caselle di Selvazzano, Padova. Japan: Nova Oshima, 9-6-14 Akasaka, Minatu-Ku, Tokyo 107. Scandinavia: Pettier Dale Jr, Italian House, Oeverland Gard, 123 Kingeriksvelen, 1340 Bekkestua, Norway. USA: Gullans International, 30-30 Thomson Avenue, Space 407, Long Island City, NY 11101. West Germany: Andrea S. Weber, 79 Nymphenburgerstrasse, 8000 Munich 19

One of a Kind Ltd 259 Lytton Avenue, Paolo Alto, CA 94301, USA

One Off Ltd 39 Shelton St, London WC2, UK

Pace 11-11 34th Avenue, Long Island City, NY 11106, USA

Pallucco SRL Via Salaria 1265, 00138 Rome, Italy. *Outlets* France: Ready Made, 40 Rue Jacob, 75006 Paris. Japan: Arc International Isugarucho, Kamanzadori, Nakagyo-Ku, Kyoto 604. The Netherlands: Hansje Kalff, 8 Puttensenstraat, 1118 JE Amstelveen. West Germany: Abitare, 3-5 Auf dem Berlich, 5000 Cologne 1

Elio Palmisano Edizioni Tessili Via Stra Madonna, PO Box 142, 21047 Saronno, VA, Italy

Suku Park Studio 16 Bergåsvägen, 02340 Esbo, Finland

Personalities Inc Azabu-Palace 503, 2-25-18 Nishiazabu, Minato-Ku, Tokyo 106, Japan

Philips NV Building SX, PO Box 218, 5600 MD Eindhoven, The Netherlands. *Outlets* Austria: Österreichische Philips Industrie GMBH, 64 Triester Strasse, 1100 Vienna. Denmark: Philips Elapparat AS, 80 Pragsboulevard, 2300 Copenhagen. France: SA Philips Industrielle et Commerciale, 50 Avenue Montaigne, 75380 Paris. Italy: Philips Italia SA, Piazza IV Novembre 3, 20100 MI. Japan: Philips Industrial Development and Consultants Co Ltd,

Shuwa, Shinagawa Building, 26-33 Takanawa 3-Chome, Minato-Ku, Tokyo 108. Norway: Norsk AS Philips, PO Box 5040, 6 Soerkedaksveien, Oslo 3. Spain: Philips Iberica SAE, 2 Martinez Villergas, Apartado 2065, 28027 Madrid. Sweden: Philips Norden AB, 115 84 Stockholm. UK: Philips Electrical and Associated Industries Ltd, Arundel Great Court, 8 Arundel St, London WC2. USA: North American Philips Corporation, 100 East 42nd St, New York, NY 10017. West Germany: Allgemeine Deutsche Philips Ind GMBH, 94 Steindamm, 2000 Hamburg.

Plus Corporation 20-11 Otowa 1 Chome, Bunkyo-Ku, Tokyo 112, Japan. *Outlet* USA: Plus USA Corp, 10 Reuten Drive, Closter, New Jersey 07624.

Polaroid Corporation 565 Technology Square, Cambridge, MA 02139, USA.

Poloflex Salotti 33011 Artegna, Udine, Italy. *Outlet* UK: Fior Fiore, Oaklands, Rivar Road, Shalbourne, Wilstshire SN8 3QD.

Poltrona Frau SPA SS77 KM 74,500, 62029 Tolentino, Macerata, Italy. *Outlets* France: Poltrona Frau France SARL, 242 bis Boulevard St Germain, 75007 Paris. The Netherlands: Poltrona Frau Benelux, 9 Parkstraat, 4818 SJ Breda. USA: Poltrona Frau USA Corp, 14 East 60th Street, New York, NY 10022. West Germany: Andreas Jaek, 3 Neuestrasse, 2900 Oldenburg.

L. Suzanne Powadiuk 176 The Esplanade no. 320, Toronto, Ontario M5A 4H2, Canada.

Proform 8170 South West Nimbus Avenue, Beaverton, Oregon 97005, USA.

Prototyp 46 St Johann-Rheinweg, 4056 Basel, Switzerland.

Punt Mobles 48 Islas Baleares, 46980 Paterna, Valencia, Spain. *Outlets* Austria: Otto Dunkelbum, 6-7-3 Herrengase, 1010 Vienna. France: Marie Bacou, 200 Rue La Fayette, 75010 Paris. The Netherlands: Amda BV, 37 Oosterheutlaan, 1181 AL Amstelveen. Scandinavia: M. Sten Bergstrom, 9 Liljekonval Jens, 13200 Saltsjo-Boo, Sweden. UK: Maison Designs, 917-19 Fulham Road, London SW6. USA: Susana Macarron, 934 Grayson Street, Berkeley, CA 94710. West Germany: Traudel Compte, 4 Weissenseestrasse, 8000 Munich 90.

Radar Ctra. Vitoria s/n, 20540 Escoriaza, Guipúzcoa, Spain.

Daniel Reynolds 17 Kensington Park Road, London W11 2EU, UK.

Ricoh Company Ltd 15-5 Minami-Aoyama 1-Chome, Minato-Ku, Tokyo 107, Japan. *Outlets* Europe: Ricoh Europe BV, 3 Groenelaan, 1188 AA Amstelveen, The Netherlands. France: Ricoh France SA, 192 Avenue Charles de Gaulle, 92200 Neuilly-sur-Seine, Paris. UK: Ricoh UK Ltd, Ricoh House, 2 Plane Tree Crescent, Feltham, Middx. USA: Ricoh Corporation, 5 Dedrick Place, West Caldwell, New Jersey 07006. West Germany: Ricoh Deutschland GMBH, 45-7 Mergenthaler Allee, 6236 Eschborn 1.

Ronchetti F. Ili Via Monte Grappa 2, Cantu, Como, Italy.

Rosenthal AG 18 Casinostrasse, Postfach 1520, 8672 Selb, Bayern, West Germany. *Outlets* Australia: Rosenthal Australia Pty Ltd, 520 Collins Street, 9th Floor, GPO Box 2029S, Melbourne, Victoria 3001. Canada: Rosenthal China (Canada) Ltd, 55 East Beaver Creek Road, Unit 6, Richmond Hill, Ontario L4B 1E5. France: Rosenthal Porcelaines-

Cristaux SARL, 50 Rue de Paradis, 75484 Paris Cedex 10. Italy: Rosenthal Studio-Line, Via Rubattino 4, 20134 Milan. Japan: Rosenthal Tokyo Liaison Office, OAG Haus, Room 405, 5-56 Akasaka 7-Chome, Minato-Ku, Tokyo. The Netherlands: Rosenthal Benelux BV, 1 Porcelainstraat, PO Box 1006, Maastricht. Scandinavia: Rosenthal Skandinavien Försäljnings AS, Box 5289, 51 Karlvägen, 10246 Stockholm, Sweden. Spain: Porcelaines Cristaux, 32 General Person, Planta 25, Madrid 20. Rosenthal China (London) Ltd, 3 Abercorn Trading Estate, Bridgewater Road, Alperton, Wembley, Middlesex HA0 1BD. USA: Rosenthal USA Ltd, 6636 Metropolitan Avenue, Middle Village, NY 11379.

Michael Rowe 24 Holyport Rd, London SW6, UK.

Charles Rozier 270 Lafayette Street, New York, NY 10012, USA.

Toby Russell 1 Arlington Cottages, Sutton Lane, London W4 4HB, UK.

Argenteria Sabattini SPA Via Don Capiaghi 2, 22070 Bregnano, Como, Italy. *Outlets* Japan: New Robin Co Ltd, 2-11 2-Chome, Kajimachi, Kokurakita-Ku,802 Kitakyushushi-Fukuoka. The Netherlands: Mobica PVBA, Gossetlaan 50, 1720 Groot, Bijaard. UK: Objects, 49 Parliament St, Harrogate, North Yorkshire. USA: Italarte, 4203 West Alamos 106, Fresno, CA 93711. West Germany: Sabattini Deutschland, 50 Kennedyallee, Frankfurt.

Sakura Color Products Corporation 10-17 Nakamichi, 1-Chome, Higashinari-Ku, 537 Osaka, Japan.

Saladino Furniture Inc 305 East 63rd Street, New York, NY 10021, USA.

Santa & Cole 10 Santisima Trinidad del Monte, 08017 Barcelona, Spain. *Outlets* France: Marie Bacou, 200 Rue La Fayette, 75010 Paris. The Netherlands: Peter van Kester, 31 Egelantiersgracht, 1015 RC Amsterdam.

Sanyo Electric Company Ltd 100 Dainichi Higashimachi, Moriguchi-Chi, Osaka-Fu 570, Japan.

Sasaki Crystal 41 Madison Avenue, New York, NY 10010, USA.

Sawaya & Moroni Via Manzoni 11, 20121 Milan, Italy.

Franz Schatzl, Design Werkstätte 4801 Traunkirchen, Traunsee, Austria.

Screens The Gallery Workshop, 60a West Street, Fareham, Hampshire PO16 0DG, UK.

Segno Piazza dello Sport 9, Parabiago, 20015 Milan, Italy.

Sharp Corporation 22-22 Nagaike-Cho, Abeno-Ku, Osaka 545, Japan.

Helen Shirk 2629 Bancroft Street, San Diego, CA 92104, USA.

SKK Lighting 110 Gloucester Avenue, London NW1 8JA, UK.

Ruth Skrastins Fabrics 29 Pritchard Street, Annandale 2038, Sydney, NSW, Australia.

Nancy Slagle 2335 Winding Brook Circle, Bloomington, Indiana, USA.

Smart Design 7 West 18th Street, New York, NY 10011, USA.

Judy Smilow Design 137 West 81st Street, New York, NY 10024, USA.

Diane E. Smith 11 Weston Street, Canberra 2600, ACT, Australia.

Soho Design Ltd 1-5 Poland Street, London WIV 3DG, UK.

Sony Corporation 6-7-35 Kitashinagawa, Shinagawa-Ku, Tokyo 141, Japan.

Søren Horns EFTF 33 Birkedommervej, 2400 Copenhagen NV, Denmark.

Sparks Co Ltd Roppongi Fumiyama Building 702, 6-8-18 Roppongi, Minato-Ku, Tokyo, Japan.

Strässle Söhne AG PO Box 164, 9533 Kirchberg, St Gallen, Switzerland. *Outlets* France: Com-System (ARIA), 31 Rue Eugène Dubois, 01000 Bourg en Bresse, 01 Ain. Italy: Costi CSPA, Via Trebbia 22, 20135 Milan. Japan: Asahi Grant KK, 11 F Maison Mita N. 1103, 2-8-20 Mita, Minato-Ku, Tokyo 108. The Netherlands: Andrea Kok, 43 Kromme Mijdrechtstraat, 1079 Amsterdam KP. Scandinavia: Don Batchelor APS, 163a Strandvejen, 2900 Hellerup. UK: Oscar Woollens Co Ltd, 421 Finchley Road, London NW3. USA: Monel Contract Furniture, PO Box 291, Oakland Gardens, NY 11364. West Germany: WK-Verband GMBH, 4 Heilbronner-strasse, 7022 Leinfelden-Echterdingen 2.

Suffolk Furniture Ltd Hollands Road, Haverhill, Suffolk, UK. *Outlets* USA: John Moore, Preferred Stock Inc, 40-B North Rock Hill Road, St Louis, Missouri 63119; James Druckman, New York Design Center, 200 Lexington Avenue, Suite 1211, New York, NY 10016.

Suku Park Studio 16 Bergåsvägen, 02340 Esbo, Finland.

Swid Powell 55 East 57th Street, Penthouse, New York, NY 10022, USA.

Syndesis Studio Inc 1708 Berkeley Street, Santa Monica, CA 90404, USA.

Jasia Szerzynska 144 Haberdasher Street, London N1 6EJ, UK.

Takefu Knife Village Kogyo Danchi, Ikeno Kami-Cho, Takefu-Shi, Fukui-Ken, Japan.

Tekstiel Design MVH 35 Grote Heerweg, 8749 Beveren-Leie, Belgium.

Tempera Fabrics Howfield Lane, Chartham, Canterbury, Kent CT4 7HQ, UK.

Tiffany & Co Fifth Avenue and 57th Street, New York, NY 10022, USA.

Tingware Flat 6, Abbeyfields, Sandbach, Cheshire CW11 9EF, UK. *Outlets* Japan: Haruyoshi Kiyoi Oakland Ltd, 102 Sunview Heights, Shirogane-Dai, 5-4-3 Shirogane-Ku, Tokyo 108.

David Tisdale Design Inc 430 West 14th Street, Room 302, New York, NY 10014, USA.

Toulemonde Bochart Z. I. de Villemilan, 14-16 Boulevard Arago, 91320 Wissous, France.

Traffic Technology Ltd Corsley House, nr Frome, Wiltshire, UK.

Transtam 63 Mariá Cubi, 08006 Barcelona, Spain.

Ultima Edizione Via Angelini 20, 54100 Massa, Italy.

Unac Tokyo 1-1-20-112 Azabudai Minato-Ku, Tokyo, Japan.

Unum SRL Viale Mazzini 73, 36100 Vicenza, Italy.

Van Houtte 1 Waregem Straat, 8760 Viehte,

Belgium.

Vereinigte Werkstätten 31 Ridlerstrasse, 8000 Munich, West Germany. *Outlets* France: Nova Distribution SARL, CIT Tour de Montparn, Bureau 883, BP 258, 75749 Paris-Cedex 15. The Netherlands: Bob Smit, 52 Jasonstraat, Amsterdam. Scandinavia: Finn Sloth, 1 Heilsmindevey, 2920 Charlottenlund, Denmark. UK: Aram Designs Ltd, 3 Kean Street, London WC2B 4AT.

View-Master Ideal Group 200 Fifth Avenue, New York, NY 10010, USA.

Mario Villa Inc 3908 Magazine Street, New Orleans, Louisiana 70115, USA.

Vistosi Murano, Venice, Italy.

Vitra International AG 15 Henric Petri Strasse, Postfach 257, 4010 Basel, Switzerland. *Outlets* France: Vitra SARL, 59 Avenue d'Iéna, 75116 Paris. The Netherlands: Vitra Nederland BV, 527 Strawinskylaan, 1077 XX Amsterdam. UK: Vitra Ltd, 13 Grosvenor Street, London W1X 9FB. USA: Vitra Seating Inc, c/o Stendig International Inc, 305 East 63rd Street, New York, NY 10021.

Rupert Williamson Furniture New Bradwell Workspace, St James Street, New Bradwell, Milton Keynes MK13 0BW, UK.

Franz Wittmann KG 3492 Etsdorf/Kamp, Austria. *Outlets* France: Horas International, 150 Rue Championnet, 75018 Paris. Italy: Wittmann Italia SRL, Via E. Filiberto 10, 45011 Adria, RO. The Netherlands: Art Collection BV, 63 Weijland, 2415 Nieuwerbrug. Scandinavia: Inside Galleria, 37 Hamnagatan, 11147 Stockholm, Sweden. UK: M. W. United Ltd, 19 Dacre Street, London SW1 0DJ. USA: Stendig International, 410 East 62nd Street, New York, NY 10021. West Germany: Franz Wittmann KG, 20a Königstrasse. 6729 Wörth.

Woka Lamps Vienna 16 Singerstrasse, 1010 Vienna, Austria. *Outlets* France: Altras, Roger von Bary, 18 Rue Lafitte, 75009 Paris. Italy: Marina de Nardo, Via Lincoln 41, Milan. Scandinavia: Ide Individuell, 8 Norra Liden, 4118 Göteburg, Sweden. UK: MW United Ltd, 16 Dacre Street, London SW1H 0DJ. USA: George Kovacs Inc, 24 West 40th Street, New York, NY 10018.

Yamagiwa Corporation 4-1-1 Sotokanda, Chiyoda-ku 101, Tokyo, Japan.

Yamaha 1370 Nishiyama-Cho, Hamamatsu-Shi 432, Japan.

Zanotta SPA Via Vittorio Veneto 57, 20054 Nova Milanese, Italy. *Outlets* Australia: Arredorama International PTY Ltd, 1 Ross Street, Glebe, NSW 2037. Austria: Prodomo, 35-37 Flachgasse, 1060 Vienna. France: Giuseppe Cerutti, 1 Località Grand Chemin, 11020 St Christophe, AO, Italy. Japan: Nova Oshima Co Ltd, Sakakura Building, Akasaka Minato-Ku 9-6-14, Tokyo. The Netherlands: Hansje Kalff, 4 Puttensestraat, 1181 JE Amstelveen. Denmark: Paustian, 2 Kalkbraendrilbskaj, 2100 Copenhagen. Norway: Bente Holm, 64 Parkveien, Oslo 2. Spain: BD Ediciones de Diseño, 291 Mallorca, 08037 Barcelona. Sweden: Inside, 37 Hamngatan, 11147 Stockholm. UK: The Architectural Trading Co Ltd, 219-29 Shaftesbury Avenue, London WC2H 8AR. USA: International Contract Furnishing Inc., 305 East 63rd Street, New York, NY 10021. West Germany: Fulvio Folci, 14 Dahlienweg, 4000 Düsseldorf 30.

Zerbetto Via Pellico 5, 35100 Padova, Italy.

BY DESIGN COLLECTIONS IN 1987

Dates given in brackets refer to the dates of the designs (from 1960 to the present day).

The Netherlands

Museum Boymans van Beuningen, Rotterdam

Ron Arad Lamp, *Aerial* (1982), manufactured by One Off, UK_____

Stereo set, *Concrete* (1985), manufactured by One Off, UK_____

Corporate Industrial Design/CID Videorecorder, *N-1500* (1971), manufactured by Philips NV, The Netherlands_____

Michael A. Cousins, Cousins Design Car vacuum cleaner, *Car Vac* (1982), manufactured by Dynamic Classics, USA_____

James Dyson *Ball Barrow* (c. 1983), manufactured by Hozelock ASC, UK_____

Giorgio Giugiaro Bicycle, *Blouson* (1985), manufactured by Bridgestone Corp, Japan. Folding bicycle (c. 1985), manufactured by Di Blasi, Italy. Folding bicycle (1986), manufactured by Strida, UK___

Heuer Designteam Watches, *Formula I* (c. 1986), manufactured by TAG-Heuer, Switzerland. Divers' watches, chronographs, stopwatches, manufactured by TAG-Heuer, Switzerland_____

Friso Kramer Office furnishing system, *Mehes* (1972), manufactured by Ahrend/Cirkel, The Netherlands_____

Dietrich Lubs, Dieter Rams Watch (1978), manufactured by Braun, West Germany_____

Louis Lucker Copier machine, *1725* (1980-1), manufactured by Océ van der Grinten, The Netherlands_____

Alex Moulton Folding racing bicycle (c. 1985), manufactured by Alex Moulton Bicycles, UK. Racing bicycle (c. 1982), manufactured by Koga Miyata, Japan_____

Wolfgang Müller-Desig Chairs, *Domino* (1984), manufactured by Wagemans Maastricht, The Netherlands_____

Ferdinand A. Porsche Compass watch (1987), manufactured by IWC, Switzerland_____

Aart Roelandt Reclining bicycle, *Roulandt* (1983), manufactured by Aro, The Netherlands_____

Marco Zanuso TV, *Black Box* (1969), manufactured by Brionvega, Italy. TV antenna, *Robot* (1981), manufactured by Brionvega, Italy_____

UK

The Victoria and Albert Museum, London

Robert Adam *Pembroke Table* (1986), manufactured by Alma, UK_____

Jussi Ahola Tableware, *Forte* (c. 1985), manufactured by Arabia, Finland_____

G.P. and J. Baker Fabrics, *The Raoul Dufy Collection* (1985); *Autumn 85 Collection* (1985); *The English Toile Collection* (1985); *Valiauris* (1985); *Villefranche* (1985); *Valensole* (1985); *Mandelieu* (1985); *Mistral* (1985); *Fréjus* (1985), manufactured by G.P. and J. Baker, UK_____

Michael Bang Vase, *Atlantis* (c. 1985), manufactured by Holmegaard, Denmark_____

H.T. Baumann Tableware, *Sevilla* (c. 1986), manufactured by Arzberg, Germany_____

K. Bjorquist Salad bowl, jugs (1985), manufactured by Gustavsberg, Sweden. Tableware, *Paris* (1985), manufactured by Gustavsberg, Sweden_____

K. Bjorquist and Lena Boije Tableware, *Caprifolium* (1985); *Stockholm* (1985), manufactured by Gustavsberg, Sweden_____

K. Bjorquist and J. Lindkvist Tableware, *New York* (1985), manufactured by Gustavsberg, Sweden_____

Maryse Boxer Tableware (1985), manufactured by Honiton Pottery and Kelsey, UK_____

Alison Britton *Big White Jug* (1987), UK_____

The Cloth Fabrics (1985, 1987), manufactured by The Cloth, UK_____

Luigi Colani Tableware, *Drop* (1971), manufactured by Rosenthal, West Germany_____

Tias Eckhoff Tableware, *Regent* (1961), manufactured by Porsgrund, Norway_____

Leif Helge Enger Pot, ladle, mugs (c. 1986), manufactured by Porsgrund, Norway. Tableware, *Saturn* (c. 1986), manufactured by Porsgrund, Norway_____

Arje Griest Carafe, goblet (c. 1985), manufactured by Holmegaard, Denmark_____

Hans Hollein, Alessandro Mendini, Paolo Portoghesi, Aldo Rossi, Oscar Tusquets Blanca, Kazumasa Yamashita Prototypes of tea- and coffee-sets (1983), manufactured by Alessi, Italy_____

Afaq Husseinova Stoneware plate (1986), USSR___

Kado Isaburo Bowls (1986), Japan_____

Poul Jensen Vase (1985), manufactured by Porsgrund, Norway_____

F. Kjellberg Porcelain rice bowl (1974), manufactured by Arabia, Finland_____

Inkeri Leivo Teapot, bowl, *Saaristo* (c. 1985), manufactured by Arabia, Finland_____

Liberty Fabrics, *Clementina* (1986); *Ianthe* (1986), manufactured by Liberty, UK_____

Liz Lowe Vase (1987), UK_____

Carol McNicoll Circular bowl (1986), UK_____

Marlene Müllertz Stoneware dish (c. 1986), Denmark_____

Rosamund Nairac Porcelain vase (c. 1984), manufactured by Rosenthal, West Germany_____

Steven Newell Jug (1987), UK_____

Fuger Persson Bowl, *Spison* (c. 1985), manufactured by Rörstrand, Sweden. Teapot, *Pop* (c. 1965-79), manufactured by Rörstrand, Sweden_____

Sigurd Persson Stoneware teapot (c. 1985), manufactured by Rörstrand, Sweden_____

Jacqui Poucelet Dishes (c. 1985), manufactured by Bing & Grøndahl, Denmark_____

Ambrogio Pozzi Porcelain vase (c. 1984), manufactured by Rosenthal, West Germany_____

Lutz Rabold Tableware, *Modern Art* (c. 1986), *Gallery* (c. 1986), manufactured by Arzberg, West Germany. Tureen, soup bowl, *Club* (c. 1986), manufactured by Arzberg, Germany_____

Fingegerd Råmon Bowl, *Mezzo* (1984), manufactured by Skruf, Sweden. Candleholders/ vases (1985-6), manufactured by Skruf, Sweden_____

Hans Christian Rasmussen Dish (c. 1980), manufactured by Bing & Grøndahl, Denmark_____

Timo Sarpaneva Teapot, cup and saucer, *Kaari* (1984), manufactured by Rosenthal, West Germany. Vases, *Claritas* (c. 1984); *Blues* (c. 1984); *Koh-i-noor* (c. 1984), manufactured by Iittala, Finland. Candlesticks, glasses, *Arkipelago* (c. 1984); *Festivo* c. 1984), manufactured by Iittala, Finland_____

Eystein Saudnes Tableware, *Eystein* (1970), manufactured by Bing & Grøndahl, Denmark_____

Rolf Sinnemark Teapot (c. 1985), manufactured by Rörstrand, Sweden. Bowl, *Atlantis* (c. 1985), manufactured by Rörstrand, Sweden_____

Edith Soane Dish, vases (1980-5), manufactured by Bing & Grøndahl, Denmark_____

K. Swanlund Bowl, vase (c. 1973), manufactured by Holmegaard, Denmark_____

Frank Thrower Various glasses, decanter, carafe, ice-bucket (1967- 8), manufactured by Dartington Glass, UK. *Celery Vase*, *Etruscan Pitcher* (1981), manufactured by Dartington Glass, UK_____

J. van Loon Porcelain vase (c. 1984), manufactured by Rosenthal, West Germany. Earthenware box (1984), manufactured by Rosenthal, West Germany___

J. Vennola Plate, *Kuusi* (1982), manufactured by Iittala, Finland. Drinking mugs (1986), manufactured by Iittala, Finland. Tumblers, *Claudia* (1986), manufactured by Iittala, Finland_____

Warner Fabrics, *Aquarelle* (1985); *Watercolour Stripe* (1985); *Panache* (1985), manufactured by Warner & Sons, UK_____

Robert Welch Ashtray (c. 1960-70), manufactured by Old Hall Tableware, UK_____

Marianne Westman Coffee-pot, cup and saucer, *Mon Amie* (c. 1965-70), manufactured by Rörstrand, Sweden_____

Tapio Wirkkala Tableware, *Variation* (1962), manufactured by Rosenthal, West Germany. Vase, *Pallas* (1983), manufactured by Iittala, Finland. Jug and tumbler, *Ultima Thule* (1983); *Viva* (1983), manufactured by Iittala, Finland_____

USA

Los Angeles County Museum of Art

Laura Andreson *Bowl with Ridges* (1981), USA___

Ralph Bacerra *Large Bowl* (1981), USA_____

Allison Britton *Asymmetrical Pot* (1982), UK_____

Carmen Collell *Teacup and saucer (1984)*, USA___

Hans Coper *Candle holder* (1969), USA_____

Ken Ferguson *Teapot* (1983), USA_____

Viola Frey *The Journey Teapot* (1975-6), USA_____

Dorothy Hafner *Sonar Teapot* (1983), USA_____

Thomas Kerrigan *Tall Architectural Pot* (1984), USA_____

Jennifer Lee *Large Vase* (1984), UK_____

Sam Maloof Music stand, *Duet* (1983-4), USA_____

Philip Mayberry *Fish Platter* (1985), USA_____

Harrison McIntosh *Large Plate* (c. 1975), USA_____

Richard Notkin Teapot and cups, *Skeleton* (1890), USA_____

Magdalene Odundo *Charcoal Burnished Pot* (1983), UK_____

Jacqueline Poncelet *Turtle Teapot* (1982), Belgium_____

Lucie Rie Vase (1979), UK_____

Mary Rogers *Double Cylinder White Vase* (1984), UK_____

Martin Smith Bowl (1984), UK_____

Sutton Taylor *Luster Bowl* (1983), UK_____

Beatrice Wood *Double Bottle* (c. 1970), USA_____

The Metropolitan Museum of Art, New York

Achille and Pier Giacomo Castiglioni Lamp, *Taccia* (1962), manufactured by Flos, Italy_____

Joe Colombo Seating system, *Additional* (1968), manufactured by Sormani, Italy. Chair, *Tube* (1969-70), manufactured by Flexform, Italy_____

Nathalie du Pasquier Fabric, *Gabon* (1982), manufactured by Memphis, Italy_____

Karen Karnes Ceramic jar with lid (1982)_____

Verner Panton Stacking chair, *Z* (1960), manufactured by Herman Miller Furniture, USA_____

Pierre Paulin Chair and ottoman (c. 1962), manufactured by Artifort, The Netherlands_____

Elsa Rady Cup and saucer (1979)_____

Ettore Sottsass Lamp, *Asteroid* (1968), manufactured by Poltronova, Italy. Table, *Le Strutture tremano* (1979), manufactured by Studio Alchymia, Italy_____

Ethel Stein Fabric, damask woven panel (1985)_____

Superstudio Lamp, *Gherpe* (1967), manufactured by Poltronova, Italy_____

The Museum of Modern Art, New York

Eero Aarnio Chair, *Gyro* (1968)_____

Peter Danko Chair, *Bodyform* (1980)_____

John Scofield Music stand (1971)_____

West Germany

Kunstmuseum, Düsseldorf

Volker Albus Light, *Lichtbogen A3* (1984)_____

Stefan Bumm Lamp, *Argus* (1983)_____

Aldo Cibic Desk, *Sophia* (1985), manufactured by Memphis, Italy_____

Michele De Lucchi, Simone Drost, Evelien van Veen Lamp, *Tender* (1986), manufactured by Bieffeplast, Italy_____

Hans Hollein Door handle, *1103* (1986), manufactured by FSB Brakel, West Germany_____

Ulrike Holthöfer and Axel Kufus Blue Armchair (1984)_____

Rodney Kinsman Bar stool, *Tokyo* (1986), manufactured by Bieffeplast, Italy. Armchair, *Vienna* (1986), manufactured by Bieffeplast, Italy. Shelving system, *Graffiti* (1986), manufactured by Bieffeplast, Italy_____

Heinz H. Landes Armchair, *Sessel 13* (1985)_____

Wolfgang Lauberesheimer Free-standing shelves (1985)_____

Alessandro Mendini Door handle, *1102* (1986), manufactured by FSB Brakel, West Germany_____

Ron Rezek Lamp, *Orbis* (1986), manufactured by Bieffeplast, Italy_____

Bořek Šipek Chair, *Gudrun am Leineufer* (1984)_____

Sottsass Associati Armchair, *Lodge* (1986), manufactured by Bieffeplast, Italy. Chair, *Greek* (1986), manufactured by Bieffeplast, Italy_____

Philippe Starck Chair, *Miss Frick* (1986), manufactured by Tribu, France_____

Siegfried Michail Syniuga Armchair, *Hotel Ukraina* (1985)_____

Hermann Waldenburg Armchair, *Schleudersitz* (1984-5)_____

DESIGN PUBLICATIONS

Australia

Belle (monthly) Showcase for contemporary Australian architecture and interior design, with a product round-up that includes many imported design influences

Vogue Living (ten issues a year) Lively lifestyle magazine on decoration and design with a glossy round-up of who's new as well as what's new in interior design

Denmark

Arkitekten (bi-monthly) and **Arkitektur** (every six weeks) Edited by the Danish Architectural Press for the professional federations of architects and building contractors

Bo Bedre (monthly) Translates into English as "Live Better," precisely the editorial policy behind this consumer home-interest magazine

Design from Scandinavia (annual) For the past seventeen years, a useful index of designers and manufacturers against a background of illustrated stories of architectural interest

Living Architecture (bi-annual) Scandinavia's best-looking glossy magazine on buildings and their interiors, both old and new, by the celebrated photographer and architect Per Nagel. Published with English text

Rum og Form (annual) "Space and Form," edited by the Danish Association of Furniture Designers and Interior Designers

Tools (monthly) Tabloid format magazine in English produced by the Danish Design Council, with lively interpretations of product design worldwide from its designer correspondents

Finland

Design in Finland (annual) Published by the Finnish Foreign Trade Association to promote the year's products abroad, with colourful, good-quality presentation of the designs and an index of manufacturers and designers

Form & Function, Finland (quarterly) As the name suggests, a magazine concerned with mass production and functional design in Finland, aimed at the export market, published by the Finnish Society of Craft and Design

Space & Place (annual) Contract furniture collections presented by the Furniture Exporters' Association

France

Cent Idées (monthly) DIY fashion and furnishings home-interest magazine with a centre section of cut-out patterns and templates for the ideas featured

Crée (monthly) Leading professional design magazine with an architectural background

Intramuros (monthly) Large-format black-and-white design and interiors magazine with in-depth interviews

La Maison de Marie Claire (monthly) Condé Nast with *le style français* in a glossy magazine in which everything from plates to pastries is chic

Maison Française (monthly) Fifty-one years old this year, this magazine covers furniture, interiors and architecture

Vogue Décoration (monthly) Weighty and opulent interiors magazine aimed at the Cartier end of the market

Italy

Abitare (monthly) English text published alongside the Italian. A heavily merchandised, up-to-the-minute round-up of new designs makes this the design writer's Bible. Architects and interior designers look to its photographic stories for an international perspective. Some issues are devoted to a single country

Casa Vogue (eleven issues a year) Definitive listing of new trends-in-the-making around the world. An invaluable talent-spotters' magazine, famous for the inspired art direction of its merchandizing stories

Domus (monthly) Gio Ponti founded this authoritative magazine on architecture, interiors, furniture and art; now Mario Bellini is its outspoken, informed editor. More textual than visual, it is taken very seriously by architects and designers

Gap Casa (monthly) Trade figures and commercial marketing strategies sit alongside the product lines in this magazine aimed at retailers

Gran Bazaar (monthly) Environmental topics and architecture in a fairly specialized formula

Interni (monthly) More than its name suggests, a round-up of products relating to external, as well as interior, design

Modo (monthly) With typical bravura, editor Andrea Branzi has made this *the* magazine of the avant-garde in Italian design

Ottagono (quarterly) A review of architecture, interior design, furniture and industrial design worldwide, published in Italian and English editions by eight Italian manufacturers – Arflex, Artemide, Bernini, Boffi, Cassina, Flos, ICF and Tecno. Leading design and architectural writers contribute to this small-format publication

Japan

Axis (bi-monthly) A high-quality round-up of furniture and product design from around the world

Brutus (monthly) A consumer magazine with informed, international coverage of design and interiors

Fusion Planning (bi-monthly) This magazine attempts to bring together significant design trends from around the world

GA (Global Architecture) Definitive photographic essays on high-quality paper, edited by Yukio Futagawa to be the *National Geographic* of architecture

Icon (monthly) An iconoclastic view of architecture, design, interiors and art

The Netherlands

Avenue (monthly) Stylish photo-reportage of cars, products, travel, lighting and furniture alongside avant-garde fashion

Wonen (monthly) A home-interest magazine

New Zealand

New Zealand Home Journal (monthly) A home-interest magazine with interior design coverage

Norway

Hus og Hem (quarterly) A consumer magazine on decoration and interiors

Skala (monthly) Architecture and design from around the world

Spain

Hogares (monthly) "Homes" is published in colour with photographic spreads on Spanish houses and interviews with Spanish designers

On Diseño (monthly) Articles on Spanish architecture and design with a strong interest in graphics and illustration worldwide. The text is in Spanish only. *On Diseño* brought together and promoted the members of SIDI, the celebrated design group now marketing the latest designs at furniture fairs around the world

Sweden

Arkitekten (monthly) A small, in-house official publication for the Federation of Architects and allied building trades in Sweden

Arkitektur (monthly) A round-up of architects' building projects in Sweden, with plans and pictures

Form (eight issues a year) The professional magazine for interior designers

Kontur (monthly) Surveys industrial design with product information for the contract market

Möbler & Miljö (ten issues a year) This specialist magazine, "Furniture & Environment," is read by the "decision-makers" who buy and make furnishings for interior designers

Sköna Hem (six issues a year) Sweden's showcase home-interest magazine with colourful photographic coverage of architecture and interior design. The *House & Garden* of Scandinavian design

UK

Architects' Journal (weekly) The professional magazine for British architects

Architectural Review (monthly) A well-written and informed magazine which examines projects, with plans, worldwide

Blueprint (ten issues a year) Fast-forward into what's being planned, built, assembled, launched or revived. Racy lay-outs in a large format, mostly black-and-white, with informed, hard-hitting comment

Design (monthly) The official publication of the British Design Council

Designers' Journal (monthly) The enlightened companion to the *Architects' Journal*, aimed at a predominantly contract market with interviews covering all aspects of design from the theatre to products

Design Week (weekly) The designers' up-to-the-minute who's who, where's where and what's what with a useful job listing. Good graphics coverage

Homes & Gardens (monthly) A home-interest magazine equivalent to the high-street design shop, seen as inspirational by those who buy it. The emphasis is on advice on any aspect of decoration and design

House & Garden (monthly) Condé Nast's biggest-selling design and decoration magazine in the UK. Although the emphasis of the editorial is on interior decoration, it features more modern furniture pages than any other UK magazine, as well as sponsoring an annual "Young Designer of the Year" competition. Design and architectural information is strongly merchandised

World of Interiors (eleven issues a year) *The* interiors magazine to be seen in, offering a voyeuristic tour around some of the world's most lavishly decorated homes. The international gallery listings are wide-ranging and talent-spotting. Collections of designer products within a theme offer stylish concepts alongside product information

USA

Architectural Digest (bi-monthly) An authoritative celebrity round-up of the lavish homes of the rich and famous, presented in a highly successful coffee-table format

Architectural Record (monthly) A professional and trade architectural magazine

HG (monthly) The new look and title of *House and Garden USA* by ex-British *Vogue* editor Anna Wintour. Features new ideas on decoration, design and architecture as well as developments in fashion and the arts

ID Magazine (bi-monthly) The industrial designers' product guide, with features on furniture

Interiors (monthly) A trade magazine for professional interior designers

Metropolis (monthly) The blueprint for *Blueprint* UK, this large-format tabloid with spirited news, views and ideas in the design world is creatively edited with a strong New York bias

Metropolitan Home (monthly) An energetic, trend-spotting magazine for the upwardly mobile, with fashions in furnishings and furniture presented by a young editorial team with a strong sense of direction. Plenty of consumer information

Progressive Architecture (monthly) One of America's two heavyweight architectural journals, a forum for spirited debate

West Germany

Ambiente (bi-monthly) A consumer magazine on interior design

Architektur und Wohnen (monthly) Interviews with the architects and owners of the remarkable homes featured. It links professional and consumer interests, as well as containing exhaustively researched product reports

Das Haus (monthly) A consumer-oriented, mid-market glossy magazine on interiors

Häuser (six issues a year) House case-histories, architectural portraits, design product round-ups and extensive floor plans. There is an English-language supplement

Schöner Wohnen (monthly) A popular home-interest magazine, featuring design awareness in homes rather than architectural tracts